SELLING WOMEN'S HISTORY

SELLING WOMEN'S HISTORY

Packaging Feminism in

Twentieth-Century American

Popular Culture

EMILY WESTKAEMPER

RUTGERS UNIVERSITY PRESS
NEW BRUNSWICK, NEW JERSEY, AND LONDON

Library of Congress Cataloging-in-Publication Data

Names: Westkaemper, Emily, 1979– author.
Title: Selling women's history : packaging feminism in twentieth-century American
 popular culture / Emily Westkaemper.
Description: New Brunswick, New Jersey : Rutgers University Press, 2017. | Includes
 bibliographical references and index.
Identifiers: LCCN 2016015514| ISBN 9780813576336 (hardback) | ISBN 9780813576329
 (pbk.) | ISBN 9780813576343 (e-book (epub)) | ISBN 9780813576350 (Web PDF)
Subjects: LCSH: Women in popular culture—United States—History. | History in
 popular culture—United States—History. | Women in advertising—United States—
 History. | History in advertising—United States—History. | Women—United States—
 History. | Feminism—United States—History. | BISAC: SOCIAL SCIENCE / Women's
 Studies. | ART / Popular Culture. | SOCIAL SCIENCE / Popular Culture. | DESIGN /
 Graphic Arts / Advertising. | HISTORY / United States / General.
Classification: LCC HQ1410 .W47 2017 | DDC 305.420973—dc23
LC record available at https://lccn.loc.gov/2016015514

A British Cataloging-in-Publication record for this book is available from the British
Library.

Visit our website: http://rutgerspress.rutgers.edu

Manufactured in the United States of America

For my mother, Kathleen Hogan Westkaemper

CONTENTS

ACKNOWLEDGMENTS

I received generous financial support for archival research from the Smithsonian Institution, the Hagley Museum and Library, the Radcliffe Institute for Advanced Study at Harvard Schlesinger Library, Smith College, the University of Wyoming American Heritage Center, Franklin & Marshall College, and an Andrew W. Mellon Foundation Fellowship at the Library Company of Philadelphia and the Historical Society of Pennsylvania. Rutgers University and its history department provided funding during my graduate study. James Madison University (JMU) provided vital assistance through an Edna T. Shaeffer Humanist Award, a College of Arts and Letters Faculty Summer Research Grant, a Madison Caucus for Gender Equality Professional Development Fund Grant, and history department research funds. I would also like to thank Gabrielle Lanier, Michael Galgano, David Jeffrey, and my colleagues and students for making JMU a wonderful place to work as a historian.

Many archivists and curators assisted my research. Thank you to Marianne Hansen and Eric Pumroy for providing access to the unprocessed Philadelphia Club of Advertising Women records at the Bryn Mawr College Library. At the Smithsonian's National Museum of American History, Larry Bird, Fath Davis Ruffins, and Susan Strange offered useful insight. Larry generously shared his *Cavalcade of America* research materials. At Schlesinger Library, Ellen Shea made fruitful recommendations. Paula Weddle and the JMU interlibrary loan staff provided important assistance.

I appreciate feedback on portions of this work presented at the JMU History Forum; the JMU Center for Faculty Innovation; the 2013 American Historical Association Annual Meeting; the 2008 Berkshire Conference; the 2007 American Studies Association Annual Meeting; and the 2007 Graduate

Symposium on Women's and Gender History at the University of Illinois, Urbana-Champaign. Participants in Bonnie Smith's research seminar at Rutgers helped me define this project. Pete Daniel, David Gilbert, Ann D. Gordon, Elizabeth Hageman, Allen Howard, Alison Isenberg, Temma Kaplan, Abigail Lewis, Sandra Mendiola Garcia, Jennifer Miller, and Melissa Stein improved my research and writing. I am also grateful to Anne Boylan for sharing her seminar paper on radio and her research on Miriam Holden. My JMU student Jessica Davis located the *Saturday Evening Post* article "Are Women Doing Their Share in the War?"

I first examined popular culture's use of the past for an undergraduate thesis directed by Grace Hale, whose insight set the path for my subsequent research. Cindy Aron, Alon Confino, Alan B. Howard, Elisabeth Ladenson, Michael Levenson, and Franny Nudelman also provided inspiration at that early stage.

Nancy Hewitt, Jackson Lears, Bonnie Smith, and Jennifer Scanlon provided expert guidance on my dissertation. I am also indebted to Nancy Hewitt for her advice and encouragement on its revision into this book.

I am deeply grateful for the editorial work of Kimberly Guinta, Carrie Hudak, Katie Keeran, and Leslie Mitchner at Rutgers University Press and for the feedback of three anonymous readers. I also thank copyeditor Romaine Perin and all the Rutgers University Press staff who have assisted with this publication.

Throughout my research and writing, I drew support from family members: Timothy Westkaemper, Richard Benedict Westkaemper, Sunya Olson Westkaemper, and Richard Barwise Westkaemper. The memory of Margaret Paradise Hogan is one of the reasons I pursued women's history. I benefited from Sarah Henry's invaluable friendship throughout the entire process. Aric Berg gave bountiful inspiration.

My mother, Kathleen Hogan Westkaemper, has sustained me in countless ways, which I am grateful to acknowledge with thanks and love.

ABBREVIATIONS

ACC Avon Company Collection, Hagley Museum and Library Digital Archives

AFA Advertising Federation of America Records, Briscoe Center, University of Texas at Austin, TX

APR Avon Products, Inc., Records, Hagley Museum and Library, Wilmington, DE

APS American Periodicals Series Online, ProQuest, http://www.proquest.com

AWNY 86–M216, SL Advertising Women of New York Records, 86–M216, Schlesinger Library, Radcliffe Institute, Harvard University, Cambridge, MA

AWNY Additional Records, SL Advertising Women of New York Additional Records, 1935–1987, 87-M31–87-M158, Schlesinger Library, Radcliffe Institute, Harvard University, Cambridge, MA

AWNY SHSW Advertising Women of New York Records, State Historical Society of Wisconsin, Madison, WI

AWSL Advertising Women of St. Louis, Missouri, Scrapbooks and Newsletters, microfilm, Western Historical Manuscript Collection, University of Missouri, St. Louis

Ayer N. W. Ayer Advertising Agency Records, Archives Center, National Museum of American History, Smithsonian Institution, Washington, DC

BDSP Bernice Dutrieuille Shelton Papers, Historical Society of Pennsylvania, Philadelphia, PA

CCSP Charlotte Cramer Sachs Papers, Archives Center, National
 Museum of American History, Smithsonian Institution,
 Washington, DC, Gift of Lilian Randall

DDPSL Dorothy Dignam Papers, A-114, Schlesinger Library,
 Radcliffe Institute, Harvard University, Cambridge, MA

DDPW Dorothy Dignam Papers, State Historical Society of
 Wisconsin, Madison, WI

GH *Good Housekeeping*

HID Imprints Department, Hagley Museum and Library,
 Wilmington, DE

HPSL Eva Hansl Papers, Schlesinger Library, Radcliffe Institute,
 Harvard University, Cambridge, MA

HPSSC Eva Hansl Papers, MS 72, Sophia Smith Collection, Smith
 College, Northampton, MA

HSP Historical Society of Pennsylvania, Philadelphia, PA

HWP Harry Warren Papers, Archives Center, National
 Museum of American History, Smithsonian Institution,
 Washington, DC

IPC Irna Phillips Collection, State Historical Society of
 Wisconsin, Madison, WI

JWTA J. Walter Thompson Company Archives, John W. Hartman
 Center for Sales, Advertising, and Marketing History, Duke
 University, Durham, NC

KTTOHP Kraft Television Theatre Oral History Project, Archives
 Center, National Museum of American History, Smithsonian
 Institution, Washington, DC

LCP The Library Company of Philadelphia, Philadelphia, PA

LTDL Legacy Tobacco Documents Library, University of California
 San Francisco, http://legacy.library.ucsf.edu/

LTPP Lucile Turnbach Platt Papers, John W. Hartman Center for
 Sales, Advertising, and Marketing History, Duke University,
 Durham, NC

NBCRC NBC Radio Collection, Recorded Sound Reference Room,
 Library of Congress, Washington, DC

NMAH National Museum of American History, Smithsonian
 Institution, Washington, DC

NWRP	Nancy Wilson Ross Papers, Harry Ransom Center, University of Texas at Austin, TX. Used by permission of Harold Ober Associates
NYT	*New York Times*
PCAWR	Philadelphia Club of Advertising Women Records, Bryn Mawr Special Collections, Bryn Mawr, PA. Citations reflect these records' original organization, prior to processing in 2009
PQHN	ProQuest Historical Newspapers, http://www.proquest.com
RAPP	Rose Arnold Powell Papers, Schlesinger Library, Radcliffe Institute, Harvard University, Cambridge, MA
RG12, Entry 174, ROE	Record Group 12: Records of the U.S. Office of Education, Special Projects and Programs, Radio Education Project, Office of the Director, Records Relating to Radio Programs, 1935–1941, National Archives and Records Administration II, College Park, MD
RG12, Entry 177, ROE	Record Group 12: Records of the U.S. Office of Education, Special Projects and Programs, Radio Education Project, Office of the Director, Progress Reports, National Archives and Records Administration II, College Park, MD
RG12, Entry 187, ROE	Record Group 12: Records of the U.S. Office of Education, Special Projects and Programs, Radio Education Project, Script Writers and Editors, Office Files, 1936–1940, National Archives and Records Administration II, College Park, MD
ROE	Records of the U.S. Office of Education, National Archives and Records Administration II, College Park, MD
SCCC	Salem China Company Collection, Archives Center, National Museum of American History, Smithsonian Institution, Washington, DC
SCR	Simmons Company Records, Archives Center, National Museum of American History, Smithsonian Institution, Washington, DC
SHSW	State Historical Society of Wisconsin, Madison, WI
SL	Schlesinger Library, Radcliffe Institute, Harvard University, Cambridge, MA
SRC	Sperry Rand Collection, Hagley Museum and Library, Wilmington, DE

SSC Sophia Smith Collection, Smith College, Northampton, MA

WACCP Women's Advertising Club of Chicago Papers, University of
 Illinois at Chicago, Special Collections, Chicago, IL

WCBA Warshaw Collection of Business Americana, Archives
 Center, National Museum of American History, Smithsonian
 Institution, Washington, DC

WP The Wanamaker Papers, Collection 2188, Historical Society
 of Pennsylvania, Philadelphia, PA

WWLC *Wonder Woman* letters collection, 1941–1945, Dibner Library,
 National Museum of American History, Smithsonian
 Institution, Washington, DC

SELLING WOMEN'S HISTORY

INTRODUCTION

The assertion that women have a history worth telling has featured promi-
nently in American feminism. Between suffrage and the women's liberation
movement—before the institutionalization of women's history as a scholarly
field—the mass media offered unique opportunities for promoting this mes-
sage. Within U.S. popular culture, feminists, historians of women, corporations,
and the advertising industry publicized diverse—sometimes competing—
discourses about women's historical roles.[1]

This book analyzes the variety of women's histories in product promo-
tions and commercial media from the 1910s through the 1970s. Patterns
established early in the century persisted for decades. Historical subjects
ranged from exceptional achievers to anonymous grandmothers. American
stories—both fictional and fact based—appeared most frequently, with an
assortment of archetypes and eras represented. Some narratives proclaimed
modern progress, seeking to differentiate the past and the present by touting
the benefits of new products—or by applauding women's growing roles in
employment, education, and politics. Other popular histories distorted the
past so it mirrored modern norms. Sentimentalized visions of eighteenth- and
nineteenth-century domestic life saturated the twentieth-century consumer
culture landscape of women's magazines, greeting cards, product packages,
and store displays. Such portrayals often supported dominant gender ideals,
particularly the importance of consumption to female identity.

Popular culture's women's histories were not necessarily feminist histories. By elevating earlier generations as models, advertisements often prescribed continued devotion to domesticity as female consumers' duty to family and nation. Such narratives suggested that present-day changes—including suffrage and new household technologies—should not remove women from their exalted position in the home. Responding to the Great Depression and World War II, corporations likened colonial women and nineteenth-century western pioneers to their modern counterparts, celebrating an inherent female capacity for maternal and patriotic sacrifice while asserting women's subordinate social status across time.

However, throughout the twentieth century, consumer culture also offered depictions of women as independent—sometimes transgressive—historical actors. Magazines, radio, film, and comic books featured biographies of famous and forgotten women, including entrepreneurs, activists, educators, and wives of notable men. Advertising women, magazine contributors, and scriptwriters elevated historical examples of women's contributions to business and politics, asserting precedents for their own careers. Women historians added to mass market magazines' and to radio's frequent forays into the past, touting knowledge of historical struggles and achievements as a pathway to improving modern conditions. In some respects, this work prefigured the subject matter and perspective of late twentieth-century academic historians, tracking changes in the expectations for women's behavior to demonstrate that society rather than biology had limited women's activities.

Such historical revisionism appeared most prominently when adwomen, historians, and activists created their own platforms, developing new programs for 1930s radio. These projects provided feminist biographies that looked beyond domesticity, seeking to rescue women's political, economic, and military contributions from obscurity. Nevertheless, strategic concessions to popular norms appeared even in these cases, as feminists sought wide audiences. Then, commercial celebrations of women's historical contributions to public life increased when corporate advertisements, women's magazines, and commercial entertainments offered the past as inspiration for women's active participation in World War II. However, ahistorical assumptions of timelessness in women's devotion to domesticity, romance, and beauty underpinned these depictions of women's public contributions as a response to crisis. Thus, while the possibilities for experimentation in early commercial radio, and then the wartime propaganda supporting women's military enlistment and paid industrial employment, brought complex, feminist portrayals of the past to new prominence, there was also significant continuity across the century because mass media consistently offered multiple models

for understanding women's history. A single magazine issue or broadcast day provided discrepant messages. A consumer in 1910 and one in 1970 could encounter mass media narratives that cast women's legacy as timeless tradition—as well as narratives whose attention to historical transformation suggested that gender ideals were a social construction. Underlying these differences, however, was the shared logic that women's history merits documenting.

The History of Women Historians

My analysis builds on recent scholarship about the diverse ways in which women told histories in nineteenth- and twentieth-century America. Bonnie Smith's *The Gender of History* examines the innovations women made as teachers, preservationists, and amateur writers after nineteenth-century professionalization defined the historian as a scientific male. Marginalized within academia, women historians nevertheless anticipated later historiographic evolutions, including attention to material culture and everyday life.[2] As Julie Des Jardins demonstrates in *Women and the Historical Enterprise in America*, women historians and historical preservationists working at the turn of the twentieth century reached wide audiences with efforts to bring greater attention to women's contributions, particularly within domesticity. An 1897 biography by Anne Hollingsworth Wharton detailed Martha Washington's political influence, proclaiming that "women have been short shrifted in historical accounts" and lamenting that George currently overshadowed his wife in popular memory. Other works, like Alice Morse Earle's *Home Life in Colonial Days* (1898) reconstructed unknown women's everyday household labor.[3] Meanwhile, women waged campaigns to preserve houses and domestic artifacts as democratic symbols. The Daughters of the American Revolution (DAR), the Society of Colonial Dames (SCD), and the United Daughters of the Confederacy (UDC) all emerged in the 1890s, presenting members' reverence for their ancestors as proof of modern women's centrality to nationalism and patriotism.[4] World War I and the Red Scare brought new significance to heritage groups' activities, forging an alliance between the DAR and the government in service of national defense and anticommunism.[5]

Des Jardins proposes that these "pageant masters, domestic writers, and preservationists . . . [who were] conservative in their political outlook and nostalgic in their views on the national past may have unwittingly paved the way for diverse groups of American women with new agendas—radicals, feminists, and race activists, among others—to engage in the public sphere, as both historians and historical heroines in the making."[6] For example,

building on the connections between historical commemoration and elite womanhood, the National Association of Colored Women (NACW) sought recognition and political capital within the civil rights movement by funding the preservation of Frederick Douglass's home in the 1910s.[7] From the 1900s through the 1940s, historians housed inside and outside the academy, among them Edith Abbott, Annie Abel, Mary McLeod Bethune, Mary Ritter Beard, Angie Debo, and Lucy Maynard Salmon, uncovered historical evidence to encourage reexamination of contemporary ethnic, racial, socioeconomic, and gender inequalities. They wrote books, advocated new pedagogies, and urged the public to participate in archive collection. Much of their work explored underresearched fields such as African American history and Native American history. Nevertheless, the DAR and SCD exerted more popular impact, their glorifications of elite white women and men amplified by collaborations with consumer culture.[8] For example, in the 1930s, as historian Francesca Morgan demonstrates, local DAR chapters designed department store windows celebrating George Washington, Martha Washington, and Betsy Ross.[9]

Building on this scholarship's attention to the diverse outlets women used to tell histories, I analyze the packaging of stories about women's pasts for mass audiences as part of the larger "historical enterprise." To consider the motives behind the creation and consumption of popular culture's histories, I draw evidence from the archival collections of corporations, advertising agencies, women's advertising clubs, and individual writers and workers. Women employed in advertising feature prominently. Like scholars Jennifer Scanlon, Simone Weil Davis, and Denise Sutton, I identify the personal feminist philosophies of adwomen as an influence on these adwomen's professional work.[10] Placing new emphasis on adwomen's professional societies, I argue that adwomen strategized, across multiple media, to construct a usable past that would support their own professional and activist goals.

IDENTIFYING FEMINIST HISTORY IN POPULAR CULTURE

This book deploys historian Nancy Cott's definition of feminism as a philosophy with three core components: the opposition to hierarchy based on biological sex, the understanding that such inequalities are socially constructed, and the consciousness of women's shared experiences and status. This identification of women as a social group can inspire collective action to combat gender inequality.[11] I define feminist history as analysis or commemoration of the past that is motivated by feminism or that supports feminism's logic. Within popular culture, feminist histories sometimes relied on ahistorical

comparisons, made without supplying sufficient context for adequately tracking change and continuity over time. Nevertheless, I categorize historical narratives as feminist activism when they strove to change social norms, publicizing the past to open new political and economic opportunities for women. Adwomen's popular histories were largely motivated by personal career ambition, but these histories also redefined gender ideals. To dramatize the suitability of women for careers in marketing, adwomen pitched their narratives to professional organizations, potential employers, and consumers.

By identifying the resonance of such feminist rhetoric in mid-twentieth-century consumer culture, I also draw from recent scholarship challenging the division of the history of feminism into discrete movements, or "waves." Beginning in the 1960s, women's liberationists described themselves as "second wave" feminists, conceptualizing the "first wave" as women's rights activism beginning in the mid-nineteenth century and cresting with the ratification of the Nineteenth Amendment in 1920.[12] Scholars adopted this model, and academic histories of feminism produced in the wake of the 1960s often assumed that the decades between the waves marked a lull in women's activism. More recent works have challenged this idea, examining varieties of feminist action in those years.[13] Accordingly, some scholars have identified alternative ways to conceptualize the evolution of feminism. In her study of four women, born between 1873 and 1896, who made feminism their life's work, Mary Trigg applies a generational framework to acknowledge these individuals' shared experiences while contextualizing their efforts within a larger feminist continuum of strategies and ideas persisting across generations.[14] Reassessing the wave model, Nancy Hewitt applies an alternative metaphor of radio communication. Imagining feminist movements as radio waves, whose lengths and frequencies affect broadcast range, she explains, would "help us think about how competing versions of feminism coexist in the same time period, but they also continue to resonate even in moments of seeming quiescence."[15]

Both the generational and the radio waves models provide a useful way to approach popular culture's histories. This book's core examples of female creators and consumers of popular history were born between 1871 and 1903, coming of age during the final stages of first-wave feminism. Some continued to produce new popular histories into the early 1960s. Many of these women expressed ambitions to leave a legacy for subsequent generations, as they sought to document histories that preceded their birth—as well as ones in which they were actors. Simultaneously, the women covered in this book also publicized diverse histories. This diversity appears not only in cultural discourse as a whole but also within individuals' bodies of work.

Many feminists used multiple media outlets, broadcasting conflicting and overlapping interpretations simultaneously. For example, the work adwomen produced for their corporate clients shared the radio airwaves—in some cases literally as well as metaphorically—with the feminist narratives created by adwomen's professional societies. By examining the interconnections between these popular commemorations, this book considers the variety of twentieth-century feminism.

How Popular Culture Evoked the Past

American popular culture has frequently cited the past to define the present.[16] As historian Michael Kammen argued, visions of the nation's creation as a dramatic rejection of European tradition inspired late nineteenth- and early twentieth-century popular histories that narrated the past as a story of progress. Then, between World Wars I and II, mass media perpetuated a "nostalgic modernism." Because celebrations of modernity required historical examples for contrast, Americans looked simultaneously to the past and to the future.[17] According to historian David Lowenthal, the concentration of commemoration in delineated, but ever-present spaces in society, including museums and historical reproductions available for consumer purchase, removed the perceived danger of backward-looking complacency.[18]

Within popular memory, the tension between nostalgia and modernity resulted in stories celebrating men as agents of progress and women as forces of stability. Early twentieth-century mass media relied on identifiable male icons as shorthand for American exceptionalism, reminders of the innovation embedded in the creation of the United States. In these stories of great men, women typically appeared in subordinate roles as patriotic nurturers. In many narratives celebrating George Washington as an agent of change, Martha's homemaking received credit for providing essential support. However, the first lady's own personality remained vague. Memorialized in historical pageantry and school lessons in the 1920s and 1930s, Betsy Ross attained unprecedented visibility as a historical heroine who created something new. But her acclaim stemmed from her resonance with the familiar image of colonial domesticity. Patriotically applying her seamstress skills to produce the original Stars and Stripes for General Washington, the mythic Ross sat at the iconic, glowing hearth of the colonial home.[19]

The historiography on gender and consumer culture illuminates the economic motives driving such stories. As William Leach, Jennifer Scanlon, and other historians have shown, early twentieth-century marketers and magazine editors encouraged consumer desire for products by elevating

housekeeping as personally fulfilling, socially important work.²⁰ By drawing parallels between contemporary life and the idealized early American epoch, women's magazines likened consumption to patriotic, democratic participation, presenting shopping as both a historically significant act and a way to honor America's past.²¹ Proclaiming colonial roots for their own products, manufacturers sidestepped popular anxieties about mass production and its perceived disruptions of the Jeffersonian ideal of household economic self-sufficiency.²² Simultaneously, advertisers asserted the stability of social differences by assuming that the ideal woman—past and present—was white. In corporate marketing campaigns pitched to the mainstream consumer public, African American women seldom appeared outside the context of nostalgia for the antebellum South.²³

Historical novels and films provided more complex portraits of women who transcended domestic support roles. Scholar J. E. Smyth contrasts the scarcity of female subjects in early twentieth-century academic narratives with the abundance of female characters popularized by such novelists as Edna Ferber (author of *Cimarron* and *Show Boat*) and Margaret Mitchell (*Gone with the Wind*) in the 1920s and 1930s. In the 1930s, when Hollywood prioritized female filmgoers as the majority of the industry's target audience, cinematic adaptations of these authors' work, and of literary classics, for example, Louisa May Alcott's *Little Women* (1868) and Helen Hunt Jackson's *Ramona* (1864), encouraged audiences to identify with rebellious female characters and their transgressions against their eras' norms. Ferber's and Jackson's stories examined racism against African Americans and Native Americans and celebrated mixed-race protagonists. Meanwhile, Hollywood also offered fictionalized biopics, portraying Annie Oakley and Calamity Jane as headstrong but feminine heroines in the American West. While "great men" inspired greater numbers of movies, these films portrayed women as active participants in the past.²⁴

Simultaneously, the films of writer and star Mae West (including *She Done Him Wrong* [1933] and *Belle of the Nineties* [1934]) provided a comedic take on historical fiction, deploying what media scholar Pamela Robertson identifies as a "feminist camp" sensibility. As West's performances combined modern slang and humor with 1890s costumes and settings, her characters mocked the limitations of nineteenth-century gender ideals. Such engagement with the past supported the feminist logic that gender was constructed and, thus, changeable. Like the camp aesthetic that Susan Sontag famously theorized, this perspective dramatized both the appeal and the ridiculousness of outmoded styles.²⁵

While historical fiction presented alternative perspectives on women's history, corporations and their own political goals dominated fact-based

popular interpretations from the 1930s through the 1950s. As historian William Bird Jr. demonstrates, the DuPont chemical company sponsored the historical anthology *Cavalcade of America* on radio (1935–1953) and television (1952–1957), dramatizing notable men's and women's lives to make the corporation's capitalist vision, rooted in opposition to the New Deal, palatable to the public. Prominent scholarly historians served as program consultants, embracing the opportunity to reach large audiences, even when their own politics differed from DuPont's.[26]

While most *Cavalcade* subjects were men, biographies of women did appear. However, the program's triumphant framework and commercial goals often limited its portrayals of feminist history. By contrast, CBS broadcast its series of dramatic historical reenactments without corporate sponsorship for its radio incarnation *CBS Is There* (1947–1950) and for half of its *You Are There* television episodes (1953–1957). Historian Erik Christiansen analyzes the program as a reflection of its male writers' leftist politics; some of them black-listed, they sought to examine social problems, including gender oppression.[27] During the Cold War, however, such candor was rare. Corporations actively shaped school curricula and public history exhibitions.[28] Scholarly historians strove to shape popular memory with enterprises like a History Book Club subscription service. However, Christiansen argues, their initial goals of exposing the public to critical interpretations ultimately gave way to political and market demands for celebratory commemoration.[29]

The subjects of my book endeavored to meld business and feminism, embracing popular culture as a forum for telling women's history. Reworking themes already prevalent in media portrayals, early twentieth-century advertising women positioned themselves as agents of modernity and as guardians of the past. By celebrating women's historical contributions, adwomen became activists on their own behalf, working in dialogue with their industry's larger efforts to claim legitimacy as a prestigious American profession with roots in the nation's founding.[30] Contemporaneous with the late nineteenth-century professional societies that standardized such fields as medicine, law, and history, associations of advertisers emerged across the country. In the 1910s, these groups sought public favor by promoting industry self-regulation to ensure "truth in advertising" and by sponsoring civic activities that celebrated the role of business in American life.[31] Excluded from membership, women formed their own societies, beginning with the League of Advertising Women (later renamed the Advertising Women of New York [AWNY]), established in 1912 "to enable women doing constructive advertising to co-operate for the purpose of mutual advancement; to further the study of advertising in its various branches; and to emphasize the work that

woman is doing and is specially qualified to do in the field of sales promotion and in the many-sided business of advertising."[32] AWNY and other women's advertising clubs combined educational programs, such as vocational courses for women, with highly publicized social and professional events. Their annual balls and their lectures on the latest advertising techniques earned prominent newspaper and trade journal coverage. Applying historical pageantry and industry history to these activities, clubs created a usable past that justified women's presence in modern business and supported feminist demands for further advancement in women's roles by asserting continuity in women's abilities across time.

Advertising women combined their feminist claim that women merited better opportunities with their acceptance of prevailing ideals of femininity. This reflected their vocation. Consumer culture—and adwomen's employment—depended on the success of corporate sponsors peddling domestic and beauty products. Accordingly, advertising women often adopted essentialist definitions of gender. They created historical narratives in which innate maternal drives or proclivities for fashion shaped women's lives. However, these stories also cast motherhood, consumption, and housework as well-established pathways to more public contributions, ascribing new value to women's culturally prescribed roles. This approach sustained professional women's efforts to claim legitimacy, and it incorporated feminist ideas during the midcentury decades between suffrage and women's liberation.

DOROTHY DIGNAM: ADVERTISING AS A HISTORIAN'S WORK

Evidence from the papers of Dorothy Dignam (1896–1988), a longtime copywriter and women's advertising club member, appears throughout this book. Dignam applied her personal interest in history to her professional work. Simultaneously, she collected substantial archives documenting her own career and the history of women in advertising—materials subsequently used by historians of advertising and American culture.[33] *Selling Women's History* expands upon these scholars' work by assessing Dignam's and her contemporaries' own efforts as historians. As adwomen strove to document their experiences for subsequent generations, they constructed histories that supported their feminist and professional goals.

Dorothy Dignam began her writing career as a child, contributing columns for the regional lifestyle magazine published by her Chicago advertising agent father. After his 1916 death, she volunteered for Chicago's *Women's Press*, seeking reporting experience. This became a paid position, and Dignam contributed articles that likened civilian responses to World War I to historical

examples of American patriotism.[34] These pieces celebrated the past's power to inspire.[35] A 1918 article praised "Martha Washington Bags," packages of clothing and toiletries for female refugees in France created by women of the Chicago Chapter of the American Fund for French Wounded with support from local groups, including the Women's Advertising Club of Chicago.[36] The kits held French-language cards with the dedication "in memory of Martha Washington[:] wife of George Washington, first President of the United States, father of his country, and friend of the Marquis de La Fayette [sic] who gave aid to America in the war for its independence."[37] Focused on the president, this biography credited Martha only for her marriage. Dignam's report provided further commendation, editorializing that "Martha Washington always has been beloved in this country. No woman in our national history had greater or more noble attributes. And associated with her are all the quaint and picturesque customs of our early days, as well as the memory of her helpful and encouraging influence upon President Washington when he was engaged in the struggle for our independence." Briefly lauding Martha Washington for her helpmeet role, this publicity attributed her appeal to a preexisting popularity. She deserved historical celebration because she had previously received historical celebration: Dignam's focus on the first lady's ability to invoke nostalgia reflects the emotional, rather than educational, tone that pervaded many popular histories.[38]

But during the coming decades, Dignam and her contemporaries would expand the mass media's historical canon, both through their own careers as women working in advertising and through their collective feminist activism to expand opportunities for women in business. It was no accident that advertising women, frequently cited as symbols of modern changes in gender roles, turned so frequently to the past. By publicizing their visions of history, they pursued multiple goals. They demonstrated professional skill through their strategic ability to capitalize on the preexisting vogue for historical references. Simultaneously, by finding examples, set safely in the past, where women succeeded by challenging social norms, they established precedents that legitimized their own feminism, making it appear traditional rather than transgressive.

This project complemented Dignam's own interest in storytelling. Writing in her early career personal diary that she preferred journalism "although the money is in advertising," she began work as a copywriter for a Chicago-based agency in 1919, noting that she was the sole woman in her department.[39] She quickly joined the Women's Advertising Club of Chicago, which connected her with others facing isolation at predominantly male workplaces.[40] By 1920, she began serving as its official historian.[41] Some pasts, however, intrigued her more than others. In her diary she flatly described spending "all day at

the library looking up dead men's quotations" to promote one of her agency's clients, Chicago's Moody Bible Institute.[42] The tone contrasted sharply with an entry applauding her city's fiftieth-anniversary observance of its Great Fire with "big celebrations and displaying of relics everywhere." She singled out the Marshall Field's department store for its "old rooms fixed up" and displays of *Godey's Lady's Book*, concluding, "I love old relics."[43] Such enthusiasm reflected Dignam's preference for women's history documented through cultural sources, an interest that shaped her later work in advertising.

Entering the influential N. W. Ayer & Son advertising agency as a copywriter in 1929, Dignam joined the Philadelphia Club of Advertising Women (PCAW).[44] First established in 1916, this organization made women's history a defining feature in its public identity. In 1929, the PCAW created an official colonial "Quaker Maid" mascot to symbolize local women's civic and professional contributions, past and present. This was a direct response to the influential, exclusively male Philadelphia advertising society, the Poor Richard Club, which proudly claimed Benjamin Franklin as the antecedent of the modern adman.[45] By the 1930s, the Quaker Maid logo, with its bonnet-wearing character, identified PCAW publications. PCAW members appeared in historical costume at industry and community events, and local radio broadcasts written and produced by the club dramatized the lives of diverse historical women. These radio performances recounted the vital roles "women of yesteryear" played in the development of American society, celebrating women for leadership, activism, and professional achievements. Subjects included familiar icons like Betsy Ross and feminist activists like Susan B. Anthony. Dorothy Dignam contributed biographies of career women, including *Godey's Lady's Book* editor Sarah Josepha Hale. With these stories, club members transcended the familiar advertising imagery of a woman in historical dress standing eternally in the background with a serving tray at the ready. In the hands of the PCAW, the Quaker Maid and her counterparts provided evidence of women's innate abilities to contribute to public life.[46]

As her career progressed, Dignam created advertising campaigns that foregrounded the past in diverse ways. Assigned to promote Ford cars to female consumers in the 1930s, she authored stories celebrating women who, by driving, challenged social conventions during previous decades. Although Dignam had sacrificed her journalistic ambitions, publications now printed her byline on Ford-commissioned articles narrating this history. A 1935 piece in the *Philadelphia Record* ridiculed turn-of-the-century newspapers for erroneously depicting women as "scatter-brained," incapable drivers. A large photograph of glamorous actress Henrietta Crosman behind the wheel in 1913 bore the caption "Feminism Encounters the Machine Age."[47]

After moving to N. W. Ayer's New York City office in 1939, Dignam also used history to bolster romantic archetypes, publicizing De Beers jewels with the slogan "A diamond is forever."[48] That campaign's 1940s magazine advertisements celebrated marriage as an eternal commitment as well as an eternal interest for women. As historian Vicki Howard has demonstrated, retailers promoted diamond engagement rings as "tradition," although the widespread use of the rings was in fact new to the mid-twentieth century.[49] Dignam wrote newspaper articles and coauthored a book on the history of marriage rituals to reinforce the historical legitimacy of her client's products.[50]

By the 1940s, Dignam and her colleagues turned increasingly to their own pasts when providing historical examples of women's capabilities. While doing so, they focused on adwomen's career success, rather than on the gender ideals promoted to attain that success. In 1944, Dignam made a small archival contribution to Chicago broadcaster WDAP: a radio script and related papers documenting the station's 1923 program of Christmas carols. When sending the material, Dignam explained that she recently inherited it from her mother, one of the vocalists, and determined to donate it "for your archives or for the benefit of anyone who may someday write a history of your station."[51] In her narrative, Dignam highlighted her own historical significance as the script's author, explaining, "I suggested a carol program with the stories of the carols read by the announcer before each song. In those days when there was little if any musical commentary, this was a great innovation." She quoted and enclosed fan mail praising the program's educational value. Her suggestion, "You may want to refer to this in your coming program of Christmas music," mirrored her own historically informed professional work.[52]

Dignam's contributions to popular, institutional, professional, and scholarly histories converged in this act of archival preservation and self-promotion. She retained a carbon copy of this outgoing correspondence, later annotating it for inclusion in the personal papers she donated to the University of Wisconsin's Mass Communications Archives in the late 1950s and early 1960s.[53] She attached a note directing researchers to the material she had previously sent to WDAP, identifying the work as "the first script writing of Dorothy Dignam" and reiterating that it represented "a great innovation at the time." A simple handwritten note in the margins of the 1944 letter copy reads, "*Historic.*"[54] In such cases, Dignam demonstrated her strong interest in documenting the past, and her impulse to record her own role.

By the end of her professional career, this drive had produced a large archive. Compiling records in 1951 as the AWNY historian during the professional society's fortieth-anniversary year, Dignam described herself as a "'predestined' historical researcher."[55] Assuming the title of "club biographer," she authored

"Yesterday's Corner" columns for the group's *AdLibber* newsletter.[56] In this forum, she also chronicled her own research process. She praised the group's first publicity chair for sending voluminous press releases on the club's activities to local publications, enabling Dignam to find information "in old scrapbooks and at the library."[57] She urged contemporary club members to keep detailed records that would "help your next biographer!"[58] In 1962, she contributed to the association's fiftieth-anniversary commemoration, an event that celebrated founders' ties to the suffrage movement.[59] Dignam retired from the industry that same year. She donated the AWNY papers she had processed to Radcliffe College's growing women's history archive, voicing enthusiasm for the institution's efforts to record women's history and to make it available for researchers.[60]

Adwomen's efforts did not register in the rhetoric of other 1960s feminists, who cited deficiencies in public awareness of women's history. Betty Friedan's 1963 bestseller *The Feminine Mystique* asserted that popular culture had long neglected the history of women's activism. Friedan blamed popular writers, editors, and advertisers for promoting "Freudian thought" in the 1940s and 1950s and for fueling the perception that the women's suffrage movement "came from man-hating, embittered, sex-starved spinsters, from castrating, unsexed non-women who burned with such envy for the male organ that they wanted to take it away from all men, or destroy them. . . ."[61] One chapter of the book offered a corrective by recounting the history of the American women's rights movement and drawing parallels between women's relegation to the home in the past and the present.[62]

As Joanne Meyerowitz, Daniel Horowitz, and other scholars have acknowledged, Friedan's arguments were influential. *The Feminine Mystique*'s success helped establish the idea that second-wave feminism marked a departure from the culture of preceding decades. Examining mid-twentieth-century popular magazines, however, Meyerowitz demonstrates that mass culture offered alternatives to the post–World War II celebrations of female domesticity.[63] Indeed, Meyerowitz hypothesizes, "Friedan's account of the 'feminine mystique' may have hit such a resonant chord among middle-class women in part because it reworked themes already rooted in the mass culture."[64] *Selling Women's History* locates similar parallels between Friedan's celebration of the feminist past and the popular depictions of feminist history that preceded and coincided with her work.

SELLING WOMEN'S HISTORIES

Considering her arguments about the ill effects of modern advertising, it is not surprising that Friedan's feminism was on a different wavelength from

that of the feminist histories promoted by advertising women. Nevertheless, history pervaded twentieth-century popular culture, leaving an overabundance of source material for this book. Offering case studies and comparative analyses of sources that reflect broader trends, I propose that discourse about history shaped women's employment, activism, domestic roles, and intellectual work. Future scholarship could use consumer culture's gendered histories to further illuminate these subjects.

Each of the book's chapters focuses on a platform or strategy used for documenting women's pasts. While there is some chronological and thematic overlap across these chapters, determined by the longevity of many popular archetypes, the book's overarching narrative progresses chronologically from the 1910s through the 1970s, a reflection of the evolution of the mass media and of shifts in women's roles. Beginning with the early twentieth-century consumer culture dominated by print media, chapter 1 assesses magazines; newspapers; and printed products, including promotional almanacs and greeting cards, published from the 1910s through the mid-1930s. Evidence includes mainstream publications as well as African American activist periodicals. As suffrage and new household technologies altered women's roles, popular media frequently promoted earlier eras' ideals of femininity and domesticity by celebrating consumption as a constant in women's lives. Nevertheless, the same women's magazines that used static depictions of the past to sell products also published writings of female historians who analyzed material culture to demonstrate the possibility for change in women's roles over time. Simultaneously, feminist activists appropriated historical imagery, gaining coverage for their efforts in newspapers and magazines.

Chapter 2 analyzes women's advertising clubs in New York; Philadelphia; and St. Louis, Missouri, from the 1910s through the 1930s. By proclaiming the integral roles of historical women in the growth of American democratic capitalism, adwomen worked both to expand their own career opportunities and to expand cultural ideals of womanhood. In their newsletters, social and professional events, and civic work, women's advertising clubs promoted new facets of familiar icons, destabilizing the prescriptions of feminine domesticity made by advertisements themselves. This is the first published scholarship on the Philadelphia Club of Advertising Women Records, which document the feminist intentions behind adwomen's focus on the past and behind the club's own Quaker Maid mascot. Using Philadelphia as the chapter's chief example, I contextualize adwomen's public histories within postsuffrage politics. Women's advertising clubs took up the themes shaping the era's feminism, as some activists adopted as their goal equality with men, while others asserted difference from men. Simultaneously, adwomen's ideology reflected

contemporary concern with the roles that motherhood, employment, and heterosexual romance should play in modern women's public lives. Because adwomen in the 1920s and the 1930s challenged women's economic marginalization by working actively to redefine gender roles, this evidence contributes to the growing historiography identifying feminist projects that flourished in the years between waves.

While analyzing adwomen's efforts to include women in public histories, I also consider the groups' biased focus on histories of white women. Comparing the iconography of women's advertising clubs, which excluded African Americans from their membership, with the advertisements and editorial content in African American newspapers and magazines, this chapter reveals African American activists' and writers' own use of the Quaker Maid archetype to signify the respectability of Philadelphia's elite black women.

Chapter 3 assesses the depictions of women's history in local and national radio broadcasts produced between 1930 and 1945, either under commercial sponsorship or with a goal of promoting business and the advertising industry. The Philadelphia Club of Advertising Women broadcast its biographies of "women of yesteryear" (1936–1939) to promote awareness of women's capabilities. Simultaneously, the influential *Cavalcade of America* identified enterprise and patriotism as values that linked Americans, male and female, past and present. These narratives shared the airwaves with soap operas, which cited historical precedents even while celebrating modernity. The chapter considers the early serials of writer Irna Phillips, as well as the Oregon Trail soap opera *A Woman of America*, which praised home front contributions to World War II by likening them to women's vital contributions in the past. Although embraced by advertisers as a modern medium, radio thus urged listeners to commemorate history.

Chapter 4 considers three feminists whose primary goal was the promotion of women's history. Although these activists and writers typically focused on other media, they lobbied periodical publishers and collaborated with radio broadcasters to reach mass audiences in the 1930s and 1940s. These women believed that historical awareness was important to securing modern rights, and their efforts brought alternative narratives to popular culture. Women's rights activist Rose Arnold Powell waged a decades-long campaign to secure public recognition for Susan B. Anthony in schools, public monuments, radio broadcasts, women's magazines, and commercial calendars. A biographical feature on Anthony in the popular *Wonder Woman* comic book was one of Powell's victories. In the chapter's second case example, historian Mary Ritter Beard cooperated with the U.S. Office of Education, the New Deal's Works Progress Administration, and the National Broadcasting

Company as a historical consultant on national radio programs dramatizing women's contributions to democracy. The project publicized Beard's ongoing effort to legitimize the study of women's history through the development of the World Center for Women's Archives. Nevertheless, the broadcasts, shaped by multiple contributors, also included celebrations of women's domestic and consumer roles that reinforced the content of commercial programs and advertising industry publicity. The third feminist profiled in the chapter is novelist and writer Nancy Wilson Ross. As author of *Westward the Women* (1944), a historical survey of the American frontier, she gained publicity from her stories' adaptation for broader radio and popular press audiences. When translated for radio and film, her feminist framework melded with commercial narrative conventions.

Chapter 5 assesses advertising campaigns that prescribed ideals for contemporary women's work inside and outside the home during World War II and its aftermath. Promotions for food and home decor products sentimentalized historical kitchens as a constant ideal. Simultaneously, heroines who had challenged eighteenth- and nineteenth-century biases in order to serve their country appeared as transgressive antecedents to Rosie the Riveter in wartime magazine advertisements for Avon cosmetics. Later, when postwar propaganda encouraged women to cede their jobs to returning veterans, some companies continued applauding fictional historical women whose employment contributed to society. Musical film became a site for these capitalist messages. The Fred Harvey Company promoted its restaurant chain by collaborating with Hollywood studio MGM on *The Harvey Girls* (1946), a narrative of the company's early history. The Remington Rand Company worked with Century 20th-Fox on *The Shocking Miss Pilgrim* (1947), a celebration of nineteenth-century expansions in women's employment following the introduction of the typewriter in offices.

Across these media, consumer products served as historical artifacts and as totems of the nation's heritage. Drawing from corporate records, the chapter considers how the historical meanings of these commodities were shaped by consumers' use of them. In 1945, Avon developed a corporate museum to promote its brand, asking the company's exclusively female sales representatives to donate vintage cosmetic packaging from their own collections and those of their clients. Transcending Avon's request for simple information on when the products were sold and to whom, letters accompanying donations emphasized the history of Avon's saleswomen themselves, paying tribute to intergenerational mentorship and to the changes that employment had brought to individual workers' lives. Through the circulation of objects used by saleswomen and ultimately returned to the corporate museum, Avon

employees and consumers used the company's promotional project to assert their own places in history. These letters reveal that the use of objects to connect past and present was not merely imposed from the top by corporations and advertisers.

The book's final chapter examines the period from the end of World War II through the emergence of the women's liberation movement, considering how, as activists in the 1960s and 1970s strove to reexamine women's pasts as a route to feminist consciousness, they competed with the diverse portrayals of women's history that saturated popular culture. Post–World War II magazines and television broadcasts typically constructed histories to support modern ideals of middle-class family life. Nevertheless, reflecting continuity with earlier decades, celebrations of historical feminism appeared in these outlets, in advertising women's activism, and in African American publications. Then, in the late 1960s, advertisements and women's magazines adapted their popular histories in response to contemporary feminism. "You've Come a Long Way, Baby," the Virginia Slims advertising campaign that ran from 1968 until 1996, touted a cigarette "tailored for the feminine hand" as the culmination of women's rights. Television ads, print advertisements, and promotional items featured sepia-toned images of early twentieth-century women encumbered by voluminous dresses and bathing suits and by social and spousal prohibitions against public smoking. Glamorous modern models posed with Virginia Slims, providing the triumphant counterpoint. This sanitized narrative, structured to capitalize on the women's liberation movement without alienating the wider public, reduced feminist change to the realm of style, minimizing the political concerns of historical and contemporary women activists. Its creators, an exclusively male team, conceptualized the brand identity without feminist motives of their own. Although women's advertising clubs continued to invoke the past to serve the clubs' professional goals, using anniversary celebrations to demonstrate modern adwomen's ties to historical feminism, Virginia Slims' co-optation of feminist history reached the widest audiences with its more restrictive idealization of femininity.

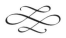

MARTHA WASHINGTON (WOULD HAVE) SHOPPED HERE

WOMEN'S HISTORY IN MAGAZINES AND EPHEMERA, 1910–1935

This chapter explores the women's history tropes that circulated in commercial print culture of the 1910s through the 1930s, attaining new meanings when applied by activists; corporations; and, ultimately, consumers. Following an introduction to the era's women's magazines and their portrayals of the past, an initial series of examples addresses feminist and activist histories appearing in print. Twentieth-century periodicals provided a platform for women historians, preservationists, and suffragists—groups who had used books and pageantry as nineteenth-century publicity tools. *Good Housekeeping* articles by historian Lucy Maynard Salmon and writer Alice Van Leer Carrick reconsidered the domestic past to advocate for change in modern women's roles. Simultaneously, print media publicized suffragists' and African American women activists' strategic references to the past.

Then follows an analysis of promotional and advertising content in periodicals. Colonial domestic figures, particularly Martha Washington and her anonymous contemporaries, dominated commercial celebrations of domesticity. However, the Colonial Revival aesthetic, which began to flourish with 1876 centennial celebrations and peaked in home decor of the 1920s and 1930s, could also support alternative models for modern women's roles.[1] In the 1920s, Eleanor Roosevelt capitalized on the style by endorsing Simmons Company beds and cofounding the furniture manufacturer Val-Kill Industries, projects she used to publicize the value of female entrepreneurship.

Cosmetics advertisements serve as a further major example of popular histories' multivalence. Commemorations of historical racial hierarchies and antebellum plantation scenes in pitches to white consumers stood in stark contrast with advertisements African American cosmetics companies placed in the National Association for the Advancement of Colored People's official magazine, the *Crisis*. That publication championed the history of black female entrepreneurship rather than of a passive feminine beauty ideal.

The chapter concludes with three examples reflecting consumption of mass-produced commercial imagery. To understand the social implications of popular histories, it is important to consider public reception of these cultural texts. While early twentieth-century consumer viewpoints were not compiled or preserved in ways that would enable a systematic empirical analysis, archival collections provide glimpses of individuals' attention to and personal adaptation of mass-produced histories.[2] As shown in the cases examined here, use of a department store's promotional calendar to record a personal diary, incorporation of newspaper clippings into a scrapbook celebrating George Washington, and circulation of mass-produced greeting cards featuring nostalgic imagery supplemented or subverted these texts' meanings. The examples show that popular histories were not necessarily complete when they left the printing presses; consumers added their own stories.

Popular Periodicals and Women's History

In the early twentieth century, women's magazines flourished, supported by advertisers' increasing efforts to target female customers. Tracking the nation's history through narratives of benevolent corporations and patriotic consumers, advertisements and editorial content marshaled the past to justify magazines' own commercial intrusions into the private space of the home. With reverent portrayals of capitalism's role in the early republic, periodicals identified historical origins for modern mass production. This celebratory approach asserted precedent for the growing power of advertisements as magazines became the most influential American medium, consistently read by 60 percent of the population beginning in the 1920s.[3] As Jennifer Scanlon has argued, popular women's magazines typically placed consumption at the center of women's identity, defining the "average" American woman as white; native born; middle class; married; and unemployed, her labor performed through product selection.[4]

Women's magazines frequently offered the past as inspiration for this archetypal modern woman, celebrating her romantic and domestic roles as timeless. Martha Washington, Betsy Ross, and Molly Pitcher, along with their

anonymous contemporaries, garnered praise. Periodicals printed idealized historical imagery, often without comment, alongside advice for contemporary living. The trend toward colonial dames and antebellum belles outlasted others, the ubiquity of these types asserting stability in women's roles. In the early 1910s, *Good Housekeeping* published small illustrations of colonial men and women in courtship scenes, and of women in colonial dress washing dishes and making quilts. These sketches filled spaces between features, flanking advice columns that described the latest housekeeping techniques and products.[5] Similarly, late 1920s and early 1930s issues of *McCall's* featured silhouettes and drawings of figures in colonial and antebellum attire. This stock imagery even ornamented fictional stories set in "the youthful world of today" and chronicling the "modern merry-go-round" of socialites pursuing romance in the Great Depression. By using traditional imagery to illustrate modernity, *McCall's* suggested a common thread of female focus on fashion and love across time.[6]

Nevertheless, women's magazines also introduced more complex historical narratives. For example, the August 1911 issue of *Good Housekeeping*, which offered colonial cartoon figures on its title page and throughout, provided two historical essays: one celebrated the achievements of women sculptors; the other, "The Tyrant Rule of the Corset," critiqued the history of fashion. Both pieces applauded change over time, presenting women as dynamic historical actors in a way that visual caricatures did not.[7] The November 1930 issue of *McCall's* used a nostalgic colonial image to illustrate a series of articles that celebrated modern women's advances in public life by profiling a "girl from each state who has come to New York City, won fame for herself and brought distinction to her old home town," praising these subjects for challenging their parents' and peers' expectations by pursuing careers in business, the arts, and aviation. The issue also promoted embroidery patterns for "quaint Colonial" silhouettes. As a whole, the magazine—initially established as a platform for promoting McCall's Company clothing patterns—simultaneously urged readers to revere and to transgress earlier eras' norms.[8]

As historian Mary Louise Roberts theorizes in *Disruptive Acts: The New Woman in Fin-de-Siècle France*, periodicals that offer varied and conflicting models of womanhood challenge gender norms by producing a subversive "cultural illegibility."[9] Confounding expectations that a women's publication be either "feminine" or "feminist," female editors and writers of the modernist French newspaper *La Fronde* combined seemingly incongruous models of womanhood, simultaneously celebrating motherhood, professionalism, politics, and fashion. They thus strategized to disrupt essentialist models for female identity.[10] Similarly, mass market magazines in the twentieth-century

United States incorporated a variety of perspectives on women's history. Alongside advertisements and nostalgic imagery promoting domesticity and feminine beauty, feminist historians contributed articles that reimagined familiar tropes and treated gender as a changeable social construction.

At the same time, publications co-opted feminism by constructing histories that legitimized the modern female consumer role. A 1914 *Good Housekeeping* article provided recipes and instructions for a "suffrage luncheon," invoking the past both to praise contemporary activism as a unique historical development and to reconcile it with the magazine's editorial mission to promote domesticity. The article opened with the line "Possibly there is 'nothing new under the sun,' but it is yet to be proved that those marvelous people the early Egyptians ever gave a suffrage luncheon." Tempering this novelty, a decoration plan melded nostalgia and modernism. The article encouraged hostesses to make a paper cutout "suffrage figure" for each guest's place setting, outfitted in a symbolic mix of styles characterized as "truly suffrage yet with a tiny touch of the Colonial": a bonnet in yellow, the "suffrage color"; a dress with a blue bodice and red and white striped petticoat; and a "Votes for Women" sash.[11] This imagery positioned political activity as a valid extension of the early American legacy, while reassuring that, even with suffrage, women would maintain the familiar feminine ideals of homemaker and consumer.[12]

Capitalizing on the popularity of the flapper style in the 1920s, when many young women rejected existing fashion standards in favor of more streamlined aesthetics, advertisers wielded historical imagery to define products as simultaneously natural and modern.[13] Advertisements emphasized the value of remembering the past in order to better appreciate the convenience of the present. Appearing in *Woman's Home Companion*, one advertisement promoted Resinol facial soap by juxtaposing the image of a modern woman with bobbed hair and a framed portrait of a colonial woman in ornate dress and hairstyle. The text explained, "Artificiality as the key note of woman's beauty is past. No longer does the powdered wig, the enameled skin and the beauty patch find favor." Drawings of a colonial woman daintily watering her garden and a more vigorous modern woman golfing illustrated the claim that Resinol's mild efficacy supported both an active lifestyle and "the natural beauty and simplicity" of "today's girl."[14]

Similarly, after late nineteenth- and early twentieth-century reformers had criticized the negative health effects of corsets and high-heeled shoes, manufacturers of these products used historical imagery to promise that their brands' mix of comfort and innovation made them compatible with timeless ideals of beauty and with the latest 1920s styles.[15] A 1921 advertisement

promoted the Gossard brand of "modern corsets" for "the most active woman" with an illustrated retrospective of women's fashions from ancient history through the present. Placed in the center of the advertisement, a sketch of a woman modeling the current drop-waist style for dresses suggested the continued importance of corsetry, even to the readers whose fashion selections disrupted the earlier norm of the tightly cinched waist. The ad's headline, "The Beauty Which Endures," encouraged potential customers to think beyond the latest trends.[16] Similarly, a 1922 advertisement for the Selby Shoe Company, placed in publications such as *Good Housekeeping* and *Woman's Home Companion*, asserted that the manufacturer's Arch Preserver Shoe distilled the best of the past and the present to satisfy "*both* Nature and Fashion." The illustration united the archetypal Eve, unencumbered by clothing, and a formally dressed colonial dame, proudly displaying her own high-heeled footwear. Both looked on approvingly as a modern woman tried on the shoe touted in accompanying text for a "scientifically-designed, built-in arch-bridge" that supported the foot while enabling the high heel that "Fashion demands."[17] This sales strategy criticized certain styles for constricting women's activities but nevertheless touted reliance on products as the pathway to greater freedom. The Selby Shoe Company acknowledged that women's experiences were socially constructed, shaped by the dictates of fashion, but the advertisement also suggested that women across time were linked by a common desire to balance practicality and beauty.

As popular culture co-opted feminist themes, feminists publicized their own narratives of women's history by staging dramatic events that earned newspaper coverage. In the 1910s, suffragists deployed historical parades and pageantry to advocate progressive change. Women workers in predominantly male fields, including medicine, banking, and business, formed professional organizations that strove to improve employment opportunities by transforming public perceptions of women's historical roles.[18] Adapting popular fascination with the past to their activist aims, scholars and professionals encouraged alternative readings of popular iconography. Nevertheless, many feminist portrayals of the past adopted gender stereotypes, attributing women's instincts, personalities, and skills to their biological sex. Accepting some social norms while challenging others, such accommodationism enabled activists to reach wide audiences.

The mass market magazines analyzed in this chapter also asserted social hierarchies by depicting their ideal reader, as well as her historical antecedents, as white. Although twentieth-century African American clubwomen and writers were documenting African Americans' historical achievements, mainstream depictions of the past typically ignored race or celebrated racism

by limiting African Americans to subordinate roles.[19] Slavery often served as a symbol for the fine living standards modern white homemakers should pursue. Printed in *Good Housekeeping*, a 1916 advertisement for Vitraline Floor Varnish depicted the elaborate entrance to a colonial home, a black man standing at the doorway and bowing deferentially to two white men in colonial dress. The company promised a "handsome art print" of the advertisement's image by mail request.[20] This approach presumed public nostalgia for the colonial era's racial hierarchy, memorializing slavery as a visible part of modern home decor.

Nevertheless, writers and advertisers challenged racism in African American newspapers and activist publications, redefining historical imagery that appeared frequently in popular culture. By highlighting the racial ambiguity of figures rendered in monochromatic silhouette, activists likened African American men and women to the colonial elites who first popularized the style. Interest in physiognomy, the supposed science of analyzing facial traits as indicators of moral character, fueled the trend toward simplicity in portraiture in the 1780s and 1790s. Although silhouettes were cheaper to produce than the oil portraits previously favored by European and American elites, they came to signify the status of such revered subjects as George Washington.[21] This association with early America, coupled with the visual simplicity of the style, suited silhouette imagery for twentieth-century magazines, advertisements, and brand logos. Simultaneously, publications by the National Association of Colored Women and the National Association for the Advancement of Colored People rendered prominent figures in African American history in silhouette, thus placing them within the tradition of the Founding Fathers. As art historian Gwendolyn DuBois Shaw reveals, African American artists from the nineteenth through the twenty-first century frequently deployed silhouettes in self-portraits and creative works to challenge the typical invisibility of African American experiences in the historical record.[22] During the Harlem Renaissance, African American artists worked extensively with silhouettes, the images created by Aaron Douglas reaching wide audiences as cover art for the *Crisis* and for influential books.[23]

The silhouette style also appeared in publications for African American consumers. *Half-Century Magazine*, with its tagline "The Colored Monthly for the Business Man and the Home Maker," targeted general audiences beyond the membership of civil rights activist organizations. In 1920, the publication featured a silhouette effect in the signature illustrations for its Beauty Hints and Domestic Science columns. Women's faces, bodies, and hair were rendered entirely in solid black, with line drawing used to indicate furnishings and clothing—a fitted bodice and full skirt evocative of the colonial

era rather than the present.[24] Notably, a publication conceptualized by its editor Katherine Williams as an alternative to mainstream commercial images, elevating African Americans as models in cover and feature photography, also offered silhouette illustrations strikingly similar to those found in mainstream commercial magazines like *Good Housekeeping* and *McCall's*.[25] Such examples reflect the adaptability of historical imagery to diverse contexts.

HISTORIANS AND ACTIVISTS IN CONSUMER CULTURE

Lucy Maynard Salmon: Making Good Housekeeping a Historian's Work

Marginalized by the professionalization of scholarly history in the late nineteenth and early twentieth centuries, women innovated as teachers and as authors publishing outside academic journals.[26] Consumer culture's interest in the past made popular magazines an opportunity for publicity, even for historians who contested popular gender stereotypes. As a history professor at Vassar College, where she taught from 1887 until her death, Lucy Maynard Salmon (1853–1927) used material culture to uncover shifts in women's roles, a perspective that challenged popular culture's static portrayals of idyllic historical scenes. Nevertheless, her analysis of household objects as reflections of women's interior lives naturally complemented *Good Housekeeping*'s coverage of design and decor.[27]

Early in her career, Salmon gained prominence rare for a woman in academia. She adapted her master's thesis into a prize-winning article, "History of the Appointing Power of the President," which was printed in the 1886 inaugural volume of the American Historical Association's *Papers*. Subsequently, she served on that organization's executive council. However, for her later scholarship, which departed from political history and prefigured the field of cultural history in its use of unconventional primary sources, she failed to achieve similar recognition. Her 1897 monograph, *Domestic Service*, based on original surveys of household servants, earned praise from popular publications and activists; academics, however, dismissed the subject matter as trivial. Nevertheless, Salmon continued experimenting.[28] One 1912 essay, "History in a Back Yard," championed sources not found in libraries and archives. Frustrated when she could not travel to Europe for research, Salmon scrutinized her own property for historical evidence. Refuting essentialism, she interpreted material culture to demonstrate that socioeconomic, rather than biological, factors limited women's activities. She celebrated abandoned clothesline posts as a record of change, their obsolescence caused by her use of a professional laundry service. However, she noted that laundry lines remained visible on properties neighboring her larger home, prompting

her to blame "some maladjustment somewhere" for the persistence of clothes washing as an expected part of women's household labor.[29] This comparison reflected faith that industrial innovation could transform homemaking tasks and hope that technology would eventually realize its potential to improve women's lives.

Rejected by academic journals and the elite publication *The Nation*, Salmon's essays on housekeeping ultimately appeared in private printings, in Vassar publications, and in *Good Housekeeping*.[30] *Good Housekeeping* had earlier reported on Salmon's career, reviewing *Domestic Service* positively and then establishing a persona for Salmon herself as both an intellectual and an efficient housekeeper.[31] One of Salmon's former students profiled her in a 1910 article that urged readers to reject strict standards of cleanliness and arrange their homes to speed the housekeeping process, freeing time for other activities. Writer Mary Hamlin proclaimed, "Miss Lucy Salmon, the head of the history department at Vassar College, has, I think, the greatest intellectual force of any woman with whom it has ever been my good fortune to come in contact." She then scrutinized Salmon's kitchen as an artifact of Salmon's "keen, well-ordered mind, as well as the great charm of her personality." The placement of each tool "was planned to save steps," Hamlin stressed, the positive result after "a large mind had been applied to small things."[32]

Then, in 1911, the magazine published two articles by Salmon. She urged a scientific approach to housekeeping, criticizing as outdated the assumption that women should devote themselves wholly to domesticity and handiwork.[33] Like the essay inspired by her backyard, these pieces emphasized the possibility for change by comparing potential and actual uses of technology. In "On Economy" she lamented that husbands' expectations relegated wives with training and skills to obsolete forms of unpaid household labor. The sentimentalization of drudgery even affected women working outside the home, Salmon argued, as entry-level male entrepreneurs benefited from typewriters and telephones while women faced expectations that they complete old-fashioned correspondence by hand.[34] Meanwhile, Salmon proposed that women merited respect not as symbolic living traditions but as skillful guardians of the past: housekeeping efforts cherished by many women but disdained by critics as trivial—particularly the salvaging of old packages, catalogs, and broken toys—were conscious acts of "collection," labor that was more important than menial cleaning. Such preservation linked people across time, she argued, as women rescued items, arranged them creatively, and passed them on to others.[35] Thus, while Salmon's scholarship treated domestic artifacts seriously as historical source material, her *Good Housekeeping* contributions likened household labor to the creative work of a historian or preservationist.

However, the magazine applied its own lens of celebratory domestic history when printing Salmon's essays. A drawing of a smiling woman in colonial dress and cap, folding a large patchwork blanket, appeared above the byline and title of "Prof. Lucy M. Salmon's" article "On Beds and Bedding," an editorial calling for sanitary materials in modern products. *Good Housekeeping's* signature nostalgic imagery suggested historical continuity by idealizing women's devotion to domesticity.[36] In this way, as Salmon reached the magazine's popular audience, her efforts to contextualize women's work risked co-optation into the dominant, ahistorical celebrations of housework as female destiny.

Meanwhile, as popular culture evolved, so did Salmon's scholarly approaches. In the 1920s, she published on the value of newspaper editorials and advertisements as evidence, an unconventional stance for historians of the time.[37] She archived press clippings and urged students to collect laundry lists and other ephemera as primary sources documenting the significance of everyday life.[38] Simultaneously, Salmon deployed the newspaper as a platform to recast cookbooks as historical artifacts, not timeless guides. In 1926, the *New York Times* published her letter to the editor, attributed only to "L. M. S.," critiquing the paper's disdain for an auction of historical cookbooks. For the *Times*, the objects belonged in homes, not historical collections, and their availability to antique collectors signaled a troubling decline in women's practice of cooking.[39] Salmon countered by emphasizing the value of cookbooks as artifacts shaped by distinct historical contexts. She asserted, "The student of history finds nowhere a more infallible record of changes in thought and in social conditions than is found in the humble family cook-book."[40] Like her scholarship, this response emphasized the potential for change in women's everyday lives, as reflected in the records of the American home.

Alice Van Leer Carrick: Telling Women's History through Antiques

Women's magazines also presented domestic objects as evidence that women merited inclusion in the historical canon. This perspective offered a corrective to the antiques market that flourished in the early twentieth century by elevating aesthetics rather than provenance or historical context as the source of objects' value. Historian Briann Greenfield argues that male collectors, dealers, and museum curators redefined New England antiques as commodities rather than heirlooms, eclipsing the historical preservation projects and heritage groups in which women served as experts.[41] Nevertheless, consumer culture enabled writers to promote an awareness of women's history by analyzing antiques. From the 1910s through the 1930s, New Hampshire resident

Alice Van Leer Carrick established a successful career authoring numerous articles and books about her own experiences as a collector who was attracted by objects for their emotional and educational rather than monetary value.[42] In a wide-ranging 1920 *Good Housekeeping* article titled "To Our Foremothers!" Carrick used objects as the point of departure for a survey of American women's history, echoing Salmon's analysis of material culture as a marker of progress. She opened with a reverie: "Often, as I sit before my eighteenth-century fireplace, a nook that induces dreams and retrospections, I think of the women who have sat here before me in times past, their hands busy with spinning or knitting or rug-making or quilt-piecing—for the Colonial woman rarely sat down to rest in utter idleness—their minds full of the vision of the future's promise."[43] Carrick cited a fireplace crane she used to balance pots safely as an example of women's historic innovation, remarking, "It was a woman, I am positive, who first felt the pinching of this particular domestic shoe, and who did not stop until the more durable crane was safely installed to bear the burden of her cookery." Crediting women for driving progress, Carrick wrote, "It is women who have urged on civilization, though it is equally true that men have usually recorded it." She lamented the absence of "interesting domestic histories," remarking that women historians would have produced such accounts, before offering her own sweeping narrative of women "standing shoulder to shoulder with men" in building the American nation.[44]

Corresponding with her vision of home decor as a mode of self-expression, Carrick highlighted women's power as consumers and housekeepers. She praised the tea boycotts and patriotic weaving of the Revolutionary War's "Homespun Army" and cited Abigail Adams's letter about "an irate mob of women who justly chastised a coffee profiteer," concluding that Adams "evidently approved, for she was always a feminist." The suggestion that any collective political action of women qualified as feminist, coupled with Carrick's celebration of Adams and other familiar figures, endorsed a model of feminism compatible with *Good Housekeeping*'s editorial mission. This strategic approach enabled Carrick to celebrate some gender norms while challenging others. She asserted that women's romantic roles and their feminism were both timeless, as she documented Maryland colonist Margaret Brent's efforts to vote by noting, "It is a womanly temptation, which I shall not even attempt to resist, to add that she must have been personally charming, for her last public appearance was made as the heir to an estate bequeathed to her by a long-time unsuccessful suitor, a proof that feminists were attractive even then."[45] Such commentary normalized Brent's status as a never-married woman by emphasizing that she nevertheless appealed to

men, thus legitimizing feminism by testifying to its compatibility with ideals of womanhood.

The article's final series of biographical sketches then focused on entrepreneurial women, including Eliza Pinckney, whose indigo trade epitomized Carrick's vision of the home's sentimental significance and its capacity for innovation. Deeming Pinckney "one of the most striking figures in our whole eighteenth century domestic life," Carrick noted, "I say 'domestic' advisedly, because, intensely interested in her home, her plantation, and all its belongings, it was from this same plantation that her great success sprang." The topic enabled Carrick to emphasize women's long-standing influence on commerce; she reported, "Women were successful printers and publishers of newspapers, and 'business women,' a term we usually think of as having a present-day significance only, existed long before our generation." Carrick described diverse advertisements that women entrepreneurs placed in eighteenth-century newspapers, citing Alice Morse Earle's 1895 book *Colonial Dames and Good Wives*.[46] Establishing this legacy as the basis for modern feminism, Carrick credited the nation's "Foremothers" for her own possession of "shelter and ease, education, a profession, and the privilege of citizenship."[47]

Carrick concluded the essay with this assurance that colonial households provided the model for advances in women's private and public roles. Again, women consumers symbolized historical feminism, as Carrick recounted the "thrifty, busy, energetic Martha Washington's" arrival at Mount Vernon, noting Washington's immediate actions to "refurnish it completely." Casting this as proof of a "forward-looking approach," Carrick proclaimed, "I am confident that Martha Washington would have approved of modern washing-machines and dish-washers and vacuum-cleaners, all the efficient equipment of household life that means better work. She would not have been concerned with my leisure but with what I *accomplished* by that leisure. And if we possess the spirit as well as the ambitious instincts of our foremothers, all will go well with us; we shall not waste our time."[48] For Carrick, scrutiny of material culture revealed that feminist progress was an American tradition nurtured at the colonial hearth.

Activism and Historical Iconography

Like Salmon and Carrick, activists secured publicity by dramatizing the historical significance of women's daily labor. In the 1910s, suffragists began staging mass spectacles using costumes and historical pageantry, garnering prominent newspaper coverage.[49] For example, a 1911 New York City suffrage parade, organized by the Women's Political Union to strengthen ties

between suffragists and women's labor advocates, featured floats tracking the evolution of women's work and crediting industrialization for expanding women's opportunities.[50] To highlight this transformation, the procession began with idyllic scenes regularly celebrated in popular culture's histories. Dramatizations of eighteenth-century spinning and cooking received praise from bystanders interviewed by the *Chicago Daily Tribune.* The newspaper contrasted this idealized past and the present by emphasizing the artifice of contemporary public women portraying colonial characters: "The Misses Rose Guylienkrook and Ella De Neergard gave the most earnest demonstrations on the float of the work of women 200 or so years ago. Miss Guylienkrook early in the afternoon placed her pocketbook in the caldron before which she sat in costume. She steadily stirred the pocketbook around as the float moved southward. Miss De Neergard sat before a loom and wove things."[51] In this account, the activists' emulation of eighteenth-century housework required performance and spared sentiment. The vague description of woven "things" called into question the utility of colonial techniques. Meanwhile, the pocketbook stew provided a tangible reminder of the female economic influence that underpinned contemporary consumer culture.

The melding of popular historical motifs with agitation for change also marked African American women's activism in the early twentieth century. Recognition of women's historical contributions supported the "uplift" strategy embodied by the National Association of Colored Women (NACW), formed in 1896 as an umbrella organization that unified preexisting local clubs. According to the uplift ideal, the morality and middle-class style of clubwomen would challenge white supremacist claims, advance civil rights, and improve civilization. Public respect for African American clubwomen would then improve the status of African American women and men. Like many local groups preceding it, the NACW cited transgressive female historical figures as models—activists, speakers, and writers, such as Sojourner Truth, Harriet Tubman, and Phyllis Wheatley, who challenged racism as well as gender norms. As historian Deborah Gray White observes, activist Mary Church Terrell celebrated this legacy in her 1916 lecture "The Modern Woman," successfully inspiring women to join the organization.[52]

Such rhetoric subsided during the 1920s, however, as the discourse of the African American women's club movement increasingly emphasized motherhood. Clubwomen sought to repudiate a new model popularized by consumer culture: an image of assertive sexuality expressed by African American women who gained renown as commercial blues singers. Simultaneously, efforts by male civil rights leaders to combat racist violence and promote black nationalism displaced clubwomen's uplift strategy.[53] The NACW's

resulting turn to local, home-centered activism reconceptualized the link between women activists of the present and the past by celebrating exemplars of African American motherhood who echoed mainstream popular ideals.

Accordingly, the 1926 book *Homespun Heroines and Other Women of Distinction*, compiled and edited by Hallie Q. Brown to promote the NACW, collected biographies of diverse African American women, prioritizing examples of motherhood. Serving as honorable president following her 1920–1924 term as president, Brown dedicated the book "in memory of the many mothers who were loyal in tense and trying times."[54] Educator Josephine Turpin Washington's foreword emphasized innate female qualities connecting women across generations, thus making historical study valuable inspiration for contemporary youth. "Conditions change," Washington explained, "but the spirit of the noble dead may be enkindled in the hearts of those who live after."[55] Immediately following this introduction, the book provided a poetic "Ode to Woman" as "the mother of man" and a biographical sketch and silhouette portrait of Martha Payne, mother of Wilberforce University founder Daniel A. Payne. This approach reflected the strategic shift described by Deborah Gray White: "In short, where NACW leaders had once combined their race and gender ideology so that race work and feminism did not conflict, now they defined race work within the context of femininity."[56]

Alongside celebrations of maternal history, however, *Homespun Heroines* praised women's activism and entrepreneurship. As a compilation with multiple authors, the book reflected some of the diversity of women's historical experiences. A Sojourner Truth biography celebrated Truth's abolitionist activism, her influence on President Lincoln's decision to admit African American soldiers to Union forces, and her work as "a zealous advocate for the enfranchisement of women." The essay emphasized that women's lives were shaped by historical context and closed with Truth's own late-in-life reflections on her experiences.[57] An entry on cosmetics entrepreneur Madam C. J. Walker praised Walker for developing a business to "serve her race," as she used African American consumer dollars to create jobs for African American men and women.[58]

Writing in the *Crisis*, W.E.B. Du Bois applauded the book for including "a good deal of information . . . concerning the work of colored women in the United States which hitherto has been difficult to find."[59] The collection did, however, echo stories of African American women's activism that would be familiar to *Crisis* readers. The depiction in *Homespun Heroines* of Walker as an innovator mirrored advertisements that promoted her company's products to modern readers by celebrating her entrepreneurship.[60] Simultaneously, the book's overarching dedication to motherhood encouraged modern women to

honor the past by focusing on the home, a model of middle-class family life currently promoted in popular culture.

Advertisements
The Women Who Became Historical

Advertisements in mainstream women's magazines presented domesticity as the site of women's history, thus differentiating historic women from historic men. The home remained stable, changed only by technologically innovative products. Strong leadership from businessmen and from the iconic Founding Fathers, by contrast, brought transformation and enabled national growth. In this model, elite white women played limited, but celebrated, parts. Advertisements cast the colonial woman as a consumer and homemaker who was vital to capitalist democracy but lacking in individuality. Women best known for their husbands' accomplishments featured heavily. The vague but ubiquitous persona of Martha Washington was frequently used to endorse products, as advertisements proclaimed her preferences without providing historical evidence. Consumers were surrounded by such messages, which appeared not only in magazines but also in store displays and promotional items designed for daily use. The 1909 *Wanamaker Diary*, a hardcover calendar and almanac sold to promote the Philadelphia retailer John Wanamaker's department store and other local businesses, speculated that Washington would approve of Ye Olde Colonials Rugs, a brand that emulated "floor coverings of the Good Old Colonial Days" by weaving modern materials into historical style.[61] According to the pitch, "A Colonial Dame, visiting the Carpet Section of Wanamaker's not long ago exclaimed: 'If Martha Washington could revisit Philadelphia, how these rugs would brighten her eyes and call up wonderful old memories!' You'll Say So, Too, if You See Them." This promise defined consumption as a way to integrate patriotic history into everyday life, and it flattered modern consumers by suggesting they could channel the tastes of the historical first lady. The diary's other content reinforced this approach. Recipes (including Martha Washington's "Rich Black Cake"), poems, and sentimental anecdotes culled from newspapers idealized the past.[62]

History also played a central, long-standing role in Wanamaker's newspaper advertisements, which positioned the store as a guardian of the nation's heritage. These promotions focused on commemorating great men, but they also celebrated women's domestic and maternal contributions. A 1921 ad observed George Washington's birthday by explaining, "Young George transcribed his mother's words into a set of 'Resolutions,' which he put together for his own use, to govern his behavior in company, at table and in business.

No wonder that the first President of the United States said, 'All I am I owe to my mother.'"[63] Reproducing this wisdom under the heading "This Is What Madam Washington Told Her Eldest Son, George," the advertisement provided morals such as "Labour to keep alive in your heart that little spark of celestial fire called conscience" and "Let your conversation be without malice or envy" rather than promoting merchandise. Casting maternal advice from the colonial era as useful even in the twentieth century, the ad expressed hope that "every boy or girl of thirteen and every man and woman we know would specifically adopt these 'Resolutions' and read them over, if possible, every day." While celebrating Mary Ball Washington for her indirect influence on history, Wanamaker's ultimately glorified its own role in preserving the Washington family's wisdom for the next generation.

Manufacturers used similar approaches, latching on to familiar names to sell new products as comforting links to tradition. A 1924 *Good Housekeeping* campaign for the Buffalo Specialty Company's Liquid Veneer furniture polish offered to prove the product's value "to the modern hostess" with a free sample bottle and the portrait of a notable female historical figure "suitable for framing."[64] Readers were invited to select their portrait subject, with options including women writers and activists Harriet Beecher Stowe, Louisa May Alcott, and Elizabeth Stuart Phelps.[65] However, the advertisements themselves focused on women associated with domesticity.

The initial entry in the series lauded Liquid Veneer for providing "labor-saving helps of modern homekeeping" that Martha Washington herself "would have welcomed" as she made Mount Vernon the "hub of political and social life of the day."[66] According to the advertisement, in spite of the "many demands for her attention," Washington's patriotic pride caused "concern over the increasing dullness of her prized mahogany and other furniture—a dullness which grew in spite of a tedious rubbing, rubbing with the beeswax of her time." In a glaring omission, this narrative ignored the reality of slave labor, thus remaking elite colonial women's work to reflect modern trends.[67] As the use of domestic servants by the middle class declined, early twentieth-century advertisements increasingly depicted consumers themselves performing housework.[68] By elevating Martha Washington as an aspirational model, Liquid Veneer simultaneously distorted the public roles of contemporary women. The white, middle-class readers *Good Housekeeping* targeted were enfranchised and increasingly likely to work outside the home while married, but the advertisement urged them to emulate a colonial wife who fostered democracy through homemaking. The advertisement never suggested that time saved by modern products would enable other political activities.[69]

Figure 1.1. Liquid Veneer furniture polish ads urged consumers to commemorate women's history on the walls of their homes. *Good Housekeeping*, February 1924.

In this formulation, women's social roles remained constant; but businesses improved their homes and daily lives. The Liquid Veneer advertisement celebrating "Dolly Madison, Hostess Incomparable!" hypothesized, "Instead of scrubbing and rubbing her floors [Madison] could have happily turned to the very efficient Liquid Veneer Mop Polish and Floor Mop. Untold time and effort would have been saved and the result—clean, smiling floors all thru the home."[70] Consumption thus promised liberation but contained women in the home, as they were assigned to pursue early American standards with the aid of modern products. Reinforcing this emphasis on domesticity as a timeless goal, another Liquid Veneer ad celebrated Betsy Ross but lamented that, as a widow, she worked as a seamstress to support her children and lived "a dull life in a drab little home."[71] In glorifying consumption, such advertisements ignored the social status that colonial women could earn through their roles as producers.[72] By narrowing the scope of historical women's activities, such portrayals equated industrialization with progress.

Selling Continuity and Change in Household Labor

Advertisements depicting modern women's everyday lives also alluded to history, often simplifying the past to glorify the present. One 1924 *Good Housekeeping* advertisement dramatized previous eras' household tools as "fetters from which every woman can be freed," promising that ironing required only "a single hour" for owners of Simplex brand clothes irons, liberating those who used them from the long legacy of drudgery that women had faced "for generations."[73] The illustration showed a contemporary woman, with metal chains physically anchoring her to an oversized metal iron, as she strained toward the light emanating from an open doorway. Although the text did not elaborate, the imagery suggested that improved household technology could free the modern woman from unnecessary restrictions, allowing her to escape the confines of domesticity.

Nevertheless, sales pitches highlighting the beauty of a clean home outnumbered the Simplex approach; such pitches urged women to apply new technologies to meet elevated homemaking and child-rearing standards. These promotions apparently worked: studies conducted in 1924–1925 and 1930–1931 found no reduction in the total time spent on domestic labor by contemporary women as compared with the previous generation. New cooking equipment bred expectations of more complicated meals. Consumption of mass-produced clothing increased the time and effort women spent laundering.[74] Popular culture encouraged women's devotion to these tasks by providing historical precedents of homemakers' nurturing, emotional power over men and children.

Brand iconography distilled this logic into visual cues. The Belle Chocolatière logo for Walter Baker & Company, the nation's oldest chocolate manufacturer, became a celebrated example. The emblem, adorning print advertisements and packaging, featured a woman in a white bonnet, apron, and simple dress with bustle, carrying a serving tray. Inspired by eighteenth-century Swiss artwork, this line drawing became the Massachusetts company's official logo in 1883 and persisted across decades of national growth.[75] In an influential 1928 study, New York University instructor Richard B. Franken and *Printers' Ink* editor Carroll B. Larrabee praised the trademark for exemplifying "timelessness," the "first great factor to consider in the design of a package."[76] Differentiating timeless and "old-fashioned" imagery, Franken and Larrabee explained, "There are today on the market many packages which have long outlived their usefulness because they picture a pretty girl of ten or fifteen years ago dressed in the clothes fashionable at that period. . . . If the manufacture [*sic*] does desire to use a human figure he should choose a figure that is dressed in clothing so far out of date as to have become classical. La Belle Chocolatière of the Baker Chocolate package is effective because she is dressed in the quaint dress of many decades ago." Because "timeless" design avoided constant updating to reflect current trends, consumers encountered it for years, incorporating it into their own memories. Such sentimental attachments promoted awareness of the product's long commercial presence, and thus of its implied quality.[77]

To support this strategy, magazine advertisements depicted the eighteenth-century Belle Chocolatière as a counterpart to the ideal modern woman. In a 1924 illustrated advertisement, she carried her serving tray directly into a present-day scene.[78] A 1929–1930 campaign appearing in *McCall's* and *Good Housekeeping* evoked the familiar logo with detailed drawings of colonial women serving cocoa to children that were placed alongside parallel illustrations featuring women and children in modern dress. One advertisement emphasized the link between these scenes with the explanation "Times and customs change . . . but the nutritive needs of children do not change. Nor does their enthusiastic welcome of a cup of Baker's Cocoa."[79] Another supplemented endorsements from modern home economists with sentimental appeals to consumers' personal histories: "When you say ' . . . and a tin of Baker's Cocoa, please,' generations of American mothers confirm your judgment. For probably your grandmother was just as fond of it as are your children."[80] According to this logic, brand loyalty confirmed American women's devotion to family and domesticity.

Corporations claimed historical roots, even when their logos did not evoke earlier eras. Quoted in a 1930 *McCall's* advertisement for canned baked

beans, the Heinz Company's home economist Josephine Gibson praised "delightful kitchens of the past" and assured consumers, "I don't think we need sigh for the baked beans of past days. You'll find all their goodness in those made by Heinz."[81] The message given by such pitches was that products enabled modern women to honor their predecessors' standards. A 1930 advertisement for Crisco frying fat applied this strategy by placing the product in an actual historical setting. Corporate home economist Winifred Carter took Crisco to an eighteenth-century Massachusetts house, which was equipped with a "200-year-old kitchen where generations of good cooks have concocted marvelous things to eat." Illustrations and text emphasized this facility's historical and patriotic significance, comparing it to "a museum room" and highlighting "a secret compartment . . . where the family stored their pewter during the Revolution." Carter testified to Crisco's compatibility with this setting, revealing that the home's current seventy-five-year-old resident had long cooked with the brand and had preferred it in a blind comparison with competitors.[82] Inserting contemporary products into such idealized settings, advertisements likened the modern consumer to hardworking women of the past.

As advertisements legitimized modern packaged foods by likening them to the fruits of historical women's labor, depictions of the African American Aunt Jemima character, proudly working for white antebellum plantation owners, promoted pancake flour by encouraging contemporary women to identify, not with Aunt Jemima, but with slaveholders. At the dawn of the Great Depression, the Quaker Oats Company's national print advertisements featured the smiling Aunt Jemima to promise "those plantation pancakes that your family enjoys so much" and "buckwheats with the old-time taste men talk about!"[83] One advertisement claimed historical legitimacy by tracing the product's formula to "documents found in the files of the earliest owners of the recipe."[84] Asserting that the convenient product pampered consumers by replicating slave-prepared foods, the brand promised prestige at the price of a box of pancake mix—as long as modern shoppers simultaneously bought into hierarchies of race and gender.[85] By contrast, the advertisements denied that class and region divided Americans, likening modern middle-class white consumers to the historical elite and sentimentalizing the nineteenth-century South for residents of northern and western cities, where the product sold successfully.[86] Thus, the campaign urged modern white women to claim social status by presuming their own racial superiority and by devoting themselves to serving home and family through consumption.

Eleanor Roosevelt: Redefining the Colonial
Revival Consumer as an Activist and Worker

In the late 1920s, Eleanor Roosevelt provided an alternative to sentimental portrayals of women's historical household labor. She worked within consumer culture to do so, cofounding Val-Kill Industries, which capitalized on the Colonial Revival by reproducing furniture from the Metropolitan Museum's famed collection. Roosevelt served as vice president of the workshop, which was based at her family's Hyde Park, New York, estate and which she founded in collaboration with Nancy Cook and Marion Dickerman, whom she met through her Democratic Party activism. The project aimed to create local jobs and demonstrate women's capacity for entrepreneurship.[87]

To support this effort, Roosevelt participated in a prominent advertising campaign that positioned her as a consumer expert on historical style: beginning in 1927, she endorsed the Simmons Company in national magazines.[88] The campaign promoted Simmons's metal reproductions of antique bed frames alongside its popular mattresses, asserting the budget products' legitimacy by photographing them in elite women's homes. Roosevelt's participation brought funding for Val-Kill, which began operating in 1927 and continued expanding production after Franklin D. Roosevelt's 1928 election as New York governor and after the 1929 stock market crash.[89]

During early planning for its testimonial advertisements, the Simmons Company made lists of esteemed families and reported to its advertising agency, the J. Walter Thompson Company (JWT), that "the Roosevelt name" inspired the greatest interest in a poll of customers at the New York salesroom.[90] The campaign was then developed by JWT's Women's Editorial Department, which included feminists who had previously worked to include progressive perspectives in their advertising work. As Jennifer Scanlon revealed, the group celebrated after incorporating feminist politics into a 1924 Pond's Cold and Vanishing Cream ad featuring suffragist Alva Belmont.[91] However, when charged with promoting Simmons beds, department head and feminist Aminta Casseres conceded that women who were notable for careers or activism, including suffragist Carrie Chapman Catt, may interest consumers but would not be trusted as experts on tasteful home decor the way "society names" would be.[92]

Glorifying upper-class women's tastemaking influence, the campaign presented products as a pathway for white middle-class families into the lifestyle of the elite.[93] Nevertheless, the absence of nonwhite consumers and nonwhite endorsers in Simmons advertisements reinforced racial boundaries. Printed in *McCall's*, the *Delineator*, *Woman's Home Companion*, the *Ladies' Home*

Journal, and *Pictorial Review,* the advertisements identified women as the living embodiments of great historical legacies, presiding over stately homes and incorporating the modern healthfulness of new mattresses into heirloom decor. For example, Simmons photographed the New York bedroom of Miss Mabel Choate with an "Early American model" Simmons metal bed. The caption explained, "Miss Choate inherits the distinction and charm of her famous father, the late Joseph Choate, who was so long Ambassador at the Court of St. James," before citing her own philanthropic work and good taste as "a discriminating collector of old books and modern art."[94] Here, pedigree and connoisseurship in antiques went hand in hand. In another advertisement, Mrs. Frederic Cameron Church Jr., "the former Miss Muriel Vanderbilt," received credit for heightening the "historic charm" of her Revolutionary-era home, "artistically preserv[ing] the beautiful historic atmosphere of the old house" by combining antiques with contemporary decorating trends like "modern colorings."[95] These narratives emphasized interest in historical styles as a central factor in endorsers' success as homemakers.

However, while highlighting Eleanor Roosevelt's domestic role as an elite wife, the Simmons campaign also depicted her as an influential activist in her own right. One advertisement placed her alongside other representatives of "America's Distinguished Women," including "Mrs. John Sargent Pillsbury" and "Mrs. John Wanamaker III." The identification of Roosevelt as a "leader in many important movements for women" set her apart from these socialites, famed for their husbands' business success. However, each woman's testimonial highlighted domesticity. Roosevelt described the comfort of Simmons Model No. 1595 and the cross-stitched homespun linens she selected to cover it.[96]

Just as Roosevelt's initial Simmons collaborations appeared in *Vogue* magazine, she applied a similar strategy to publicize Val-Kill Industries' accessibly priced products, exhibiting them in her own residence.[97] However, the Thompson agency apparently knew nothing about Val-Kill before it reached the news. An interoffice memo reported surprise that the *New York Sun*'s society page featured Roosevelt "in the guise of a new business woman interested in furniture," asking whether this should disqualify her appearance in Simmons testimonials.[98] The *Sun* article focused on the philosophy behind Val-Kill rather than on products themselves, praising Roosevelt's "new business idea" as an innovative reflection of ongoing increases in women's public roles. The newspaper observed that the "glamour of novelty that once surrounded the venture of a noted woman into the business world has been dimmed by frequent repetition, but when such a woman finds a new field for the development of her individuality and acumen, her venture stands out."[99]

Similarly, the *New York Times* later praised Val-Kill Industries as a progressive "woman-run factory," explaining, "Today women are adventuring in practically all trades monopolized, until recently, by the sterner sex."[100]

Simmons and JWT decided to continue employing Roosevelt, a collaboration that created indirect publicity for her own smaller, competing furniture manufacturer. A 1929 promotional newspaper issued by Simmons boasted the essay "Hooked Rugs! Their History and Use Today" by "Mrs. Franklin D. Roosevelt," with a biographical byline identifying Roosevelt only as "a connoisseur of Early American antiques."[101] She had rejected copy identifying her as "first lady of the Empire State," stating, "I am sorry but I cannot advertise my husband's position."[102] Ultimately, her credited expertise on historical decor dovetailed with Val-Kill's own introduction of rugs to its 1929–1930 product line.[103] In the article, she praised early nineteenth-century hooked rugs that "are interesting to us as an expression of the craving for beauty in their homes which was as prevalent among our pioneer ancestors as it is today." She commended the style's ability to "conjure up before us pictures of old fire-lit kitchens of Colonial days."[104]

Although this advertising campaign sentimentalized domesticity, Roosevelt simultaneously used speeches and news interviews about Val-Kill Industries to spotlight women's work outside the home. Thus, while promoting antique decor, she celebrated modern changes in women's roles. Exhibiting furniture at the 1930 Exposition of Women's Arts and Industries in New York City, she spoke on employment prospects for middle-aged women.[105] She encouraged female entrepreneurship, predicting that women's professional success would challenge sexism and enable further social progress.[106] As Val-Kill Industries grew, it sold furniture to Vassar College and Sloane's Department Store, yielding profits for investment back into the business and supporting Roosevelt's personal goal of financial independence from her husband.[107]

Timeless Beauty

Cosmetics advertisements provided another major site for defining the relationships between continuity and change and between public and private life. Beauty product pitches to the white middle class focused on women's roles as consumers and romantic objects. Deploying diverse historical settings, promotions emphasized women's eternal devotion to their appearance and to pleasing men, even while highlighting dramatic changes in fashions and acknowledging the expanding scope of twentieth-century women's activities. Cosmetics advertisements and brand logos offered glamorous departures from the colonial hearth by citing ancient Egypt and early modern Europe as

ideals. However, the beauty industry reproduced familiar tropes, celebrating adherence by elite historical figures to strict standards of femininity.

The Armand Company, established in 1915 by an Iowa drugstore owner, marketed face powders nationally by publicizing the emblem featured in monochromatic silhouette on the product's packaging, described as "the belle of the time of Louis XVI of France."[108] Print advertisements developed by the N. W. Ayer advertising agency provided detailed illustrations of this figure and her elaborate eighteenth-century attire, accompanied by copy focused on modern life.[109] The text of one 1927 magazine advertisement described the brand's hygienic, long-lasting ingredients as essential for "the active, modern housewife, the sportswoman or the smart young business executive."[110] The ad's imagery provided a more passive example of ideal womanhood: the Armand "belle" looked in a hand-held mirror and was served by a dark-skinned boy who stood by, offering an open box of cosmetics on a satin pillow. Their hierarchical relationship paralleled other commercial depictions of white women's supposed superiority, and the copy's silence about the scene presumed its applicability to modern consumers. The image recurred in multiple Armand advertisements, never accompanied by writing about the past. One iteration promised that Armand's cosmetic powder would complement contemporary aesthetics, which were invisible in the ad itself: "organdy and picture-hats . . . the cool fashions and soft colors of summer."[111] Another offered the product as a solution helping the consumer "to look your best . . . traveling, motoring, dancing or just existing under the summer sun."[112]

While such examples split their focus between nostalgic images and modern narratives, other advertisements in the series produced visual analogies for the presence of the past in everyday life. One, prepared for publications such as the *Christian Science Monitor* and the *Ladies' Home Journal* in 1928, showed a stylish, contemporary woman in slim, knee-length skirt and cloche, peering into an Armand package. In the background, the contrasting silhouette of a full-skirted figure in eighteenth-century dress and hairstyle mimicked this pose, suggesting a shadow cast onto the wall.[113] The headline announced, "This one distinctive face powder meets the changed conditions of your active modern life." Another illustration, featured in publications including *Better Homes and Gardens*; *Good Housekeeping*; and *Holland's*, a magazine marketed to Southerners, showed a contemporary woman admiring an almost life-sized framed portrait of the company's eighteenth-century ideal woman. The drawing dramatized reverence for feminine ideals of earlier periods alongside copy that stressed the product's suitability for the current "era of woman's freedom and activity."[114] While this wording embraced recent

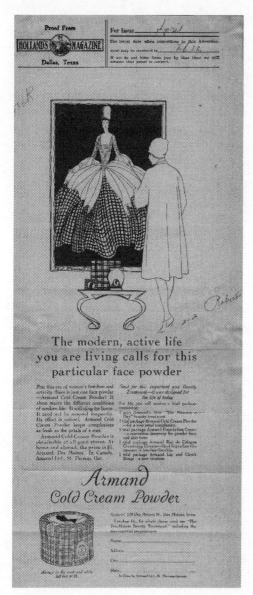

Figure 1.2. Armand advertisements deployed historical imagery mirroring the brand's packaging. Advertising proof, *Holland's*, April [1928], N. W. Ayer Records, Archives Center, National Museum of American History, Smithsonian Institution.

change in gender norms, the advertisements prescribed consumption as a persistent priority for the white middle class.

African American beauty companies, by contrast, developed sales strategies that focused on women's roles as workers and innovative entrepreneurs.[115] In 1925 the Madam C. J. Walker Company commemorated its late founder with advertisements, featuring her portrait and narrating her leadership

successes, that were placed prominently on the back cover of the *Crisis*. Rather than offering shopping as the drive connecting women across genera- tions, these promotions encouraged contemporary women to emulate Walker herself, trumpeting the "Independent Livings Made" by the company's female sales agents.[116] The competing Poro cosmetics brand placed similar emphasis on its female entrepreneur with *Crisis* advertisements proclaiming, "Mrs. A. M. Turnbo-Malone, Founder of this great business, has put into PORO her character, personality and ability."[117] Such sales pitches celebrated women's transformative influences on their corporations and on society, testifying that their success reflected positively on the African American race by "Glorifying Our Womanhood," in the words of a Walker campaign.[118]

Brands promoted to white readers of mass market publications, how- ever, tied women's significance to their romantic influence on men. A 1918 advertisement for Sempre Giovine cosmetics celebrated Cleopatra. Without inspiration from her physical beauty, the ad claimed, "Caesar would not have attempted a war in her behalf and the history of the world might have been changed."[119] This model cast attractiveness as the source of women's histori- cal significance, and advertisements emphasized that anonymous beauties of the past also merited acclaim for such allure. A 1924 series of newspaper and periodical advertisements for the National Toilet Company of Paris, Tennessee, elevated antebellum Southern belles as archetypes. Under the title "Why Do Southern Women Fascinate Men?" one advertisement touted Nadine Face Powder as a product "used for years by Southern belles to make them still more lovely."[120] Dramatizing the continued importance of carefully maintained beauty, parallel drawings depicted nineteenth- and twentieth- century romantic couples. Although fashions may change, these scenes reminded readers, approval from men remained the goal. The Nadine brand presented itself as a proven tool to help women fulfill this timeless destiny.

Through these pitches, the National Toilet Company actually obscured its own history as a firm that marketed skin-bleaching cream to African American women. The Old South motif reflected a determination to attract white consumers to new products.[121] Depicting nineteenth-century homes and fashions to suggest that generations of white Southern women had favored the brand, the resulting advertisements applied racial hierarchies implicitly. However, campaign copywriter Dorothy Dignam, responsible for wording and visual composition, later claimed that the company never informed her of its current popularity with black consumers or of its hopes to redefine itself as a manufacturer for white consumers.[122] While this recollection—expressed in an annotation Dignam made while donating the papers for archival preservation—cannot be proved and may indeed reflect a

conscious effort to disclaim the campaign's racism, it testifies to the power of scenes from the antebellum South. For the advertisements' creator, donating her papers in the wake of 1960 civil rights sit-ins that brought new media attention to racism, the antebellum setting ostensibly made creative sense independent from the effort to construct a white market, as she claimed to have authored the campaign while ignorant of this context.[123] However, the company's approval of Dignam's work reflects the compatibility of her ad design with the underlying racial motive. When placed alongside an illustration of a doorway to a mansion and women in elaborate nineteenth-century dress, copy touting "a perfect powder for Southern skins and Southern temperatures," but never explicitly mentioning skin color, certainly promoted a racialized beauty ideal.[124]

In-store presentations of the company's new Southern Flowers face powder underscored these intentions. A cardboard countertop display case offered to retailers in 1926 romanticized the racial hierarchies of slavery by including African American as well as white figures. The centerpiece of the design reproduced the facade of an idyllic, white-columned antebellum mansion. A full-skirted white woman stood on the building's second-story balcony, as a well-dressed white man on the lawn clutched a gift and tipped his hat in tribute. One elderly, white-haired African American man attended the horse-drawn carriage, while another stood invitingly at the front door. Communications to merchants emphasized the significance of this scene, revealing that, for the manufacturer, the name Southern Flowers carried automatic associations with plantation slavery: "[The display's] illustrative theme develops the romance of an old-time Southern garden which the [product] name suggests."[125] Meanwhile, the National Toilet Company used modern rather than historical imagery for ads that continued marketing Nadinola brand bleaching cream in African American newspapers.[126] With such a strategy, advertisers demonstrated their logic that historical scenes carried messages about race and gender and that some modern ideals held natural, exploitable links, in the popular imagination, with an idealized past.

CONSUMPTION OF POPULAR HISTORY

Corporations urged women to make daily engagements with the past through popular culture. As consumers used calendars, advertisements, and greeting cards with nostalgic themes, they could incorporate preexisting products into new historical narratives, exemplifying the process that the anthropologist Claude Lévi-Strauss defined as bricolage.[127] Making selections from a vast array of competing and overlapping historical narratives, consumers adapted

popular culture's preexisting models of continuity and change to explore their own place in the historical record or their own roles in documenting the past. In some cases, their use of popular history expanded creatively on corporate prescriptions that women devote themselves to consuming and conserving domestic history.

Customer responses to popular culture are difficult to chronicle, as they were preserved infrequently in comparison with the perspectives of corporations. However, archived print ephemera carry traces of their original owners. Comparing the content of popular media with the context in which consumers used them, I will explore three examples: the *Wanamaker Diary*, which provided an outlet for a Philadelphia teenager to contemplate her own historical significance in the 1910s; a scrapbook of newspaper clippings revealing the attention a small-town Virginia woman in her sixties paid to the Colonial Revival of the 1920s and 1930s; and a collection of greeting cards with historical silhouette imagery, sent to African American Philadelphia journalist Bernice Dutrieuille Shelton in the 1920s and 1930s.

Margaret Moffat's Diary

As a yearly almanac combining advertisements, informative articles, and calendar pages for documenting daily engagements, the *Wanamaker Diary* encouraged consumers to imagine themselves as inheritors of a prestigious European American legacy. The 1909 edition described the twenty-two-room House Palatial gallery, opened the previous year in the New York City Wanamaker's store to showcase European antiques dating to the sixteenth and seventeenth centuries.[128] The retailer portrayed this as a public service, reflected in the diary's description of Wanamaker's as "A Great Gathering Place" with the legend

> Here are gathered constantly the finest creations of human skill from all over the earth.
> Here Art gathers her treasures, as in a chosen temple.
> And here the people, old and young, gather day after day, generation after generation, to read the story of the human race as told in its creations and achievements.[129]

Functioning as a museum, the department store thus glorified itself and the capitalist system for bringing the world's greatest accomplishments to consumers, both as inspiration and in the form of new purchasable products which followed in the footsteps of earlier achievements. The House Palatial, with one million yearly visitors reported by Wanamaker's after 1912, placed the department store at the culmination of a triumphant progress narrative.[130]

The *Wanamaker Diary* also emphasized the important role that consumers could play in recording history, encouraging them to imagine their own diary keeping as part of a grand tradition. The 1912 edition identified Christopher Columbus as author of the first American diary. Elsewhere, it commemorated Hester Lynch Thrale Piozzi, a Welsh woman whose six-volume commonplace book, kept from 1775 to 1809, gained twentieth-century praise and drew high bids at a recent London auction.[131] Providing a visual illustration of this diary-keeping legacy, the title pages of 1920s *Wanamaker Diary* editions featured drawings of men and women in colonial attire, writing in their own journals.[132]

As historian Molly McCarthy reveals, consumers did answer Wanamaker's call, using the diaries to record their experiences, budgets, and philosophies.[133] Margaret Moffat, age fifteen, adopted the 1913 volume, continuing the habit yearly. In her 1914 diary, she documented personal experiences, including a suffrage parade in which "2,000 marched," a lunch trip to Wanamaker's with a friend, and success on a geometry test as the "only girl [who] got A."[134] The printed entries surrounding these notations included stories about familiar icons like Abraham Lincoln, as well as stories that urged commemoration of less familiar lives.[135] One article touted Wanamaker's funding for an American Indian Memorial at Fort Wadsworth, New York, designed as a museum exhibiting art, tools, and clothing in "witness of the passing race . . . to perpetuate all that the Indian was."[136] Saluting Native American civilization but proclaiming its modern decline, Wanamaker's positioned itself as a protector of forgotten stories. Another article in the 1914 edition, titled "Clara Schumann's Diary," commemorated that "little known" German composer and pianist by quoting a late-in-life diary entry in which she confessed frequent concern that her artistry would be forgotten.[137] By publicizing this fear of obscurity and thus invalidating the fear, Wanamaker's suggested that diary keeping could bring immortality.

Ultimately, however, the retailer differentiated consumers' daily activities from the great creative achievements that earned a place in the historical canon. While homemaking tips, advertisements, and historical anecdotes acknowledged the value of women's work, depictions of continuity in domesticity contrasted with reverent descriptions of creative artistic achievements. An advertisement for Columbia Yarns in the 1914 diary featured a colonial woman at a spinning wheel. Such imagery connected women past and present through their household labor and consumption, an approach that echoed the earlier *Wanamaker Diary* portrayal of Martha Washington as a twentieth-century department store shopper.[138] In such advertisements, it was the manufacturer, not the consumer, who ultimately claimed credit for the high living standards brought through purchases.

Margaret Moffat echoed some of these conflicting messages about the historical value of everyday life. She authored "A True Poem," handwritten in the space labeled "Engagements" at the back of her 1914 calendar, explaining her frustrations after reviewing the daily records she had produced. Remarking that her "diary looks well enough" and that she had written copiously, she lamented in a poem, "I never seem to do a thing / Worth putting down," before concluding that she would stop documenting her mundane thoughts and experiences.[139] In devoting her efforts to this verse, Moffat applied creativity, dramatically bemoaning her life and thoughts as insignificant. This simultaneous attention to and dismissal of her activities echoed the mass media's approach. Women's historical contributions to home and family were essential, popular culture maintained, but the greatest glory went to notable men identified as transformative agents in social progress. Nevertheless, Moffat—who chose to work and live independently, never marrying—continued recording her social activities and personal pursuits, selecting the *Wanamaker Diary* as her template every year through 1971.[140]

Emma Estes's Scrapbook

A scrapbook compiled in the small town of Iron Gate, Virginia, between 1929 and 1934 carefully preserved historically themed advertisements, articles, and illustrations that elevated colonial American leaders as models for Depression-era citizenship.[141] Its author, Emma Estes, born in 1866 and married just before the turn of the century at thirty-three, preserved little detail about her own life. The census documented that her husband, William, worked as a laborer and then, by 1930, owned a general store. It reported no employment for Emma.[142] Scattered local news stories, obituaries, programs for Baptist church meetings, greeting cards, and Emma's membership certificate in the Rebekah Lodge of the Independent Order of Odd Fellows made the scrapbook's pages. However, the collection devoted greater attention to preserving popular histories of iconic American men.

Estes's collection merged the modern and the nostalgic, placing great events of the past alongside documentation of current progress and problems.[143] The book combined contemporary ephemera, such as train schedules and newspaper reports on current events, with clippings on historical figures: Robert E. Lee; Abraham Lincoln; Thomas Edison; and, most prominently, George Washington.[144] On several pages, portrait prints of Washington stood alone, without supplementary text or citation. Estes also included newspaper advertisements featuring Washington. An ad for the First National Bank in Clifton Forge, Virginia, featured a portrait of Washington and encouraged readers to follow his model of "self discipline" and to "Start Saving Regularly NOW."

Another First National Bank advertisement urged readers to be honest with themselves about economics, retelling the mythic story that "every school boy knows" of young George and the cherry tree. Indicating the resonance of this narrative for Estes, separate clippings of a colorful illustration of cherries and a mail-in offer for a teaspoon commemorating the 1932 bicentennial of Washington's birth embellish the page. When clipping these advertisements, Estes kept them intact, although scissors could have easily excised promotional statements from the patriotic imagery and mottoes.[145] By contrast, the collection omitted page headings that would identify the newspaper and date for article clippings, a common occurrence in scrapbooks.[146] That Estes decided to preserve the commercial, but not journalistic, context reflects the reach of marketers. While she did not comment on her motives in archiving advertisements, she consumed their sales pitches and historical celebrations whole.

The book also archived the serialized, illustrated newspaper strip *George Washington's Travels*, produced by the American Highway Educational Bureau and the United States George Washington Bicentennial Commission.[147] In spite of the feature's dual focus on Washington's career and the triumphant history of transportation, it praised women who performed domestic roles to serve the Revolution. One episode documented Washington's service on the Flag Committee in 1776 that selected "Betsy Ross, an expert needle-woman." In a parallel with other popular representations of Ross, the strip emphasized that she sewed the new nation's flag in her own home. Another installment illustrated the contribution of Mary Murray, "a loyal American [who] entertained British officers with a sumptuous dinner at her home while Washington got his colonial troops beyond British reach."[148]

Estes's clippings thus mirrored the mass media's hierarchical preference for "great men," and then for the women who supported them, as they entered the popular historical canon by adapting their traditional homemaking activities to national crises. The scrapbook's documentation of contemporary life echoed this vision, identifying reverence for the past as part of women's social responsibility. Coverage of Franklin D. Roosevelt's presidential appointments detailed the hobbies of Cabinet members' wives, describing the activities of Daughters of the American Revolution members and the "passion" of "Mrs. William Woodin . . . for anything colonial."[149] In the pages of Estes's scrapbook, women did not translate such proclivities into their own entrepreneurial or productive efforts, of the type that Eleanor Roosevelt had publicized.

Bernice Dutrieuille's Correspondence

Greeting cards enabled consumers to register their own interpretations of popular histories. By the early twentieth century, mass-produced cards had

become central to holiday observances.[150] In the late 1920s and the 1930s, nostalgic scenes in monochromatic silhouette were ubiquitous in stationery products and on gift-wrapping papers.[151] A "Scrapbook of Competitors' Cards" compiled by the Rust Craft company in the 1930s demonstrated the popularity of historical scenes in silhouette, as competitors offered close, cheaper copies of Rust Craft designs featuring domestic and courtship scenes with figures dressed in colonial and nineteenth-century fashions.[152] Yet while the monochromatic scheme of this imagery simplified the printing process, designers tied the style to elite status. A telegram envelope circulated in 1933 promoted "Western Union Gift Orders" through the illustration in solid black on a solid red background of a man in a colonial wig offering a full-skirted woman a piece of paper. This simple sheet echoed the look of a contemporary telegram. A framed oval silhouette on the wall behind the pair—a silhouette portrait within the silhouette scene—further underscored the association of this artistic style with historical gentility by reminding consumers of the style's origins.[153]

Ultimately, this ever-present imagery proved more inclusive than other contemporary representations. Most greeting cards with detailed illustrations either pictured whites or mocked African American, Asian, and Native American figures as primitive. By contrast, silhouette designs placed racially ambiguous figures in idyllic settings, thus enabling marginalized African American consumers to align themselves with mass ideals while rejecting the racist stereotypes that flourished, not only on greeting cards, but also in product advertisements. Economist Paul K. Edwards's 1932 study of black residents of southern cities documented their rejection of consumer brands that sentimentalized slavery. However, rare, realistic portrayals of African Americans sparked positive reactions from survey participants, yielding commentary that highlighted the desire of black consumers to find representation in popular culture.[154] Edwards did not isolate historical imagery in his study, but African American consumers, including those who shaped public discourse themselves as activists and writers, used mass-produced nostalgic tableaux. The African American writer Bernice Dutrieuille (1903–1983), who became a journalist and society columnist for the *Pittsburgh Courier*, the *Afro-American*, and the *Philadelphia Tribune* in the late 1920s, received numerous Christmas cards from colleagues and friends. Of the cards she preserved from the late 1920s and early 1930s, many showed silhouetted figures in nineteenth-century clothing engaging in holiday celebrations and gift giving; silhouettes were also used to depict the nativity.[155] On some cards faces and bodies were rendered in black while clothing and ornamentation were embellished with white, red, and blue.[156] This effect suggested dark

skin more explicitly than would a monochromatic silhouette. Such imagery resonated with Dutrieuille's professional and activist work as the author of articles and speeches denouncing media bias against African Americans and against African American women.[57] While neither she nor her correspondents recorded direct commentary about the silhouette imagery providing the backdrop for their exchanges, their belief in the social power of imagery likely shaped their selections. African American–owned greeting card companies did not flourish until after World War II, at which point mainstream card manufacturers began including more realistic depictions of African Americans in addition to the racist caricatures featured on many of their products. Prior to this product diversification, companies marketed the cards featuring blackface minstrel stereotypes, typically showing young children, to African American audiences.[58] The silhouettes favored by Bernice Dutrieuille's circle clearly offered a more inclusive and dignified alternative.

From the 1910s through the 1930s, popular culture provided a variety of models for understanding history. Women's magazines and newspapers reflected the input of activists, historians, and corporations. This chapter considered how Lucy Maynard Salmon, Alice Van Leer Carrick, and Eleanor Roosevelt exploited the popular interest in the past to publicize their feminist ideas. Their messages could counteract the familiar nostalgic images often used to promote feminine beauty and domesticity. Consumer culture offered products and stories that emphasized women's dynamic roles as historical actors, and others that disrupted assumptions that true history was made by elite white men. Simultaneously, as the next chapter will explore, women employed in advertising applied historical imagery transgressively to their feminist work in professional organizations. In publications and pageantry, women's advertising clubs provided backstories for the historical icons that pervaded advertisements themselves. With this work, they added new facets to the popular canon of women's history that their industry promoted.

CHAPTER 2

"THE QUAKER GIRL TURNS MODERN"

HOW ADWOMEN PROMOTED HISTORY, 1910–1940

After their emergence in the 1910s, urban associations of women working in advertising flourished during the 1920s and 1930s, advocating women's employment by publicizing women's centrality, past and present, to America's development.[1] As adwomen defined their modern personas through comparison with historical antecedents, they dramatized the feminist tenet that gender ideals can be socially constructed and reconstructed. This chapter compares these groups' publicity efforts with narratives of the past in advertisements, entertainments, and news coverage, revealing ways that women advertisers adapted existing historical mythology to make transgressive claims about women's abilities. The colonial Quaker Maid mascot developed in 1929 by the Philadelphia Club of Advertising Women provided a new, more complex identity for the familiar commercial image of a young woman in bonnet and demure eighteenth-century dress. As historical imagery appeared both in advertising targeted to women and in advertising women's professional activism, anonymous, stylized colonial logos gained new significance as celebrations of women's influence on public life.

Making a public feminist challenge to gender norms, adwomen echoed an earlier generation of women employed within popular culture. Historian Susan Glenn identifies the professional culture and creative work produced by women during the height of American vaudeville and theater in the 1880s and 1890s as a "feminist moment." Although female performers did not

conceptualize an explicitly political project, Glenn concludes, the personae they created within the era's dominant entertainment medium advanced "some of the themes that later became central to the projects of off-stage women who called themselves feminists."[2] Similarly, as advertising clubs publicized women's historical significance, their rhetoric prefigured the work of later activists and historians.

This analysis of adwomen's clubs complements the growing historiography demonstrating that, in the aftermath of the Nineteenth Amendment, feminism did not disappear.[3] Scholars and activists of the 1960s and 1970s first popularized the wave metaphor, dividing American women's rights activism into discrete eras with a long period of stagnation after suffrage.[4] Subsequently, late twentieth-century scholars identified organizations, political activities, and employment that filled the gap between this "first wave" and the women's liberation movement of the 1960s. As Nancy Cott demonstrated, feminists of the 1920s and 1930s explored women's economic roles, disagreeing on the proposed Equal Rights Amendment (ERA), which would establish legal parity between men and women in the U.S. Constitution. The National Woman's Party prioritized the ERA, arguing that it was necessary because of the wide variety of existing laws that discriminated against women, and that it would help wage-earning women, whose job opportunities were currently restricted by gender norms, to secure better positions and to obtain financial independence.[5] Other feminists, striving to prevent exploitation of working-class women by industrial employers, opposed the ERA because of its potential to invalidate the protective legislation that limited work hours and established wage minimums for female laborers. Protective legislation asserted biological differences between women and men, and many of its activist supporters, including leaders of the League of Women Voters, deployed maternalist rhetoric, arguing that women could best serve society by staying out of business and focusing on childbirth, child rearing, and social reform. This approach sought to increase the social value attributed to women's work, including unpaid household labor.[6] While both these conflicting viewpoints focused on women's work, Cott argues that "neither side distinguished nor addressed directly the situation of the fastest-growing sector of employed women, those in white-collar jobs."[7] Meanwhile, advertising women promoted a feminism and a feminist history designed to inspire public and professional respect for that population.

Adwomen combined elements of the "equality" and the "difference" models of feminism but focused on their own professional goals, rather than on women's status as a unified, oppressed class. Women's advertising clubs monitored employment legislation, tailoring their interventions to suit the

specific goals of white-collar workers. For example, the Philadelphia Club of Advertising Women protested a 1935 state bill limiting women to a forty-hour work week. Expanding on statements of opposition from other local business and professional women's organizations, the adwomen proposed an amendment "exempting women executives with weekly salaries of $35 and over" so that such workers could remain competitive with their male counterparts.[8] The Women's Advertising Club of Chicago sponsored periodic discussions of the Equal Rights Amendment beginning in 1938, but the group did not officially endorse the ERA until the 1970s.[9] Instead, adwomen activists prioritized cultural change in attitudes toward women, applying strategies from the new public relations field developed by advertisers to build goodwill for the early twentieth century's growing corporations.[10] Striving to expand employment opportunities for women in advertising—and for women pursuing clerical work as a pathway to advertising—professional clubs cited history to prove female workers' abilities. To reach general and industry audiences, women's advertising clubs deployed gender stereotypes strategically, constructing histories that supported the advertising profession's investment in domestic and romantic ideals of womanhood while simultaneously emphasizing the work women performed, both as employees and as consumers.[11]

In their efforts to establish a public identity, women's advertising clubs defined American women as vital historical actors while at the same time promoting modernity as a goal. This approach made adwomen's interest in the past compatible with the "Modern Girl" ideal that pervaded consumer culture in the 1920s and 1930s. In recent scholarship, the Modern Girl Around the World Research Group has analyzed advertisements produced worldwide, identifying cigarettes, lipstick, and clothing, among other commodities, as the prevailing signifiers of a woman's modern status.[12] Notably, these very items played a central role in adwomen's dramatizations of the past, particularly when the clubs staged historically themed social events that welcomed male guests.

This juxtaposition of old and new thus came to the forefront as—like many feminists of the time period—adwomen asserted both professional and romantic identities. As historian Mary Trigg demonstrates, young feminists of the 1920s and 1930s "strove to redefine [feminism] in the context of male/female relationships and similarity between the sexes," a departure from nineteenth-century feminist discourse that emphasized "female friendship and difference from men."[13] Reflecting this mindset, the *Nation* magazine published "These Modern Women," a series of autobiographical feminist essays in 1926 and 1927, editorializing that the combination of paid employment and heterosexual romance made the contributors "modern."[14] Women's

advertising clubs pursued this balance: as professional associations, they publicized women's contributions as equals to men in their industry; in parties staged for male guests and the press, they playfully celebrated the appeal of heterosexual romance. Making stylistic references to the past as they did so, adwomen modeled an engagement with feminist history compatible with their professional goals and with the pleasures of consumer culture. While many women coming of age in the 1920s rejected feminism as old-fashioned, favoring the glamour of the flapper, women's advertising clubs strove to reconcile feminism, modernity, and reverence for the past.[15]

The Advertising Industry's Interest in History

By publicizing their visions of history, adwomen capitalized on their industry's hunger for historical ties. During the 1910s and 1920s, advertising agencies and professional societies carefully deployed the past to claim respectability for their newly professionalized field and its growing national influence. Modern advertisers sought to dispel memories of the patent medicine peddlers and door-to-door confidence men frequently portrayed as unethical manipulators in late nineteenth- and early twentieth-century literature.[16] Accordingly, the industry cast itself as the guardian of truthfulness in business, reaching further into the past to identify the nation's founders as the forebears of contemporary admen.

Advertisers' communications with one another emphasized this historical legacy. In the trade journal *Printers' Ink*, publishing firms and advertising agencies frequently asserted their value to potential clients by invoking early America. A 1916 advertisement for the Knickerbocker Press featured a town crier in colonial garb, signifying the press's established status.[17] In 1928, Westvaco paper mills traced the historical "pageant of advertising" through such milestones as the development of the railroad, emphasizing that the advertising industry's history intersected with the nation's own growth.[18]

Advertising agencies embedded reminders of this heritage in their daily work. In the early 1930s, speakers in the J. Walter Thompson agency's staff forum established a long genealogy for contemporary advertising practices. One talk traced the evolution of typography from the invention of printing to the present. A presentation titled "Importance of Strategy in Copy" argued that advertising required the same brilliance as the battlefield, citing Napoleon, Julius Caesar, Alexander the Great, and Joan of Arc to demonstrate that, just as great military leadership held timeless lessons, well-constructed advertisements from earlier eras provided models for today's writers.[19] In 1937, the chair of the lecture series urged intervention to preserve this past, as

libraries had discarded advertisements before archiving nineteenth-century magazines.[20] Such discussions portrayed the advertising profession as a pioneering force that merited new appreciation by insiders and outsiders.

THE EMERGENCE OF WOMEN'S ADVERTISING CLUBS

Adwomen applied their industry's interest in the past as they encountered biases against women workers. Employers treated women as models for female consumers' thought processes, frequently limiting the accounts given to women employees to cosmetics and household products. Although the trade and popular press trumpeted advertising's opportunities for female workers in the 1910s, few women attained prominence. In late 1920s advertising agencies, men outnumbered women ten to one.[21] Exclusion from professional advertising societies both reflected and further entrenched this marginalization, prompting adwomen to form their own associations. The League of Advertising Women of New York grew from fewer than three dozen members in 1912 to 116 members in 1920.[22] Home economist and *Ladies' Home Journal* contributor Christine Frederick, who founded the league with her advertising executive husband, gained recognition as an industry authority.[23] During the 1910s and 1920s, parallel organizations developed across the country, affiliated with one another and with male advertising societies through umbrella organizations. By 1930, women's clubs in Los Angeles, New York, Philadelphia, St. Louis, Chicago, Cleveland, Buffalo, Baltimore, Milwaukee, Providence, Toledo, Detroit, and Grand Rapids had received Advertising Federation of America charters.[24]

Newspapers reported these groups' activities and publicized the promotions and earnings of adwomen, treating the industry as a bellwether of broader change.[25] As economic shifts that increased advertising jobs simultaneously produced new employment in corporate offices and retail outlets, successful adwomen became public representatives of women in business.[26] From this platform, adwomen aligned themselves with both femininity and feminism, placing their experiences in the context of women's larger historical and social roles. In 1913, a member of the League of Advertising Women of New York spoke at a meeting of the city's admen, receiving press coverage for her argument under the headline "Women Trained in Business Make Best Wives and Mothers," which expressed a logic that promised continuity in women's domestic roles.[27] Focusing instead on a narrative of progress, another league member contributed a historical essay to the trade journal *Publishers' Guide,* celebrating adwomen's accomplishments and attributing the "recent origin" of women in advertising to the courage of earlier women

who had challenged social norms by pursuing education in the mid-nine-teenth century. The article predicted future expansions of opportunities for adwomen.[28] In 1916, adwomen pursued feminist political change by propos-ing a women's suffrage plank to male and female delegates of the Associated Advertising Clubs of the World convention.[29]

THE LEAGUE OF ADVERTISING WOMEN OF NEW YORK

Adwomen activists often defined their feminism and professionalism by juxtaposing past and present. In 1917, the *New York Herald* published League of Advertising Women leader Jane J. Martin's critique that many of her con-temporaries "are still not working to their full capabilities" because "so many of them still cling hard to old fashioned, nineteenth century ideas," reflected in their refusal to attend events without male escorts and in their avoidance of late meetings.[30] To encourage movement beyond outmoded gender roles, adwomen's clubs combined public educational efforts, including vocational courses for women, with social and professional events. There, the "old-fashioned" had its place. Echoing familiar industry imagery, the printed announcement of the League's 1917–1918 schedule included a drawing of a male colonial town crier.[31] However, members also presented themselves as agents of modernization, their expertise in contemporary styles denoting their professional skill. In 1926 the league staged a play for industry audi-ences, referencing Anita Loos's popular 1925 novel *Gentlemen Prefer Blondes* in its title, *Gentlemen Prefer Advertising Women*; in the league's play, members portrayed style experts who updated the appearance of a female character identified as "The Antique."[32] This dramatization celebrated modernity as a canny strategy, while adhering to gender norms that romantic appeal was a woman's aspirational goal.

At social gatherings and public lectures, adwomen commingled with male advertisers who excluded them elsewhere. These events juxtaposed nostalgic and modern imagery to celebrate contemporary women. The League's 1921 ball invited guests to "leave the busy world behind . . . in costume of another time," garnering extensive publicity through photographs printed in trade publications and newspapers nationwide.[33] Members' historical costumes invited congratulatory comparisons between past and present. At least five papers captioned the image of Jane Martin dressed as a "Colonial Dame" with the proclamation that she was the highest-earning woman in adver-tising. Emphasizing the progress of women in business, the *Chicago Daily Tribune*'s headline proclaimed, "Her Headdress Is Colonial, but Her Salary Is Modern."[34] Similarly, an invitation for the 1928 annual dinner dance, attended

by more than one thousand guests, juxtaposed a *Godey's Lady's Book*–style illustration of a woman in nineteenth-century dress with lowercase, new-fashioned typography stating that "it is to be a modern affair."[35] This combination of the word *modern* with an image that looked outdated reminded readers that modernity was relative. Fashions changed over time, and the implied difference between a nineteenth-century hoop skirt and contemporary attire evoked the transformation of women's activities. Appearing in the mainstream press, these events referenced the past to establish advertising women as up-to-date professionals.

The Philadelphia Club of Advertising Women and the Poor Richard Club

Adwomen also asserted historical precedents for modern feminism. The Philadelphia Club of Advertising Women (PCAW), founded in 1916, publicized forgotten histories as proof that women merited inclusion in contemporary business.[36] The PCAW first emerged when the city hosted a national advertising convention, and a handful of local adwomen planned social events for female advertisers and "advertising wives" of male visitors.[37] The club subsequently recruited employees of Philadelphia's nationally influential advertising agencies and magazine publishers, as well as women who coordinated publicity for local businesses or sold advertising space for local publications. Bylaws adopted in 1922 asserted a mission "to secure for its members the benefits of discussion and cooperation in matters of interest for the purpose of mutual advancement; to further the study of advertising in its various branches; and to emphasize the work that woman is doing, and is specially qualified to do in the field of sales promotion and in the many sided business of advertising."[38] Membership grew from about 80 in 1921 to 114 in 1928.[39] Inclusion of women working with advertising in any capacity meant that the group represented diverse segments of the city's economy. Approximately 10 percent of active members in 1928 were business owners.[40] As it grew, the PCAW performed community service; collaborated with local women's clubs; and developed joint programs with the city's exclusively male society of advertisers, the Poor Richard Club. Beginning in 1926, the PCAW devoted significant funding and effort to publishing its monthly *Adland News* magazine, circulated to members and to other professional organizations.[41]

By responding to male advertisers' use of the past, the PCAW justified adwomen's expanding presence in the profession. In the 1920s, the club presented lectures on topics such as Revolutionary War newspapers and the imagined state of twentieth-century advertising "if Ben Franklin wrote

copy today."[42] Members taught an advertising course for women at the local YWCA, in which they stressed the industry's history.[43] Further, patriotic pageantry featured heavily in social events. Corresponding with its 1921 colonial theme, the PCAW's annual dinner dance featured a period fashion show and a toast celebrating George Washington's mythic truthfulness about the cherry tree as a precursor to the modern "truth in advertising" movement. This tribute united adwomen with the evening's guests, who included National League of Women Voters chair Maude Wood Park, Oklahoma congresswoman Alice Robertson, and Poor Richard Club members, as heirs to "the unchangeable ideals of the past . . . our heritage of true Americanism."[44] Such events reworked the industry's discourse to align women with historical continuity in professionalism rather than in domesticity.

The PCAW defined itself as the counterpart of the Poor Richard Club, which celebrated Benjamin Franklin as its patron saint: a patriotic, industrious advertising pioneer as publisher of the *Pennsylvania Gazette* and *Poor Richard's Almanack*. Established in 1906, the Poor Richard Club organized lectures on the history of advertising and other historical topics, particularly Franklin's life and times. Social events often featured colonial costumes or reenactments.[45] The club's close identification with Franklin inspired civic commemorations, reported in local and trade publications.[46] Annual memorial services at Franklin's gravesite drew participation from the PCAW, other local groups, and national political leaders.[47]

This approach defined history as a chronicle of great men's achievements— recorded by the great men who best appreciated this past. In spite of his popular resonance, Philadelphia's male advertising professionals characterized Franklin as an underappreciated figure.[48] In its 1927 proposal for construction of a Franklin monument, the Poor Richard Club determined "rather conclusively that America has been very tardy in acknowledging the greatness of this greatest of all Americans." Members selected Cyrus Curtis, publisher of the *Ladies' Home Journal* and *Saturday Evening Post*, as "Honorary Chairman" of a proposed three-million-dollar fund-raising effort, citing his status as "the best posted citizen of Philadelphia and perhaps of the country on the very broad subject of Frankliniana." Remarking that the American public robbed Franklin of recognition merely because he had not served as the nation's president, the club staged historical tableaux at its 1927 formal dinner—an event held annually to honor Franklin's birth date— placing Franklin alongside George Washington, Abraham Lincoln, and Theodore Roosevelt. Franklin earned this position in the pantheon for forward-thinking resistance to the constraints of the past, celebrated with members' toast "To Poor Richard—for you culled the ages for its wisdom,

pruned from it the parasites of tradition and custom, realized that life could be simple, full and joyous—and so lived it."[49] However, in spite of its opposition to unquestioned "tradition and custom," the Poor Richard Club found perennial inspiration in the story of Ben Franklin and his work.

This approach omitted women from the industry's origin story. Instead, Poor Richard members playfully dramatized Franklin's romantic appeal to women as a direct parallel for contemporary relationships. The 1927 dinner toast directed to "the Ladies" again channeled Franklin: "With us, Ben would say, 'God bless 'em!'" PCAW members and other female guests observed this tribute from the distance of the balcony. Their closest encounter with the event's pageantry came in the form of courtship. Through a prize drawing, Poor Richard Club members won the "Benjamin Franklin Dolls" decorating each table, followed by the instruction that each "winner must go at once to the Balcony and give the Doll to the lady of his choice." Warning these men to return immediately to their seats for the rest of the show, the program noted, "Anyhow, the woman's interest in you ceases when she gets the Doll."[50] Here, the only place for women in the idealized past was as a romantic object Ben Franklin would admire. In turn, female guests' interest in Franklin as a substitute for their dates went unquestioned, in a joking portrayal of female romantic fanaticism. In fact, it was the Poor Richard Club's consistent emphasis of Franklin as the ideal citizen, leader, advertiser, and man that obscured other topics.

Reimagining the colonial past that fascinated admen, the PCAW developed its own official historical mascot in 1929. During deliberations, members emphasized that the result should be an emblem that could become just as recognizable at professional meetings as the pin featuring Franklin's bust that Poor Richard Club members wore.[51] In selecting the image of the Quaker Maid, adwomen recognized their city's heritage and drew from existing archetypes: twentieth-century popular culture frequently deployed characters in Quaker plain dress to embody American tradition.

Indeed, responding to this trend, the PCAW had already deployed Quaker themes. Participants at the 1918 PCAW dinner dance performed an adaptation of the popular song "There's a Quaker down in Quaker Town," changing it to "Quaker Maid in Quakertown."[52] At the 1919 Valentine's Day–themed dinner dance, the drawing on the program's cover featured a woman clad in a bonnet and simple gray dress. She wielded a feather quill pen to amend writing on a sheet of paper bearing the title "Advertising."[53] Such portrayals attributed traits of professionalism to the Quaker Maid archetype popularly associated with romantic femininity.

QUAKERS IN POPULAR CULTURE

By the time the PCAW reinterpreted the Quaker past, nostalgia for the Quaker Maid had had a long history of its own. Throughout the mid- to late nineteenth century, Quakers played a prominent symbolic role in American culture. After the Civil War, Quaker Friends increasingly abandoned the styles that once differentiated them from the rest of the country—including the bonnet that women had worn in renunciation of worldly concern with fashion—but cultural fascination with those aesthetics flourished.[54] In the 1860s and 1870s, *Godey's Lady's Book* cited "soft Quaker drabs" and simple silhouettes as inspiration for contemporary fashion. Quaker costumes became popular for women attending fancy dress parties; in 1885 *Godey's* compared them to "Puritan" getups, another common choice, indicating that the paradox of their presence in festive settings created an opportunity to celebrate modernity and the distant past simultaneously.[55] Scholar Jennifer Connerley explains, "Rapidly eroding Quaker speech and Quaker dress were preserved and converted, in depictions, into attractive anachronisms that by association linked all Americans directly back to a simpler colonial past."[56]

Simultaneously, attributions of honesty, modesty, and morality to Quakers suited them for product endorsements; introduced in 1877, the Quaker Oats man became one of the nation's most recognized advertising emblems, associating mass production with healthful simplicity. Subsequently, various commercial products adopted "Quaker" imagery.[57] Presenting the iconic Quaker as simple, thrifty, and rural, corporate brands obscured the significance of religion and commerce in the lives of actual Friends, many of whom were both urban and affluent.[58]

As symbolic depictions of Quakers proliferated, feminists were publicizing the historical contributions of Quaker abolitionists and suffragists. In prominent magazines, Lucretia Mott (1793–1880) was praised as a transformative activist who nevertheless devoted herself to familial domesticity. In a sculptural portrait displayed by suffragists at the 1893 World's Columbian Exposition in Chicago, her bonnet denoted her faith.[59] Early twentieth-century suffragists sometimes deployed the Quaker costume in pageantry intended to attract large audiences.[60]

However, public discussion of Quaker women's contributions as activists and preachers declined in the early twentieth century, eclipsed by fictional and nonfictional explorations of the Quaker Maid archetype as a marker of shifting sexual mores.[61] The 1910 musical comedy *The Quaker Girl*, first staged in London, popularized Quaker style as a symbol of modern womanhood.

A U.S. tour soon followed its October 1911 New York debut, introducing American audiences to Prudence, the character described in the title.[62] An unmarried Quaker in what was present-day England, she lived a "proper and sedate" life, while longing for romance.[63] When she drank champagne to celebrate a local wedding, her community disowned her and she became a dressmaker's muse, inspiring a Parisian fad for "Quaker" fashion, characterized as both modest and attractive to men.[64] The curtain closed on Prudence's happy engagement to a non-Quaker American man, and press coverage of the show idolized her for balancing old-fashioned morality and newfangled sex appeal. Newspaper reports conflated performers with their characters, admiring both their physical beauty and their rumored resolve to decline stage door propositions from male fans.[65] Urging consumers to emulate this unique blend of propriety and allure, stores advertised such products as "the new QUAKER GIRL dress," "Quaker Girl" hats, and a "'Quaker girl' Silk negligee (with cap)."[66]

As this trend persisted, the press reflected on its social significance. In 1915, newspapers publicized a young Los Angeles woman's prediction that Quaker style would inspire a new "happy medium" of femininity, triumphing over frivolity as well as female attempts to emulate "mannish modes." This evolution would reflect the Quaker Girl's romantic appeal, for "it's a natural law of the swinging of the pendulum that the tango-mad, cocktail-drinking girl of recent times shall sway back to the type of the generations when the Puritan maid and the Quaker girl were the cynosure of all admiring eyes."[67] And yet as the Quaker trend continued, it inspired concerns that boldly manipulative women could masquerade as guileless innocents. A 1917 McClure's article criticized the "Demure Young Thing" who emulated celebrities' "Quaker" costumes: "She has seen Isadore [sic] Duncan in a soft gray cape and toque, or Ina Claire as the Quaker Girl in organdy fichu and turn-back cuffs—oh, yes, other things of course. So she searches the shops for just the softest, bluest, silveriest-gray, and puts a mere touch of dark blue grease paint on her eyelashes, apple blossom rouge on her face, and the fichu, when no one else is wearing fichus, over her flat bust, and a droopy hat with scraps of lace and blue velvet ribbons and pale pink flowers, and she really thinks that she is fooling the world into believing that she knows naught of evil and all of the good and the true!"[68] Feigning disinterest in glamour, such women purportedly manipulated nostalgia to mask their undesirable traits.

In the 1920s, the press emphasized the powerful effects of such deception on men. Newspaper reports on an unsolved 1923 Los Angeles murder applied the phrase "Quaker Girl" as shorthand for the threat of immorality under a demure veneer. The victim, California aviator and engineer Earle Remington, had told friends about a mysterious, unnamed woman he admired "because

she was old fashioned"; and, as the *Chicago Daily Tribune* and *Los Angeles Times* emphasized, "he repeatedly tried to get this 'Quaker girl' on the phone" in the days before his death.[69] In a more jovial tone, a 1927 *Life* magazine poem dedicated "to a Quaker Maid in Fashion" highlighted the flirtatious effect of artificial modesty with the confession

> Quaker Maid I long to kiss,
> With thy merry, wanton quips
> And thy quirking, lip-sticked lips—.[70]

A style initially promoted as a nostalgic signifier of simplicity now symbolized calculated female sexuality.

In contrast with such critiques painting the faddish Quaker Maid as a transgressor, the press continued to applaud women who earned the moniker for Pennsylvania backgrounds. A 1927 society column in the *Atlanta Constitution* eagerly anticipated the arrival of Miss Florence May Edge of Kennett Square, Pennsylvania, daughter of an executive. She was the houseguest of a local socialite, and the paper predicted she would influence the city's social scene so much that "this time next week, no doubt, Atlanta belles will be affecting the quaintly delightful ways of a Quaker maid!"[71] Press reports of the 1936 Democratic National Convention held in Philadelphia celebrated the local women who dressed as "Quaker Maids" in long skirts and bonnets to welcome delegates.[72] In this context, the phrase evoked social pedigree and patriotism, casting Pennsylvania women as aspirational models for national audiences.

Quaker motifs also continued appearing prominently in product design. Most visibly, beginning in the 1920s the A&P grocery store chain marketed its low-priced Quaker Maid line, which included canned beans, ketchup, chili sauce, baking powder, and cocoa.[73] During the Depression, the newspaper ad promise of "Old Time Quaker Thrift for You" normalized the austerity required in the current economic crisis by making it a legacy of the idealized past and a tribute to consumer prudence.[74] The brand's simple packaging, pictured in some advertisements, featured no Quaker Maid in the flesh but was adorned instead with lettering and geometric shapes.[75] With this invisibility, the A&P Quaker Maid's identity could be imagined by consumers.

Reflecting the wide reach of its promotional campaign, the chain advertised in mainstream papers, as well as in newspapers published by and for African Americans, using the same strategies for both markets. Simple layouts often included text and the A&P lettered logo only. Other advertisements featured a stereotypical Quaker Maid or figures in nineteenth-century dress. When these historical scenes appeared, often in conjunction with store

anniversary promotions, illustrators used spare line drawings and silhouette effects, providing no clear-cut skin color for the men and women pictured.[76] This ambiguity marked a sharp contrast with A&P advertisements depicting modern shoppers, which asserted a white ideal, even in African American publications, through photographs of white models and detailed drawings suggesting white complexions.[77]

Philadelphia Adwomen's Modernized Quaker Maid

Although corporate promotions obscured women's dynamic historical roles as activists, the Quaker Maid's familiarity served the PCAW's feminist goals. In its final report to members, the group's 1929 Emblem Committee narrated its initial difficulty finding a historical figure who could represent "women, advertising and Philadelphia." Popular memory offered no female counterpart to Ben Franklin. Betsy Ross was rejected as a mythic icon whose fabled actions could not provide practical inspiration. The committee eliminated Letitia Penn and Deborah Franklin as women known for their marriages. The absence of a famous heroine associated with American commerce produced the conclusion "Women in advertising, or any business for that matter, are not old enough to have a well known leader, therefore the best we could suggest was the use of the Quaker Maid." The committee then worked to cast its Quaker Maid as part of a long legacy, redefining the history of modern businesswomen by looking further into the past: "The word Quaker always suggests Philadelphia, and Quaker women have always been known as progressive and independent thinkers, sharing equally with the men in their Church, home, and business life."[78] This conceptual model redefined continuity so that the common thread in the female character across time was a readiness to embrace innovation and contribute to society. As an embodiment of adwomen's professionalism, the Quaker Maid adorned the club's letterhead and membership pins and every *Adland News* cover. She appeared either in silhouette or in a simple profile line drawing with "PHILADELPHIA CLUB OF ADVERTISING WOMEN" visible on her ever-present bonnet.[79] Although the committee acknowledged that women's employment in business was new, this design retroactively identified the Quaker Maid as an adwoman. Contemporary adwomen thus became direct counterparts of the idealized Quaker Maid.

Further emphasizing links between past and present, the emblem's earliest official appearance was the club's 1930 dinner dance, an evening with the theme "La Danse Moderne." The event program proclaimed, "Tonight the Quaker Girl turns modern."[80] Cover imagery displayed the silhouette profile of a Quaker Maid in traditional bonnet. In the foreground, a contemporary

Figure 2.1. The Quaker Maid profile adorned Philadelphia Club of Advertising Women publications and letterhead. "La Danse Moderne" Program, 1930, Philadelphia Club of Advertising Women Records, Bryn Mawr Special Collections.

woman's hand brandished a stylish art deco cigarette lighter.[81] A built-in pocket below this imagery provided cigarette storage: seven thousand cigarettes, donated by the manufacturer, were to be shared by eight hundred guests.[82] Given billing with the Quaker Maid, the Chesterfields brand name completed the design. Here, style became the chief marker of different eras in women's history, and engagement with the past assumed the fun of costumed play and a glamorous night spent smoking and dancing with Poor Richard Club guests. But the emphasis on stylistic change held significant implications, suggesting that performances of femininity were historically and socially constructed and asserting that modern adwomen were fluent in contemporary consumer culture.

The PCAW's modernized Quaker Maid also embodied a flirtatious fashionableness that highlighted differences between past and present comportment. In a commemorative copy of *Adland News* produced for the dance, photographs under the heading "Modern Quaker Maids in Their Lighter Moments" illustrated members' social activities over the past year. One image, titled "Modern Maids with Modern Ways," showed a man with two PCAW members, each clinging possessively to one of his hands in mock

Figure 2.2. The Philadelphia Club of Advertising Women introduced its historical Quaker Maid emblem by emphasizing her modernity. Cover, "La Danse Moderne" Program, 1930, Philadelphia Club of Advertising Women Records, Bryn Mawr Special Collections.

romantic competition that, presumably, a traditional Quaker maid would disdain.[83] Thus, some of the club's depictions of its new emblem highlighted change in fashion and socialization while others asserted continuity between historical and modern professionalism.

Selection of an icon with colonial Pennsylvania roots did not confine the PCAW's subsequent historical play to that era. Underscoring the Quaker Maid's versatility, the next year's dinner dance traveled across time to an 1890s setting. The evening's program told guests to identify members through the "tiny golden Quaker Maid head—worn with a coquettish black velvet ribbon on the left wrist, in the mood of the Gay Nineties."[84] Historical costume also played a central role in performances for Poor Richard Club guests and civic leaders, highlighting stylistic change as evidence of progress. At a May 1936 joint meeting of the PCAW and the Poor Richard Club, also attended by presidents of local women's charitable and civic groups and by executives from local department stores, PCAW members celebrated the previous year's "most enjoyable and friendly relations with our Big Brothers" by staging a "Fashion Show of Yesterday." Two PCAW members dressed in Quaker costume to serve as ushers, and a parade of adwomen modeled historical clothing to mock previous eras' repression of women. As documented in the PCAW magazine, sarcastic description characterized an elaborate "Gay Nineties" outfit as "a simple little street dress." In "the bathing costume of yesteryear," a modest suit with long pants, long sleeves, a full skirt, and a bonnet, PCAW member Mathilde Hayes became "dashing . . . daring . . . wickedly revealing."[85] These commentaries stressed the difference between historical restrictions and then current norms, celebrating adwomen's modernity by identifying women's comparative contemporary independence as more reasonable.

Simultaneously, the historical "Fashion Show" provided an unconventional spin on the stereotypes that women love clothing and that they dress to attract attention. The event placed members in attire that, rather than highlighting their bodies, emphasized their professionalism. Dorothy Dignam's costume, a long turn-of-the-century driver's coat, complete with goggles and hat, established a link with her professional work at N. W. Ayer, pitching the Ford V-8 to female consumers nationwide. Reminding Poor Richard Club audience members of this campaign, the performance publicized Dignam's own career, in the guise of entertaining spectacle. The Ford promotions she authored echoed this retrospective approach, celebrating the long history of female drivers who challenged prejudice against their abilities by embracing new automotive technology. Her *Women's Driver Manual*, distributed by Ford

in 1937, countered narrow definitions of women's abilities by placing opposition to female drivers in the past:

> Women have been driving cars for about forty years. And while it was first feared that their "natural hysteria" would get them into trouble, and that "youths under 18 and all women" should be refused motor licenses for the public good, men began to reason that if women continued to take "motor management" seriously, they might eventually influence the design of the cars.
>
> And, sure enough, they did![86]

Dignam then provided historical examples, citing female consumer demand as the reason manufacturers added windshields and closed tops that would not require goggles or disturb women's hats. Because modern consumers—male and female—would appreciate these modifications as standard, such stories dramatized the significance of women's input. Adwomen's activism and employment thus intersected, stressing that their consumer roles enabled women to influence business history.

History as a Career Guide

Alongside their dramatic pageantry, women's advertising clubs of the 1920s and 1930s launched serious public education campaigns. The PCAW taught advertising courses and published curricula for public and professional audiences. While focusing on contemporary techniques, members asserted women's vital roles in the industry's history. These projects presented advertising careers as accessible to any experienced female shopper; but adwomen also acknowledged the persistence of discrimination, advocating strategic accommodation to gender norms. (In a 1933 lecture, "Up the Ladder We Must Go," Dorothy Dignam advised, "Keep a stiff upper lip, with some lipstick on it.")[87] Accounts of advertising women's history—from the industry's origins to the recent successes of club members—offered encouragement for such strength.

Because academic courses and texts on advertising remained rare, these projects both earned popular press coverage and were adopted into college curricula, securing visibility for the adwomen who authored them, as well as the historical figures they profiled.[88] In 1939, Harper & Brothers published *Advertising Careers for Women*, a collection of lectures from the Philadelphia Club of Advertising Women's courses.[89] The book was endorsed by the U.S. Department of Education and in industry publications, with *Printers' Ink* ranking it among the top ten books on advertising.[90] The Strawbridge & Clothier department store hosted a conference, promoted as an opportunity

to obtain the expert authors' "advice in seeking your first job—or a better job!"[91] In her foreword, club president Elsie Weaver emphasized the attainability of an advertising career by reporting that the first eleven years of the Philadelphia Club's advertising course had educated eight hundred women, with at least two hundred alumnae currently employed in the field.[92] The conclusion promised possibilities for advancement through hard work, surveying one hundred current adwomen and reporting that 65 percent of them began their careers in stenographic, secretarial, or clerical positions.[93]

In the book's introductory chapter, Christine Frederick emphasized the intergenerational legacies that enabled such employment. She remarked, "The recent Department of Labor pamphlet entitled 'Women in the Economy of the U.S.' not once mentions women in advertising. But this does not alter the fact that women have been in advertising, in one capacity or another, almost from the beginning of the profession." To counter this amnesia, she identified the influence of Matilda C. Weil, who began working in advertising in 1867 and later developed her own agency; Frederick remarked that Weil's career predated that of the "young Francis Wayland Ayer," who established the famous Ayer agency in 1869. Tracing a direct link between past and present, Frederick remarked, "Mrs. Weil's successor, who took over her business in 1903, is still engaged in advertising."[94] Offering another example for the PCAW's target audience, Frederick praised Jane Martin for her rise from stenographer in the 1880s to high-salaried advertising manager in the 1900s and for her influence as the leader of the League of Advertising Women, "encouraging women in business and advertising and helping to found clubs."[95] Frederick reported that the early advertising club leaders mentored by Martin "are still young, active, successful: only to be classed as 'pioneers' of the post-war period!" She ended her historical overview with a look to the future, as she identified the contemporary consumer movement, and its protests of current advertising and marketing practices, as the greatest modern "opportunity for women in advertising." This activism, she asserted, would push the industry to pay more attention to "what women actually want in advertising information" and to rely on female employees as corporate delegates to the public.[96]

Recent shifts in the industry supported this hypothesis. Initially caught off guard by consumer interest groups that demanded government intervention to regulate advertising, the National Association of Manufacturers, the Advertising Federation of America, and the American Association of Advertising Agencies developed public relations campaigns in the mid-1930s to undermine activists' criticism by casting advertising as a service that was central to democratic capitalism.[97] Adwomen's existing civic and media

partnerships served the new goals of establishing friendly relationships with consumers.[98] Embracing the opportunity to demonstrate their modern professional vitality, adwomen continued celebrating the links between past and present. Women's advertising clubs throughout the East staged a pro-advertising play published in 1935 by *Woman's Home Companion* associate editor Anna Steese Richardson.[99] The Philadelphia Club of Advertising Women visited local civic groups to perform, circulating fliers featuring the Quaker Maid logo.[100]

The Philadelphia Club of Advertising Women and Racial Identity

However, the PCAW did not always approach historical subjects with respect. Adopting ancient Egyptian and antebellum Southern themes for social events in 1930 and 1940, members staged performances to juxtapose adwomen's progressiveness with the supposed primitiveness of non-white and non-Western women. In promotions for the parties—circulated not only to invited guests but also to local newspaper and radio audiences—Egyptian women appeared as sexual objects and African American women appeared as slaves. In contrast with the "Fashion Show of Yesterday," adwomen promoted rather than mocked these stereotypes when dressing in costume. This mindset reflected the influence of fancy dress masquerades' popularity for late nineteenth- and early twentieth-century social parties and charitable fairs. Organized by upper- and middle-class women, these events fused elements from diverse national traditions into an exoticized Orientalism, equating Eastern civilizations with the past.[101] Simultaneously, adwomen's racialized performances echoed current trends in their own industry. As scholar Alys Eve Weinbaum argues, marketers identified the ideal "Modern Girl" of the 1920s and 1930s through her ability to engage in "racial masquerade": she could purchase clothing and commodities inspired by the aesthetics of African and Asian cultures as a way to "try on racial otherness or exoticness."[102] Because her own status as a white woman remained clear regardless of costume, her consumption of fashions inspired by other societies ultimately highlighted her own purported superiority.[103] Referencing historical settings in their racial masquerades, PCAW members asserted long-standing continuity in the racial hierarchy and celebrated their own modernity by emphasizing their whiteness.

In 1930, the PCAW staged an "Egyptian Holiday" party for members and friends, summarized in *Adland News* as "colorful, Oriental, bizarre, with its never-ending sources of amusement."[104] The event, with attendance around

250, assumed eternal primitiveness in Egyptian society by jumbling refer-
ences to the past and the present. Invitations offered "a night in Old Egypt,"
and the evening featured a "slave market" for bids on female dance partners.[105]
However, a radio broadcast by club members compared the event to a trip to
a contemporary Egypt of "picturesque scenes and vivid colorings," populated
by "women with their faces veiled."[106] The evening's program bore the leg-
end "this is thy passport," making travel to an "Old Egypt . . . untrammeled
by petty prohibitions" a matter of geographic distance.[107] This ahistoricism
asserted Western superiority over a purportedly uncivilized culture. Instead
of locating a legacy of Egyptian women's innovation to parallel the Quaker
Maid, the PCAW limited Egyptian women—past and present—to a sexual-
ized caricature, providing club members with an excuse to deviate from their
typical decorum by dressing in costume.[108]

This clothing became the main planning concern. There were no dis-
cussions of historical inspiration as there were in the development of the
Quaker Maid; instead, the Egyptian woman was defined entirely through her
perceived sexuality. The initial invitation featured a drawing of a woman in
a strapless, brassiere-like top, a diaphanous skirt, and an ornamental head-
dress.[109] She evoked popular imagery of Cleopatra, including Theda Bara's
1917 screen portrayal.[110] However, an internal memo claimed, "The figure
illustrated is *not* wearing the costume we'll have so don't be alarmed!"[111]
Rather, the event's organizers asked members to donate items from their
own closets and purchased cloth for skirts and blouses to be customized with
beads and jewelry.[112] Although contemporary popular culture associated "Old
Egypt" with the ancient past, not with the Ottoman period (1517–1914), the
planning committee simply requested either "Turkish" or "Egyptian" outfits.
One member volunteered a Chinese costume as a backup.[113]

By conflating Egypt with other nations, advertising women also referenced
their industry's iconography. Egyptian cigarettes, manufactured with Turkish
tobacco, became popular in Europe and the United States in the late nine-
teenth century. Early twentieth-century American companies subsequently
developed their own brands with Egyptian and Turkish motifs.[114] PCAW
correspondence about costume inspirations made frequent references to
"Fatima," an American brand marketed as a "Turkish Cigarette" and offered
as a concession at the party.[115] Echoing popular imagery that racialized and
sexualized Arab women, the Fatima logo featured a woman's face, entirely
veiled beneath her eyes. PCAW members imagined this persona—portrayed
in advertisements wearing a transparent veil, seductive smile, and a regal
jeweled headdress—as a regression: to be Egyptian or to be Fatima was to
be primitively sexual.[116] Some club members jokingly compared their social

interest in men, and their desire to be attractive on the night of the event, with their preconceived stereotypes of Fatima as an erotic figure. In planning correspondence, one participant offered the encouragement "Just think how Fatima-ish you will look in a costume; but with a little more to it than the lady on the card!"[117] Nevertheless, some participants were concerned that an appearance as Fatima would make them less attractive. One member volunteered, "I'll help in a tent if there's a sheik in it!! But I donno about the costume, the only thing I can think of is Fatima and I'm funny enough looking as it is."[118] This remark recalled Rudolph Valentino's starring role in the popular 1921 film *The Sheik*. His modern-day title character, initially introduced as a domineering North African Arab, is ultimately revealed as a European in disguise who rescues the white female protagonist.[119] The movie's flirtation with interracial romance was echoed by PCAW members' ambivalence toward the prospect of masquerading as a racialized Other. For some, the boundaries between "Egypt" and Philadelphia should be clear, even in make-believe. As one member wrote in response to the request that she dress as an Egyptian, "Whoever heard of one of those with red hair?"[120] Nevertheless, in spite of adwomen's hesitance to identify with their characters, the club used the event to define its public image, inviting representatives of Fatima cigarette manufacturer Liggett and Myers, Philadelphia mayor Harry Mackey, and members of the press as guests.[121]

A decade later, PCAW members asserted an even stricter boundary between black and white Americans: when costumed as an African American, an adwoman was no longer an adwoman. The 1940 dinner dance was called "Southern Serenade," staged on the heels of the film *Gone with the Wind*'s (1939) popularity. Exaggerated cartoons of smiling African Americans decorated invitations, and the evening's entertainment included a historical tableau sentimentalizing slavery: three club members in antebellum-style gowns posed with another club member in blackface, kerchief, and apron.[122] Making the city's general population an audience to that scene, the *Philadelphia Record* newspaper printed a publicity photograph taken during rehearsal. As presented in the newspaper, the performance aligned adwomen's business success with the Southern belle archetype while endorsing the marginalization of African Americans, past and present. Evoking *Gone with the Wind*'s enslaved "Mammy," the blackface character carried a serving tray, and the newspaper's headline supplied her with dialogue of wonderment further differentiating her from the other characters. She poses the question "Is You-All Really Advertisin' Women?" The caption responds, "Yes, Mammy, that's what they are."[123] This answer presented white slaveholding ladies and modern advertising women as parallel, both deserving of admiration. Mammy's

surprise at women's professional activity served as a source of humor, reliant on assumptions of African American ignorance or backwardness. Furthering this depiction of African Americans as subordinate to adwomen, guests were promised a post-dance late-night "plantation breakfast" featuring pancakes by the Quaker Oats Company's own Aunt Jemima.[124]

The PCAW's idealization of racial hierarchies as a tribute to white female professionalism echoed Margaret Mitchell's text. As scholar Tara McPherson explains, novel and film protagonist Scarlett O'Hara strategically deployed her beauty while functioning as a lumber industry entrepreneur, simultaneously adhering to and challenging gender norms. Her genteel femininity gained definition through its contrasts with the physical labor of the asexual, maternal Mammy character. Nevertheless, although Scarlett relied on Mammy's material support, just as the Southern economy relied on African American women's labor, the story never commented directly on this intersectionality of race, class, and gender that shaped both white and black women's experiences.[125] Like its fictional inspiration, the PCAW's tableau divorced the antebellum Southern woman from her true historical context, assuming racial distinctions as natural and unproblematic to glorify the antebellum lady and grant her agency.

AFRICAN AMERICAN WOMEN AND THE QUAKER MAID ARCHETYPE

Mocking African Americans, the PCAW demonstrated the racial limits of its feminist history. Members assumed the whiteness of their Quaker Maid historical heroine. However, civic pride in the Quaker past transcended the white population. In African American newspapers, the phrase Quaker Maid was used to compliment a woman's style and social status. In 1924, the *Philadelphia Tribune* printed a photograph of a smiling young woman, posing on the beach with her hands on her hips, in a modern bathing suit that bared her arms and legs. The pithy caption read, "A Quaker Maid at Ocean City. Miss Vera Vanton."[126]

Like their white counterparts, African American socialites and club-women embraced historical costumes. In 1938, the *Chicago Defender* reported on Philadelphia's Omega Psi Phi fraternity's masked ball, remarking, "Mrs. Carl Day was quaint and pretty in a demure Quaker Maid's gown of grey and white." Other costumes at the event were described as "Chinese maiden," "Spanish costume," "a costume of Cleopatra's day," and "transparent harem girl's garb"; and there was even the archetypal Southern belle: "Miss Edna Allen wore a demure little old fashioned gown of pale green and was squired by Herman Miller who disguised himself as a gentleman of the old South."[127]

Society columns did not comment directly on the implications of these costumes, but such pageantry presumably held different meanings for black participants.

African American journalists also used historical iconography in their efforts to advance civil rights. In the 1920s and 1930s, Philadelphian Bernice Dutrieuille wrote for African American newspapers, redefining the Quaker archetype to support her own activist goals of critiquing white racism and improving black women's career opportunities. Beginning in the late 1920s, Dutrieuille applied the "Quaker" identity to the black elite populating her Bits by Bernice society column, published in the *Afro-American* (Baltimore), the *Pittsburgh Courier*, and the *Philadelphia Tribune*. Virginia's *Norfolk Journal and Guide* printed the same column under the title Quaker Quips.[128]

While identifying with Philadelphia's iconic heritage, Dutrieuille also deployed this past in more complex ways to criticize modern racism. In one edition of Bits by Bernice, nestled between reports of a Glee Club recital and an "adorable" party, was an extended indictment of the racial prejudice that defined "conservative old Quaker Ville," from its cherished past to the present. Arguing that Philadelphia's residents should spend the upcoming Lenten season contemplating this problem, she explained: "It is difficult to follow the workings of Philadelphia's mind, in all its ramifications, but we daresay that the religious fervor of her Quakers in the past, was hardly more the manifestation of love for fellow-being than is the cool aloofness of her nordic element, exhibited toward her darker brethren today. Rather, it seems, that our foreparents, sad to relate, were given to extremes, and being swayed—despite a calm exterior—by their emotions, could be equally cruel and at times almost barbarous. Their narrowed confines were only conducive to an even more constricted outlook on life." Characterizing early America as a society in which strict regulations enabled hierarchical oppressions, Dutrieuille then expressed optimism. She argued that modern business practices diversified people's professional networks, weakening "clannish" thinking. Thus, although racism persisted, Dutrieuille urged her readership to work diligently. With recognition of African Americans' contributions, she argued, the deeper problem of prejudice "will automatically take care of itself."[129] This accommodationist approach placed responsibility on African Americans to challenge discrimination by supporting the society that marginalized them. However, the criticism of white society was pointed, emphasizing the failure of contemporary citizens to live up to the precepts of Christian morality while simultaneously striking at the city's beloved historical mythology. Still, she claimed this past as the heritage of modern African Americans, describing Quaker leaders as "our foreparents."

Dutrieuille's media career aligned her with the PCAW's vision of the Quaker Maid as a contributor to business and public life. However, the club excluded African Americans from membership.[130] Nevertheless, in 1935 Dutrieuille completed the PCAW's tuition-free advertising course; she later used information from its lectures in a 1938 *Philadelphia Tribune* series advising black women about business and professional employment.[131] Like PCAW members, Dutrieuille sought to expand women's opportunities. In the 1930s and 1940s, she argued that African American women journalists could make vital contributions to newspaper coverage of the civil rights movement but were limited by hiring practices that relegated them to reporting on fashion and gossip.[132] However, in spite of intersections between Dutrieuille's philosophies about women's professional capabilities and Philadelphia adwomen's vision of the Quaker Maid, white adwomen's biases precluded an activist collaboration.

The Women's Advertising Club of St. Louis: Creating a Usable Past outside the Shadow of Colonial Heritage

While the PCAW marginalized African American women, the group established strong connections with sister organizations of white women across the country. Women's advertising clubs organized regional meetings, exchanged newsletters and invitations, and reported on one another's activities in their own publications.[133] Chronicles produced by adwomen in New York; Chicago; and St. Louis, Missouri, suggest that Philadelphia advertisers' Poor Richard and Quaker Maid were unique; other members of the advertising club network did not attach their identities so closely to long-standing mascots. However, the clubs all referred to the past to assert professional legitimacy, to challenge biases, and to structure social events. Without a direct counterpart to the civic pull of Philadelphia's colonial heritage, adwomen of St. Louis developed a more irreverent stance while still deploying history to define modern women's roles.

Like the PCAW, the Women's Advertising Club of St. Louis formed in 1916 as the counterpart to a group that admitted admen only, an origin that shaped the group's engagement with the past.[134] Reconfiguring stereotypes of women's devotion to frivolous fashion, club members often satirized male icons of the past as equally foolish, effeminate consumers. During the 1932 bicentennial of George Washington's birth, the club promoted a card game party to its members by jokingly comparing the gathering's fund-raising goals to Washington's Revolutionary War campaigns: "Today George would not risk his life, his tri-corner and his platinum blonde marcel by standing on the deck as he crossed the Delaware. He would simply reach down into

the pocket of his knee-panties, extract a dollar and pay his bridge toll. Stand on the deck? Nay! He would deal the deck and perchance help himself to the prize that will adorn each and every one of the tables."[135] This scenario lampooned George Washington by imagining him in "platinum blonde marcel"—a modern hairstyle associated with glamorous female film stars—as he chose a game of bridge rather than strategic military navigation.[136] This approach ridiculed femininity while mockingly equating the club's activities with historical milestones by debasing a male icon as frivolous.

Placing Washington in feminine fashions, St. Louis adwomen encouraged homophobic laughter while simultaneously mocking the prospect of a man falling short of masculine ideals. This caricature coincided with the 1920s and 1930s trend that historian George Chauncey characterizes as the "pansy craze": the vogue for heterosexual, middle-class attendance at urban drag performances. Chauncey explains, "At a time when the culture of the speakeasies and the 1920s' celebration of affluence and consumption might have undermined conventional sources of masculine identity, the spectacle of the pansy allowed men to confirm their manliness and solidarity with other men by distinguishing themselves from pansies."[137] Simultaneously, however, male social and professional organizations regularly staged spectacles and rituals in which members dressed as women. This tradition dates to the eighteenth century at elite universities, and modern advertising clubs now used it. As scholar Marjorie Garber explains, cross-dressing in such context also highlighted participants' "common privilege of maleness."[138]

The Women's Advertising Club was responding to local admen's reliance on such performances. Beginning in 1932, the male St. Louis Advertising Club held an annual Gridiron Dinner, "strictly a stag affair" designed to strengthen relationships between the advertising industry and local business leaders.[139] St. Louis Advertising Club members staged satirical sketches about politics and business, performing both male and female roles in costume.[140] In 1935, the Women's Advertising Club began hosting its own annual Gridiron Dinner on the same night as the admen's event.[141] In 1939 the adwomen welcomed 550 guests, among them wives of admen, and received prominent coverage in the St. Louis press, which emphasized a performance—titled "Gender on a Bender"—that caricatured the iconic hero of Romeo and Juliet as effeminate.[142] According to press reports, members "summed up their ideas about men in a scene burlesquing the Municipal Opera in which they had Romeo dressed in scarlet satin shorts, socks and garters, and a floppy hat. Romeo talked with a lisp."[143] These papers did not comment further on the adwomen's implied portrayal of homosexuality. However, an article by the club's former president, published in the employee newsletter for the local Stix, Baer &

Fuller department store, quoted the skit's dialogue, in which Romeo "in a lisping voice refuses Juliet's plea, 'I want you for my husband,' replying, 'But, lady, I don't know your husband.'"[144] This exchange treated homosexuality as a punch line, and an intention to ridicule gays may be suggested in the fact that Romeo faced such mockery, while the evening's skits did not skewer any examples of conformity to the ideals associated with manliness. Advertising clubs and agencies did not comment directly on sexuality the way they, at times, did on race, leaving questions about the inclusion or exclusion of gays and lesbians as members; but, because homosexuality was treated as a joke when it did appear here, the performers presumably intended to degrade gay men, and to claim for themselves some of the professional privilege associated with mockery of effeminacy.

In local newspaper reports, the Romeo spoof gained context from the evening's other skits, which ridiculed female frivolity. The *St. Louis Post-Dispatch* summarized the evening with the subheading "Members Burlesque Their Own Sex as Well as Men," reporting on the Romeo skit and a send-up of women "going to cooking schools, marrying off their daughters, using all the room on a bus, asking gossipy personal questions, and looking for a man."[145] Men were mocked for emulating cultural ideals of femininity, and women were mocked for reflecting stereotypes of romantic schemers. The common thread became disdain for those feminine clichés.

Carrying this perspective forward, the 1940 event, which departed from tradition by welcoming two male guests—the mayor and a Washington University football coach—offered a humorous fashion parade. The "new 'dumb-bell silhouette'" featured tin boxes as shoes, sarcastically described in the *St. Louis Star-Times* as useful "for graceful strides." The club criticized stylistic nostalgia too, presenting "the demure model of the romantic old south in a hoop skirt, until a gust of wind whipped up by two fans blew her skirt off . . . 'It's Gone With the Wind.'"[146] This spectacle mocked fashion itself as artificial, past and present. Celebrated as satirists in the local press, club members placed themselves above this triviality.

The St. Louis adwomen also developed whimsical historical iconography that referenced the past to applaud contemporary women's professional status. Club member Lillian Thoele's 1934 newsletter cover illustration featured a woman in ornate nineteenth-century dress, wearing gloves and a bustle, daintily pointing her foot as she fanned herself. On the wall behind her a large framed image depicted a woman in 1930s clothing, bearing a large stack of books.[147] The drawing inverted the familiar advertising trope of modern women's admiration for the female beauty in historical portraits.[148] Now, the modern working woman occupied the position of honor. The editor's letter

characterized this as "advertising of long ago, gazing in wonderment at advertising of the 20th Century, who has all the charm and grace and poise and color of the modern day."[149] Here, the contemporary adwoman received some ribbing, as the "graceful" cover girl displayed dramatic disorientation and clumsiness. Eyes open and mouth agape, she stared back at her more elegant historical counterpart. Automobiles behind her established the frenetic activity of modern life, as her outstretched arms, turned-in feet, and toppling books suggested she had stopped in her tracks. Her animated reaction suggested her surprise at finding herself trapped in a portrait, but she was there nonetheless, idealized by her more traditional counterpart. The text of a 1935 club history published in the St. Louis Star-Times again contrasted old and new styles to highlight modern professionalism. Under the heading "Multi-Petticoated Girls of '16 Wouldn't Recognize Organization They Formed," descriptions of founders' "generously-adorned hats resembl[ing] vegetable casseroles," prim "ankle-length skirts," and "high-laced shoes" contrasted with a celebration of modern members' confidence and professional achievements.[150]

The Women's Advertising Club of St. Louis also asserted its professional reputation by deploying historical pageantry in events shared with male advertisers and community members. The adwomen staged a 1941 "Gay Nineties" roller skating party to raise funds for preservation of fur trader Robert Campbell's home as a historical landmark and museum. The diversity of participants reflected the advertisers' engagement in a civic network. The senior and junior men's advertising clubs provided organizational assistance. The Red Cross supplied a historical exhibit. For a costume contest, the city's Society of Colonial Dames chapter donated a prize. As the local press reported, a "men's auxiliary committee" of "bustle judges" would determine winners. Servicemen received complimentary tickets.[151] This humorous, flirtatious spectacle of historical style, tailor made for photographic features in local society pages, received prominent news coverage that cast modern St. Louis adwomen themselves in the more serious role of public history patrons.

Reconfiguring popular iconography, women's advertising clubs used history to define adwomen's modernity and professionalism. Some performances asserted identification with the past, while others established strategic distance between club members and the historical archetypes they performed. The organizations promoted a career-oriented feminism by publicizing a record of women's contributions to public life in hopes of expanding future employment prospects. As will be addressed in the next chapter, the modern medium of radio provided an additional platform for the efforts of Philadelphia adwomen to establish their historical Quaker Maid identity and to demonstrate their skills.

BROADCASTING
YESTERYEAR

WOMEN'S HISTORY ON
COMMERCIAL RADIO,
1930–1945

As radio took hold in the United States, American history quickly became a prominent subject matter in broadcasts. Dramatizations of past events mediated between modernity and tradition, and between domesticity and public life, to define women's roles. These popular histories reached large audiences; radio revolutionized entertainment and politics, increasing the influence of urban media on consumers' everyday lives. During the Great Depression, Americans tuned in for an average of four to five hours a day, and scholars have attributed the emergence of a new, standardized national identity to the growth of commercial broadcasting.[1] Nevertheless, radio presented diverse perspectives on women's historical significance. Some commercial narratives idealized domesticity as a timeless national tradition, but other programs reached into consumers' homes to proclaim that women were important as dynamic historical actors, both in the past and in the present.

As scholar Michelle Hilmes argues, in the 1920s and 1930s broadcasters sent conflicting messages about gender.[2] Radio's commercial success relied on women as consumers and workers. Meanwhile, boundaries between public political space and domestic private space eroded as diverse discourses came directly into American homes in the seemingly personalized package of conversational announcements spoken directly to the consumer.[3] However, broadcasters sought prestige by adopting existing social hierarchies, including the characterization of public discourse as a predominantly male domain.

This tension gave rise to gendered distinctions between genres, broadcast hours, and subjects.[4] In the 1930s, the use of history as subject matter helped define these boundaries. At night, a time allotted for public service and reputation-building programming, the DuPont Company presented its historical biography series, *Cavalcade of America*. With input from academic historian consultants, the program encouraged citizens to imagine history as a nation-building enterprise that was vital to contemporary life. Scripts tailored the past to DuPont's political goals, providing a platform for advertisements claiming the company's contributions to progress.[5] Marketed to audiences of both men and women, the series often acknowledged women's contributions but ultimately prioritized the history made by men over that made by women. Meanwhile, broadcasters cited such educational material as justification for the entertainment offered during the day, when soap operas dominated. Targeting female consumers, these serials dramatized contemporary daily life but emphasized intergenerational tradition, placing the past at the center of the modern woman's identity. Advertising agencies adapted familiar iconography as major corporations began to sponsor network series. For example, the Aunt Jemima character inspired a daytime NBC network program.[6] The Baker's Chocolate Belle Chocolatière sponsored a soap opera. These programs emphasized continuities in women's domestic histories, a contrast with *Cavalcade*'s celebrations of entrepreneurial innovators.

Simultaneously, feminists brought alternative perspectives on women's history to the airwaves.[7] In the 1930s, the Philadelphia Club of Advertising Women (PCAW) produced local radio series that looked to the past to translate the group's feminism for general, evening audiences in the nation's third-largest broadcast market.[8] These fact-based biographical dramas offered more complex portrayals of women's history than did those of the stock historical characters that populated advertisements. The PCAW asserted that history proved women's achievements as vital contributors to public and professional life: "With little or no encouragement toward achievements outside the home, women in yesteryear made monumental accomplishments that live vividly in our State's history and growth," the club's radio committee explained in publicizing one of the series.[9] Nevertheless, the broadcasts also capitalized on familiar stereotypes of femininity. This chapter will analyze scripts written by Dorothy Dignam; although twenty-six club members alternated writing responsibility over the course of the series, Dignam's are the only biographical scripts available, preserved in her personal papers.[10] The club's iconography and visual promotions for its radio project, letters written by listeners, and contemporary radio plays that Dignam drafted for a proposed commercial campaign will contextualize the creation and reception of the PCAW's biographical dramas.

To explore corporate-sponsored histories' messages about women's roles, I will also analyze dramatizations of women's public and domestic responsibilities in *Cavalcade of America* and in writer Irna Phillips's influential daytime serials. The chapter concludes with writer Mona Kent's *A Woman of America*, a soap opera that celebrated its female audience's current contributions to World War II by dramatizing the fictional story of a woman on the nineteenth-century Oregon Trail. These sources reflect radio's heavy reliance on the past as precedent for modern women's domestic, professional, and civic activities.

THE PHILADELPHIA CLUB OF ADVERTISING WOMEN ON THE AIR

Dorothy Dignam and her PCAW colleagues embraced radio as a unique tool for promoting the club's agenda. The group's initial foray into radio drama, beginning in 1930 on local airwaves, proclaimed advertising's public service functions. In a Monday afternoon slot, club members performed weekly fifteen-minute discussions between the characters Aunty Antique and Mary Modern, as the younger character Mary advised the older on savvy consumption. According to the club's radio committee, "In the end you won't be able to tell Auntie from the most up-to-date of city matrons, all because of advertising."[11] Simultaneously, the project strove to demonstrate adwomen's facility with the new medium, just as agencies were starting to employ it in projects for their major clients.[12] Noting positive listener response to the series, the committee chair reported to members, "We trust that we have interested the public in our cause—but if we have done nothing else, we have brought the Philadelphia Club of Advertising Women before the Public Eye thru Advertising's Lusty infant—radio—again proving that we are a progressive and up-to-the-minute organization."[13]

The PCAW's dramatic scripts emphasized that even modern women drew inspiration from the past. Although she urged Aunty to update her "antique" style by embracing new products, Mary contemplated advertising history. In one installment, she claims that advertising slogans originated with "the war cry of the old Scottish clans."[14] The discussion then turns to the longevity of successful twentieth-century examples—many, the script noted, created by women. Echoing the strategy promoted by industry experts, Mary explains that the best modern ad slogans are "time-proof."[15] Notably, for the adwomen of the PCAW, change and continuity, modernity and awareness of the past, went hand in hand.

As the percentage of U.S. households with radios continued to increase throughout the Depression, the PCAW's radio programming evolved.[16] From

1936 through 1939, the group produced four series of local radio plays about notable historic women and their contributions to public life. The titles of the different series reveal their focus: in early 1936, *Famous Philadelphia Women of Yesteryear*; in late 1936 and early 1937, *Famous Pennsylvania Women of Yesteryear*; in 1938, *Famous American Women of Yesteryear*; and in 1939, *World-Famous Women of Yesteryear*. Reconfiguring popular culture's assumption of a universal female nature, the broadcasts cited past achievements as proof of women's inherent capacity for progress. After the shorter inaugural series on Philadelphia women, each subsequent series featured over twenty programs, broadcast in a fifteen-minute weekly evening slot, on either Monday or Thursday and with start times ranging between 7:45 and 9:00 PM across the years.[17] Each installment offered a dramatic biography, complete with music and sound effects. PCAW members researched, wrote, and performed the original stories.[18] Their broadcast schedule put large audiences within reach. The first three series aired on WFIL, affiliated with the NBC network and a major player on the Philadelphia airwaves. Market research conducted in 1937 showed that 18.22% of telephone survey participants in the city and surrounding areas who were listening to the radio between 6:00 and 10:00 PM on Thursday, February 11, had listened to WFIL during the block. On that evening, the station broadcast the PCAW's biography of Molly Pitcher at 8:15 PM.[19]

Paralleling the Poor Richard Club's promotion of Benjamin Franklin, these programs positioned Philadelphia's advertising women as authoritative, passionate guardians of local and patriotic history. The PCAW president wrote to leaders of other local women's clubs, asking that they promote the broadcasts to their members and emphasizing that "all of the incidents mentioned will be authentic . . . bringing to light seldom-mentioned or almost-forgotten but nevertheless interesting incidents in [women's] lives."[20] The broadcasts thus provided a new context for the club's anonymous Quaker Maid mascot, whose silhouetted head appeared on publicity brochures. In language that later promotions echoed, a printed announcement explained the goals of the first series to the general public: "We want you to listen; we want you to be interested in these programs. Our aim is to remind men, as well as women, that Women—as Women, today, and yesterday, are and were important in the scheme of things. . . . Back in the Colonial days women were making history; women were working and accomplishing outstanding results."[21] Thus, the group emphasized its intention to use the past to shape public attitudes about modern women's roles.

The initial 1936 performances focused on colonial, early Republic, and Quaker histories with portrayals of Peggy Shippen, Betsy Ross, Lydia

Darragh, Dolley Madison, Deborah Franklin, and Sally Wister. Many of these iconic women had already featured in popular culture. *Famous Philadelphia Women of Yesteryear*, however, stepped beyond the most familiar stories of Revolutionary War heroines and famous men's wives. The subjects included women who flourished in nondomestic roles. The second broadcast centered on nineteenth-century editor Sarah Josepha Hale (1788–1879). Another installment featured Rebecca Gratz (1781–1869), who remained single throughout her life and founded a number of local charitable organizations and Jewish institutions. The subsequent series included such figures as Cleopatra, Pocahontas, George Sand, Susan B. Anthony, Harriet Beecher Stowe, Rosa Bonheur, Louisa May Alcott, Jane Addams, Marie Curie, Sarah Bernhardt, and Amelia Earhart.[22]

Dorothy Dignam's scripts presented consumer culture as a space in which women could parlay natural skills and interests into fruitful work and activism. A script on hymn writer Fanny Crosby (1820–1915) prioritized her success selling verses to publishers over her efforts as a teacher and social worker.[23] A later installment on Queen Victoria took a different approach, presented as a scripted interview in which Dignam described her personal collection of prints showing young Victoria, using the prints to narrate the monarch's life story and to emphasize Victoria's modern commercial pull as inspiration for "furniture and decoration and jewelry and bouquets."[24] The 1936 story about Sarah Hale took a more traditional biographical approach but nevertheless attributed historical significance to women's influence on fashion and trade. Dignam contended that Hale's varied accomplishments "rival" those of Benjamin Franklin, emphasizing her efforts to alter social norms.[25] In addition to her editorial work at *Godey's* beginning in 1837, the narrative cited her advocacy for women's education and women's employment as teachers, her influence on the creation of home sewing and washing machines, her encouragement of women's exercise, and her campaign for an official Thanksgiving holiday. Structured as an interview between Hale and two young women visiting her office, the script portrayed the fashion magazine editor as a capable professional while underscoring her conformity to the ideals of feminine beauty and maternal nurturing. Although Hale was a grandmother, one of her visitors exclaimed that "she's perfectly beautiful!" and marveled that Hale's "hands are exquisite . . . so white and dainty." Further reflecting Hale's multiple roles, that visitor sought advice on an editing career, while her friend asked for "secrets of charm" to help her "get a good husband." With Hale gamely offering each woman suggestions, the script validated both choices. While advising her husband-hunting visitor that charm requires femininity, however, Hale stressed that women should not accept clothing styles just to follow fashion.

The career-oriented visitor chimed in, quoting a poem written and published by Hale to protest hoop skirts that restricted women's movement.[26]

This script dramatized the simultaneously repressive and transgressive possibilities of popular culture. As suggested by her characterization of Sarah Hale, Dignam created a complex body of work. Her ads sometimes focused women's ambitions on romantic goals.[27] Nevertheless, work on accounts like that of Ford Motors celebrated the possibility for change, heralding increasing freedom for women as they became drivers earlier in the twentieth century. In *Godey's*, Dignam located a parallel for this variance; even as a fashion editor, Hale criticized sexist styles. Notably, these critiques then inspired one of the young reader characters Dignam scripted to move beyond the consumer role and pursue her own career. The *Famous Philadelphia Women of Yesteryear* script thus urged listeners to consider that a commercial forum like a women's magazine could successfully challenge gender ideals and stimulate women's business opportunities.

This logic also shaped two radio scripts Dignam drafted for promoting automobile accessories in 1937. She conceptualized a series to be titled *Motor Matters* as fifteen-minute local daytime broadcasts that would encourage women to drive as they were inspired by the series' celebration of early female motorists as historical figures who challenged social norms.[28] One script identifies Philadelphia station KYW—which aired the final series of PCAW's historical biographies—as broadcaster, but neither specifies a commercial sponsor, suggesting that the series never aired.[29] The writing parallels the PCAW broadcasts' integration of history into portrayals of modern everyday life. Dignam cast herself as the host of *Motor Matters*, bantering with a male announcer to refute accusations that women are "wild," inadequate drivers; interviewing guests about their historical experiences; and providing evidence of women's long-standing success behind the wheel by citing the 1907 formation of the Quaker City Ladies Motor Club. In the initial script, Dignam enacted a present-day car trip to a Bryn Mawr tea room with guest "Mrs. Hayes Agnew Clement, who lives at 1615 Walnut Street, and was given her first automobile by Dr. Clement when she was little more than a bride." Identified as one of the city's earliest female motorists, Clement emphasized the power she enjoyed as an automobile consumer in 1904. Scripted remarks recalled her driving attire, including an "auto bonnet from Paris, the first one in Philadelphia." Precise descriptions of her stylistic choices stressed the individualism of this role: "Dr. Clement bought me a big Studebaker and I went out to Ohio, to the factory, to have them take my measurements for the placement of the various levers. It was so unusual for a woman to drive a car that we often traveled a long distance to the factory to make these arrangements. And then, of course, I had to pick my color-scheme!"[30] This dialogue neutralized

the historical controversy of women drivers by invoking the familiar theme of women's interest in fashion.

Simultaneously, Dignam emphasized women's roles as advertisers. The series' male announcer narrated Dignam's "arrival" at the show by car, prompting a response in which she highlighted her professional role: "Well, I'm an automobile broadcaster. You don't expect me to arrive in a row-boat, do you! This car is part of my act, just like trained seals." Although her script characterized style and homemaking as indisputable women's interests, the depiction of herself as performer of an "act" reminded that skill, work, and strategy shaped an adwoman's career.[31]

Applying similar themes in the PCAW's 1938 series, *Famous American Women of Yesteryear*, Dignam contributed a biography casting Susanna Wright as a colonial "Quakeress" precedent for modern businesswomen. In this script, "the Silk Lady of the Susquehanna" planted mulberry trees and raised silkworms, making Pennsylvania's Susquehanna Valley "the cradle of the *silk industry in this state!*" Emphasizing Wright's active contributions to the nation, Dignam described her collaboration with Benjamin Franklin to clothe Washington's Revolutionary Army. Simultaneously, Dignam courted the attention of twentieth-century audiences by highlighting Wright's reverence for fashion. The narrator of the broadcast responded to the eighteenth-century English folk song "The Lass with the Delicate Air," which opened the program, by exclaiming, "What a picture that phrase calls up of a young Susanna Wright. Can you see her in her slim, high-waisted dress and little brimmed bonnet!"[32]

The dramatization emphasized the inspirational power of historical women, closing with supernatural dialogue between Wright and her seventeen-year-old great-great-grandniece. Notably, domestic responsibilities enabled this connection: the modern heir polishes a silver cup presented to Susanna Wright by Queen Charlotte, pondering the family treasure's provenance. Then the spirit of Susanna Wright appears. The relatives converse about the silk stockings that were fashionable in 1938, with Pennsylvania producing half the nation's supply and proving the long-term influence of Wright's "silk experiments." In comparing Wright with her modern counterparts, this closing scene also associated industrial progress with expanded professional opportunities for women. The great-great-grandniece reassures her predecessor that in 1938 she would be called "a career woman" rather than the pejorative "blue stocking."[33]

Nevertheless, Dignam's radio dialogue reconciled women's careers with family. Asked why she never married, Wright responds, "Well! Well! Girls are just the same *today!* Here I've been gone a century and a half, and the only thing you want to know is why I didn't marry a widower!" Yet her explanation— that she was too busy caring for her father and siblings, as well as

"the whole community" she affected by "start[ing] this silk industry"—defined her as a nurturer.[34] She expresses hope that her great-great-grand-niece will marry, prompting the response, "Don't worry; I intend to marry sometime!" Nevertheless, both the Wright and the Hale scripts urged respect for women who prioritized career over marriage—a choice made by many twentieth-century adwomen. Dignam never married, and her club colleagues were predominantly single: of 127 active members in PCAW's 1938–1939 roster, only 37 were designated as "Mrs."[35]

Although these scripts invented dialogue and scenarios, the PCAW proclaimed the educational effectiveness of its radio series, reporting that public school principals recommended the broadcasts to teachers, students, and students' families. Some schools used PCAW scripts for their own dramatic productions.[36] Responses to the broadcasts, solicited through a PCAW contest asking listeners to identify their favorite figure portrayed in the second series, suggested that the program's message of women's historical significance did translate to listeners. One listener wrote, "Something historical and *worth* knowing is always enjoyed."[37] Another, though conceding, "I don't expect to win a prize with my grammatical and orthographical shortcomings," applauded the insight he had gained from the broadcast on Molly Pitcher.[38] As a stamp collector, he already had known of this heroine, whose name was printed over George Washington's face on a 1928 stamp commemorating the sesquicentennial of the Battle of Monmouth.[39] Pitcher, likely a mythologized amalgam of women who followed their soldier husbands during the Revolutionary War, earned this honor because she was purported to have abandoned her usual task carrying pitchers of water to the battlefield and taken over her fallen husband's cannon.[40] Although Pitcher had already attained this fame, this listener praised the broadcast for deepening his understanding: "It really seems a shame that an ordinary two cent stamp with her name on it was all the recognition given to Miss Molly by our Government. After hearing your program on her life, I feel an injustice was committed."[41]

While these responses cited educational value, the PCAW's radio programs, like many popular depictions of the past, also appealed to an interest in luxury and style. Responding to a dramatization featuring Harriet Lane, who assumed the duties of first lady during the presidency of her uncle James Buchanan, one listener described a treasured photograph of Lane in the listener's private collection. Her description, rather than using objects and imagery from the past to understand a historically specific moment or to celebrate the possibility for change, highlighted the ahistorical appeal of aesthetics. She detailed the floral decoration on Lane's "period gown" and hair, likening it to a Hawaiian lei. She explained:

Hawaii—so far away so alive—Harriet Lane—so far along the years, she seems lost in the mists of time.

Yet, the twain meet on a decorative note just for a moment in my mind—as I close the old Album—clasping within its mellowed gilt-edged leaves the glamorous picture of Harriet Lane—a famous Pennsylvania woman of Yesteryear.[42]

This response, like many of the period's advertisements, fashions, and entertainments, cultivated a superficial, stylistic engagement with the past; historic objects became part of the present through their glamorous appeal. This listener celebrated adornment for its own sake rather than exploring the more complex relationships between consumption and business opportunities that Dorothy Dignam's scripts dramatized.

CAVALCADE OF AMERICA

In its use of history to define women's status, the PCAW was in dialogue not only with the visual iconography of the advertising industry and print culture but also with the historical drama as an emerging genre on national radio. Philadelphia adwomen provided an alternative to commercial broadcasts that acknowledged women's contributions but elevated individualistic male leaders as the driving force in American society. *Cavalcade of America* pioneered that format, first on the national CBS network (1935–1939) and then on NBC (1940–1953). A collaboration by DuPont and noted academic historians, and by the advertising agency Batten, Barton, Durstine & Osborn, the series emphasized the educational value of history for modern audiences.[43] The words of Miss Mabel Thatcher Washburn, identified as president of the National Historical Society, prefaced one 1936 broadcast: "The DuPont Company is rendering a real service" by sponsoring stories "so full of drama, of thrill and romance, yet so little known to a great proportion of the people."[44]

Cavalcade emphasized the relevance of history's entrepreneurs. An early episode celebrated Frederick Tudor's nineteenth-century ice export business as a precedent for current refrigeration technology. Describing a "national trait of enterprise," the broadcast assured listeners that "the optimism and energy that spur men to enterprise have always been notable in American character" and have "often led to astonishing progress."[45] The DuPont Company's own founder, Eleuthère Irénée du Pont, was characterized in multiple dramatizations, gaining historical weight as "a true American pioneer" through his relationships with the nation's founders.[46]

While the series emphasized patriotic icons like Thomas Jefferson and George Washington, *Cavalcade* also devoted biographical episodes to women.

Indeed, as historian Anne Boylan has calculated, 21 percent of installments in the program's nineteen-year run prominently featured female subjects.[47] Some were famous for their own careers and activism. Nearly two years after Dignam's portrayal of Sarah Hale, Hale appeared in a *Cavalcade* episode that praised her for advocating women's education and thus enabling the "diversified employment of over one-fifth of the women of the United States today."[48] However, in contrast with Dignam's narrative, the *Cavalcade* script belabored Hale's relationships with and approval from men, starting and ending with discussions of her husband's support for and pride in her intellectual pursuits. The story stressed that Hale began working to support her family only in her widowhood, imagining that her husband had encouraged her to pursue a career just before his death. The episode never made direct reference to Hale's influence on her female readers.

In other cases, women earned inclusion as supportive family members. A 1940 biography of Mehitabel Wing dramatized her journey to secure the New York governor's intervention in the trial of her husband, William Prendergast. Convicted for inciting a renters' protest, Prendergast ultimately received a pardon that furthered "the struggle of the people to own the land on which they live."[49] Introducing Wing's dramatic efforts to prevent Prendergast's execution, program advisor and Yale history professor Frank Monaghan proclaimed, "Her ride is as notable as the midnight ride of Paul Revere."[50] The episode's courtroom portrayal of Wing as the dutiful wife, beside her husband "in gray Quaker dress," resonated with popular depictions of women's contributions as essential but bound to their prescribed roles as wives and mothers.

The series stressed the universality of romance, even when celebrating atypical women who ultimately rejected the standard family model. In the hands of *Cavalcade* writers, unmarried protagonists known for their independent success also felt the pull of love. An episode devoted to the never-married Emily Dickinson focused the poet's life story on a relationship with George Gould and the romance's end at her father's insistence.[51] The 1940 biography "Jane Addams of Hull House," broadcast from the General Federation of Women's Clubs annual council meeting in "dedication to all the women of America who have devoted themselves to the welfare of humanity," portrayed Addams as a transgressive figure who challenged social norms to fulfill her need to help others.[52] Yet the drama opens during her youth, as she walks with a male companion, Charles. After returning home, she tells her father she would like to marry Charles, adding the qualifier "if I marry." As young Addams contemplates sacrificing romance for humanitarianism, she cites Abraham Lincoln as an inspiration, prompting her father's objection that "Abraham Lincoln was a man" and that social change remained outside

the domain of women.[53] As the story progresses, both Addams's father and her suitor warn her against pursuing controversial activism. This narrative highlights the anomaly of Addams's ultimate decision to remain unmarried, and it presents Addams's willingness to displease the men in her life as a precondition of her success as an activist. However, *Cavalcade*'s fictionalized dramatization also normalizes Addams. A woman who in reality chose long-term same-sex domestic partnerships that late twentieth- and early twenty-first-century historians would identify as lesbian relationships, fit within the familiar story of young heterosexual romance on *Cavalcade*.[54] The narrative denies that Addams's unmarried status reflected her sexuality, or that her marriagelike relationships with women provided important personal and professional support.

Although Addams remained single, *Cavalcade* cited approval from men as proof of her success. By the end of the broadcast, she earns a Nobel peace prize and gains Theodore Roosevelt's support. In a conversation at the White House, the Hull House founder argues that voting should be a "human right" for women as well as men, leading Roosevelt to admit, "Of course you are one of the best arguments [for women's suffrage] yourself." Jane Addams gained such endorsement and Mehitabel Wing prompted a comparison to Paul Revere to signify their importance. In divergent stories, *Cavalcade of America* proposed two pathways to female glory: devotion to family and self-less sacrifice of romance.

Four weeks after the Addams installment, *Cavalcade* aired a parallel celebration of Susan B. Anthony's transgression against family expectations.[55] The program opens with the announcer describing seventeen-year-old Anthony's return home from boarding school "presumably to fold her hands and wait for a husband." Her father urges, "You better begin doing some work for your hope chest," prompting Anthony's lament that she "feel[s] so useless" at home. Subsequently, she takes employment at a local factory, over her father's strong disapproval.[56] Co-workers invite her to a women's rights meeting, launching a narrative highlighting Anthony's teaching career, her petitioning for suffrage, and her being put on trial in 1873 for voting. The story emphasized popular objections to Anthony's efforts, objections typically voiced by men. As one man exclaims angrily in response to Anthony's request for a signature supporting suffrage, "Why don't you stay home where any decent woman belongs?" By the turn of the century, however, Anthony finds praise from journalists that stands in sharp contrast to her earlier experiences. She laments, nevertheless, that women still exist as political subjects rather than as citizens; she notes in her closing dialogue, "Someone has said that a man is immortal as long as one idea lingers behind him when he's gone. I can only

hope that the idea I have fought for will be of everlasting good when I have gone." *Cavalcade's* announcer then affirms that "the right to vote was the priceless heritage she has left to the women of America," and the broadcast closes with a speech by Cornelia Otis Skinner, who played Anthony; she proclaims that if Anthony lived today, she would still be agitating for "life, liberty, and the pursuit of happiness," for "Susan B. Anthony was that kind of woman." Although these comments did not specify modern gender oppression as a problem Anthony would be combating, they suggested that women should be praised for contributing to public life, even when, as in Anthony's case, they caused discord by doing so. Like others in the series, the episode presumed that devotion to public service required sacrifice of romance and domesticity, but it applauded Anthony as a historical pathbreaker for making this decision.

SOAP OPERAS

The themes of heterosexual romance and family devotion that peppered *Cavalcade of America* pervaded the burgeoning radio medium of the soap opera, which focused on stories about women.[57] Typically set in the present, with characters from multiple generations, soap operas explored tensions between traditional and modern ideals of womanhood. Serial programs presumed young women's interest in careers but associated maturity with devotion to family life. The "modern" desires for independence and career were not presented as evidence of historical change; rather, they reflected timeless, temporary life stages shared by women past and present. Mothers and grandmothers served as role models, urging young women to keep familial and patriotic histories ever present in their minds.

Debuting on Chicago station WGN in 1930, the first soap opera, *Painted Dreams*, tracked a mother and daughter's competing ideas about the daughter's best interests.[58] Writer and creator Irna Phillips replicated its themes in her later serials—including the long-running *Guiding Light*. Describing *Painted Dreams* in an early proposal to commercial sponsors, Phillips defined the trajectory of a woman's life as progress toward the natural outcomes of marriage and motherhood.[59] The program's Irish American matriarch, inspired by Phillips's own mother and performed by Phillips on air, personified this viewpoint.[60] The daughter, by contrast, was "the aspiring modern girl, with ambitions toward a career." However, domesticity and product promotion beckoned. In her proposal to prospective program sponsor Montgomery Ward, Phillips declared, "It is my plan to have an engagement, the wedding, (in June) the trousseau, the furnishing of a home, actually occur via the air."[61]

Today's Children, Phillips's close adaptation of *Painted Dreams* for national broadcast, achieved popularity under Pillsbury Flour Mills Company sponsorship on NBC. The program, which depicted Chicago as an immigrant "melting pot," ran from 1933 through 1937, reappearing in 1943 for a new run that ended in 1950.[62] The *"Today's Children" Family Album*, a twenty-four page promotional booklet available in 1935 to Pillsbury consumers who mailed in a product label, provided a history of the show's characters by emphasizing home and family as the goals connecting generations of women. Its biography of the Moran matriarch emphasized her "quiet old-fashioned philosophy" and the stability it offered when her adult children temporarily lost sight of the priorities "as sound and as enduring as the eternal hills—love of family, love of home, and love of fellow man."[63] The character sketch of twenty-five-year-old daughter Frances cited her career and her love for a married advertising agency executive as evidence of her self-proclaimed modernity: "An ambitious, talented, and successful commercial artist, she is typical of the modern business girl. Ordinarily practical and level-headed, she has occasionally let the dictates of her heart lead her into difficulties, but has a way of regaining her balance."[64] This cycle asserted that the stability of attachment to family would eventually outweigh the momentary allure of career. Although the focus on family initially appeared "old-fashioned," it would outlast the "modern" drive for public success. As Phillips explained to *Radio Guide Weekly* while publicizing the national *Today's Children* debut, "People are fundamentally alike. Underneath the surface the flapper of today and her mother are the same."[65] Pillsbury reinforced the assertion that "Mother Moran's" mature perspective would win out: she was the sole character on the cover of the *"Today's Children" Family Album*, pictured in silhouette, knitting in a rocking chair.

Such emphasis on traditional values as timeless and inescapable contrasted with *Cavalcade*'s approach to public figures like Jane Addams. In the DuPont series, uncommon public roles became possible for women. By dramatizing Addams's courtship, *Cavalcade* stressed her similarity to the ideal, romantic young girl. Yet as the narrative progressed, Addams centers her life around public service and gains significant acclaim. By contrast, in daytime serials, women's plans and desires faced many disruptions; but home, tradition, and family were portrayed as necessary goals whose absence prevented a woman's fulfillment. This model emphasized the continuity of women's familial roles across history.

Soap operas presented consumer products as a shortcut to this legacy of domestic happiness. Commercial messages praised women past and present for the savvy consumption that enabled brands' longevity and pleased

families. *When a Girl Marries* (1939–1957), writer Elaine Sterne Carrington's
show about a young wife—one of the era's most popular daytime serials—
made selection of the sponsor's products a testament to women's historical sig-
nificance.[66] One 1942 episode opens with the announcement that "ever since
Martha Washington's time women all over America have *preferred* Baker's
Chocolate for their chocolate cookery!" A dramatized classroom exchange
follows, as a child interrupts her teacher's lesson on George Washington: "I
know something about *Martha* Washington, too! She used to bake one of
George Washington's favorite cakes *herself!* It was a bee-u-ti-ful Devil's Food
cake! [*When a Girl Marries* announcer] Mr. Stark says he bets she used Baker's
Unsweetened Chocolate for it . . . 'cause even then, American women were
using Baker's. My mother makes *her* cakes with Baker's Chocolate too . . .
and gee, do they taste *good!*"[67] This dialogue presented homemaking as jus-
tification for inclusion in the patriotic study of American history. Within
the world of the broadcast, advertising publicized women's histories, while
teachers did not. The enthusiastic young student credits *When a Girl Marries*
and its General Foods sponsor for her knowledge. The episode's closing com-
mercial prompted listeners to associate the long-standing Belle Chocolatière
logo with their own personal histories. Mr. Stark recalls "begging for a cup of
the 'Chocolate Girl's' cocoa!" during childhood and speculates that listeners
would also place "that famous symbol of quality in everything chocolate . . .
among the happiest of your childhood memories."[68] Through such messages,
contemporary radio dramas adapted advertisers' visual invocations of the
past to the medium of radio.

A WOMAN OF AMERICA

Unique for being a soap opera set in the past, writer Mona Kent's *A Woman of
America* (1943–1946) likened contemporary women's industrial and domestic
contributions during World War II to the nurturing femininity of women on
an Oregon Trail wagon train immediately after the Civil War.[69] The show was
sponsored by the manufacturer of the dishwashing detergent Ivory Snow; at
the beginning of each daily fifteen-minute broadcast, an announcer intro-
duced "the story of Prudence Dane, a woman of America whose courage
and faith are the glorious heritage of all women of America today," before
commenting on the current World War II conflict to assert that a unifying
national spirit, inherited from the nation's past, prepared the United States for
its contemporary role on the world stage.[70] One episode's preface assured that
the "unrelenting force of the free American spirit which today is spelling the
doom of the Axis on the far flung battlefields of the world is no new thing.

It had its roots in the character of those men and women of yesteryear who carved America out of a wilderness, men and women like those in the covered wagon caravan of Prudence Dane, a woman of America."[71] Military men and women or their family members were presented as guests at the beginning of many episodes, and they urged listeners to serve the war effort by rationing, volunteering on the home front, and enlisting.[72] Echoing these introductory speeches, the dialogue in Prudence Dane's stories celebrated individuals' roles in building family and community for "the common good."[73]

The show emphasized the importance of women's daily work to American triumph, voicing regular reminders that "when you waste soap, you waste vital war materials" and that "sav[ing] every drop of your used kitchen fat . . . can save a soldier's life as ammunition or military medicines."[74] The serial's romantic plotlines offered parallel examples of women's self-sacrifice for their men. "Prue" Dane, traveling on a wagon train to Oregon with her sister and married aunt, selflessly supports her fiancé, Wade, a leader of the caravan who unknowingly is afflicted with a serious illness. Prue, apprised of the diagnosis by a doctor, resolves to marry Wade and give him a period of happy family life before his health deteriorates. She plans to devote herself to his care, because a materially comfortable "home means a lot to a woman, but being with the man she loves means more," a sentiment not shared by her selfish, promiscuous romantic rival Fanny Carlisle, who travels West with ambitions of wealth as proprietor of a dance hall.[75]

While romance provided the story's emotional center, Prudence Dane also exemplified devotion to community service. After a setback in her relationship with Wade, she concludes, "There's so much more in this world for a woman than being in love. Work that means something, that amounts to something. Oh, I can see that now. There are clothes to be made, people to be taken care of. So much to do."[76] Prue later helps the wagon train respond to Native American attacks and thwarts an unethical caravan member's scheme to lend supplies at high interest rates.[77]

Even within this historical setting, the familiar consumer ideal remained dominant. By promoting women's domestic contributions to the war effort, including soap conservation, the program glorified the Ivory Snow dishwashing product. The announcer's segue into one episode's commercial spot proclaimed, "Today as in the pioneer days of Ivory Snow's story of a woman of America, American women have always been glad to find a better way of doing things. So lend an ear to the story of a modern pioneer: a lady who searched for and found a better way to do dishes [by using Ivory Snow]."[78] Other announcements indicated that the program's female characters would have eagerly embraced Ivory Snow as a tool for higher standards and greater

efficiency in housekeeping, for they had to produce their own soap.[79] This pitch emphasized the centrality of women's domestic support to American success, while differentiating corporate technological progress from the continuity in women's character across generations. It was the purchase of a great product that allowed a modern woman to become a pioneer.

In her happy performance of domestic chores to support family, community, and nation, Prudence Dane mirrored familiar icons. Newspaper advertisements promoting the series' January 1943 debut showed a woman in a simple full skirt, a bonnet obscuring her face except for the shadowed hint of a profile. Although Dane was unmarried and childless in the broadcasts, these advertisements featured her protective hand on the shoulder of a male child, accompanied by a text identifying her as "a great-hearted woman—one of those Western pioneer mothers whose faith, devotion, and courage set the pattern for our American Way."[80] Some advertisements featured Dane's bonnet and silhouetted face only, an image that echoed both the PCAW's Quaker Maid emblem and the modest, bonneted woman featured in product logos like Baker's Belle Chocolatière.[81]

The significance of Prudence Dane's attire is suggested by informal caricatures sketched on series creator Mona Kent's personal script copies. These drawings exaggerate events from the program's scripts by fitting characters into stereotypes. The brazen Fanny Carlisle wears only her stockings while Wade sleeps in her bed, an event that is not depicted so frankly in the dialogue. An African American servant appears inept and lazy, passively watching events unfold without taking action. And a sketch of Prudence imploring Dr. Hargrave to take leadership over the caravan defines her entirely by her clothing. She wears a simple dress, apron, and bonnet, the bonnet's size greatly exaggerated so that it obscures her face entirely and suggests a downcast gaze. By obscuring Prue's individuality, this visual parody highlights the character's selflessness as her dominant trait. This contrasts sharply with the unnamed Quaker Maid figure that the PCAW had presented as an active participant in progress.[82] It likewise contrasts with A Woman of America's celebration of its heroine's "spirit," but it suggests that series staff associated feminine weakness with the historical tropes they dramatized.

The narratives broadcast by the PCAW and by corporations threw contemporary listeners into reenactments, historical fiction, and sentimental discussions of tradition, encouraging them to identify with women of the past. While many of the era's commercial narratives emphasized maternity and domesticity as inherent female characteristics that tethered women's activities to private life, some radio stories recast the continuity in women's lives as a continuity of contributions to public life. Dorothy Dignam's scripts portrayed

consumption as a potential pathway to activism and to employment. They urged the public to turn to the past for inspiration, and they dramatized the mass media's capacity to promote feminism by focusing on career women who strove to reshape gender norms.

Nevertheless, in the examples covered in this chapter, this public history function played a supportive, secondary role. Corporate sponsors wanted to sell products. The PCAW set out to improve career opportunities for contemporary women, providing justification by pointing to the past. However, the most popular of media, including network radio, comic books, and women's magazines, also provided strategic platforms for women whose chief objective was to promote the serious study of women's history. The next chapter considers feminists of the 1930s and 1940s who were not employed chiefly by corporations or broadcasters but who chose to collaborate with them to publicize women's histories.

GALLANT AMERICAN WOMEN

FEMINIST HISTORIANS AND THE MASS MEDIA, 1935–1950

This chapter focuses on three feminists who strove to place factual stories about women at the center of popular historical narratives. By identifying women whose actions had shaped history, these feminists sought to elevate the status of modern women and to promote women's history as a worthy subject. In working with broadcasters and periodical editors, they weighed the threat that their messages would be diluted against the opportunity to reach wide audiences. Although the process involved concessions to popular stereotypes, mass media publicized innovative conceptualizations of women's history that prefigured later scholarship.

The chapter begins and ends with episodes from the decades-long activism of Rose Arnold Powell, who sought to elevate Susan B. Anthony in the popular imagination. Powell publicized Anthony as the "third great emancipator," alongside George Washington and Abraham Lincoln, asserting that this balance would ultimately improve modern women's opportunities. In the 1930s, she sought Anthony's inclusion on commercial radio, in women's magazines, and in civic commemorations. One of the prominent figures she approached for support, historian Mary Ritter Beard, the author of several books on women's history, is the second woman examined. Beginning in 1939, Beard served as a consultant on NBC radio dramatizations about women's history, bolstering her campaign to develop the World Center for Women's Archives as a repository for documenting the diverse experiences of women throughout

history, and as a global movement involving modern women in the collection of historical source material. The third woman, Nancy Wilson Ross, authored *Westward the Women* (1944), a book narrating nineteenth-century frontier settlement through women's eyes to support a feminist argument for modern women's inclusion in public life. This interpretation reached general audiences through adaptation of the book into magazine articles and a *Cavalcade of America* episode. The chapter considers the ways that Powell, Beard and her collaborators, and Ross viewed their engagement with popular culture in the context of their other work. Further, it explores the ways that these feminists' contributions fit into the larger context of contemporary mass media. To that end, the chapter closes with an analysis of Rose Arnold Powell's 1940s activism and of the *Wonder Woman* comic, which debuted in 1942, publishing biographies under the title "Wonder Women of History" along with the modern-day superheroine's adventures. Powell exerted an uncredited influence on the series' Susan B. Anthony narrative that appeared in 1943.

ROSE ARNOLD POWELL

In her midforties, Rose Arnold Powell (1876–1961) read two books by colleagues of Susan B. Anthony: Ida Husted Harper's biography of Anthony and suffragist Anna Howard Shaw's autobiography.[1] Powell later credited these histories with convincing her, a former teacher who had not yet participated in women's rights activism, that the nation needed a female icon "to share the fame of Washington and Lincoln."[2] These heroes, she determined, personified the nation's history, while educators omitted women's stories.[3] Determined that Anthony most deserved recognition, in 1923 Powell moved from her home state of Minnesota, where she had recently worked as a door-to-door book sales agent, to Washington, DC. There, she participated in the National Woman's Party's efforts to commemorate the suffragist.[4] She later described her campaign as a "contribution . . . to the woman movement," made possible by the desertion of her husband after seven years of an unhappy marriage that began in 1909, his action freeing her from "the delusion" of his love and domestic burdens that would have precluded activism.[5] She also credited her crusade with enabling her to pursue intellectual fulfillment.[6] To earn money, Powell returned temporarily to Minneapolis and worked for the Internal Revenue Service there from 1926 through 1930. In a diary entry in which she looked back on the evolution of her feminism, she described her resignation from the IRS, so she could commit herself to full-time activism, as rescue from "mentally deadening work" that left her on the "verge of a nervous breakdown."[7]

In 1930 Powell returned to Washington, where she sought congressional recognition for Anthony. For years, she devoted most of her efforts to securing Anthony's inclusion on sculptor Gutzon Borglum's Mount Rushmore.[8] She urged periodicals, schools, and educational associations to acknowledge Anthony's birth date.[9] In 1934 she established the Susan B. Anthony Forum, an organization focused on promoting Anthony and on reshaping popular histories so they acknowledged women's contributions alongside men's.[10] Powell enlisted support from the forum's small membership, and from prominent women's clubs and feminist organizations, to amplify her message; she also conducted much of her campaigning through personal letters to public figures and corporations.

Tailoring her requests strategically, Powell embraced stereotypes to target large audiences. In January 1935, she sought Anthony's inclusion in NBC's national radio comedy *Amos 'n' Andy*, which derided African Americans as ignorant, its title characters a variation of minstrel show caricature. Reminding executives that the series had previously included a biography of Abraham Lincoln, Powell proposed that its protagonists discuss the value of Anthony's women's rights achievements as a way to memorialize Anthony alongside Washington and Lincoln, as the "third great emancipator" with a February birth date. Making a differently tailored appeal four days later, Powell reacted to NBC's broadcast of "negro spirituals," accompanied by narratives of Frederick Douglass's achievements. Powell identified Douglass as a friend of Anthony "for years" and as a friend of the women's rights movement, and she detailed Anthony's abolitionist petitioning, criticizing the omission of this work from "history text-books" as she asked for its inclusion on the airwaves.[11]

The following month, Powell rejoiced when NBC commemorated Anthony—not in the programs she had recently targeted, but as the first in a set of brief eulogies commemorating notable historical figures born on February 15. In a celebratory diary entry, Powell expressed certainty that the campaign was her calling and that it could influence the masses: "All who heard it, and there no doubt were millions—in all parts of the country and the world—never did and never will hear of me—just a mouse gnawing at the ropes which imprison *woman*—If I do not write to N.B.C. year after year, as I have done, asking for her recognition, I wonder if it would be done."[12]

This description of self-sacrifice reflected Powell's belief that feminists had a social responsibility to commemorate the past, an idea she emphasized when asking surviving figures of the suffrage movement to support her Mount Rushmore campaign. Throughout her congressional lobbying for this cause, she sought support from Carrie Chapman Catt, who replaced the retiring Anthony as president of the National American Woman Suffrage

Association in 1900. This fact made Catt a logical link to Anthony's life, as did content of Harper's Anthony biography. In her entreaties, Powell used this text to link Anthony, Catt, and the problem of public history. Powell opened a 1934 letter with a lament: "Your prediction many years ago, as recorded in the Harper biography of Miss Anthony, that in another quarter of a century every boy and girl would know the name of Susan B. Anthony, is far from realization." In such requests, Powell emphasized the importance of public recognition both as a goal and as a tool for securing additional publicity. Through the end of the decade, Powell continued appealing to Catt to lend her own fame to the cause, arguing that a *Ladies' Home Journal* survey, based on the input of the magazine's readers on the greatest American women leaders of the past century, had devalued Anthony (who placed fifth) because of public ignorance about "the facts." However, according to Powell, Catt's strong performance in the same survey—as one of only three living women "voted as the nation's greatest"—obligated her to crusade for Anthony.[13]

Although she offered brief endorsements for Powell, Catt was unwilling to devote significant effort to the project, arguing that the drive to include Anthony on Mount Rushmore would be futile. Resigned to her conviction that "men dote on glorifying themselves," Catt dismissed monuments and renown as irrelevant to her current focus, the National Committee on the Cause and Cure of War. Rejecting Powell's request that this committee join the Susan B. Anthony Forum, Catt explained that the group's pacifist members "are not, necessarily, interested in Susan B. Anthony."[14]

Powell's argument was that the ascendance of Anthony in popular memory would further modern feminism. She asserted that the prominence of one great female historical figure would secure public recognition for all women by extension. In pursuit of this goal, she wrote to Mary Ritter Beard (1876–1958), requesting support for the Mount Rushmore campaign and commenting on the women's history syllabus "A Changing Political Economy as It Affects Women," which Beard had created for the American Association of University Women. Powell praised Beard's bibliography but advised Beard to read Harper's biography, "if you have not already done so." Lamenting that the biography's two volumes were out of print, Powell noted that Beard, "inadvertently, I am sure," had omitted them. Explaining that the volumes did important work by detailing Anthony's contributions not only to suffrage but also to abolitionism and the Civil War, she asked Beard to "use your influence to get proper recognition for this phase of [Susan B. Anthony's] life." In her supportive response, Beard offered to approach publishers about reissuing the volumes. She admitted that she was "ashamed" of being unfamiliar with the Harper biography.[15] Observing that it would help if she had copies in hand,

she arranged to buy one of Powell's two personal sets.[16] As Beard read the texts, the pair continued to correspond, conferring on publicity strategies.[17]

Although in 1935 Beard endorsed Powell's Mount Rushmore campaign, and although she expressed admiration for Powell's determination, the correspondence illuminates the two women's differing approaches to translating women's history for public audiences.[18] Beard worked to publicize women's roles in all aspects of history. In addition to her own books about women, she authored innovative surveys of U.S. history with her husband and collaborator, Charles Beard, including *Rise of American Civilization* (1927) and *The Making of American Civilization* (1937).[19] Integrating women into the larger story, these books avoided elevating individual figures to greatness.[20] In her letters, Beard defended this strategy to Powell: "Susan B., if I had given her all the space allotted [in history textbooks] to women, would have seemed to be unique among women. She was in many ways but what I mean is that she would have figured as too great an exception with respect to our sex when, as a matter of fact, women have always been at the center where history has been made."[21]

This logic was central to Beard's writing and feminism. An opponent of the Equal Rights Amendment, Beard believed that its National Woman's Party supporters distorted history to suit their campaign. They celebrated the agitation for women's suffrage and legal equality from 1848 through the present as a transformative, progressive development that rescued women from subordinate status. Beard countered this narrative with a multicultural and international "long history" that considered all eras and realms of life, identifying examples of female influence that preceded modernity. Access to these stories, she argued, would empower contemporary women to look beyond politics when setting their feminist goals.[22] The aim of reshaping popular memory along these lines inspired Beard's efforts, at the close of the decade, to broadcast women's pasts to radio audiences.

MARY RITTER BEARD AND DOCUMENTARY RADIO

Mary and Charles Beard's 1939 publication *America in Midpassage*, which extended the chronology of their 1927 textbook into the present, criticized the radio medium for "canned rumbles, thumps, and rattles" that prevented serious thought.[23] However, in 1939 and 1940, radio listeners could tune in to *Women in the Making of America* and *Gallant American Women*, weekly dramatizations announced as stories of "daughters of destiny—mothers of might—co-makers of history." The programs were produced by the U.S. Office of Education, Federal Security Agency, Works Progress Administration, and

Women's Activities Division of NBC. Mary Beard served as a historical con-
sultant, her interpretation of women as vital actors at the center of history
clearly reflected in the portrayal of women as "co-makers of history" in poli-
tics, law, education, science, the press, and business. Beard had advanced this
approach in her single-authored book *On Understanding Women* (1931) and
in *America through Women's Eyes* (1933), an edited collection of documents
presenting evidence that "woman has always been acting and thinking, intui-
tively and rationally, for weal or for woe, at the center of life."[24] She would later
develop the idea further in *Woman as Force in History* (1946).[25]

Beard embraced radio drama, complete with orchestrations and sound
effects, to publicize the World Center for Women's Archives (WCWA). She
had cofounded the project in 1935 with Hungarian feminist and pacifist
Rosika Schwimmer, who had already begun compiling an archive. As direc-
tor of the WCWA until 1940, Beard strove to promote public awareness of
women's pasts through the collection of diverse primary sources reflecting
the scope of women's experiences.[26] She conceptualized the institution as
an alternative to academia and its biases against women's history. Members
of state and local WCWA branches would drive grassroots involvement,
working within their communities to solicit donations of papers, heirlooms,
and relics. Beard wanted this material to change the definition of modern
womanhood by proving women's capabilities. To publicize the project, Beard
ensured that credits of radio programs identified the WCWA as her affilia-
tion.[27] Following the broadcasts, branch membership grew, bolstering Beard's
goal of engaging women nationwide in the collection of documents, and of
collecting diverse materials so that the historical record would transcend
region, race, and ethnicity.[28]

The NBC Blue Network, which focused on commercial-free public ser-
vice and experimental programming, broadcast the thirteen *Women in the
Making of America* episodes (May–August 1939) and forty-six episodes of
Gallant American Women (October 1939–June 1940).[29] *Gallant American
Women* was carried by a peak number of stations, ninety-two nationwide,
in March 1940.[30] Most of the two series' thirty-minute broadcasts aired
Friday afternoons at 2:00 PM; six *Gallant American Women* episodes aired
on Monday nights late in the program's run.[31] Described as "Documentary
Radio," the project portrayed "women's contribution to the building of
American Democracy" through "the story of women pioneers in every
field of endeavor" and demonstrations of "how their work is being carried
on today."[32] An October radio spot promoting the series emphasized both
its novelty and its natural connection with modern American women. It
opened with the appeal "Calling all gallant American women! Women in

the home—in the factory—in schools—women everywhere—to listen to a new, dramatic, educational radio series." The announcer promised that the broadcasts would rectify a deficiency in contemporary narratives: "The quiet, fruitful work of women often goes unrecognized. Now, for the first time the deeds of women past and present come to life. Records have been dragged into the light from dusty archives in order to provide the materials for this new kind of educational broadcast—records which show how women have worked unceasingly, dauntlessly, gallantly, in many fields from homemaking to industries, the arts, the professions and science."[33] In contrast with commercial radio's frequent focus on domesticity, *Women in the Making of America* and *Gallant American Women* detailed women's roles in government and activism—including mobilization for the rights of women and immigrants—as well as women's contributions as mothers.

Each episode presented a theme, dramatizing events from the lives of several relevant women. Many installments thus spanned the colonial era through the present in order to illustrate women's central contributions to American institutions. At the beginning and end of the episodes there were guest speakers and comparisons were made between historical content and contemporary life, emphasizing the wide influence of women's historical actions. Illustrating the scripts' scope, the inaugural *Gallant American Women* broadcast, "These Freedoms," narrated "the part women have played in building our great heritage of freedom . . . freedom of worship—freedom of speech—freedom of assembly." The episode closed with a speech from Eleanor Roosevelt on modern American men's and women's responsibilities to preserve freedoms in the face of potential war.[34]

The historical drama in "These Freedoms" emphasized cultural restrictions on women, as well as the boldness of women who challenged these restrictions to protect their rights and those of others. The broadcast began with examples of sacrifice in pursuit of religious freedom, detailing Anne Hutchinson's 1637 trial and Mary Dyer's 1660 execution under Massachusetts law. Traveling across time, following stories dramatized contributions of the nineteenth-century abolitionists Lydia Maria Child, Lucretia Mott, Angelina Grimké, Abby Kelley, and Sojourner Truth. The stories emphasized male resistance to women's antislavery activism, although Grimké's narrative highlighted the admiration of her husband, Theodore Weld, for her work. Paralleling Beard's efforts to document African American women's histories as a means to combat modern racism, the broadcast offered a respectful performance of Sojourner Truth's 1851 "Ar'n't I a Woman?" woman's rights convention speech, avoiding the racialized dialect often used on radio. In a press release for the episode, the Office of Education emphasized that "Sojourner

Truth, a Negro woman who helped to lead the struggle for freedom of her race," would feature heavily as one of the "unsung heroines."[35]

As collaborative efforts, *Women in the Making of America* and *Gallant American Women* combined the input of historians, public figures, and governmental agencies. Beard, program supervisor Eva vom Baur Hansl, and scriptwriter Jane Ashman shaped the programs' feminist narratives. Hansl, a WCWA member and a writer and editor with experience at the *New York Tribune*, the *New York Times*, and *Parents' Magazine*, originally developed the idea for the series and structured the research and plotlines for the episodes.[36] After Hansl wrote preliminary script outlines, Beard and script editors employed by the Office of Education offered feedback.[37] J. Morris Jones of the Office of Education organized these suggestions, sending them to Hansl and to Jane Ashman, a well-regarded radio writer with Federal Theatre Project experience who authored most of the series' scripts.[38] The series also bore the influence of Office of Education writer Irve Tunick, who contributed in 1940 when scriptwriting fell behind schedule.[39] The writers completed drafts based on research supplied by Hansl, WCWA member Miriam Holden, and Office of Education teams in Washington and New York City. Beard then assessed the scripts for accuracy.[40] Dr. Eugenie Leonard, former dean of women at Syracuse University, served as another official historical consultant.[41]

Other feminists participated more informally. Historian Eleanor Flexner contributed to the bibliographies published with episode scripts.[42] Carrie Chapman Catt shaped early episodes, advocating that scripts acknowledge a variety of women's contributions, rather than isolating individual figures.[43] While this approach resonated with Beard's philosophy, Eva Hansl later claimed that "the plan for the first five programs in the initial series 'Women in the Making of America' was definitely [Catt's]."[44] Through her involvement, Catt gained publicity for her current activism, concluding the broadcast chronicling the history of suffrage with a speech on pacifism.[45]

Within the mix of contributors, Beard's position as consultant limited her authority. In her comments on scripts, Beard worked against generalization by encouraging the incorporation of broad chronologies and diverse contexts. In notes on a draft script for "Women in Politics and Government," Beard requested "historic background [that] would make the contemporary story a fine continuum" by emphasizing that women's contributions to politics extend "far back in time, far beyond the founding of our republic." While acknowledging the constraints of airtime, she requested a global perspective, advising, "We can point out that even the idea and practice of women as foreign ministers is not original with America."[46] Nevertheless, the final script remained focused on the United States.[47] Four months later, Beard resigned

from her role in the program, frustrated that her requested revisions to the "Women for Peace" script—not enumerated in the archived correspondence—had been ignored. The Office of Education convinced her to continue with the series but emphasized that although it would solicit her advice on "questions of accuracy and policy" it would retain the right to make all final decisions about broadcast content.[48] Nevertheless, the office used Beard's involvement as a publicity tool. A press release about the series trumpeted a bibliography compiled by Beard with the proclamation "Famous Historian Prepares Free Reading List."[49]

In other cases, Beard made strategic concessions to adapt her ideas to the medium of radio. Critical of capitalism, she did not think women should pursue jobs in fields governed by professional criteria that men had established. These standards, she asserted, devalued women's unique abilities.[50] In 1939, she published essays in women's rights magazines criticizing the individualistic modern "career girl" as a departure from historical women who had labored without ambition.[51] Nevertheless, through promotional materials for the NBC radio programs, she appealed to women with different perspectives. She endorsed a description for the "Ladies of the Press" episode that promoted "the thrills of a glamorous profession packed into a single program." She replaced a proposed "Women in Science" description that focused exclusively on the past with the practical promise of "the story of new opportunities in great modern laboratories and observatories and the discoveries and inventions which women achieve."[52] These celebrations of women's occupations contrasted with Beard's maternalist philosophies about women's roles in promoting civilization.

The radio series also harmonized with modern consumer culture, even though they were government sponsored and commercial free. The first *Women in the Making of America* broadcast's title, "Cavalcade of American Women," clearly invited comparisons with DuPont's established program, *Cavalcade of America*. Later episodes celebrated women's employment in business and industry. A planning outline emphasized that "civilization can progress only through increasing participation of women in commerce, trade, and manufacturing."[53] The 1940 *Gallant American Women* episode devoted to commerce and trade asserted that contemporary female entrepreneurs contributed to American business by using the unique skills of their sex: "tact, intuition, [and] the art of handling people." In a sentiment similar to the Philadelphia Club of Advertising Women's earlier description of its Quaker Maid emblem, an opening narration explained, "Little as moderns realize it—women have *always* been in business—along with the men—ever since business began."[54] The program highlighted widows and wives who ran

family enterprises in colonial America, women who developed promotional strategies for nineteenth-century department stores, and post–Civil War female office workers whose opportunities expanded with the introduction of the typewriter. Throughout this survey, the dialogue dramatized initial objections to each shift in women's roles, based on biases that were ultimately refuted by the subjects' achievements. The broadcast simultaneously defined female consumption as a pathway to collective action, celebrating Florence Kelley's work with the National Consumers' League to improve conditions for early twentieth-century workers in factories and department stores.[55] The episode closed with the story of the Knox Gelatine Corporation, a business built on the partnership of Charles Knox and his wife, Rose Markward Knox. The program celebrated Rose's success in running the business after her husband's 1908 death, emphasizing the widowed mother's use of a feminine perspective to target consumers and foster community for factory employees.

Although this biography touted women's capacity for corporate leadership, it assumed a patriarchal model. The script identified Rose Knox only as "Mrs. Charles B. Knox," now age eighty-two, and it prioritized her interest in factory workers' family lives over her business strategies.[56] To heighten the drama of her husband's death as a transformative moment, the plot minimized Rose's earlier innovations. In reality she first developed the company's promotional cookbook *Dainty Desserts for Dainty People* in 1896.[57] Reprints played a central role in the Knox Corporation's promotions for decades.[58] Rather than describing this work, however, *Gallant American Women* dramatized Rose and Charles's wedding and Charles's efforts to ensure that Rose could support herself "if anything ever happens" to him.[59] This narrative adopted popular culture's visions of women's domestic and familial responsibilities, obscuring the full story of Rose Knox's own contributions.

Gallant American Women also incorporated some of consumer culture's racial tropes. The broadcast celebrating historical preservationists, "The Bronze Tablet," sentimentalized historical plantations of the South.[60] The installment focused on the Mount Vernon Ladies' Association's nineteenth-century origins and on the more recent preservation of the Stratford estate, "ancestral home of the Lees of Virginia." The script applauded the drive by preservationists to preserve the homes of notable men, casting it as a reflection of women's ability to serve their nation patriotically through their interest in domesticity. In a dialogue set in the 1850s between Sarah Hale and Louis A. Godey, the publisher of *Godey's Lady's Book*, Hale demands that the magazine support the efforts of Ann Pamela Cunningham, who used the pen name "The Southern Matron" to lobby legislators to preserve George Washington's Mount Vernon estate. Over Godey's objections that support

for the project would alienate readers in the North, Hale stressed that she required "complete control of the editorial policy" and proclaimed that preserving a symbol of the nation's birth would inspire American women's love of nation and hatred of war.[61] Sending a script draft for feedback on the episode's other major story from May Field Lanier, who worked to preserve Stratford as a memorial to Robert E. Lee, Eva Hansl touted a "charming scene" penned by Irve Tunick to dramatize that now "life is going on in the old plantation just as it did 200 years ago."[62] Stage directions called for the chorus of a "darky chant—field workers singing as they hoe the fields" before narrators praise modern Stratford as a "living, working plantation" and "magnificent memorial to a civilization that gave us some of our founding patriots." They rhapsodize about the "old grist mill" producing "whole wheat and buckwheat and cornmeal" and the "smokehouse" where "sweet Virginia hams are curing and sausages snake among the rafters." The program praises women preservationists as "unselfish" leaders, quoting Robert E. Lee biographer Douglas Southall Freeman's remarks on Stratford's 1935 dedication: "We . . . must realize that here we have an expression of the instinct for home that is one of the main factors in making women, as de Toqueville [sic] said a century ago, the true conservators of society."[63] While this argument echoed some aspects of Mary Ritter Beard's feminism, including her convictions that maternalism should drive women's social contributions and that domesticity should command historians' attention, the program simultaneously sentimentalized histories of racial hierarchy, suggesting that these hierarchies merited reenactment—not examination—in the present. Such nostalgia conflicted with Beard's vision of feminist maternalism as a challenge to modern racial and ethnic inequalities.[64]

Another *Gallant American Women* broadcast, "Women the Providers," simplified the realities of slavery to praise white women's productive household and agricultural labor. Identifying Martha Washington as one of the women who "presided over great plantations, with servants to wait on them hand and foot," the play depicts her as a benevolent, industrious mistress.[65] When the young slave Belinda complains about fatigue, Martha supposedly fulfills Belinda's tasks, retrieving molasses from the storeroom and inspecting meat in the smokehouse, accepting assistance only in the carrying of building keys. Martha then declares herself the busiest worker at Mount Vernon and bakes a cake in preparation for her mother-in-law's visit, because she "wouldn't trust anyone else to mix it." As the narrative progresses through the nation's history, it aligns antebellum women, faced with the challenge of "feeding hundreds of relatives and slaves," with the modern era's new humanitarian problem: "New mouths to feed—millions of them—coming from

hunger to the land of plenty. Germans, Irish, Hungarians, Swedes."[66] Like many radio dramas of the 1930s, this episode celebrated American culture as an assimilating force, praising the work of domestic scientist Ellen Richards to instruct late nineteenth-century Boston immigrants in proper nutrition.[67] Although Mary Beard wanted her WCWA project to produce a multicultural history that was attentive to racial and ethnic diversity, such broadcasts emphasized the leadership of white, Anglo-Saxon women.[68] In doing so, they echoed contemporary media narratives.

While Beard, Hansl, NBC, and the Office of Education brought diverse strategies to the series, listeners also sought to shape its content, often by volunteering reactions to broadcasts. Activists and historians contacted Beard and Hansl, offering critiques shaped by personal allegiances. After the inaugural episode in 1939, Alice Stone Blackwell objected that her mother, Lucy Stone, was not mentioned along with the women's rights accomplishments of Elizabeth Cady Stanton and Susan B. Anthony. Historian and National Woman's Party activist Alma Lutz, author of a 1940 Stanton biography and one on Anthony in 1959, claimed that the same broadcast gave program collaborator Carrie Chapman Catt "too much credit for the suffrage victory." Lutz offered to share her own books, her "Feminist Collection," to aid in preparation of future scripts. Responding to the June 1939 "Freedom of Citizenship" broadcast, one listener who "was brought up in a suffrage atmosphere in Boston, and had a small part in the activities of the Amer. Suffrage Assn., the College Equal Suffrage League, and the Natl. Woman's Party" expressed her gratitude for the series but argued that the National Woman's Party "never let up its work for a moment" and should have received greater acknowledgment.[69]

In addition to such tensions, others emerged during script development, particularly when recent history was the subject. The Office of Education solicited input from modern practitioners on scripts about industries and professions. Dramatic license in formulating dialogue troubled many of those consulted, who feared that female characters would come across as unintelligent or overly emotional. Accordingly, female doctors requested revisions to lines spoken by historical and modern characters in the "Women in Medicine" script.[70] Elise L'Esperance, a leading cancer researcher who earned her MD in 1900, felt the plot downplayed men's resistance to female medical professionals and that it romanticized women doctors as nurturers rather than acknowledging their contributions as scientists.[71] Scriptwriter Jane Ashman objected to these criticisms, refusing to meet with medical professionals.[72] She made moderate changes but complained that "the barrage of pennies thrown its way by all the people who are authorized (or not) to stick

in their two cents . . . ruins the script."[73] Ashman favored dramatic unity over the accuracy demanded by some subjects.

NBC policy required approval from living subjects before programs were broadcast and scripts published. During this process, scenes that underestimated women's foresight while exaggerating the influence of men caused controversy. Margaret Mitchell objected vehemently to a brief vignette in the script for a January 1940 "Women of the Letters" broadcast. In dramatized dialogue between Mitchell and a male publisher, the publisher encourages Mitchell to submit her *Gone with the Wind* manuscript for publication, but she hesitates, professing to have written it merely for her own amusement. Mitchell forced NBC to cut her story from the broadcast. However, Office of Education administrators failed to remove the offending passage from scripts sold to listeners. After the *Nyack-Journal News* reported that a Suffern, New York, women's club performed "Women of Letters" with Margaret Mitchell among the cast of characters, the famed author threatened legal action. On her behalf, Mitchell's husband, John R. Marsh, demanded acknowledgment that this depiction was incorrect. Arguing that audiences would accept as fact a dramatization performed under the aegis of NBC; the U.S. government; and the Columbia University Press, the publisher of the scripts, March protested Mitchell's lack of control in telling her own history. In response, Hansl wrote a letter to script holders explaining Mitchell's objection and asking that they physically remove the Mitchell dramatization from pages seventeen and eighteen and return the clippings in an enclosed envelope.[74]

Parallel with Mitchell's concern that the radio script undermined her seriousness as a writer by suggesting that her publishing success was a fortuitous accident after amateur scribbling, Ida Tarbell objected to a "Women in Journalism" script draft dramatizing her 1902–1904 *McClure's* magazine exposé on the Standard Oil Company.[75] The problematic dialogue had Tarbell receiving, and resisting, orders from publisher S. S. McClure to investigate Standard Oil.[76] Using Tarbell's memoir as a guide for revisions, Jane Ashman apologized to the journalist for errors made in haste to meet weekly deadlines for scripts on diverse topics. Explaining that her interpretation was inspired by a newspaper clipping, Ashman noted that Mary Beard had rightfully questioned this portrayal of a passive Tarbell: "When I sent my script to Mary Beard for her historical check-up, she phoned to ask if I was *sure* that Mr. McClure *asked* you to undertake that [Standard Oil story]. I replied that I was. She said she knew you had a personal interest in the subject, having lived in the Oil Region—she didn't have her copy of your book here in New York—but if I had looked at it and was *sure—*." Ashman's apology concluded with a statement of shame and an observation attesting that "all I can say in

self defense is that if you had tried to do your history of the Standard Oil Company in a week. . . ."[77]

Hansl and Ashman often smoothed over such disagreements by inviting their critics to contribute to subsequent episodes. In her response to Tarbell, Ashman asked the Lincoln biographer for advice on the upcoming "Mothers of Great Americans" broadcast. "This is a fine way to apologize for an erratical script—to ask you to do my research for the next one," she noted sarcastically.[78] After this latter installment aired, Hansl cited Tarbell's input to deflect criticism from United Daughters of the Confederacy president Parke C. Bolling. Bolling perceived inaccuracies in the dramatization of Mary Ball Washington's interactions with a slave: contending that slaves would have addressed Washington as "Miss" and "Ole Miss," Bolling protested the utterance of "Mix Washton." She also wished greater emphasis had been placed on Mary Ball Washington's and Nancy Hanks Lincoln's effectiveness in rearing their sons, instead of on reenactments featuring "crying infants . . . lisping children . . . deathbed scenes etc." Without addressing these specific critiques, Hansl defended the program's depictions of plantation life, writing that "Miss Ida Tarbell, one of the foremost Lincoln enthusiasts loaned us her own books and passed on the authenticity of that part of the script."[79]

As a result of this correspondence, Bolling had a meeting with Hansl, Beard, and Irve Tunick to provide input on their research for the upcoming "Bronze Tablet" program.[80] Weeks later, the tone of Bolling's correspondence changed significantly. She thanked Hansl for incorporating her suggestions into "The Bronze Tablet" script's portrayal of historical preservation, judging it a "marked improvement." Bolling had recommended Lee's Stratford estate, a preservation project the United Daughters of the Confederacy funded, as a topic.[81] Perhaps reflecting their growing awareness that participation in the research process produced audience loyalty, Hansl and Ashman incorporated listener participation when they pitched the series to potential corporate sponsors after the end of its 1940 run. They suggested that consumers "be encouraged to send in stories of women they know . . . women whose stories match those found in the annals of the past—the Unsung Women to whom honor is long past due."[82]

In their efforts to honor subjects' preference for performances of calmness and competence, Beard, Hansl, and Ashman often faced opposition from NBC and federal executives. William Boutwell, director of the Office of Education's Division of Radio, Publication and Exhibits, wanted characters and listeners to emote. Reacting to a script for "Women as Nurses," he praised the "sensitive writing" and requested more "tearjerker or comedy scenes."[83] The following week, he praised a "sobbing scene" in "From Tavern

to Tearoom," an episode celebrating women's diverse culinary achievements, including in restaurant entrepreneurship and nutritional science. An early twentieth-century housewife followed home economist Ellen Richards's suggestions, weeping when her husband praised the food because she felt she could not claim it as her own. Boutwell declared this to be "one of the best episodes we have had in a long time."[84]

One Office of Education employee, responsible for compiling transcripts, sought to refocus program content on motherhood, citing a racist and anti-Semitic pronatalism as his goal, a purpose that differed sharply from Mary Beard's intentions. In October 1939, he complained that the list of upcoming episode titles omitted women's familial roles, underscoring that the broadcasts carried the imprimatur of the U.S. government and thus should serve national interests. He remarked, "I personally never heard of a man having a baby and doubt that women are more important as peace makers, fighters for freedom, etc., than as home makers and mothers. I believe if I were an impressionable high school girl listening to this program I would get the idea our Government is saying that they should become Carry Nations (vile maniac that she was) rather than wives. After all, our birth rate is falling fast enough as it is, + the only prolific species seem to be the Semetic [sic] and the Ethiopian."[85] While it is difficult to prove a direct connection between this diatribe—sent to Boutwell, who was closely involved in the program—and subsequent broadcasts, the finalized series did include episodes devoted to women's domesticity.[86] Young listeners could interpret "Mothers of Great Americans" and "Wives of Great Americans" as encouragement that women influence history indirectly, through their familial responsibilities.

However, the thematic structure to the series, with multiple individuals featured in each broadcast and a different topic covered each week, ensured that no one model ascended as an unimpeachable ideal. For example, the "Women of Learning" episode celebrated teachers' influence on children, echoing maternalist rhetoric that revered domesticity while advocating that women bring their mothering instincts into public life.[87] Simultaneously, it memorialized those who expanded access to higher education in the nineteenth century, securing for woman "what she was designed to be by her Creator—a thinking, reflecting, reasoning being, capable of comparing and judging for herself, and dependent upon none other for her free unbiased opinions."[88] The program closed both by acknowledging women who had attained educational professional credentials and by emphasizing that equal access to education best served democracy.

Gallant American Women strove to claim its own place in academia as part of this democratic educational process. The Office of Education promoted the

series with letters to women's organizations and women's colleges, and with thirty-five thousand posters sent to institutions. Secondary, postsecondary, and "Negro college" administrators; public and high school librarians; and Works Progress Administration and Civilian Conservation Corps advisers were among those targeted.[89] These mailings yielded requests for additional posters. A University of Maine house director requested advertisements to post in women's dorms and in "each building where women's classes are held."[90] The show gained endorsements from administrators. During the 1939 period when the fifteenth through twentieth installments aired, there were formal listening groups in ten women's colleges. Hood College in Maryland arranged for its entire student body to listen to the broadcast. A Duke University dean of women reported that she changed her class's meeting time so she could tune in at 2:00 PM.[91] Office of Education staff continued sending promotional materials to women's colleges and teachers colleges. By January 1940, there were twenty-one official listening groups at such institutions.[92] Eva Hansl quoted praise she received from an unnamed "representative of the Association of Deans of Women," who said, "It hurts to say so—but you are showing us up in what we are NOT doing—in the teaching of social studies and history."[93]

Nevertheless, response from the general public remained modest. By mid-February 1940, 2,135 script copies had sold.[94] The Office of Education reported 1,939 letters received about the program between October 9, 1939, and May 3, 1940. In comparison, *The World Is Yours*, a program on diverse educational topics that was produced in collaboration with the Smithsonian, inspired 13,247 pieces of incoming mail in the same time period. *Democracy in Action*, a series detailing government responses to social problems, produced 30,157.[95] *Gallant American Women* was not renewed and ended in July 1940. Eva Hansl and Jane Ashman made an argument for the potential reach of the series when they pitched it to corporate sponsors the next year. Women's organizations that had listened to and promoted the program, they asserted, represented the vast "buying power" of both mass and elite audiences.[96] This appeal did not work, and the program did not return to the airwaves.

The World Center for Women's Archives dissolved in September 1940, hurt by fund-raising challenges and by disagreements that paralleled some of the conflicts over radio program content.[97] Beard resigned her leadership position in June 1940, following internal tensions in the organization. She had faced opposition from her colleagues after the Washington, DC, WCWA branch barred African American membership; while WCWA board member Miriam Holden favored a direct challenge to this racism, Beard tried to avoid conflict by collaborating directly with the city's African American WCWA

supporters, suspending bylaws requiring members to affiliate with their local groups.[98] Meanwhile, political alliances dating to the suffrage movement limited archival donations, as Carrie Chapman Catt and Alice Stone Blackwell found the WCWA to be biased toward the National Woman's Party. Other activists felt that women had made progress in business and politics that would be minimized by the segregation of their papers from established repositories.[99] However, the WCWA's mobilization of women would later influence the development of academic archival collections and of curricula acknowledging the history of women. WCWA documents became the foundation for the significant women's history collections at Radcliffe College and Smith College.[100]

For Mary Ritter Beard, *Gallant American Women* merited inclusion in these later academic efforts to tell women's history. In 1943, as archivist Margaret Grierson developed Smith's women's history archives and strategies for applying them to instruction, Beard recommended that a college course illustrating "that women have been a force in history" could deploy guest lecturers to cover different themes, and that the curriculum "might be enriched by the reading of one of the scripts in the 'Gallant American Women' radio program."[101] In making such an endorsement, Beard judged her radio collaboration as serious educational work.

In 1950, Beard turned again to the medium of radio as an outlet for publicizing women's histories, delivering her address "What Nobody Seems to Know about Woman" on NBC. Here, she summarized the argument of *Woman as Force in History*: that women had played central roles in all historical developments, and that they should not be viewed as an oppressed or "subject" class. Focusing on women's diverse actions in the long trajectory of world history, Beard warned against generalization. She argued that women had promoted both war and peace, and that they had been both powerful themselves and subjected to others' power. She ended by explaining women's contributions to the development of knowledge, predicting that modern youth risked "shut[ting] themselves off from their own history." Ignorance about "woman's historic force," she cautioned, was enabling educators to limit the training "of our American high school girls and college women to home responsibilities."[102] This statement reflected frustrations Beard had expressed in private correspondence in the late 1940s, disappointed that researchers rarely used the WCWA materials now housed at Smith and Radcliffe, and that college administrators and professors continued creating curricula that marginalized women's history.[103] Reaching out directly to the public through the airwaves, she urged exploration in "documentary sources and books" for evidence of "woman's great historic meanings."[104] In correspondence with

Rose Arnold Powell, Beard called the broadcast a "weapon in the advertising of woman," reporting that "fan mail was remarkably enthusiastic."[105]

NANCY WILSON ROSS

While Rose Arnold Powell worked, often without visible credit, to reshape popular memory, and while Mary Ritter Beard embraced the mass medium of radio strategically, Nancy Wilson Ross (1901–1986) built a career as a feminist writer whose work gained significant exposure in popular culture. From 1932 through 1980, she wrote several novels, children's books, and works of nonfiction on various topics. In the 1940s, she was praised for her explorations of women's history as a model for contemporary life.[106] As a follow-up to her 1943 book on women's World War II naval service, Ross wrote *Westward the Women*, which was lauded for its depiction of the nineteenth-century American frontier.[107] She introduced her narrative as the rescue of historical women from "anonymity," lamenting, "It is men who have written the world histories, and in writing them they have, almost without exception, ignored women." But women had left journals, letters, and publications designed to document their experiences, and Ross promised that her account would humanize the "generic" vision of "The Pioneer Mother" who currently received her only recognition in sentimentalized, patriotic tributes.[108] The book's subjects included wives, missionaries, Native Americans, entrepreneurs, suffragists, and professionals, leading to a concluding chapter that prescribed a feminist function for this new, usable past. Ross argued that modern gender ideals paralleled those of the nineteenth century, restricting women's self-realization and impairing democracy. She urged her contemporaries to draw inspiration from the adventurous predecessors who had challenged their era's social norms. The book's conclusion warned against entreaties that women "return to the home" at the end of the war, consigned to isolated "household drudgery" and the "dope of radio's soap operas." Ross asserted that modern American women needed to work collectively, pursuing such alternatives as child care centers and community kitchens. Envisioning the benefits of such changes, Ross argued that women "must join together to make possible the next step in their emergence as whole creatures. They must put their mind to the solving of the release of woman's energies from a stale round of nineteenth-century chores so that she may function more intelligently as a wife and mother, or as a worker in the world if that is her choice. There should be, as a matter of fact, no need for any choice. There should no longer be the necessity of having one experience only at the expense of another."[109]

This feminist approach featured prominently in promotions for the book. The publisher, Alfred A. Knopf, placed advertisements quoting the *New York Herald Tribune Book Review*'s assessment of the publication's unique popular appeal: "A witty modern feminist has patched us a warm quilt of recollection ... a dramatic and entertaining book . . . the restoration of a fading legacy."[110] Then, the book reached popular audiences through radio and magazine adaptations. DuPont's *Cavalcade of America* presented suffragist and feminist publisher Abigail Scott Duniway's (1834–1915) biography in a 1945 broadcast titled "Westward the Women," which announced Ross's book as its source. Scriptwriter Turner Bullock adapted the material, advancing Ross's critique of nineteenth-century women's legal and social inequality by dramatizing the hypocrisy of coverture.[111]

However, *Cavalcade*'s framing device departed from Ross's text by making Ben Duniway the narrator of his wife's life story, belaboring the notion of the compatibility of women's activism with familial responsibilities. Ross urged her readers to challenge cultural ideals that placed the home at the center of a woman's identity; her chapter about Abigail emphasized Abigail's thoughts about society, with only brief mention of Ben.[112] By contrast, Bullock's emphasis on Ben's personal approval of Abigail kept home and marriage at the center of Abigail's story, even while celebrating Abigail's success with the activities that took her outside the home. At the end of the radio broadcast, Ben praises Abigail: "You do what every wife and mother does and you run a business and you travel around making speeches and you publish a newspaper and even find time to plant nasturtiums." Although Ben's foolish business dealings and unemployment, compounded by employment discrimination against women, have brought economic catastrophe to the family, Abigail's closing dialogue returns praise to her husband, celebrating the strength of their marriage as a "partnership," based on the idea that "God created both men and women and gave them dominion over every living thing in the world, but didn't give them dominion over each other." This sentiment did not appear in the original chapter about Duniway, although it provided a family-focused echo of Ross's overarching efforts to show a history of "men and women sharing life equally."[113]

Ross had structured her biography of Duniway to emphasize the idea that women's history needed commemoration. She closed with quotes from Duniway's 1914 autobiography, in which Duniway reflected on recent advances in women's access to education and politics. Duniway remarked that "the young women of today, free to study, to speak, to write, to choose their occupation, should remember that every inch of this freedom was bought for them at a great price," before concluding that "the debt that each

generation owes to the past it must pay to the future."[114] Ross hypothesized that Duniway's own experiences shaped this philosophy, interpreting quotes from the pioneer's autobiography to explore her disappointment when she traveled to visit the 1876 centennial exhibition in Philadelphia and found only "'a few dresses sacred to royalty . . . the baby cap worn by John Quincy Adams, Jr.,' and similar dull and ill-assorted oddments," but nothing reflecting the sacrifices she and other women had made. Proposing the objects that would better reflect women's vital roles, Ross wrote, "Why not a faded calico dress and sunbonnet, a pair of homely shoes worn thin by tramping through the dust and stones of the American continent—so Abigail, the pioneer, might well have wondered."[115] Here, Abigail's imagined perspective on the past, an element absent in *Cavalcade of America*'s version, had the last word, supporting Ross's project of defining a feminist history.

Other aspects of Ross's narrative fit seamlessly into the *Cavalcade of America* format. Bullock replicated *Westward the Women*'s accounts of Duniway's careers, endeavors first sparked by economic necessity. Ross explained Duniway's calculated strategies for drawing readers to her feminist newspaper, a reflection of her business savvy after years as a milliner. Assuming that women were interested in style, she authored an advice column, responding to readers' letters with advice about fashion, but shaping her prescriptions to support feminism and encourage women's economic independence. To illustrate this approach, *Cavalcade* incorporated quotes from Duniway's columns, as included in Ross's book, into a scene dramatizing Duniway's writing process. She advised one reader, "You need not make a skirt with a train," for that style hindered women's movement. She also suggested that women parlay consumer culture into employment, advising another reader to open a clothing factory, and promising that she could help with the procurement of materials and "exact patterns of the most celebrated styles."[116] These examples corresponded well with the program's interest in celebrating enterprise.

While acknowledging that the process required concessions, Ross embraced such adaptations as tools for disseminating her ideas. To another writer, she expressed particular pride in magazines' use of extracts from the publication, remarking that "*Reader's Digest* had never heard of Sacajawea and took a piece on her, and followed with the woman doctor [Bethenia Owens Adair]."[117] In correspondence with presses, Ross cited her media presence as evidence that there was demand for her books.[118]

Ross was less successful in garnering publicity for her work through film. She pitched *Westward the Women* for a movie adaptation but found no Hollywood interest in its story.[119] In the 1940s and 1950s, the Western film

flourished as a popular genre, promoting narratives of American exception-
alism with modern resonance; but male heroes predominated, with female
characters typically reduced to stereotypes and depicted chiefly as motivation
for male characters' actions.[120] In this climate, Ross failed to sell her vision
of Bette Davis starring as pioneer Narcissa Whitman.[121] Ross succeeded in
selling the book title only, approving its use for a 1951 MGM film about the
fictional journey by wagon train of two hundred mail order brides. MGM's
mythic 1851 lacked historical context, relying on modern gender stereotypes
to portray a male caravan leader resolved to "make men out of" his female
charges so they could survive the perilous journey before retreating into
domesticity with their new mates.[122] Ross had granted the title rights for
twenty-five hundred dollars based on a synopsis, but she ridiculed the final
result, refusing to have her name directly linked to the project.[123]

Despite this experience, Ross later briefly worked in the motion picture
industry, drawing income in 1954 as a story scout. She secured Alan LeMay's
historical Western novel *The Searchers* for a C. V. Whitney Pictures and Warner
Brothers Pictures 1956 film.[124] While filmmakers and critics have called *The
Searchers* a masterpiece, its focus on female captivity and rescue by men has
been criticized by feminist scholars.[125] Ross regretted that the outlooks of her
producers limited portrayals of gender and race. In personal notes, she docu-
mented C. V. Whitney Pictures vice president Merian Cooper's "tabus." His
opposition to stories with "Civil War themes if anti-South[,] Women (except
as frail flowers)[,] Negroes[,] and Jews," frustrated her, as they "left as possi-
bilities: Dogs, Small children, He men, Horses, Indians (noble) and Clinging
Vines."[126] When corresponding directly with her Hollywood employers, Ross
expressed pride that the success of *The Searchers* built a reputation for the
producers, and she hoped that they would pursue her future recommenda-
tions of stories significant to her.[127] However, she did not express pride in the
social implications of the film as she did when describing her own writing.
To a friend, she rejoiced in her bonus pay, remarking, "Isn't it HILARIOUS? Me
and Hollywood." But commenting on the disjuncture between this work and
her current writing on Buddhism, she wondered how long she could tolerate
working with film moguls.[128]

As she was moving on to these projects, Ross received letters from read-
ers who found inspiration in the pages of *Westward the Women*. In 1945,
one woman applauded the book's historical approach to exploring modern
gender roles, writing, "During ten years as a housewife, I have become more
and more consciously a feminist and have wanted an answer to my discon-
tent. The last chapter of 'Westward the Women' gave me the first honest
answer, indeed the first suggestion that there is an answer other than my own

'lean[n]ess.'"[129] A fan who wrote three decades later also highlighted the past's relevance to modern life. The correspondent praised Ross for conjuring vivid images of pioneer women's daily labors and expressed shock that a work so compatible with contemporary feminism had first appeared in 1944.[130] Such responses embraced the feminist value of asserting that women had a history.

Westward the Women also had an academic audience. Scholars long cited the work as an early exception to Western historiography's focus on men.[131] Educators applied it in the classroom. In 1945, J. Almus Russell, chair of Dakota Wesleyan University's English department, reported including the book in his courses. Decades later, in 1979, the Berkeley, California, Unified School District distributed excerpts to high school teachers as part of a curriculum revision project, "Integrating Women into American History."[132]

The book also prompted a request in 1944 from Margaret Grierson, who asked Ross to donate a copy of *Westward the Women*, along with related research, to Smith College's Historical Collection of Books by Women and on Women, which was then growing.[133] Grierson sent material describing the Friends of the Library's effort to extend the work of the World Center for Women's Archives and to gather sources with instructional value.[134] Surpassing the original request, Ross offered to write a magazine article for *Good Housekeeping* or a similar publication. The early letters in response to *Westward the Women*, she explained, had convinced her even more deeply that contemporary women needed to study the past. Publicity for women's history, she argued, would help stimulate women's intellectual engagement in modern life. Ross quickly sent out a proposal for such an article, joking that her husband would chide her for taking time away from her current novel manuscript, but that enlightened women would be necessary for her own future career success. Grierson, however, declined Ross's offer, explaining that she was still in early stages of cataloging acquisitions and that the fledgling collection was not ready for publicity. She wrote, "While there may be a story for so good a story-teller, it is not ripe."[135] Ross's eagerness to promote the archive, by contrast, reflected her belief that mass media's storytelling stage could play a vital role in the ripening.

ROSE ARNOLD POWELL AND 1940S FEMINISM

In the 1940s, Powell's efforts to memorialize Anthony continued, operating as the centerpiece of her feminism as she also devoted significant attention to the campaign to pass the Equal Rights Amendment (ERA). Disabled after multiple accidents, she had returned to Minnesota and the care of family members, continuing her lobbying efforts by mail.[136] She urged the National

Woman's Party to adopt the Declaratory Act, which she had authored in 1943 in response to the "incompleteness of the present Equal Rights Amendment."[137] Arguing that feminists should not focus on only equality of rights, she criticized the wording of the proposed amendment for omitting the "duties, obligations, and responsibilities" currently assigned to male citizens. Without a direct acknowledgment of the reciprocal relationship between these contributions and rights in defining citizenship, she argued that the ERA would ultimately differentiate women from men in the public mind.[138] As an alternative, her Declaratory Act, if adopted by Congress, would assert that all references to "citizens" and "people" in the Constitution already applied to men and women equally.[139] In the statement accompanying her proposal and in her correspondence with activists, she emphasized that the Fourteenth Amendment, which established criteria for U.S. citizenship so to define the role of African Americans after emancipation, should be interpreted as a statement of equality for all.[140] As Powell noted, this position echoed Anthony's argument in the 1870s that the Fourteenth Amendment enabled women to vote. Powell presented this logic as a solution to feminists' philosophical and strategic disagreements over the ERA. This focus on unity as a goal for modern women paralleled her assertion that reverence for one great historical woman could improve society as a whole.[141]

In the 1940s, her hopes for a successful outcome for her Mount Rushmore crusade dashed, Powell sought to increase Anthony's public profile by securing Anthony's presence in the Hall of Fame for Great Americans, then housed at New York University. The National Woman's Party had campaigned unsuccessfully for Anthony's induction since 1930.[142] Powell now made personal appeals to Hall of Fame electors. While Anthony would not be selected until 1950, the campaign enabled Powell to secure commemoration in more ephemeral form.[143] After she appealed to historian and Hall of Fame elector James Truslow Adams, he requested her input for an article, "The Six Most Important American Women," which he was writing for a 1941 issue of *Good Housekeeping*. She sent him documents, among them her personal selections from Harper's biography and the 1933 *Ladies' Home Journal* survey she had long cited as troubling evidence that the public was forgetting its suffrage pioneers. When Adams's article was published, Anthony was included.[144]

In 1943, Powell secured a place for Anthony in a new outlet for women's history: the comic book. There, her strategies supported the vision that impelled psychologist William Moulton Marston (1893–1947) to invent the figure Wonder Woman. Historian Jill Lepore argues that this character "braided together more than a century of women's rights rhetoric"; it was secretly inspired by Marston's feminist family members and by the suffragist philosophies and imagery that

had shaped Marston as a university student.[145] Rose Arnold Powell was also an uncredited influence, lobbying to secure Anthony's status as a historical Wonder Woman in one of the comic's early issues.

WONDER WOMEN OF HISTORY

Each issue of the *Wonder Woman* comic book, which debuted in 1942, featured a "Wonder Women of History" biographical narrative, typically given four pages at the book's centerfold. These installments celebrated noted nurses, social reformers, educators, scientists, and activists who had worked to protect others and, in so doing, had challenged the gender norms of their time. Captions made explicit comparisons between the historical women profiled and the character of Wonder Woman.[146]

Famed tennis player Alice Marble had proposed the feature when she met Marston at a cocktail party.[147] He hired her as an associate editor, and she initiated research for the biographies. In July 1942, publisher M. C. Gaines sent a statement by Marble to prominent business and professional women, educators, and authorities on child psychology and social welfare, asking them to identify suitable subjects for future issues.[148] With Marble credited as their author, the biographies appeared prominently in promotions for the comic book, and advertisements targeted to parents touted their educational value.[149] Gaines excerpted them and donated hundreds of thousands of copies for classroom use.[150]

The historical biographies and Wonder Woman's modern-day adventures both supported Marston's mission: promoting what he described as the "universal truth" that social progress required "women taming men so they like peace and love better than fighting."[151] His heroines pledged themselves to advancing the public good, using political and diplomatic skill to enact justice.[152] Training boys, the majority of comics readers, to respect such female strength was central to Marston.[153] During the planning stages, he warned All-American Comics editor Sheldon Mayer, "I fully believe that I am hitting a great movement now under way—the growth in power of women and I want you to let that theme alone—or drop the project."[154] Press releases for the inaugural issue of *Wonder Woman*—the first comic book devoted to a female heroine—boasted the success of this hypothesis, reporting that 80 percent of children who had responded to the character's earlier appearances in established comic books preferred her over male heroes.[155] The *Hartford Courant* speculated that the superheroine would help promote the wartime expansion of women's employment.[156] Sales for *Wonder Woman*'s third issue surpassed half a million copies, and by 1945 Marston claimed a readership of 2.5 million.[157]

The origin story of Marston's superheroine invoked historical mythology to justify the empowerment of modern women. Wonder Woman came from an ancient utopian female society on Paradise Island that had been created so women could escape men's subjugation. In isolation, women's capacity for intellect and physical strength developed fully, producing "new women" holding power that they "have to use . . . for other people's benefit or they go back to chains, and weakness."[158] Secluded from modern nations, Paradise Island had thus far successfully preserved this female strength, untouched by twentieth-century encroachments on women's and individuals' rights.

The comic book's first issue trumpeted this legacy. When she travels to America to return a fallen U.S. pilot and aid the Allied cause in World War II, Wonder Woman accidentally drops "an old parchment manuscript," written in Greek and identified by "Dr. Hellas at the Smithsonian Institute" as "an ancient document sought for centuries—the history of the unconquerable Amazons!" By dramatizing the Smithsonian's interest in this civilization, the comic asserted its historical importance. Promotional material predicted that Wonder Woman's ancient past would also interest young readers, leading them to "model themselves on the self-reliant, strong, comradely woman who can be honest and fearless because she is not dependent upon a man for her living."[159]

The "Wonder Women of History" installments played a central role in establishing this ideal. Demonstrating the message of female service to others, the first four biographies covered famous nurses—Florence Nightingale, Clara Barton, Edith Cavell, and Lillian Wald—emphasizing their wartime contributions.[160] Their stories linked the nursing profession to the capacity for motherhood, praising the ability of women to nurture all people as they would their own children. However, they also celebrated nurses for deviating from social norms by leaving their homes to pursue public service. An opening legend emphasized that Nightingale's innovation required her to abandon traditional expectations and make personal sacrifices: she, "LIKE WONDER WOMAN, GAVE UP THE BIRTHRIGHT OF HER HAPPY AND PROTECTED HOME TO SAVE THE LIVES OF SUFFERING HUMANITY."[161] Similarly, "GENTLE LILLIAN WALD, BROUGHT UP WITHIN A JEWISH FAMILY OF COMFORTABLE CIRCUM-STANCES [CHOSE] THE ARDUOUS, OFTEN THANKLESS PROFESSION OF NURS-ING." In her work as "THE MOTHER OF NEW YORK'S EAST SIDE," Wald "HAD NO FAVORITES. HER BOUNDLESS SYMPATHY AND CARE WENT OUT TO ALL . . . REGARDLESS OF RACE, COLOR, OR RELIGION."[162] Like Wonder Woman, these historical characters gained respect by serving others, even when this service required them to challenge social norms.

The "Wonder Women of History" biographies also emphasized the inspi-rational value of history, by portraying heroines who drew courage from their

understanding, more spiritual than academic, of women's unique legacies. Florence Nightingale's story opened with her touring Rome and receiving a telepathic message from "AN ANCIENT STATUE OF AN AMAZON MAIDEN." Astride a horse and brandishing a sword and shield, the statue communicated the message "STRONG WOMEN ONLY . . . CAN SAVE SUFFERING MANKIND/YOU ARE CHOSEN: BEGIN YOUR WORK!"[163] This narrative asserted parallels between earlier conflicts and the contemporary crisis of World War II, while emphasizing that history had long provided inspiration for women's heroism.

The fifth "Wonder Women of History" installment, the first to move beyond stories of women in nursing and the first allotted five pages in the book, expanded this model by celebrating nineteenth-century suffragist Susan B. Anthony as a "wonder woman" who challenged gender biases.[164] Rose Arnold Powell had contacted the publisher after learning about the comic book's historical feature.[165] Celebrating Anthony as a "great emancipator" who was an equal to Lincoln and Washington, the biography clearly echoed Powell's often repeated rhetoric.[166] This influence provides unique insight into the creation of *Wonder Woman*'s feminist history. As Jill Lepore explained after her examination of Marston's complete private and public papers, the true authorship of the "Wonder Woman of History" episodes remains a mystery, and available papers do not include responses to Marble's request for nominations of subjects. Marble exerted an early influence and her name remained on the masthead as associate editor, but personal and professional events beginning in 1942 removed her from close involvement with the publication.[167] However, Powell's correspondence demonstrates her role as an outsider in shaping one of these widely circulated narratives.

In her correspondence with All-American Comics about the final product, Powell stressed her gratitude for the placement of male pioneers alongside Anthony: "For years I have labored to weld her name with those of Washington and Lincoln as 'a third great emancipator,' and I can not express how grateful I am that you have linked their names together in this story. We have had no commanding *feminine* figure uplifted beside the masculine to express the BALANCE of national greatness." Powell rejoiced that her collaboration with the comic's editors on this tribute made them "co-workers in the *unfinished business* of the blessed pioneers of the woman movement."[168] Without a commemoration of feminist history, Powell feared, the work of historical feminists could be negated, but she argued that the elevation of Anthony and of a new Wonder Woman character to act as a counterpart to Superman would help further the work Anthony had done.

For Powell, the value of this promotion of women as equals to men superseded factual accuracy. After receiving a draft from All-American Comics,

Powell forwarded biographical and bibliographical information for review but did not correct factual errors. She did advocate greater attention to Anthony's activism during and after the Civil War to "connect Miss Anthony's life work with the present participation of women in war activities." Proposing that the subject's desires should influence her memorialization, Powell also requested the addition of Anthony's "alleged illegal voting in 1872 and her dramatic trial in 1873 [which] she considered the highlight of her life."[169] Despite these requests, the published version omitted the Civil War and Anthony's trial for voting, skipping from the 1860 New York Married Woman's Property Law—driven by Anthony's petitioning—to the end of her life. The narrative erroneously placed Anthony as a co-organizer with Elizabeth Cady Stanton of the 1848 convention at Seneca Falls, New York; in reality, Anthony did not attend this event and had not yet joined the woman's rights movement.[170] In correspondence with one of Anthony's relatives, Katherine Boyles, Powell conceded that "not everything is entirely accurate," but she praised the biography for conveying "the long struggle [Anthony] waged."[171]

In turning to *Wonder Woman*, Rose Arnold Powell deployed mass media to raise public consciousness of women's history, making compromises in order to reach a wide audience. As she explained to Boyles, she disliked the "bad art displayed" in comic books and anticipated that other feminists would criticize the Anthony comic. But "since the sale is enormous I pocketed my prejudices and took the opportunity to get Miss Anthony's life story out to the public."[172] She mused, "We can't always bring out our highest personal ideals, but we can raise others by approaching them on their own plane of thinking." So, she said, she "did not give [All-American Comics president] Mr. Gaines permission to send out my name in connection with it but I did accept his invitation to send him twenty or twenty-five names to whom he could send copies."[173] She had the book sent to Anthony's family members and to women writing about the history of suffrage. In private letters to some of these recipients, she claimed that Anthony's inclusion had resulted directly from her "plea" to the publisher.[174]

Anthony's appearance in *Wonder Woman* subverted popular assumptions about women's significance to history while deploying the narrative conventions of comics and other cultural scripts about gender. *Wonder Woman* consistently celebrated service to family and attractiveness to the opposite sex, and the Anthony biography assured readers that powerful women would still be feminine. The comic portrayed the suffragist receiving numerous romantic proposals but opting instead to focus on her activism to improve the legal rights of married women. The biography focused on Anthony's efforts to improve the status of women as a group, and on the historical significance

of her achievements. Opening text proclaimed Anthony's relevance: "THIS INDOMITABLE FIGHTER FOR FREEDOM AND JUSTICE STARTED THE WOMEN'S MOVEMENT WITH RESULTS MORE FAR-REACHING *THAN ANY WAR OR REVOLUTION SINCE HISTORY BEGAN*." Historical comparisons justified this assertion: "AMERICA HAS THREE GREAT EMANCIPATORS. GEORGE WASHINGTON WELDED FOUR MILLION COLONISTS INTO A UNITED STATES OF AMERICA, ABRAHAM LINCOLN FREED FOUR MILLION NEGROES FROM SLAVERY. AND SUSAN B. ANTHONY STRUCK THE SHACKLES OF LEGAL, SOCIAL, AND ECONOMIC BONDAGE FROM MILLIONS OF AMERICAN WOMEN. BRAVE, DARING, GENEROUS, SINCERE, THIS *WONDER WOMAN* LED HER SEX TO VICTORY AND BECAME 'THE LIBERATOR OF WOMANKIND.'"[175] To illustrate this, the opening panels showed Anthony unlocking metal chains binding the hands of a female figure. This image paralleled the exploits of the comic book's protagonist, whose storylines frequently featured such restraints.[176] It also echoed language long used by Powell and her supporters in publications emphasizing that history's emancipators "struck the shackles of human bondage."[177]

Reinforcing Marston's efforts to make children respect women's authority, the story's next page emphasized Anthony's early experience as an educator. Anthony responds forcefully to an unruly male student who proclaims, "WE WON'T MIND NO *WOMAN* TEACHER," as she brandishes a stick and pulls him by his hair onto a desk. By the next panel, her pupils respectfully offer bouquets of flowers, with text revealing that "THE BOYS SOON LEARN TO ADORE SUSAN AS DID LATER SUCH NOTABLES AS PRESIDENTS MCKINLEY, GROVER CLEVELAND AND THEODORE ROOSEVELT." To explain Anthony's efforts to promote married women's property rights, the illustrations relied again on stylized violence: a state senator punches his wife after she threatens to expose his alcoholism, her last recourse in her hope that he would reform "FOR OUR CHILDREN'S SAKE." The next panel pictures the senator's wife "BEHIND BARS AT AN INSANE ASYLUM," imprisoned at her husband's behest. Anthony provided rescue, the significance of her actions again demonstrated through comparisons with other celebrated histories: "SUSAN HELPS THE TORTURED WIFE TO ESCAPE HER CRUEL MASTER AS MANY PEOPLE HELPED FUGITIVE SLAVES."[178]

In this portrayal, Anthony also mirrored the character traits of Wonder Woman. Using her physical strength and a magic lasso that compels others to speak the truth, the superheroine repeatedly saves the world from male violence. Time travel and fantastical encounters with notable historical figures helped highlight the significance of these feats. One Wonder Woman episode, appearing in the same issue as Susan B. Anthony's biography, featured an ectoplasmic "George Washington" apparition. The creation of Dr. Psycho,

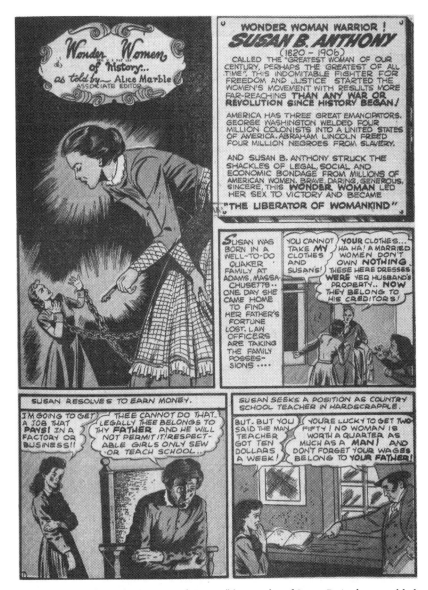

Figure 4.1. The "Wonder Women of History" biography of Susan B. Anthony melded Rose Arnold Powell's rhetoric and the visual conventions of the comic book. *Wonder Woman*, June–July 1943. Courtesy of the Smithsonian Libraries, Washington, D.C.

a dangerous Nazi scientist whose violence stems from romantic rejection and a pathological hatred of women, the fake Washington tries to sabotage the United States by warning that women's industrial and military involvement signified a threat to the nation. He proclaims, "WOMEN SHOULD NOT BE PERMITTED TO HAVE THE RESPONSIBILITIES THEY NOW HAVE!. . . . WOMEN WILL

BETRAY THEIR COUNTRY THROUGH WEAKNESS IF NOT TREACHERY!"[179] Only Wonder Woman ascertains that this realistic-looking George Washington figure is not genuine, thwarting Dr. Psycho's plot. Freeing his wife from captivity, Wonder Woman urges her, in the final frame of the story, to "GET STRONG! EARN YOUR OWN LIVING—JOIN THE WAACS OR WAVES AND FIGHT FOR YOUR COUNTRY!"[180]

The input Powell added to Wonder Woman's content ended after she secured Anthony's biography; but the "Wonder Women of History" installments continued, celebrating heroines who rebelled against social norms to help others. Couplings of femininity and strength allowed "BRAVE, BRILLIANT, LOVELY JANE ADDAMS" to stand up against "THE MOST POWERFUL POLITICIANS AND BUSINESS MEN IN THE COUNTRY" as an advocate for children. Soon after her death in 1947, Carrie Chapman Catt was praised as a feminist: the comic highlighted her contributions to women's suffrage, the League of Women Voters, and the United Nations, as well as her pacifist efforts. An entry devoted to "GALLANT WONDER WOMAN" Sojourner Truth argues that Truth's activism on behalf of African American rights "OPEN[ED] THE GATES OF INDUSTRY TO ALL MEN AND WOMEN, REGARDLESS OF RACE." Illustrations depicted the persuasive power of her women's rights speeches over white audiences. Personalizing Truth's heroism, the comic dramatized her efforts to claim custody of her enslaved son, as she appears in court despite the dismissal of judicial officials.[181]

Praise for Truth's "rebellion" and "independent airs" under slavery paralleled descriptions applied to Wonder Woman, and reinforcing this comparison, Truth's biography was published in the same issue as a story about Wonder Woman's rescue of female residents of Eveland, the "lost garden of Eden," an undersea utopia under assault by brutal Seal Men who capture the maidens to make them "garden slaves." The episode closes with Wonder Woman negotiating a treaty ensuring the freedom of Eveland's women, which prompts their proclamation "YOU'VE SHOWN US, PRINCESS, THAT CLEVER WOMEN CAN CONQUER THE STRONGEST MEN!" Wonder Woman's achievement also prompts a marriage proposal from her love interest, Steve, which she refuses, suggesting that the engagement would become a form of slavery: "IF I MARRIED YOU, STEVE, I'D HAVE TO PRETEND I'M WEAKER THAN YOU ARE TO MAKE YOU HAPPY—AND THAT, NO WOMAN SHOULD DO!"[182] By exposing young readers both to Truth's biography and to Wonder Woman's intervention in Eveland, All-American Comics urged them to associate equality and independence with ideal womanhood.

Regular readers of "Wonder Women of History," however, would also encounter more restrictive definitions of women's place in society. Abigail

Adams appeared as "AN INSPIRING EXAMPLE OF THE TIMELESS ROLE OF WOMAN AS . . . *WIFE AND MOTHER!!*" The biography briefly acknowledged that Abigail requested "equal rights" for women in her Revolutionary War correspondence with her husband, but it removed the rebellious tone of her appeal. Instead, the narrative declared, "HER FAITH, COURAGE AND DEVOTION TO FAMILY PLACES HER IN A SPECIAL GROUP OF *WONDER WOMEN* . . . THOSE QUIET, SELF-EFFACING, GENEROUS WOMEN WHOSE ONLY AMBITION WAS TO BE. . . . *WOMEN!*"[183] Such narratives celebrated women for accepting social norms that limited them to family responsibilities.

Racial stereotypes appeared in a historical biography devoted to Juliette Gordon Low, founder of the Girl Scouts. The narrative opens in the South of 1864 and identifies Juliette as the three-year-old daughter of a Confederate captain. An African American woman in kerchief and apron comforts the child as Sherman's troops approach the Gordon home. This character's devotion to the family that enslaved her reflected popular culture's familiar "Mammy" archetype.[184] The comic presented this opening scene as an important inspiration for Low's future "interest in peace" and her drive to create a "world camp" to unite Girl Scouts from across the globe, the achievement that ends the narrative. However, by simplifying the Civil War as a battle that traumatized children and the "Mammies" resolved to protect them—without mentioning the abolitionist implications of the conflict—this *Wonder Woman* episode distorted reality and sentimentalized racism. Despite this slant, when feminists of the 1970s reintroduced the Wonder Woman ideal they had embraced as children, they remembered her rebelliousness and independence rather than these stereotypical elements.[185]

MEMORY AND ARCHIVES: ENVISIONING THE LEGACY OF POPULAR HISTORIES

As the "Wonder Women of History" cavalcade grew, Rose Arnold Powell continued working to reach mass audiences, maintaining regular correspondence with those who had previously acknowledged Anthony, urging them to reiterate this recognition.[186] Trying to build on the momentum of a 1944 *Reader's Digest* article, "Susan B. Anthony, Trail Blazer," Powell praised the editors but pressured them to devote even more attention to the suffragist in the future. Citing pedagogical scholarship, she criticized the *Digest* and other popular magazines for featuring female historical figures less frequently than they did figures like Lincoln.[187] Simultaneously, Powell worked to secure notations of Anthony's birth date on commercial calendars, prioritizing her campaigns based on publishing companies' output. She rejoiced when she

won participation from the Brown & Bigelow Company in 1944, claiming that this would ensure Anthony's presence in 75 percent of the national market.[188] Powell approved Anthony's appearance in all promotional items, privately noting the irony that a calendar put out by a "brewing company" would show reverence for "an old temperance pioneer."[189]

She regularly shaped her narratives about Anthony to maximize their public appeal, recording in her diary that she excised references to Abraham Lincoln in material sent to southern presidents of the General Federation of Women's Clubs. In the "'seceded states' where Civil War animosities still exist," Powell did not want to jeopardize her request that clubwomen recognize Anthony's birthday and lobby Congress to do the same.[190] Although Powell did not compare this decision to Anthony's own actions, Anthony had advocated a similar accommodation by supporting the National American Woman Suffrage Association's "southern strategy" in the 1890s. Prioritizing the vote over other causes, NAWSA courted southern supporters who advocated women's suffrage as a white supremacist tool to protect racial hierarchy.[191]

Again expressing a philosophy that echoed that recorded by Anthony herself, Powell contemplated the long-term influence of her own crusade in the mid- and late 1940s. In 1944 she "confide[d]" to Alma Lutz her own "long cherished desire" to write a book on Anthony's life.[192] Explaining that her injuries had disrupted that dream, she shared her vision in hopes that it would shape the biography Lutz was writing. She requested inclusion of topics that she felt were important to the suffragist: Anthony's interpretations of the Constitution and her protest at the nation's centennial exhibition.[193] In subsequent years, as Lutz and Powell continued corresponding about their efforts to shape modern women's historical consciousness, they frequently returned to the significance of that 1876 event. In 1946, Powell asked Lutz to publicize a particular quote from the *History of Woman Suffrage*, the voluminous chronicle that Anthony, Elizabeth Cady Stanton, and Matilda Joslyn Gage had edited. The passage described the suffragists' motives for disrupting patriotic celebration with their "Women's Declaration of Independence": "their work was not for themselves alone, nor for the present generation, but for all women of all time. The hopes of posterity were in their hands and they determined to place on record for the daughters of 1976, the fact that their mothers of 1876 had asserted their equality of rights, and impeached the government of that day for its injustice toward women. Thus, in taking a grander step toward freedom than ever before, they would leave one bright remembrance for the women of the next centennial." This quote encapsulated Powell's belief that, for both Anthony and herself, the drive to

create a historical legacy and that to advance the feminist cause went hand
in hand. Looking ahead to the 1976 milestone and hoping that women then
would indeed be knowledgeable about their predecessors, Powell observed,
"Children born this year will be thirty years old then. I believe that now is the
time to begin planting this seed." Lutz concurred: "I think we should begin
emphasizing this now. 1976 is only thirty years away."[194]

However, both Lutz and Powell worried about broken links in this chain
connecting the past to the future, concerned that modern women were apa-
thetic about the history of feminism. Commenting in 1947 on the traveling
Freedom Train exhibit coordinated by corporations and the government
to celebrate patriotic history, Lutz lamented "the meager space . . . given to
women's contribution to our heritage," concluding, "This is women's own
fault because they don't regard their contribution as sufficiently important."[195]
She reported that attendance at a centennial celebration of the 1848 Seneca
Falls Convention "was very disappointing," as Powell bemoaned the fact
that clubwomen resisted holding dinners to honor Anthony's birthday the
way they did to honor Lincoln's.[196] Nevertheless, Lutz did find a bright spot:
"You'll be interested to hear I am sure, that I am continuously locating new
collections of Susan B. Anthony letters which have just recently been placed
in libraries. Interest in preserving women's record is growing."[197] While she
was concerned with the place of historical feminists in the popular canon,
she perceived archival seeds that she hoped would shape future scholarship.

In the 1930s and 1940s, popular culture offered multiple, often competing,
perspectives on women's history. Writers and activists publicized narratives
that reached beyond the colonial mythology elevated by advertisements and
academic teachings. These feminists presented workers, consumers, and
activists as valid historical subjects to enhance claims for modern women's
significance in public life. Although they had differing visions of a usable
feminist past, Rose Arnold Powell, Mary Ritter Beard, and Nancy Wilson
Ross each expressed concern that modern women lacked access to the
full picture of women's histories, and that such ignorance would threaten
women's contemporary and future status. To correct absences in scholarship
and curricula, they turned to popular culture, where theirs were not the only
voices urging commemoration and documentation of women's history. The
feminists covered in this chapter lobbied the mass media as outsiders; the
next chapter considers how corporations applied history to sell products in
the 1940s. Advertisements often touted the awareness of history as a duty of
modern women and a rewarding pursuit. Within the context of World War II,
some of these promotions upheld familiar ideals of femininity, while others
promoted the expansion of women's roles.

BETSY ROSS RED LIPSTICK

PRODUCTS AS ARTIFACTS
AND INSPIRATION, 1940–1950

During World War II and in its aftermath, advertisements urged modern women to identify with historical examples of female boldness. But there were conflicting messages about what historical bravery signified for the present. Stories about Molly Pitcher's wifely devotion on the battlefield and pioneer women's labor to establish homes in the West asserted that there was long continuity in women's familial responsibilities. These narratives paralleled propaganda depicting women's wartime service as a temporary response to crisis, a sacrifice for family and nation. However, corporations publicized other histories—including the nineteenth-century expansion of jobs open to women—that offered inspirational examples of women who transgressed against the gender ideals of earlier eras, ultimately achieving advances celebrated in the present. These accounts were compatible with assertions by feminists that modern women's wartime employment should extend into new postwar opportunities. This chapter assesses corporate advertising campaigns that promoted women's history to define modern women's work—both public and private—and to sell products. These cases led to contradictions: women's historical actions were treated as both exceptional and quotidian and as markers of both continuity and change. Some popular histories were based in fact, while others were fictional. Throughout, however, popular culture asserted that women's work was historically significant and that the history of women's work merited commemoration in modern popular culture.

These competing models for understanding women's history reflected other tensions within World War II propaganda. Recent scholarship by Melissa McEuen and Donna Knaff considers how ambivalence about women's new roles manifested itself in popular culture's scrutiny of female bodies.[1] As Knaff demonstrates, an abundance of visual imagery in posters, cartoons, advertisements, and comics urged women to show strength in service to industry and military while simultaneously remaining feminine. This concern also shaped popular depictions of the past, which elevated historical heroines' bodies and handiwork to the status of modern inspiration. Manufacturers created platforms for selling products—like Betsy Ross Red lipstick and muffin mix featuring what was called Early American Flour—that purported to emulate the mythic past in material form and to help women meet traditional standards while simultaneously taking on new responsibilities.

The chapter begins by considering ways government propaganda and the press established the historical context for contemporary women's wartime roles. Corporate advertising campaigns made parallel turns to the past. The Avon cosmetics company positioned itself as an educator, publishing wartime magazine advertisements containing biographies of notable women in American history. While such content celebrated women as historical actors, the company also emphasized women's eternal responsibility to be "lovely." After the war, Avon created a museum to celebrate its own history; contributions from consumers and sales representatives reflected their own interpretations of women's historical significance, as they highlighted their work experiences, rather than the beauty through cosmetics or the corporate innovation Avon prioritized.

Deploying another strategy for defining corporate brands through depictions of the past, two movie musicals released shortly after the war, *The Harvey Girls* and *The Shocking Miss Pilgrim*, offered fictionalized histories of women workers, produced in collaboration with the companies featured in the plots. They celebrated women's employment by dramatizing its compatibility with romance. Simultaneously, these high-profile films positioned themselves as correctives to historical narratives that omitted women. *The Shocking Miss Pilgrim* reflects both the feminist intentions of its original screenwriters and the capitalist goals of its producers.

When selling food and household goods, corporations placed additional emphasis on continuity in women's familial roles. Manufacturers characterized female domesticity as a timeless virtue while acknowledging the need for time-saving products that would enable consumers to work outside the home. Advertisements celebrated symbolic historical women who maintained domestic tradition during periods of disruption, relying on products

as vital aids. The chapter concludes by considering popular culture's defini-
tions of consumption itself as historically significant women's work, through
products with design elements that evoked needlework, a genre associated
with historical domesticity and personal family memories. The Salem China
Corporation, which produced dinnerware adorned with a "petit point"
embroidery design, exemplifies this trend and provides insight into the
meanings consumers could add to the products they purchased. Nebraskan
Grace Snyder produced an elaborate quilt that copied the imagery on her
Salem dinnerware; media reports remarked on her historical background on
the Western frontier and gave her credit for artistic creativity that had origi-
nated in consumption.

The Responsibility of Women's Domestic and Public Work

During World War II, propaganda elevated patriotic historical icons to sym-
bolize women's inherent strength. The Office of War Information highlighted
Molly Pitcher as a model for modern women's service on the assembly line
and in the kitchen, emphasizing continuity between the past and the present.
One poster placed the image of a modern woman riveting metal alongside
the image of Pitcher loading a rifle; the caption read, "It's a Tradition with
Us, Mister!"[2] A poem and accompanying cartoon distributed to news-
papers commemorated "Mistress Pitcher, '43" by comparing her donation
of cooking fat for gunpowder production to the earlier battlefield exploits
of "Mollie Pitcher, a heroine / Whom everyone ought to know."[3] Meanwhile,
corporate-sponsored propaganda echoed this message. A series of magazine
advertisements by the Pennsylvania Railroad celebrated Pitcher as an inspira-
tion for modern women's industrial labor.[4] The Kalamazoo Stove & Furnace
Company sponsored an advertisement in *Life* magazine advising women on
household conservation, explaining, "You're Betsy Ross, Barbara Fritchie
and Molly Pitcher, reborn—with all their traditional qualities for work, loy-
alty and self-sacrifice."[5] Such praise emphasized continuity, urging modern
women to repeat the "traditional" past.

 Cultural commentators added another layer to this mythology by elevat-
ing familiar iconic women as models but criticizing corporations that capi-
talized on patriotism. In her 1943 book, *It's All in the Family: A Diary of an
American Housewife, December 7, 1941–December 1, 1942*, Dorothy Blake cast
Pitcher's bravery as an authentic source of inspiration, contrasting it with
advertisements that equated consumption with contributions to national
defense. Blake, a regular contributor of parenting and housekeeping advice in

women's magazines, wrote as a recognized interpreter of domesticity; Eleanor Roosevelt had praised Blake's 1936 book, *Diary of a Suburban Housewife*.[6] Now, assessing the new wartime home front, Blake remarked, "The five and ten is pushing Courage lipstick—too bad Molly Pitcher didn't have the advantage of it."[7] Her mockery of aggressive promotions emphasized that women could make history, even without the benefit of modern beauty products.[8] In the same passage, she expressed pride in a friend's salvage drive and in her contributions to this work by offering "my own special cinnamon buns with the raspberry jam in their middles." For Blake, such labor represented a sincere contribution to morale, while patriotic consumption did not.

Similarly, historian J. C. Furnas urged women to emulate Pitcher, but to reject corporate assertions that consumption enabled them to do so. Writing in the *Saturday Evening Post*, Furnas challenged the media's historically themed praise for modern women's military, industrial, and domestic efforts.[9] Denying that women were living up to their ancestors' model, Furnas refuted Eleanor Roosevelt's recently published account of women "doing a grand job on both the fighting front and the home front." Roosevelt had cited women's accomplishments as she advocated day care centers and government-sponsored meals that would ease their labor, and as she criticized "false chivalry" for limiting women's military assignments.[10] While Roosevelt identified institutions as barriers to women's voluntarism, Furnas reprimanded modern women for falling short: "The implication in [Eleanor Roosevelt's *Reader's Digest*] article and in much current advertising that the ghost of Molly Pitcher would approve of her female descendents is dubious. Mistress Pitcher, a rough-and-ready type, would probably ask harsh questions about why, if women are doing themselves so proud, the Wacs have recruiting trouble, hospitals clamor for unobtainable nurses' aides, retail sales are still stepping up the inflation hazard and so much household salvage still goes to waste."[11] Furnas criticized advertisements for enabling such apathy and quoted a newspaper promotion for mink coats as indulgences earned through rationing.[12] Furnas noted, "It would be tough convincing Molly Pitcher that learning all over to cook and keep a house tidy was such grim, exhausting work that it called for $3500 worth of pampering." With this logic, he asserted that women could achieve historical greatness, but he denied that they automatically reached this bar simply by performing their modern daily labor. Presenting Pitcher's fabled exploits as fact, he expected women to honor her example.

Reiterating that the past had inspirational value, *Mademoiselle*, a popular magazine targeted toward college students, recent graduates, and young wives, featured an article lauding women's diverse contributions to

the American Revolution. However, author Richard Erdoes criticized the impulse to idolize familiar heroines. Textbooks celebrated only "a few stray females like Betsy Ross and Martha Washington," Erdoes argued, obscuring the variety of women's contributions.[13] He prescribed a reassessment of "dusty diaries" and "faded" newspapers to produce an expanded historical narrative that included women's daily activities, from fund-raising for the military to boosting soldiers' morale. Erdoes highlighted women's use of homemade cosmetics during the Revolution as evidence of their patriotism. Such participation reflected familiar modern ideals of femininity, but Erdoes framed his argument as a dramatic correction to popular narratives about the past.

ASSESSING CONTINUITY AND CHANGE
TO ADVOCATE WOMEN'S EMPLOYMENT

Meanwhile, popular and professional periodicals also cited history as inspiration for women's World War II employment. In contrast with discussions of patriotic female icons, depictions of women's careers more frequently emphasized the possibility for change. Magazines provided vocational advice and celebrated the female wage worker, not only in the context of defense production but also as indicative of progress in women's roles. Comparisons between past and present emphasized the personal benefits women receive from paid employment. *Glamour*, a commercial fashion and lifestyle magazine published for young working women, structured the feature story of its annual "Career" issue around the theme "1942 looks at 1896," with fashion photography juxtaposing a model in modern dress operating a gleaming golden cash register with a display borrowed from the National Cash Register Company's archives: a mannequin in 1896 attire and an antique machine. The accompanying article, "Career Girls, THEN and NOW," proclaimed that women have always "worked side by side with men, tilling the soil, weaving, spinning, sewing, washing, cooking, preserving, all in addition to bearing and rearing their young." However, author Gladys Shultz attributed dramatic progress in women's paid employment outside the home to corporate technological innovations, including the sewing machine, the telephone, and the typewriter: "This is going to hurt, but the fact—the cold, scientific, low-down—is that the 'emancipated,' independent career woman as we know her today is nothing more nor less than a by-product of the machine age." The mechanization of production in areas such as textiles had freed up time from household labor. While the accompanying photographs emphasized retail employment, Shultz celebrated the variety in women's activities, now that machines had allowed them to cast off restrictive domestic stereotypes: "Today it's commonplace for

women to plan cities, probe crime, produce plays, perform appendectomies, perfect patents and pay taxes—to say nothing of wearing pants. They sit on judges' benches, in the President's cabinet, at the head of large industries, at the helm of newspapers and magazines, and it's as natural to them as breathing. That picture of the female as a frail creature designed for communing with the poets or gently playing the pianoforte in the parlor was a neat hoax perpetrated on us by the Victorians."[14] Such articles promoted feminism by asserting that women's natural abilities suited them well for public service, and by criticizing historical ideologies that imposed artificial limits on women's activities. Simultaneously reinforcing the goals of fashion magazines and advertisers, such pieces celebrated the corporate "career girl" as evidence of progress. By looking to the past, *Glamour* established deep historical roots for the modern woman worker-consumer.

As feminists responded to the new patterns of World War II employment, they also advocated that women workers use history as a guide for planning postwar careers. In 1942, Dorothy Dignam, now working in public relations at N. W. Ayer's New York City branch, publicized the ramifications of the current conflict by tracing changes in women's work from World War I through to the present. Dignam lectured on this history to the Advertising Women of New York, contributing a companion *Printers' Ink* article billed as "a look backward and ahead through women's eyes." She emphasized transformation, arguing, "The last war brought a great shift in jobs for women, and history is beginning to repeat itself."[15] Dignam's account of progress accentuated the interconnectedness of women's social contributions as earners and as consumers. She noted that women used earnings from World War I jobs to buy beauty products, thus improving national morale and personal romantic relationships. Their purchasing power then led agencies to hire women, like Dignam herself, as copywriters on cosmetics accounts. Inspired by this history, Dignam offered advice for those hoping to extend their careers into peacetime: alert women could cultivate insights about packaging and design from defense industry assembly line work and could select wartime positions with postwar goals in mind. By analyzing the past to promote women's professional advancement, Dignam embraced World War II as an opportunity for securing lasting change in women's employment.

Yet Dignam's *Printers' Ink* article reflected the persistent expectation that professional women fulfill standards of femininity. Two photographs of Dignam accompanied the piece. Commentary on the first, a portrait snapped early in her career, cited Dignam's slight smile as evidence that the "advertising woman of 1918" was "not too self-assured." By contrast, in the second, photographed as the "advertising woman of 1942," she exhibited "considerably

Advertising Woman of 1918
Young, rather prim with her parted hair, not too self-assured and smiling only faintly, Dorothy Dignam faces the advertising world during the First World War

Advertising Woman of 1942
Her long hair still parted on the forehead and with considerably more confidence in her bearing, Miss Dignam looks as though her advertising experiences had been agreeable

Figure 5.1. A visual chronicle of Dorothy Dignam's appearance accompanied her analysis of continuity and change in women's employment. Dorothy Dignam, "More Women in Advertising Now Than in World War I," *Printers' Ink*, May 29, 1942, Dorothy Dignam Papers, Schlesinger Library, Radcliffe Institute, Harvard University.

more confidence in her bearing" and yet retained "her long hair still parted on the forehead." These captions applauded the increase in Dignam's poise while reminding readers that influential women still faced judgment on their appearance. Similarly, Dignam's article evoked stereotypes of feminine vanity: "I am glad to turn the calendar to the wall—so you won't just sit there and check up on my age—and recall some of the history of women in advertising between the two wars." Such reassurances that charm and feminine appearance were compatible with women's professional labor paralleled the ubiquitous promotions of beauty as part of the World War II woman worker's uniform.[16]

Writing in 1944 for the three million readers of *Woman's Day*—a magazine sold exclusively by A&P grocery stores and focused on domestic advice and product promotion—anthropologist Margaret Mead offered another method for reconciling women's traditional roles with their modern employment.[17] She argued that postwar women should be free to decide "where they belong—at home or in industry." Some liked to "darn socks," and some liked to "tend machines," she reasoned, as the article's photographs presented a visual parallel between a woman on an assembly line and a woman canning food at home. The ability to choose between these two forms of production,

including the option of hiring someone to cook for one's own family, would best serve society as a whole. Concluding that the postwar economy could accommodate all who chose paid employment, Mead argued that traditional social definitions of femininity provided the only true barrier to women's careers. To encourage transformation of these ideals, she traced previous historical shifts in gender norms, from the initial entry of women into the public sphere to the ratification of the Nineteenth Amendment. In this analysis, society defined and limited women's behavior, but history provided a guide for change; this reflected a different perspective from the celebrations of icons like Molly Pitcher, which often placed the burden on individual women to fulfill an ideal of feminine sacrifice.[18]

AVON

Throughout World War II, Avon Products cast its cosmetics as tools to help modern women serve as living embodiments of the nation's patriotic heritage, a campaign that grew out of the company's long-term growth strategy and its sales structure. Avon had evolved from the California Perfume Company, which began selling toiletries, food colorings and flavorings, and cleaning products door to door in 1886. In 1929, the "Avon" line first appeared, and within a decade the Suffern, New York, company officially adopted the Avon name and turned its focus to color cosmetics.[19] The company recruited its exclusively female sales staff with the slogan "Now you are in business for yourself." In reality, women could make some decisions about when and where they would canvas, but executives dictated products, prices, and promotional themes. There were minimal possibilities for advancement, and sales representatives' status as contractors working entirely on commission excluded them from New Deal protections like the Social Security Act. Under this system, Avon remained profitable during the Great Depression, enabling its forays into national magazine advertising in the late 1930s.[20] During the 1940s, the company used this platform to praise its saleswomen as morale-boosting patriots, echoing the government's propaganda that equated the cosmetic beauty of female laborers and military recruits with the triumph of democracy.[21] Many consumers embraced this mindset: women surveyed by the War Production Board identified lipstick as a necessity that should remain exempt from rationing.[22] By 1944, Avon's sales force surpassed twenty-six thousand individuals nationwide; the company had $547.98 in average yearly sales per representative.[23] Total sales had risen from $4.2 million in 1937 to $15.8 million in 1944.[24]

Promotional campaigns defined Avon cosmetics as distillations of American patriotism. The 1941 introduction of the lipstick and nail polish

color Betsy Ross Red started an era of history-themed marketing.[25] In 1942 and 1943, magazine advertisements created by the Monroe F. Dreher agency paired the brand's cosmetics with clothing specially designed to salute the nation's heritage.[26] One advertisement, appearing in *McCall's*, *Woman's Home Companion*, and the *Ladies' Home Journal*, attributed Avon products with "the Spirit of Early America" because they empowered women for wartime responsibilities. The text likened a tweed skirt suit by designer Vera Maxwell—an ensemble named "the Frontiersman"—to the convenience of door-to-door Avon service. This accessible glamour allowed "today's war-minded women" to emulate "our courageous ancestors who helped make America great" and whose "spirit still lives in the heart of every gallant American woman."[27] Characterizing the company's modern products as an emotional link to this legacy, another advertisement promised that Paul Revere Red nail polish "gives new patriotic vigor to your fingertips." The shade accessorized high-fashion designer Omar Kiam's "white sheer organdy evening gown highlighted with embroidery and sequins," which was also "inspired" by Paul Revere's ride.[28] Paralleling other ads in the series, the style proffered no visible or factual link to history beyond the claim of inspiration from an iconic event and a decorative background illustration of Revere.

Further integrating the idealized American past into the brand's identity, the company's 1943–1945 advertising campaign, "Heroines of Yesterday and Today," promised to educate the public about history. The focus shifted from the "spirit" of the past to women whose physical beauty denoted their vigorous work to support the nation. Rather than promoting product features, each ad provided the biography of a historical woman and praised her modern counterparts.[29] The series ran in prominent women's magazines, among them *Good Housekeeping*, *Vogue*, *McCall's*, the *Ladies' Home Journal*, *Parents'*, and *Holland's*; sales agents received a bound volume of the illustrated color advertisements, with the promise "It is a book you will want to read and reread, show to your customers, and keep for a long, long time."[30] The collection profiled presidents' wives and mothers (including Martha Washington, Dolley Madison, and Nancy Hanks Lincoln); patriots (among them Lydia Darragh, Catherine Schuyler, and Julia Ward Howe); and women who served their government and their families as colonists, frontier settlers, and nurses (such as Ruth Wyllys, Anne Burras, Narcissa Whitman, Louisa May Alcott, and Clara Barton).[31] Designed to encourage modern women's identification with the past, this campaign was nevertheless exclusionary. Although African Americans made up part of the company's clientele and sales force, the "heroines" remained uniformly white.[32]

Each ad depicted a modern woman admiring the framed portrait of the historic "heroine." Visual parallels emphasized their shared characteristics. In a Betsy Ross installment, a woman in a fashionable polka dot dress knits intently, sitting before a framed portrait of Ross, who is sewing stars onto the original American flag. Ornamental bows on the modern woman's bodice and in her hair mirror the bow decorating Ross's colonial cap. The text reinforces the two women's connection in a contemplation on the flag: "It is fitting, indeed, that this Emblem made by a woman should rally a new generation of her countrywomen. The machines their deft fingers operate . . . the bandages they roll . . . the comforts, happiness and health they bring to their families . . . are creating a pattern of Victory for America as surely as the fingers of Betsy Ross created our Flag. All are America's modern heroines."[33] With this language, the advertisement echoed the rhetoric of World War II industrial employers, who cited assets like "deft fingers" as they channeled women into production jobs they deemed suitable for female bodies. Designed to justify women's factory employment while protecting distinctions between men's and women's work, this approach limited women's future opportunities.[34] Avon's take on Betsy Ross supported the logic that there was a natural and timeless feminine mode of work determined by women's bodies and patriotism. Dramatizing a historical continuum, Betsy Ross's fingers earned credit for their power to inspire others' diligent textile production centuries later.

However, while the Betsy Ross biography portrayed traditionally feminine labor, some of Avon's historical biographies encouraged contemporary women to draw direct inspiration from predecessors who had challenged their own eras' norms. These installments saluted women who fought in eighteenth- and nineteenth-century wars, always highlighting their audacity as well as their femininity. Avon identified wifely devotion as Molly Pitcher's motivation while depicting a woman in modern military uniform walking purposefully and smiling serenely at a portrait of Pitcher in an even more dramatic state of action. With her long blonde hair and wine-colored lips complementing her dress, Pitcher furrows her brow and loads a cannon in the midst of battle.[35] Another advertisement celebrated Lucy Brewer's War of 1812 heroism; its headline, "She Brought Loveliness to the Halls of Montezuma," paradoxically points to Brewer's feminine beauty while introducing an account of her success in disguising herself as a man to serve with the marines. The illustration pictured her in military uniform, albeit with long hair and red lips that differentiated her from two comrades standing by her side.[36]

Another installment praised the "loveliness and graciousness as well as courage and competence" that suited modern women for military service,

finding its historical parallel in the defiant but patriotic transgressions of Deborah Sampson Gannett, who "dressed as a man" and "volunteered her services in the American Revolutionary War in 1778." Distinguishing this past from a present in which "everything possible is done so that women may readily join the armed services," a contemporary woman in military uniform stands before the mounted tableau and takes notes. The portrait depicted Gannett after the army discovered her subterfuge. Summoned by George Washington, she stands before him with her chin proudly raised. The caption noted that Gannett successfully concealed her identity even after two battlefield injuries, and that Washington granted an honorable discharge. By contrasting this story with the modern military's official inclusion of women, the advertisement highlighted the possibility for changes in gender ideals over time. Nevertheless, this woman who lived as a man in order to serve the military still became an icon of beauty in Avon's hands. In the image she is outfitted again in women's clothing: a cap and a vibrant red, white, and blue gown. The text explained, "The courage of Deborah Gannett is symbolized by every one of these women in the armed forces and on the home front who desires to be useful to her country, and is determined to be lovely at the same time."[37]

With this sentiment, beauty became a patriotic collaboration between Avon and consumers. In communications to sales agents, executive Henry Bachler proclaimed that the series "demonstrates convincingly that Avon Representatives are truly heroines because of the service they render their customers and the consequent morale-building effect of such service."[38] This message also came imbedded in each advertisement. Following its historical biography, the Betsy Ross advertisement explained, "In your community there is a woman who serves her country by serving you. She is your Avon Representative. She brings to you, in your home, the means to a more inspiring beauty—so important to your country's morale."[39]

As the "Heroines" advertising campaign continued, company executives also emphasized representatives' roles as ambassadors of history. The *Avon Outlook* newsletter sent to sales representatives proclaimed that schools, historical societies, and college student researchers had used the advertisements. Appreciation for this educational value would support in-home sales pitches, executives asserted, quoting customer letters that echoed the ads' messages.[40] One wrote, "In your advertisements you tell us about the courage of the American pioneer women such as Molly Pitcher. Yes, today we are all Molly Pitchers whether in the kitchen, nursery, or on the production line."[41]

Meanwhile, Avon urged its sales agents to imagine themselves as beneficiaries of the company's historical greatness. Mirroring its own corporate structure, which filled upper management exclusively with men, Avon's

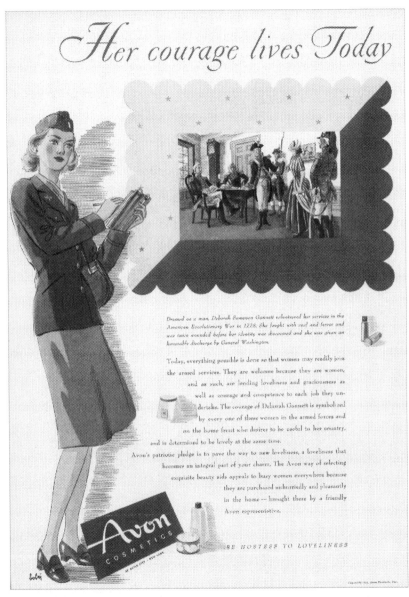

Figure 5.2. In magazine ads celebrating historical heroines, Avon dramatized modern women's reverence for the past. Avon advertisement, 1945. Courtesy of the Hagley Museum and Library.

histories of the cosmetics industry—presented in internal publications rather than in product promotions—placed women firmly in supportive roles.[42] *Avon Outlook* told triumphant stories of the company's progress at each Avon anniversary, honoring founder D. H. McConnell as a visionary for hiring female representatives. A 1943 narrative explained, "The need he saw was to offer occupation to women, for he had seen and felt their great need and desire to earn money when he called at their homes to sell books," and he persisted in spite of opposition, "start[ing] an industry that was destined to change the future of all women—destined to employ millions of people— destined in a little more than 50 years to be one of the country's leading industries." According to Avon, the company's success did no less than trans-form living standards: "Through these business opportunities the years since 1886 have likewise been wonderful years for American people; they are better fed, better clothed, better housed, better educated. They have so much more security that it is hard for us to realize now what life was like in 1886."[43]

While Avon offered the dainty and fashionable nineteenth-century sales-woman as the embodiment of female contributions to business, picturing her to illustrate *Avon Outlook* articles about the company's past, this anonymous figure did not transform history the way the company's great founder did. She earned praise for hard work, but not for innovation.[44] The "Heroines" cam-paign reflected this as well: its protagonists' sacrifices served the best interests of family and society. These were not women who centered their activism around the quest to transform society by promoting women's rights. Rather, they worked to support governmental and corporate visions. Notably, there were no examples of female entrepreneurship, or of paid employment beyond nursing, in the long-running campaign. Although they highlighted specific figures, the ads stressed their subjects' similarities with others—as reflections of universal womanhood—rather than their individuality.

In 1945, the "Heroines" campaign evolved into a celebration of modern women, still drawing connections between past and present. Women who had served the military, government, or public during World War II now appeared in the ads' central portraits, designated as recipients of the Avon "Medallion of Honor." Its design, which was also pictured, featured a cameo of a colonial woman in a bonnet, underscoring that the mythic past remained an inspiration.[45] Simultaneously, Avon developed a new project to celebrate its own past, enlisting customers and saleswomen to collect artifacts for a corporate museum. While many corporations publicized their own histories as a sales strategy, Avon's structure created a unique dynamic. The company's male leaders envisioned the museum as a record of product quality and inno-vation. Female agents and customers, however, prioritized different stories.

Moving beyond the scripts of advertisements and campaign instructions, saleswomen refocused the project on their own work, submitting letters that narrated their careers and collaborations with other women, and sometimes using the opportunity to make strategic appeals regarding their assignments and performance.[46] Their correspondence also reveals strategies that Avon representatives had developed for using history as a sales pitch, providing unique insight into the ways these products were handled in the home.

These personal testimonies are an anomaly in Avon's official historical archives. The bulk of material donated five decades later to the Hagley Museum and Library for use by scholars is dominated by the perspective of company leadership, as told through advertisements, publications, training manuals, annual reports, and philanthropic records. As scholar Lindsey Feitz observes, "Researchers who are interested in studying the lived experiences of Avon Ladies, whose informal labor networks and house calls were the engine that fueled Avon's tremendous domestic and international growth, will need to look outside the archives for answers."[47] The meticulously documented museum collection efforts, however, provide a unique platform for workers' and consumers' own histories in the official archives.

The Dreher advertising agency recommended the 1945 project to Avon leadership. Arguing that corporate museums promote and thrive upon goodwill of consumers and employees, the prospectus advised including sales representatives in collection building.[48] Corresponding with Avon's overall approach to managing its workforce, such involvement could strengthen employees' identification with a company they often dealt with indirectly, through mailed catalogues and sales instructions. As historian Katina Lee Manko demonstrates, executives sought to standardize sales representatives' performance by making them feel that they were active autonomous participants in their adoption of corporate philosophy.[49] Nevertheless, Avon's initial museum collection emphasized product innovation that emanated from the top of the corporation. The Dreher company recommended starting with an existing display of "Avon's contributions to victory," toiletry kits produced under contract with the U.S. military during World War II.[50]

Avon then asked representatives to donate vintage cosmetic packaging, especially materials predating the 1930s, from their own collections and those of their clients. While the company simply requested "the name of the person who bought [the product], the approximate date of the purchase and any remarks that would prove of interest from an historical standpoint," representatives made particular note of the personal and professional relationships behind the sale and use of items.[51] Because the vintage items they collected from customers typically preceded their own Avon employment,

correspondents traced the genealogy of the sales markets they inherited. Letters recorded the names of former sales representatives and described their familial and community ties. These details produced complex narratives of intergenerational collaborations between customers and sales representatives and of individuals' transitions between Avon consumption and sales. From Federalsburg, Maryland, Mrs. J. D. Johnson reported that she had no "old boxes or bottles" to offer, but she recounted that she bought California Perfume Company products from that region's "first saleslady," quickly becoming the "second agent" herself.[52] Carrie Abbott, a former representative, wrote to Avon executive Henry Bachler, explaining that "Mrs. N. E. Phillips, a friend of mine, also your agent in Norfolk, Virginia handed me your letter asking if I had any of the California Perfume Company Products prior to 1929. She was a customer of mine when I was your agent several years ago." Abbott continued, describing her 1905 initiation as a California Perfume Company (CPC) representative after health problems afflicted her mother, whom she identified as the area's first agent.[53]

Many donations came with historical annotation from the donor as well as the agent sending the artifact, their letters far surpassing the details requested by the corporation. One customer supplemented a "package containing powder, coloring set, and Spots out cream" with portrait photographs of herself and with a letter from her daughter-in-law, former CPC representative Cora Wallick Shambarger. This testimonial documented the personal significance of Avon sales work. Shambarger detailed her success selling CPC products in rural Ohio, recalling that the profit allowed her to attend the 1904 World's Fair in St. Louis. She then noted her reintroduction to the company in 1929 after her "daughter bought a bottle of perfume from Mrs. Northway" with a fragrance reminiscent of "something of long ago." Finally, Shambarger identified herself as a loyal customer of her current sales representative, Mrs. Gebs. In turn, Gebs's cover letter to Avon praised Cora Wallick Shambarger as "the Mrs. Shambarger who sold Avon when she was a young lady—who was most helpful to me in the beginning of my 'Avon Career' as it was all so new to me at that time and has been a customer ever since up to the present time."[54] Such remarks cast women's collaborations as central to the persistence of the Avon brand. While the company's request focused on products, responses deployed these objects as markers of customers' and employees' intertwined professional and personal histories and of the significant overlap between consumption, work, and mentorship.

By soliciting contributions to the museum, Avon underscored assertions in its advertisements that American women shared a tradition of actively maintained beauty. Complementing this strategy, donors emphasized their

sentimental attachment to the products. One agent sent a can of talc, likening its persistent fragrance to her vivid childhood memory of the can's place on her mother's dresser.[55] Another donated a glass bottle she received around 1906 from her aunt, a CPC agent. She explained, "While a 'treasure' from childhood, I am glad to now pass it back into its 'family' and hope it is usable in the Museum."[56] Further demonstrating such intergenerational ties, another contributor revealed that many of her own customers had previously sold Avon products and that she planned to ask them for items that may "have been handed down from mother and grandmother."[57]

Contributors also reported that they had already been treating the products as artifacts of Avon's history. One district manager wrote that many of the sales representatives she oversaw "delight[ed] in bringing [old CPC/Avon products] out" even before the museum collection campaign began; these objects demonstrated employees' status as "old timers."[58] Similarly, one sales representative reported a customer's eagerly "showing me some old relics, just the very day before I received your interesting letter about collecting these."[59] Florence Kohli, a sales representative, reflected on the promotional value of such interactions. Seeing the products a woman kept brought insight on her preferences, and the juxtaposition of old and new products gave saleswomen the opportunity to "explain improvements."[60] The company had not recommended this specific pitch, so such responses suggest variability and creativity in individual women's deployment of the past to promote Avon.

These letters reveal that the connection between objects and history was not merely imposed from the top by corporations and advertisers. Women had retained products, associating them with memories of service on Avon's sales force and with beloved family members. They described participation in the museum's collection as a way to introduce the company's history into the nation's larger public memory. Kohli praised the museum as a "wonderful project" which "bring[s] to my mind many happy hours I spent in [the] 'Field Museum,' Chicago."[61] Writing on district manager letterhead, a woman from Arlington, Virginia, envisioned the Avon museum as a capitalization on public interest in the past that would honor the company and its employees. She explained that she "would like to be able to walk into a museum of our own," while observing, "as you know Washington D.C. and sections of Virginia thrive upon things of this type."[62] Imagining the repository as a parallel to esteemed public institutions, agents predicted that it could demonstrate the company's growth, and then provided evidence to document their own places in this history.

Between 1941 and 1945, Avon's promotions had evolved from celebrations of the "spirit" of the past to educational biographies on women's history. By

1945, the archiving of modern women's experiences also assumed a place in the company's public identity. Applying their own models of Avon history, sales representatives added to advertisements' celebration of the beautifying functions of cosmetics. As they collected artifacts and sent them to corporate headquarters, their narratives broadened the company's definition of women's historical significance to include women's labor.

HISTORIES OF WOMEN WORKERS ON STAGE AND SCREEN

In the 1940s, Broadway and Hollywood also turned their attention to women's pasts. On screen, the popularity of historically themed musicals provided a platform for promoting iconic American corporations. Reworking familiar tropes from theater and film, MGM collaborated with the Fred Harvey Company, the restaurant and hotel chain, on *The Harvey Girls* (1946), a fictional history of waitresses from the late nineteenth century. Twentieth Century-Fox's *The Shocking Miss Pilgrim* (1947), a fictional story about office workers also from that period, provided publicity for typewriter manufacturer Remington Rand. Reconciling women's public roles with their family responsibilities, these two films framed corporate employment as a safe route to romantic fulfillment. At the same time, they dramatized stories of change, not only in the growth of the nation and its businesses, but also in gender roles. Proclaiming the importance of women's contributions, they encouraged a revision of historical narratives to include women workers. Initially developed during the war but completed and released after it ended, these films offered timely contemplations on the value of women's employment and on the compatibility of work and romance in women's lives.

The films reflected the evolution of the dramatic musical in the 1940s, as historical portrayals of everyday life defined a new era for the genre.[63] Film studios, producing new musicals and stage adaptations, drew inspiration from Broadway. Often cited as a turning point in the development of serious musical theater on stage, Richard Rodgers and Oscar Hammerstein II's *Oklahoma!* (1943) announced its innovation by beginning with a woman churning butter at the turn of the twentieth century.[64] The show gained notice for rejecting the tradition of glamorous opening dance numbers and presenting a story of nation-building that spoke to modern concerns: the effects of the Great Depression on the West and the importance of patriotic cooperation during World War II. Within the plot, women's contributions as domestic laborers and romantic partners helped the Oklahoma Territory meet parallel challenges.[65] *Oklahoma!* inspired subsequent Broadway musicals, with Rodgers and Hammerstein and the era's other major writers and

composers frequently turning to historical contexts. These stories celebrated women for diverse achievements, the common thread being women's power to affect society through their influence on men. In Harold Arlen and E. Y. Harburg's successful *Bloomer Girl* (1944), the title character promoted feminism and abolitionism in 1861 New York. Her love converted a slaveholding Confederate to the Union cause, presented as an important victory for democratic human rights.[66] The popular *Annie Get Your Gun* (1946), inspired by late nineteenth-century sharpshooter and entertainer Annie Oakley, assumed that good women could possess skill and ambition along with femininity, but that they should prioritize the desires of the men they loved.[67] Scholar Andrea Most interprets composer Irving Berlin and playwright Dorothy Fields' narrative as a metaphor for modern women's sacrifice of their wartime employment for returning male veterans.[68] *The Harvey Girls* and *The Shocking Miss Pilgrim* offered a different perspective, crediting women's corporate employment for advancing settlement in the West, women's rights, and romantic fulfillment.

THE HARVEY GIRLS

Filmed during the first half of 1945 and released early in 1946, *The Harvey Girls* celebrated business for the opportunities it provided women to shape society and to bring material comforts to the frontier. It portrayed women's employment as waitresses as a natural extension of their domestic roles.[69] The studio originally acquired Samuel Hopkins Adams's novel *The Harvey Girls* as a dramatic project, potentially starring Clark Gable and Lana Turner, before transforming the material into this starring vehicle for Judy Garland, capitalizing on the ascendance of movie musicals as Hollywood's dominant genre. The resulting romance narrative, set in 1890 Sandrock, New Mexico, emphasized that femininity would prevail even in the Wild West. The movie proved profitable, one of the highest earning of the year.[70]

The Harvey Girls reworked conventions of the historical film drama, a genre typically focused on men, by inserting women's handiwork into the story of national progress. Emphasizing the movie's basis in historical research, the film opens with printed text thanking the Fred Harvey Company for providing information.[71] A lengthy legend superimposed on the screen then applauds the restaurant chain's expansion along western railway lines for bringing "one of the first civilizing forces this land had known—THE HARVEY GIRLS." These employees "conquered the West as surely as the Davy Crocketts and the Kit Carsons—not with powder horn and rifle, but with a beefsteak and a cup of coffee."[72] The film closes with a title card proclaiming,

"To these unsung pioneers [the Harvey girls], whose successors today still carry on in the same tradition, we sincerely dedicate this motion picture." The formality of these statements positioned the movie as an entry in Hollywood's historical canon. Scholar J. E. Smyth argues that filmmakers used intertitles in historical dramas produced between 1931 and 1942 to establish the screen as a legitimate forum for recording history. According to Smyth, Hollywood styled itself as an authority on the past in order to bring prestige to movie studios. Textual declarations suggested that movies offered objective, definitive histories.[73] The Harvey Girls then used this established device to assert that women merited serious recognition for their historical significance.

This commendation supported the Harvey Company's own promotional strategies for its dining cars, restaurants, and hotels. During World War II, executives had shifted away from marketing focused on tourist destinations and began to celebrate waitresses as the embodiment of the company.[74] Wartime advertisements commended these "patriotic women" for boosting the morale of traveling GIs, drawing parallels to the tradition of service established by the company's original female employees.[75] Similarly, in the months leading up to the film's release, the Harvey Company placed advertisements in Life magazine that asserted modern Harvey Girls' identification with this past and their eagerness to see it portrayed on screen. Illustrations of modern waitresses accompanied proud first-person reactions to the creation of a "movie about US"—one that acknowledged that "wherever we went the rugged frontier blossomed with new homes and wholesome communities."[76]

The film itself characterized these early Harvey Girls' public service as a function of women's innate domesticity and morality. The plot focuses on residents' resistance to the company's latest outpost, with customers and workers at the Sandrock saloon and gambling hall initially fearing the waitresses' civilizing influence. These women persevere by tenaciously defending their company (Judy Garland's character, Susan, politely brandishes pistols to reclaim steaks stolen from the restaurant) and winning men over with romantic love. In the film's closing scenes, the displaced Harvey House (destroyed by arsonists before its ultimate acceptance by the larger community) takes over the saloon, its decorative statues of nude women now outfitted in gingham. Aware that Sandrock can no longer support their work, the saloon's showgirls (and implied prostitutes), relocate to Flagstaff.[77] Susan marries her former adversary: Ned, the saloon owner. Highlighting the significance of such change, Decca Records' promotional material for the soundtrack album proclaimed this the story of "a revolution."[78]

Throughout, it is the Fred Harvey Company that enables these social and personal triumphs. Susan first travels to Sandrock to marry a man who had

advertised for a wife. Realizing upon her arrival that her intended husband had misrepresented himself, Susan finds refuge with the Harvey Company, joining the team of employees who had arrived on the same train. In the musical number "It's a Great Big World," Susan and two other Harvey waitresses advance the film's portrayal of the company as a protector of unmarried women. Each character confesses to personal deficiencies that have prevented her from finding a mate. Susan confides that buying a "bonnet to suit [her] face" and wearing her "petticoat trimmed with lace" could not give her enough confidence to meet the "cold, cold, cold" world. Alma reveals anxiety about her appearance as she responds, "I learned to sew and I learned to bake. / I even frosted an angel cake. . . . I thought by learning each social grace, / Some likely chap might forget my face. / I can't understand it, I've knitted and purled. . . . Alas and alack it's a great big world." In the song's third verse, Deborah admits her inability to cook, but wonders at the failure of her beauty and dancing skill to bring a "prince charming."[79] These lyrics demonstrate the characters' struggles to meet all the ideals of womanhood simultaneously. Rather than dismantling these expectations, however, the film proposes service to the Harvey Company as the solution. Each of these women ends the film having gained the appreciation of the Sandrock community for her work as a Harvey employee, and having gained a romantic partner in the process.

THE SHOCKING MISS PILGRIM

Like *The Harvey Girls*, director George Seaton's *The Shocking Miss Pilgrim* presented a corporation as central to history and to feminine personal fulfillment. While doing so, it celebrated suffragists' feminism for expanding women's access to corporate employment. Married screenwriting team Frederica Sagor Maas (1900–2012) and Ernest Maas (1892–1986) sold the story to Century 20th-Fox in 1939 and completed the dramatic screenplay in 1941, using the 1873 invention of the typewriter to narrate women's entry into office work.[80] In their original scenario, when the heroine's presence causes a violent romantic rivalry in the workplace, the resulting murder trial becomes a referendum on women's rights, drawing intervention from movement leaders, including Susan B. Anthony.[81] After the studio rejected this "Miss Pilgrim's Progress" script as trivial "Americana," Twentieth Century-Fox head Darryl Zanuck resurrected the project years later as a vehicle for studio star Betty Grable. The final script, revised by Seaton, also transformed the Maases' story into a platform for the music of George and Ira Gershwin: Ira contracted with Twentieth Century Fox to develop songs and the score out of incomplete, previously unpublished work from his celebrated partnership with his late

brother.[82] The movie omitted the murder plot, but the title character's entry into women's rights activism still drove the narrative. While Frederica Sagor Maas later criticized this final product for simplifying her original intentions, the film nevertheless champions feminism, providing a rare postwar celebration of a woman who prioritized her career.[83]

The final cut of *The Shocking Miss Pilgrim* melded the original script's feminism with the promotional strategies of typewriter manufacturer Remington Rand and the Hollywood studio system. Remington Rand provided Seaton and Twentieth Century-Fox with historical materials and artifacts, and the resulting film elevated the typewriter as a historical milestone. Text introducing the film presents this technology as the third engine of emancipation in the nation's history: "On July 4, 1776, men became free. On January 1, 1863, slaves became free. On June 10, 1874, women became free, or at least independence winked at them for the first time. Not because Congress passed a law, but because of the newly invented typewriter which was called most impractical,—and a handful of daring young ladies who were called—any number of things." In spite of its playful explanation that women merely experienced a "wink" from independence, *The Shocking Miss Pilgrim* nevertheless cast women's presence in the workplace as a clear sign of progress, mocking the nineteenth-century controversy that it provoked.[84]

The film presents protagonist Cynthia Pilgrim's employment as her pathway to romance, professional fulfillment, and meaningful activism. The opening scene shows her graduation at the top of her coed Packard Business College typewriting class. At the ceremony, the faculty speaker explains that female graduates face a particular responsibility in promoting "the future of this newly invented machine," for "until now, the business world has been a man's world." The next speaker, an agent of the Remington typewriter company, provides job placement for each graduate, prompting Pilgrim's journey to Boston to join the Pritchard Shipping Company. John Pritchard, the young heir to the family business, initially objects, having assumed that "all expert typewriters were men," a policy that Pilgrim criticizes as "old-fashioned." However, Pritchard's Aunt Alice, the owner of the business and a suffragist (in her first scene she is identified as a friend of "Mrs. Stanton"), demands that the company hire Pilgrim.

Initially, Pilgrim faces derision from the all-male staff for embracing stereotypically female behaviors: cleaning the workspace and shopping during her lunch hour. She ultimately wins them over by joining in their laughter, demonstrating her proficient typing, and being beautiful. In a nod to Betty Grable's fame for her legs, the camera portrays Pilgrim's first day at the office through lingering shots from the perspective of male co-workers secretly

watching her operation of the typewriter foot pedals. John Pritchard decides to make Pilgrim a permanent employee, and to pursue her romantically, after spying her legs when she lifts her long skirt to inspect a run in her stocking.

Meanwhile, through Alice Pritchard's influence, Pilgrim quickly becomes a central figure in the local women's rights movement. Activists eagerly embrace her criticism of their current tactics: "You can't gain equality with brass bands and speeches. Women have got to earn equality. That's why I became a typewriter: to show men that women can do men's work." Pritchard, hearing Pilgrim speak, cites her prescription of open communication between management and female employees as an excuse to ask for a date. During their courtship, he humors her activism by going along to suffrage meetings, and Pilgrim softens her personal rules against dating a boss and dining unchaperoned with a man, actions she feared would invite public scorn.

After his marriage proposal, however, Pritchard expects Pilgrim's activism to stop. While he argues that complete devotion to home is a female "duty" abandoned by "old maid" suffragists, she cites her commitment to women's rights: "But why is it always the woman who has to change her way of living and thinking? . . . Equal rights is not a habit like biting your nails. It's a principle, and you don't give up principles overnight. In the last three months I persuaded over four hundred women to get jobs and go out and work. I've convinced them that it's the only way to achieve equal rights." The engagement, and Pilgrim's post with the Pritchard Shipping Company, ends over Pritchard's objection to married women's employment.

The film introduces Pilgrim's replacement by showing disappointed office workers staring not at Betty Grable's legs but at a scrawny young man's red socks, exposed as he operates the machine's foot pedals. Unhappy with the performance from a succession of new hires, Pritchard concludes that the typewriter is "just not a man's machine." Reflecting his expectations, he also rejects a series of efficient but unattractive female secretaries. In the film's final scene, he goes to the Boston Academy of Typewriting's placement agency. His intake interview, which includes questions on the suitability of married women for employment, leads him to admit that women have a right to work and to express themselves freely, and then to realize that Pilgrim, as the agency's manager, created these questions. Pritchard rushes into Pilgrim's office, prompting her to declare that she knew he would come to accept her way of thinking. As in other contemporary musicals, the resolution highlighted a woman's effect on a man; however, *The Shocking Miss Pilgrim*'s celebration of feminism's triumph was unique.

The film received negative reviews, which described the performances and score as weak. Ticket sales were modest.[85] Nevertheless, the movie

had substantial press coverage, stemming from Betty Grable's position as the top female box office draw and from Remington Rand's collaborations with Twentieth Century-Fox.[86] The typewriter manufacturer held approval rights over each component of the film's publicity campaign, seeking to glorify its current products by aligning Grable's character with contemporary office workers.[87] The studio provided Remington Rand with poster prints of Grable's character, seated at "the first typewriter," along with parallel images of Grable dressed in modern clothing using the company's current model.[88] Local Remington sales divisions distributed them to movie theaters and department stores, which featured elaborate displays, contests, and events to promote the film.[89] A ten-day Fresno, California, competition to identify the city's fastest typist made direct links between the historical film and contemporary career proficiency, as contestants competed for the new typewriter prize in a lobby display of old and new models.[90]

Remington Rand adapted its long-standing promotional strategies, which paralleled the film's celebration of women's entry into business, to this new multimedia event. A booklet that had been published in 1933 for typing teachers and students featured an illustration of a nineteenth-century woman operating the first commercial typewriter, proclaiming that "women were freed" and given "their first real chance to enter business" with this invention.[91] *Shocking Miss Pilgrim* campaigns echoed this characterization of the typewriter as a revolutionary force in women's history. Twentieth Century-Fox submitted a narrative for syndicated writer and broadcaster Walter Winchell, proclaiming that the invention of the typewriter "brought women into the bizness world and started the suffragette movements in this country."[92] A print advertisement for the 1947 Remington model likened Grable's 1873 character to her modern-day counterparts. Before describing the efficiency of Remington's modern technology, the advertisement celebrated women's essential contributions to "the office as we know it today."[93]

Remington publicity materials, like Twentieth Century-Fox's film, applauded the first female typist as a daring, shocking disruption who won women a place in public life. The company contrasted nineteenth-century men's closed-mindedness with secretaries' full integration into the twentieth-century workplace. However, *Shocking Miss Pilgrim* promotions left radical change squarely in the past. On the cover of Remington's *Memo: How to Be a Super Secretary* educational pamphlet, illustrations of nineteenth-century placard-carrying women activists provided the background to a contemporary photograph of Betty Grable.[94] These drawings replaced the women's suffrage placards featured in the film with the proclamation "MY BOSS—RIGHT OR WRONG," carried by one woman and causing another to hold her hand

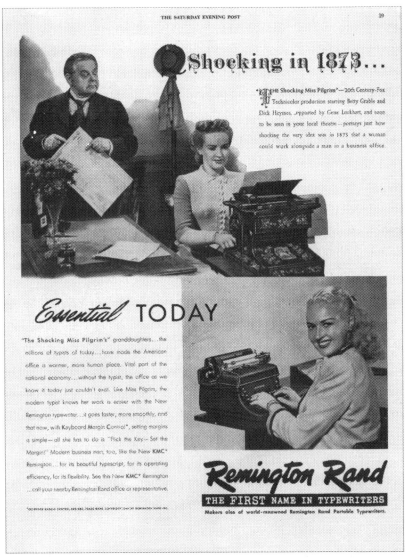

Figure 5.3. Capitalizing on *The Shocking Miss Pilgrim* film, Remington Rand advertised typewriters with a celebratory history of women workers. *Saturday Evening Post*, January 4, 1947.

to her mouth in an expression of shock. A Milwaukee movie theater lobby display created by local Remington offices featured signs reading "My BOSS RIGHT OR WRONG" and "My BOSS THE WORLDS BEST," as costumed models sat at typewriters from 1873 and from the present time.[95] Recasting secretarial employment and deference to male authority as the goal of women activists, these promotions portrayed contemporary business as a triumphant end

point for feminism. Simultaneously, Twentieth Century-Fox and Remington Rand ultimately portrayed females' contributions to business as crucial, but as supportive rather than transformative.

Nevertheless, along with the clear influence of Twentieth Century-Fox's efforts to promote Grable's star persona and of Remington Rand's efforts to promote its brand, the film also preserves the voice of screenwriter Frederica Sagor Maas. Maas's own life story, as recorded in her 1999 auto-biography, has many parallels with the onscreen experiences of Cynthia Pilgrim. Maas explains that she worked as the first female "copygirl" at the *New York Globe*; relished shopping on her lunch hour; met her husband through work; and faced resistance and dismissal of her abilities during her early film career, as she advanced from secretary to screenwriter in the 1920s.[96] Providing insight into how and why the Maases' script would turn to historical film to dramatize these experiences and promote feminism, she recalls the influence of trailblazing women and of dramatic entertain-ments on her own mindset. As a child, young Frederica Sagor admired women who transgressed social norms. Her childhood doctor, Eva Dembo, inspired her to pursue college education.[97] Maas praises her New York City public school history teacher as the greatest inspiration for her ultimate career in film. Miss Lillian Vion took students to see D. W. Griffith's histori-cal Civil War and Reconstruction epic, *The Birth of a Nation* (1915), a story that captivated the teenage Frederica. After collecting the students' written reactions to the film, however, Vion debunked Griffith's sentimentalization of southern slavery and the Klan, a lesson Maas credits for teaching her the importance of critical thinking.[98]

During her own Hollywood career, Maas embraced the medium as an outlet for serious reimaginings of the past. Contemporaneous with the writ-ing of Cynthia Pilgrim's story, she and her husband spent five years on a love story about the photographer Mathew Brady, before failing to sell it in 1946.[99] Executives dismissed its Civil War setting after the failure of several *Gone with the Wind*–inspired films. Maas, however, later characterized her script, not as an effort to capitalize on Scarlett O'Hara's popularity, but rather as "a chance to reflect on past mistakes when rebuilding a nation after a war." To illustrate these serious intentions, Maas in her memoir describes Ken Burns's 1990 public television documentary series, *The Civil War*, with its cinematic use of archival photographs, as "the reenactment of the Civil War as Frederica and Ernest Maas had envisioned it fifty years before."[100] Even after the failure of the Brady project, the Maases developed new ideas for historical films, including a biography of Susan B. Anthony with roots in the research con-ducted for the Pilgrim film. This project never came to fruition. Bankrupt

and placed on the Hollywood blacklist as accused Communists, the Maases left the industry, and Frederica built a new career, beginning as a typist at an insurance office and rising to the position of broker.[101]

Unsurprisingly, *The Harvey Girls* and *The Shocking Miss Pilgrim*, films with corporate ties, emphasized the compatibility of paid employment with accepted gender norms, as well as the power of employment to improve women's lives. Echoing the themes of 1940s advertising, the films celebrated corporations' ability to employ women in service of national progress while letting them continue their ostensibly natural civic and familial duties. Nevertheless, the endorsement of women's employment for its personal, corporate, and national benefits—beyond the context of wartime crisis—was notable. This was a different focus from that of wartime government propaganda and corporate advertisements that anticipated the peacetime return of soldiers to their jobs and women to their kitchens. It also departed from postwar magazines, medical manuals, and films that prescribed women's complete devotion to the home. Accompanying the rising marriage and birth rates of the "baby boom," late-1940s films with modern settings cheered women for settling into the cultural norms of female domesticity and provided film noir cautionary tales dramatizing consequences for deviance.[102] Set safely in the past, however, *The Harvey Girls* and *The Shocking Miss Pilgrim* sympathized with those who challenged their eras' social norms by pursuing careers. By emphasizing women's presence in the workplace, they actually mirrored modern women's experiences in a way that depictions of the present day—which rarely celebrated, or even portrayed, female protagonists who successfully prioritized their careers—did not. Despite popular ideology and hiring practices that limited women's opportunities, 1947 began a sustained period of increases in women's work outside the home.[103] Nevertheless, while trumpeting women workers' historical significance, these two films still assumed the importance of romance and family in women's lives, and they celebrated women's employment in service and clerical positions—fields that had, by the 1940s, long been categorized as women's work. They portrayed benevolent corporations, sidestepping historical and modern labor feminists' concerns with employment and compensation practices.[104] However, they cast women's employment as a triumphant, permanent result of progress.

THE LEGACY OF DOMESTIC LABOR

While depictions of women's employment focused on change, World War II popular culture portrayed the history of the American home as a story of stability and tradition. Advertisements for culinary products celebrated familial

and patriotic heritage to assert that consumer goods would help modern women honor the legacies of women who came before them. Many promotions assumed women's persistent devotion to domesticity, in spite of the labor-saving potential of new household products and the wartime increase in women's wage labor. These campaigns often emphasized the unique influence that women's traditional domestic roles could exert during wartime. Alternatively, some companies claimed that time-saving food products were just as good as traditional homemade food, thus excusing consumers for devoting less time and effort to cooking—as long as they selected the proper brand.

These campaigns had legacies of their own: corporations had long promoted products by claiming approval of "mother" and "grandmother." Many national brand logos featured anonymous maternal figures, sometimes in historical dress.[105] As historian Katherine Parkin demonstrates, images of grandmothers wearing glasses and aprons and flanked by children recurred in food advertisements throughout the twentieth century. Marketers sentimentalized these characters' hard work to exploit consumers' anxiety about contemporary change, positioning food products as solutions to nostalgia.[106]

This strategy flourished during World War II, with historical settings providing a model for contemporary women's vigilant maintenance of domestic traditions under disruptive conditions.[107] A recipe book from 1944 that was provided free to consumers with a magazine advertisement's mail-in coupon commemorated the Pillsbury Flour Mills Company's seventy-fifth anniversary by tracing the experiences of "your pioneer grandmother and mine" on the western frontier.[108] The cover imagery replicated the look of a handmade patchwork quilt, with squares bearing silhouettes of a woman in elaborate nineteenth-century dress, a steamboat, a covered wagon, a butter churn, a rolling pin, a stove, and an open hearth. These visual emblems of the pioneer woman's experience stressed her idealized beauty; the physical labor her domestic work required; and the larger narrative of American technological progress, embodied by the transportation that had brought her to the frontier.

Balancing the quaint familiarity of domestic imagery with applause for women's "courage" on the treacherous overland trail, the book identifies "the job of keeping the family fed" as American women's most persistently difficult task.[109] Episodes in a nineteenth-century woman's life story, from young motherhood on the frontier to grandmotherhood, introduce the recipe categories. Illustrations dramatize her familial role: she wears a modest brown dress and cradles an infant who is obscured by a colorful wrapped blanket. Behind her stands a man, hands on hips, as they both look into a nighttime sky. His greater height and his pose, filling space with a wide

stance, symbolize the traditional male role of family protector, while the woman holds direct responsibility for their child.[110] Nevertheless, while visually stressing the difference between men's and women's roles, the text credits the entire family as "stalwart pioneers" who "transform[ed] a vast wilderness into a great United States."[111] Simultaneously, Pillsbury praises the pioneer woman's sacrifices by emphasizing that the frontier introduced new challenges. The legend accompanying the recipe for "Pillsbury's 75th Anniversary Cake" dramatizes a grandmother's endurance after "Indians swooped down and destroyed the whole village," as she "dragged her little iron stove from the smoldering ashes, set it up on its feet and fed it wood from the wreckage of her home." As Pillsbury's journey through American history progresses, the grandmother instills the importance of such hard work in younger generations. The narrative of World War I celebrated the work of "farmers and millers . . . to keep the world supplied with bread," attributing equal significance to "Grandmother, already a veteran of another war . . . up at five to feed the family, off to the Fire Hall to make surgical dressings, dropping a letter to Jimmy—fighting in France—on the way. But her biggest job, these crowded days, is to help the younger women make use of the foods allowed them and get the most out of them."[112]

Placing the company itself in this story, the book describes the delight of western pioneers at the establishment of Pillsbury mills. The chronicle culminates with contemporary women's appreciation of Pillsbury products, as the company's scientific experts provide new information about wheat's nutritional value to their long-standing customer: "Grandmother is a little old lady now, and as she sits enjoying her afternoon coffee and sandwiches she remembers her little iron stove and the tiny hand mill. Seeing her bag of flour in the cupboard, with its familiar 'XXXX' on the label—and now with the new word 'enriched'—she thinks, 'What a long way we pioneers have come together—and what an exciting future lies ahead.'"[113] Significantly, Pillsbury's trademarked XXXX logo inspires this reflection: the company thus presented itself as a partner in women's historical achievement and as a sentimental reminder of the past.

Such promotions asserted that corporate brands had long shaped women's work. However, the growth of the dry goods industry in the mid-1940s signaled changes in the modern kitchen. Market research compiled by *McCall's* magazine cited a 230 percent increase in sales of prepared baking mixes between 1942 and 1946. This report argued that wartime rationing and women's employment suddenly made female consumers more amenable to products that had been marketed nationally since the 1920s.[114] Casting prepared mixes as a patriotic, frugal choice, some companies encouraged women

to embrace these tools as they expanded their roles outside the kitchen. The inventor and entrepreneur Charlotte Cramer Sachs (1907–2004) promised that women could still honor tradition while relying on time-saving products when promoting her new 1942 Joy line of cake and muffin mixes, initially available at Wanamaker's, B. Altman & Co., and Gimbels department stores in New York state, and sold nationwide by 1944.[115] One promotion exclaimed, "There's nothing quite comparable to JOY MIXES in possessing THAT HOME-MADE TASTE and FLAVOR—just 'LIKE THE KIND that MOTHER BAKED'!"[116] Newspaper advertisements for the product featured white backgrounds and women rendered as black silhouettes, preparing food on modern appliances. This imagery mixed the nostalgic visual cue of the silhouette style with allusions to modern efficiency.[117]

Cramer Products also gestured beyond familial history to the larger national story: a line of Early American Muffin Mix packages touted "Early American Flour" as an ingredient.[118] On the packages, this ingredient was not defined; the suggestion was that an authentic piece of the past was incorporated directly into the product. A printed sales pitch to store owners described the manufacturing process, asserting that modern Joy mixes contained the power of traditional labor, even though the consumer needed to only add water and bake.[119] Early American Flour came from grain "milled by the old STONE GRINDING method in a century old mill, operated by water power as by our forefathers, so as to preserve and retain all the essential VITAMINS as nature gave them to us for our well being."[120] Like Pillsbury, Cramer likened the careful selection of modern brands to the care women's ancestors devoted to nurturing their families.

In its 1940s campaigns for adoption by retailers, Cramer Products emphasized this logic that labor came packaged inside the Joy mixes, thus "sav[ing] time and work for the homemaker or business woman." One headline promised, "Our Work, Your Family's Delight," and consumer participants in a 1947 Joy Prepared Mixes survey echoed these selling points in describing the products' value.[121] One woman remarked, "The Joy cake mix is a wonderful time-saver," while another confided, "My family enjoyed your prepared cake better than my own home made."[122] Another consumer explained that she planned to keep a package on her shelf in case of emergency, though clarifying, "I am still old-fashioned enough to like to mix my own however."[123] In such cases, postwar women differentiated brand consumption from productive labor; a cake baked with a mix did not qualify as "my own."

In the 1950s, Cramer's larger competitor, General Mills, answered such concerns, arguing that its Betty Crocker mixes produced superior cakes because the baker mixed in a fresh egg by hand. General Mills consultant

Dr. Ernest Dichter advocated this as a psychological appeal to women's guilt about the convenience of mixes that required addition of water only.[124] He argued that modern efficiency-minded consumers "look back with nostalgia at the days when things were done for you with thoughtfulness and care. The long hours that our mothers used to spend in the kitchen signified to us how much she loved us."[125] By referencing history, 1940s promotions for Joy mixes had proposed a different connection between the present and the past, one that avoided the notion that the amount of time and effort women spent in the kitchen was paramount. Cramer advertisements asserted that, even if women used a pre-made mix to bake muffins after a day of paid labor, their discerning selection of Early American Flour lived up to previous generations' standards for household work.

TRADITION AND THE CREATIVITY OF THE CONSUMER'S LABOR

Throughout the twentieth century, popular culture elevated consumption to the status of a timeless calling, justifying modernization by highlighting the creativity and care involved in product selection. Product packages and designs often evoked traditional handiwork to signal their worthiness to discerning consumers, adapting the style of needlepoint and quilting into new forms. Manufacturers applied these decorative touches to products promoted as indulgences for female consumers. For example, logos on the paper wrappers of Lux soap, which was marketed in the 1930s and 1940s as a luxurious beauty aid, featured a cross-stitch pattern.[126] The Lux bar within bore imprints echoing this imagery.[127] Because these were clearly not historical replicas but rather translations enabled by modern production methods, such items evoked the familiar while simultaneously highlighting changes wrought by industrialization.[128] No longer the effect of an individualized educational tool or a practical method for identifying ownership of household linens, needlepoint sampler imagery had become entirely decorative and sentimental.

By the 1940s, national brands also promoted reverence for earlier eras' domestic production as a time-consuming demonstration of women's devotion to family.[129] Advertisements urged consumers to incorporate the aesthetics of spinning, needlepoint, cross-stitch, and quilting into their daily lives, often asserting these styles' links to idealized maternal figures. For example, General Mills promoted its Gold Medal Flour with a recipe for a "Calico Quilt Cake." In a 1940 magazine ad, the Betty Crocker promotional character placed this dessert, iced to look like a floral quilt, in the context of the generational evolution of women's work: "Your great-grandmother wore 'sprigged'

calico in dresses—your grandmother pieced it into quilts—You may have a full-skirted evening dress in this pattern. . . . *Now you see it in a gay cake!*"[130] With recipes for this and other "Creations" in each package, the brand offered access to the idyllic past. Although the advertisement stressed the convenience of scientifically developed flour, the cake's elaborate decoration manifested the devotion to domestic service shared by contemporary home-makers and their ancestors. The modern consumer may not have adapted old clothing into useful quilts, but she could still honor the past with her careful brand selection and food preparation.

Household product designs also adapted historical aesthetics in ways that dramatized the transition from production to consumption in women's labor. Rather than reproducing antique plates, the Salem China Company used decals featuring historical scenes to decorate its low-cost dinnerware lines. Salem advertised these products to middle-class audiences in national women's magazines. The company distributed to independent and chain grocery stores, as well as to movie theaters, hardware stores, and drugstores that used the china in giveaways.[131] The Colonial Fireside line, introduced in the 1930s and sold throughout the 1940s, pictured a hearth, spinning wheel, and cradle.[132] Print advertisements praised this scene as expressing one of the "oldest and most cherished traditions of American life." However, the accom-panying photographs of Salem's plates, cups, and serving dishes—pictured in otherwise authentic Colonial Revival homes, decorated with hooked rugs and candlesticks—highlighted the differences between past and present. Women no longer cooked daily meals over the hearth, but the selection of these nos-talgic products was now encouraged as part of their familial labor.[133]

The company's popular petit point lines, which adapted the look of needlework into two-dimensional form, also emphasized the aesthetic value of old-fashioned labor. Even the illustrations in small black-and-white print advertisements rendered the designs so that individual "stitches" were vis-ible.[134] As one promotional brochure claimed, the "quaint old-fashioned" image of a floral bouquet adorning plates and cups in the Basket Petit Point product collection was "just as fresh in color and dainty in detail as the work in Grandma's sewing basket."[135] The product thus urged nostalgia for fad-ing domestic traditions, simultaneously highlighting differences between past and present. While the petit point design suggested homemade work, grandmother never actually embellished china serving ware with needle and thread.

Consumers could respond creatively to these nostalgic household com-modities. During World War II, Nebraska wife, mother, and former teacher Grace Snyder (1882–1982) adapted the Salem China Company Basket Petit

Point pattern, producing an elaborate, 85,789-piece quilt over a period of six-teen months as a gift for her husband.[136] While the Salem plate that inspired her used a single decal to represent multiple stitches, Snyder's adaptation required an even more complex process than embroidery. She used small triangular pieces to represent the individual stitches pictured on the china design. Snyder also made original decorative quilts, narrative quilts depict-ing American and Nebraskan history, and functional work produced for wartime drives and charitable causes, but her "petit point" quilt received the most acclaim, winning multiple exhibition prizes in the late 1940s, appearing in *McCall's Needlework* magazine in 1947 and entering the Nebraska State Historical Society's permanent collection.[137]

Salem sent Snyder complimentary petit point dinnerware and incorporated her story into its promotional strategy.[138] Newspaper articles publicized her success with dramatic accounts of a nineteenth-century frontier childhood—echoing familiar commercial celebrations of pioneer domesticity—that she later debunked in her memoir. She recalled that one account "had me piecing my first doll quilt while on the way to Nebraska in a *covered wagon* at the age of *three*. Another had me carrying my little box of quilt pieces and herding cattle on the prairie, while still in danger of having to run for my life from the Indians."[139] Such articles emphasized Snyder's family-centered labor, but her quilting virtuosity also brought her unique recognition as an artist.

Although she had copied German artist Wendelin Grossman's original design for the Salem China Company, press coverage gave Snyder creative credit.[140] Before allowing Salem to reproduce a magazine photograph of the quilt in its dinnerware mailings and promotions, the McCall Corporation required Snyder's permission. Both Grossman and Salem accepted the logic that Snyder had produced something admirably original.[141] Grossman wrote her a letter about the artistic work ethic that linked her quilting and his painting career: "I was astonished to hear that the design having been so much in favor of the Salem China Co., was even used for a quilt. The work must be wonderful and I only admire your patience and troubles and I understand quite well that you are proud of the great success in the exhibi-tions. This being a pleasure for me too, hearing that with my design so many nice things arose. It will encourage me to go on working and to create many good ideas. . . . It is astonishing that men, being so far off from each other, get acquainted by a chance and this time by our work."[142] Addressing Snyder as a peer and repeatedly classifying her quilt as "work," Grossman found art in domestic tradition and in consumption, minimizing the role of gender in determining individuals' abilities. Like descriptions by Avon consumers and workers of the packages they kept to commemorate the past, Snyder's story

provides a rare window onto women's use of products to commemorate the past and to refocus popular histories on actual women's labor rather than on abstract corporate innovation.

TRANSLATING HISTORICAL DOMESTICITY
FOR THE 1950S CONSUMER

In the 1940s, advertisements applied familiar colonial and nineteenth-century archetypes to their prescriptions for female wartime and postwar sacrifice. Corporations cast consumption as an inherited form of domestic and patriotic work, asserting continuity in women's devotion to family and nation. In the process, they defined their products as markers of historical progress and as spiritual links to the past. In the face of changes in women's employment, these promotions emphasized the continued importance of femininity. Yet, as reflected in the creation of Avon's corporate museum and Grace Snyder's quilt, employees and consumers could rework these themes, placing alternative emphasis on the creativity and individuality behind women's labor. Both perspectives, however—the one that emphasized corporate innovation and the one that emphasized consumer creativity—made the history of women's work a physical presence in consumer culture.

The portrayal of women's domestic labor as an important link with the past persisted in 1950s advertising. As historian Shelley Nickles has argued, decorative floral flourishes on household products were popular, particularly with working-class consumers whose purchasing power increased in the postwar economy.[143] Salem China strategized for this market by offering its Basket Petit Point pattern as a supermarket premium in the 1950s. Store displays featured the china as part of the company's budget Quaker Girl line: a drawing of a woman in profile wearing a traditional bonnet provided the only illustration on the cardboard display case, further emphasizing the product's link to an idealized past.[144]

Another of the era's popular products featuring needlework imagery was candy manufacturer Stephen F. Whitman & Son's Sampler box of chocolates, promoted in 1940s and 1950s magazines as a luxurious indulgence favored by women.[145] In publicizing this product, the manufacturer positioned itself as a curator of women's histories. First introduced in 1912, the package echoed stitches on a sampler owned by the company's president.[146] This legacy became an important part of the brand's identity. During the 1930s and 1940s, the Whitman company sent employees on collection trips to acquire historical samplers.[147] After World War II, the resulting archive was displayed in the flagship Philadelphia confectionery and in traveling exhibits.[148] Whitman

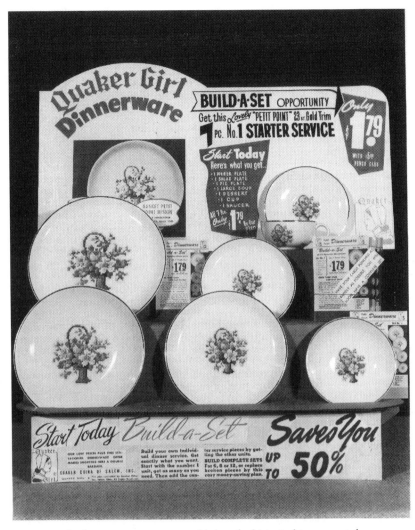

Figure 5.4. In the 1950s, consumers could shop for historical imagery at the supermarket. Photo of Quaker Girl Dinnerware store display featuring the Basket Petit Point pattern, Salem China Company Collection, Archives Center, National Museum of American History, Smithsonian Institution.

touted the value of these artifacts by praising women's domestic work and lamenting its absence in traditional narratives. Notably, Whitman's advertising agency, N. W. Ayer & Son, emphasized these themes with a special advertisement placed in the 1956 "golden anniversary" publication of Philadelphia admen's Poor Richard Club. Although the professional association's milestone also marked the 250-year anniversary of Benjamin Franklin's birth, the

contribution from Whitman and N. W. Ayer celebrated an obscure woman's history rather than focusing on Franklin.[149] The advertisement reproduces a large photograph of a framed sampler, its stitches rendering flowers, trees, a house, a man and woman in colonial dress, and a religious proverb. Likening this creation to the iconic work of the club's own mascot, the advertisement explains, "Poor Richard put his 'Sayings' in print . . . Little girls like Sarah Tripp spelled their pious mottoes out with needle and thread!"[150] Reflecting on this object's role in the historical record, the text continues, "We don't know much about Sarah. Whether her eyes were blue or brown. Not even where she lived. All we know is 'Her Work'—this quaint Sampler cross-stitched with the date, 1769. Perhaps she did her daily embroidery stint by the warmth from a Franklin stove!"[151]

This acknowledgment of the unknown Sarah Tripp parallels the efforts of women historians—decades before and after 1956—to preserve records of, and reassert the value of, women's work. For the Whitman company, however, such reverence for a historical woman was strategic. As the advertisement explained, the manufacturer had collected 650 samplers and exhibited them nationwide as examples of "early-American art."[152] Such celebration of domestic labor coincided with Cold War consumer culture's emphasis on women's domestic roles, and it bolstered the Whitman company's efforts to associate its mass-marketed products with the quality of homemade handiwork.[153] In 1969, Whitman's parent company, Pet Incorporated, donated the Whitman Sampler Collection to the Philadelphia Museum of Art. The artifacts were featured in prominent exhibits and eventually provided evidence for scholars and inspiration for feminist artwork.[154] After advertising campaigns had worked to assert the historical value of domesticity, such preservationist roles could further bolster a brand's image. In 1974, the Ladies' Home Journal pitched "museum sampler" embroidery kits to readers, crediting the Whitman Collection for a pattern design and promising, "You can stitch your own heirloom."[155] Popular culture thus positioned corporations as conservators of women's history whose efforts enriched modern women's lives. The next chapter will consider how this logic, most famously promoted in the Virginia Slims "You've Come a Long Way, Baby" campaign, intersected with feminist activism and writing from the 1950s through the 1970s.

"YOU'VE COME A LONG WAY, BABY"

WOMEN'S HISTORY IN CONSUMER CULTURE FROM WORLD WAR II TO WOMEN'S LIBERATION

In early summer 1968, the downtown office of Chicago's First Federal Savings and Loan Association devoted nine windows on Madison and Dearborn Streets to a display on the history of "The Grand Old American Ad." The Women's Advertising Club of Chicago (WACC) curated the exhibit, and one window commemorated the club's fiftieth anniversary. To culminate a yearlong celebration, the WACC presented historical advertisements from its members' collections, as well as from the national industry publication *Advertising Age*. Photographs of officers from the club's early years dramatized the longevity of women in the profession.[1] Centrally located, steps from the famed Marshall Field's department store, and several blocks from the Hilton Hotel and Grant Park sites where rioting would erupt during the Democratic National Convention later that summer, the exhibit's business-centered feminism strategically embraced many aspects of the status quo. In an approach commonly used by women's advertising clubs across the country, Chicago's adwomen targeted public audiences by correlating the club's own history with the triumphant growth of corporate America. Plans for sending the collection on a tour of local schools supported the group's existing outreach campaigns to encourage young women, and men, to pursue advertising careers.[2]

The project reached both public and professional audiences. According to the club's *Ad Chat* newsletter, the May exhibit "attracted throngs of interested observers and numerous enthusiastic comments," prompting First Federal to

extend it through June.[3] The display generated corporate interest: the *Chicago Sun-Times* and Baker's Chocolate asked to borrow materials for their own exhibitions, positioning WACC members as archivists documenting the industry's past.[4] This visibility reflected the status of adwomen's activism. Forty years earlier, Philadelphia's adwomen had struggled in vain to identify precedents for their own professional inclusion. Finding no organic examples of historical feminists in popular memory, they recast the anonymous Quaker Girl to justify modern women's participation in business by evoking the legacy of women's dynamic contributions to public life. In subsequent decades, as they became public advocates for both women's history and the legitimacy of the advertising industry, adwomen themselves received recognition as historical pathbreakers. Capitalizing on such legacies, women's advertising clubs now centered their own stories when they portrayed history.

These narratives appeared as new employment patterns constricted women's professional opportunities. While ad agencies hired women writers in the 1920s because they felt that only women could think like women, the 1950s saw increased emphasis on psychoanalytic ad pitches and sociological theories—based on the idea that experts, including men, could crack the code for reaching female consumers.[5] Meanwhile, Cold War popular culture celebrated female domesticity as a patriotic duty, urging women to sacrifice their jobs to make them available for returning World War II GIs.[6] Women's advertising clubs responded, broadening their advertising education programs to include veterans and to serve the goals of wider professional networks like the Advertising Federation of America. After adwomen expanded their civic activities beyond a focus on women, institutional histories like the Chicago First Federal exhibit held increased significance to the groups' feminist goals.

Because they celebrated consumer culture for enabling women's careers, adwomen's projects conflicted with the approaches of many other contemporary feminists. As women's rights activism evolved in the late 1960s and the 1970s, a variety of strategies and philosophies emerged, but challenges to consumer culture's gender norms appeared prominently.[7] Betty Friedan's influential 1963 bestseller, *The Feminine Mystique*, which received significant media attention and established Friedan as a feminist figurehead, lambasted Madison Avenue's "sexual sell" for binding womanhood with consumption. Friedan blamed this "obsolete image of femininity" for obscuring feminist history and stifling women's professional ambitions in order to peddle products.[8] Scores of women wrote to Friedan, testifying that the book helped them recognize the social, rather than personal, cause for the sense of dissatisfaction they had suffered quietly.[9] In the late 1960s and early 1970s, some feminist organizations staged public protests against the type of popular culture

stereotypes Friedan had criticized. Launched by New York Radical Women, the September 1968 picket of the televised Miss America Pageant gained extensive, although often dismissive, news coverage for its repudiation of the "Consumer Con-Game" used to sell products and beauty ideals.[10]

Some activists strove to change depictions of women by working within the media, although this strategy caused controversy. In 1970, the sit-in against sexist content and male editorship at the *Ladies' Home Journal* caused tensions between Media Women, the group of feminist journalists that had conceptualized the protest, and participants from groups including Redstockings, the Feminists, and the New York Radical Feminists. Members of Media Women negotiated with the magazine to expand professional opportunities for women writers, sparking harsh criticism from those who opposed accommodation to mainstream culture and who perceived elitism in writers' advocacy for their own careers within a capitalist, hierarchical system that exploited women as consumers and secretarial workers.[11] Meanwhile, organized adwomen continued advocating a form of feminism tailored to their professional goals of self-promotion, but now they worked to differentiate themselves both from feminist critiques of American enterprise and from new commercial co-optations of the women's liberation movement. Most prominently, Chicago's Leo Burnett advertising agency launched Virginia Slims cigarettes in 1968 with the "You've Come a Long Way, Baby" campaign. The advertisements related narratives of progress in women's public roles that shared striking superficial similarities with the histories long told by women's advertising clubs. However, Virginia Slims' focus on smoking and fashion as the triumphs of modern feminism failed to recognize women's professionalism, provoking outspoken criticism from adwomen and from activists outside the industry.

This chapter analyzes the public histories promoted by corporations, adwomen, and feminists from the 1950s through the 1970s. It considers women's histories portrayed by commercial television broadcasts and magazines; the evolution of women's roles in the advertising industry, which informed women's advertising clubs' depictions of their own pasts; and feminist responses to popular portrayals of women's history. The chapter ends by analyzing Virginia Slims, using corporate records to assess intentions behind and reception of the brand's message about history's relevance to modern women.

WOMEN'S HISTORIES IN CONSUMER CULTURE BETWEEN WORLD WAR II AND WOMEN'S LIBERATION

While previous scholarship has considered the complexity of gender ideals in Cold War popular culture, it has not focused on gendered depictions of

history. I surveyed all issues of *McCall's* and *Mademoiselle* published from 1945 through 1963, considering their fictional, nonfictional, and commercial depictions of the past. *The Feminine Mystique*, which later shaped many scholars' and activists' assessments of post–World War II popular culture, looked primarily at fiction in women's magazines, contrasting positive portrayals of career women as independent and individualistic characters in 1939 with articles published in 1949 and later that urged women to focus all their efforts on being housewives.[12] Friedan paid particular attention to *McCall's*, deeming it "the fastest growing of the women's magazines" in the early 1960s and "a fairly accurate representation" of the industry.[13] After examining a broader sample of the nonfiction features published in mass circulation magazines targeted to women, to African Americans, and to "middlebrow" and "highbrow" readers from 1946 through 1958, historian Joanne Meyerowitz concluded that postwar culture offered alternatives to the domestic ideology Friedan criticized.[14] By placing advertisements alongside editorial and fictional features, my sample includes contradictory and diverse portrayals of women's history that support Meyerowitz's assessment. Historical themes were prominent, even as advertisers set to work selling new technologies and products and urging women to imagine their futures. Readers would encounter multiple references to the past in every issue, with history's prominence varying based on the content of feature stories. Readers of *McCall's* would find some form of reference to women's historical significance, to historical styles, or to women's historical experiences on 9 of 120 pages in the January 1958 issue; 25 of 152 pages in the March 1958 issue; 8 of 136 pages in the June 1958 issue; and 43 of 148 pages in the October 1958 issue, which contained a photo retrospective of Eleanor Roosevelt's "life in pictures" and a fictional suspense story about the family history behind an old gothic mansion in New Orleans.[15] While *McCall's* targeted white, married, middle-class women, and the majority of its historical references focused on household labor, *Mademoiselle* targeted middle-class and elite college women. Educational historical content appeared in *Mademoiselle* articles about college curricula, European and American travel destinations, and careers. Nevertheless, the magazine often depicted women's history as a narrative of continuity, sentimentalizing tradition in advertisements that addressed future brides.[16] By 1962, *McCall's* circulated to eight million readers; from the late 1940s through the early 1960s, *Mademoiselle* reached around five hundred thousand readers yearly.[17]

In this sample, the majority of advertisements and editorial features that referenced the past promoted ideals of domesticity while emphasizing the importance of women's historical contributions in that sphere. My sample offered no equivalent to Avon's World War II magazine advertisements

profiling "American heroines" who acted independently. Instead, *McCall's* profiled historical homes of great men and celebrated women for cooking those men's favorite recipes.

Meanwhile, other popular outlets that had previously publicized feminist histories narrowed their focus. In 1950, the *Wonder Woman* comic book replaced its historical biographies with a feature illustrating global wedding customs.[18] Television brought historical drama into American homes, but it did not offer series created to promote feminist history, as 1930s radio had. The TV Western proliferated—at the genre's 1959 peak, the national prime time schedule featured forty-seven Westerns weekly—but its fictionalizations of the frontier seldom offered dynamic female characters.[19] Such comparisons parallel *The Feminine Mystique's* observation that popular culture of the 1930s and 1940s offered stronger female protagonists than those of following decades.[20] However, reverent portrayals of suffragists and women who had challenged gender norms of earlier eras did appear in 1950s and 1960s magazines. Similarly, corporate-sponsored television dramas idealized women of the past who focused on domesticity and family, but they also applauded women who made contributions to public life. Thus, my evidence supports the conclusions of Meyerowitz and of literary scholar Nancy A. Walker that *The Feminine Mystique* obscured complexities in postwar popular culture.[21] Friedan had proclaimed that, after 1949, popular culture portrayed the "housewife-mother" role as the only pathway to "fulfillment as a woman."[22] When depicting the past, however, media narratives acknowledged some women's dissatisfaction with relegation to domesticity and their resulting efforts to transcend that role.

Television created a powerful stage for these messages. The DuPont Company's *Cavalcade of America* migrated to the new medium, running from 1952 through 1957 and reaching large audiences. Research by the advertising agency Batten, Barton, Durstine & Osborn calculated that 40 percent of adults had viewed at least one broadcast in the three months prior to a 1956 survey.[23] Like its radio antecedent, the television series typically focused on histories of great men. However, episodes included female protagonists who attained business success as wives and widows; supported their husbands' political careers; sacrificed as nurses and doctors; and aided Revolutionary War soldiers, their bravery driven by familial love. While the show emphasized the familiar ideal of wifely devotion, it nevertheless elevated some women who challenged social norms and worked outside of the home. For example, "Petticoat Doctor," the 1955 installment on Dr. Elizabeth Blackwell, celebrated both her beauty and her bravery in the face of public and professional resistance to her work as the first American woman physician.[24]

Simultaneously, new programs used familiar historical topics to appeal to mass audiences. *Kraft Television Theatre* (1947–1958) broadcast plays weekly, offering a mix of classic theatrical and literary works, adaptations of popular films, and new stories.[25] Producer Maury Holland cited as his model middle-brow plays with high profits on nationwide tours.[26] Kraft Foods Company favored such source material because it bypassed controversial topics, yielding high sales of advertised products and write-in requests for featured recipes.[27] Serious works, such as Shakespeare, appeared sparingly, with producers assuming that female consumers felt obligated to experience the classics but truly favored less "artistic" fare.[28] History appeared in adaptations of recent plays like John Cecil Holm's *Gramercy Ghost*, which connected its modern American working woman protagonist with the inspirational patriotic past through supernatural intervention from a Revolutionary War soldier. He united her with a romantic soulmate.[29] Literary classics such as *Jane Eyre* and *Hedda Gabler* invited more serious reflection on the history of gender norms. Henrik Ibsen's *A Doll's House* received multiple stagings over the series' run.[30] More frequently, episodes dramatized familiar male historical subjects, including Benjamin Franklin; George Washington; John Wilkes Booth; and Kansas Senator Edmund G. Ross, whose actions during Reconstruction were adapted from Senator John F. Kennedy's best-selling 1956 book, *Profiles in Courage*.[31]

The Hallmark Hall of Fame, debuting as an NBC anthology series in 1951, also spotlighted women's histories. Across seasons, to showcase Hallmark greeting cards, the series experimented with different formats, including opera, literary adaptations, and biographical dramas. In 1952, many of the thirty-minute episodes took place on a set representing a hall of fame: series presenter Sarah Churchill began the broadcasts by nominating a woman for inclusion in this commemorative space. Dramatization of the historical figure's life followed. These installments typically featured women whose achievements fit familiar models of femininity: writers, educators, nurses, and wives of great men. However, as scholar Leigh Goldstein has argued, the biographies highlighted subjects' unwillingness to devote themselves entirely to domesticity. In one installment, Puritan poet Anne Bradstreet described her determination to write in spite of her family obligations.[32] Promotions for a 1954 broadcast, which was rare for the series in its focus on women's activism, emphasized the damage that Elizabeth Cady Stanton's campaigning for married women's property rights and for suffrage caused to her husband's career, while nevertheless celebrating this "story of America's first successful feminist movement."[33] As the series later shifted its focus to literary adaptations, portrayals of women's efforts to transcend domesticity recurred.

A 1959 *Hallmark Hall of Fame* presentation of *A Doll's House* was likely the broadcast that Betty Friedan intended to praise in *The Feminine Mystique*. She applauded a recent television performance of the play as an unusual subversion of the era's "happy housewife" mythology because its story of a late nineteenth-century mother's dissatisfaction mirrored the internal struggles of "millions of American housewives" to claim identities as full human beings.[34]

However, as Cold War politics and culture promoted the suburban family as the embodiment of American democracy, most historical references relegated women to the private domestic sphere. Although the number of married women performing wage labor outside the home was increasing, post–World War II women's magazines continued presenting devotion to family and home as the ideal.[35] Historical references offered the reassurance that, despite the increasing availability of time-saving appliances and products like cake mixes and TV dinners, women's interest in homemaking was the result of a timeless biological drive and was an honored tradition. In fact, historically inspired styles of decorating and entertaining created new housekeeping tasks that could fill time freed by scientific advances.

Articles and advertisements regularly instructed women to honor the past by reproducing historical meals. From 1955 through 1959, the *McCall's* series "Our Living Heritage" offered recipes favored by presidents and Civil War leaders, including Confederate Robert E. Lee. One installment encouraged readers to prepare one of the many "good recipes from Mary Lincoln's day," promising that decorative layers of creams, jams, and jellies distinguished these desserts from the standard "1957 version." Photographs, complete with actors in period dress, provided a model. By electing to produce these cakes, *McCall's* suggested, contemporary women emulated the "endless hard work" that had yielded "comfort and good food" for President Lincoln.[36] As the growing circulation of *McCall's* made the publication an influential shaper of the suburban family ideal, these vignettes were some of the nation's most visible women's histories.[37]

Magazine advertisements paralleled this presentation of homemaking as a fulfilling way for women to engage with the past. A series of 1956–1957 promotions encouraged housewives to "make history" with Dromedary brand cake mixes inspired by "Treasured Historic Recipes." Photographs showed costumed reenactors in the homes of historic U.S. presidents.[38] The headlines presented the mixes as both novel and traditional with such encouragements as "Now you can bake White Cake inspired by a favorite recipe of Mrs. James Monroe." Rather than celebrating women themselves as historical heroines, or treating women's history as a topic for serious study, this approach limited women's historical significance to their domesticity.

Advertising industry commentators remarked that the past's popularity as a visual motif was increasing in the late 1950s, becoming a cliché.[39] In the early 1960s, historical objects served as shorthand in the pages of *McCall's*. Duncan Hines ads offered a line of "Early American Cake Mixes," promoted with a patriotic eagle logo and photographs of cakes on antique tableware, surrounded by candles.[40] Historical props also illustrated housekeeping editorials that embraced technological innovation while asserting women's continued devotion to domesticity. Photography accompanying the 1962 article "Step-by-Step to Old-Fashioned Icebox Cookies" showed a large icebox with a decorative cookie jar inside it. A 1963 article, "Blend It Round [*sic*] the Clock," praised time-saving electric blenders for making it possible to prepare foods for any occasion and at any time of day. In the accompanying photograph, an antique grandfather clock's pendulum case housed a sleek, modern blender.[41]

The resulting pastiche stripped objects of historical context. As historical tools became mere illustration, depicted because they were obsolete, their presence suggested that time operated differently in the domestic realm of women. *McCall's* encouraged consumers to hunt for such "unsophisticated objects" from the past, including Franklin stoves, manual coffee grinders, colonial-era brass bed warmers, apothecary bottles, and building plans for outdated machinery, for their home decor.[42] A 1961 article encouraged collecting several broken clocks from the eighteenth and nineteenth centuries and placing them together on one wall.[43]

Fiction published in *McCall's* assigned emotional power to these items: mere proximity to antiques transformed female characters by evoking the timeless joys of pregnancy and childbirth. Such mystical connections replaced the objects' function as markers of specific time periods. In "The Cradle," protagonist Elinor performed housework with "assembly-line efficiency," aided by the latest modern products but disinterested in her responsibilities. To her husband's annoyance, she bought antiques, simply to fit in with "everybody else." Her detachment dissolved, however, after she bought an old cradle at a flea market. Transfixed, she soon forgot her original intention to repurpose it as a plant holder. She became pregnant and worked with her husband to repair the cradle, strengthening their relationship. The story's narrator explained: "She could see, through the years, babies who rested here: the future was linked to the present, and the present was chained to the past."[44] Contact with this object gave Elinor a new appreciation of her maternal destiny. Similarly, another story traced improvements in its protagonist's homemaking skills after she moved into a nineteenth-century house, crediting supernatural influence for the change.[45]

Although outnumbered by these sentimentalizations of domestic history, histories of women's public contributions did not disappear, even in the pages of *McCall's*. John F. Kennedy provided an essay, "Three Women of Courage," in 1958, highlighting Puritan dissenter Anne Hutchinson, abolitionist activist and educator Prudence Crandall, and pacifist Congress member Jeannette Rankin. A 1959 feature, "Eminent Women," offered original painted portraits of important women from world history, as selected by the publication's editors, who urged readers to submit their reactions. A 1961 article, "Woman's Suffrage," presented a portfolio of paintings capturing key moments and leaders in the women's rights movement. It reviewed activism from the 1848 Seneca Falls Convention through the Nineteenth Amendment, explaining, "If we remember what a little band of women achieved without the vote, we will find no room for apathy, but only inspiration to move ahead."[46] Notably, this sentiment celebrated both past and future change.

Mass market women's magazines also occasionally offered dissenting voices that decried nostalgia for physical objects, urging more serious considerations of women's pasts. In a 1958 *Mademoiselle* article, "The Feminine Principle," the novelist and literary critic Elizabeth Hardwick made an argument similar to one Betty Friedan would make five years later in *The Feminine Mystique*.[47] Adapting lecture material from a course she taught at Barnard College, Hardwick suggested that contemporary women should look to the past, where they would find that their nineteenth-century counterparts suffered the same discontent in their restricted roles. However, she lamented, modern women failed to analyze history through this lens of common experience because they focused on the superficiality of style, distorting their interpretations of historical feminists like activist Julia Ward Howe: "If we remember Mrs. Howe at all, we recall the photograph taken in her old age. She is a wrinkled old lady in a white cap and she sits in a great, hooded rattan chair on her veranda in Newport. At the moment, fashion having resurrected yet another group of corpses, our minds reach out greedily for the delicious rattan chair, an old object once more le dernier cri. And that is about all of Mrs. Howe we would seek to have about us."[48] Hardwick criticized such thought as dangerous "false simplicity" that made women expect true fulfillment through feminine roles. This critique, which could easily apply to other content in the very magazine housing it, urged readers to seek alternatives to mass culture. If they did not, Hardwick predicted "hysteria and breakdown" for the American woman who was rendered "as compliant as her dishwasher."[49]

Popular magazines published for African American audiences offered other challenges to the ahistorical archetype of the white, suburban, middle-class female consumer. *Jet*, an influential weekly magazine covering entertainment and current events, in the early 1950s included the regular columns

This Week in Negro History and Yesterday in Negro History. Although their brief summaries typically focused on men, and on famous cases where the judicial system successfully punished racism, they also included African American women noted as educators, entrepreneurs, and activists.[50] Simultaneously, *Jet* monitored public discourse about history, applauding new books and articles that documented African Americans' experiences. Again, these narratives typically focused on men.[51]

But the publication also urged greater awareness of the vital roles African American women played alongside men in building the nation. Historian and magazine editor Lerone Bennett Jr. wrote in 1963 that his young daughter studied Abraham Lincoln in school but remained unaware of Frederick Douglass's contributions. Prescribing significant revisions to the stories Americans told themselves about the past, Bennett explained that white and black children should study "Negro history" because "one cannot know very much about America unless he knows a little about the Negro."[52] Bennett followed this call to action with examples of African American women's historical achievements: Phillis Wheatley's poetry; Sojourner Truth's activism; and the efforts of educators, including Mary McLeod Bethune, whose early twentieth-century school leadership improved opportunities for African American girls.[53]

The African American press also celebrated contemporary educators' innovative efforts to acknowledge black women's historical significance. In 1961, monthly news and lifestyle magazine *Ebony* profiled one Mrs. Howard Thurman, the creator of a doll collection that illuminated the past. Thurman's responsibilities as the wife of a Boston University dean included welcoming international students to campus, work that inspired her to commission dolls that represented diverse nations. Lending them to universities nationwide, Thurman hoped to spark students' appreciation of the common humanity underlying cultural differences. *Ebony* placed particular emphasis on her representations of historical African American women, among them Phillis Wheatley, Sojourner Truth, and Harriet Tubman. Taking a similar approach, a 1963 *Ebony* photo essay celebrated the capacity of antiques to document the past, applauding the collection and restoration efforts of Harlem resident Mrs. William David Finkley. Her home decor included a staircase "hall of fame," with portraits of African American men and women, including the often-celebrated Wheatley.[54]

WOMEN'S ADVERTISING CLUBS BETWEEN WORLD WAR II AND WOMEN'S LIBERATION

From the 1940s through the 1960s, women's advertising clubs publicized a variety of women's histories, offering alternatives to magazine portrayals

of static domesticity by celebrating women's achievements in business as
feminist progress. During this period, the groups focused less on women's
shared national heritage and more on documenting the twentieth-century
achievements of adwomen themselves, placing them within the context of
industry-wide initiatives to improve the public's perception of advertising.
During World War II, women's advertising clubs devoted increased efforts to
civic activities that were not directly related to the groups' original feminist
goals. For example, the Philadelphia Club of Advertising Women promised
100 percent of its efforts to defense-related activities, creating all the publicity
for the state's salvage campaign. Such voluntarism paralleled national proj-
ects designed to improve advertising's public standing, as industry leaders
strategized against the New Deal model of increased government economic
regulation. The War Advertising Council emerged in 1942, coordinating
advertising professionals in the development and circulation of official gov-
ernment propaganda.[55] Its successor, the peacetime Advertising Council, led
by employees of advertising agencies, corporations, and media outlets, sought
goodwill by developing public service messages.[56] Its campaigns combated
communism by extolling the virtues of capitalist democracy. In doing so,
advertisers promoted the general interests of corporate clients, while posi-
tioning themselves as nonpartisans.[57]

These contributions earned recognition; however, the focus on civic
activism sometimes eclipsed adwomen's feminism. After 1945, women's
advertising clubs, including the New York, Philadelphia, and Los Angeles
groups, offered advertising instruction and job placement services for male
veterans in hospitals and rehabilitation centers.[58] While continuing to provide
advertising courses for women, clubs also devoted new effort to shaping the
education of schoolchildren. The Philadelphia Club of Advertising Women
(PCAW) successfully promoted local participation in an annual Advertising
Federation of America (AFA) high school essay contest on the importance of
advertising in American life. Of twelve thousand entries submitted nation-
wide during the inaugural 1947 competition, thirty-five hundred came from
the Philadelphia region. In recognition for this contribution, the PCAW
received a first-place AFA club achievement award.[59] Emphasizing this work,
the Philadelphia adwomen chose *Useful to the Community* as the theme
for a 1948 booklet on the club's history, distributing five hundred copies to
local businesses, advertising agency executives, news media, national AFA
leadership, and advertising club presidents across the country.[60] In this reen-
visioned history, service to others, rather than service to improve women's
career opportunities, defined the group's legacy. Celebrating its role in the
AFA essay competition, the group cited its first local essay contest in 1930 as

a precedent.[61] While still turning to the past to claim contemporary signifi-cance, Philadelphia's adwomen were no longer dramatizing women "making history" through independent transformative contributions, as the PCAW's radio series on historical women had done in the 1930s. After World War II, adwomen of the PCAW were focused instead on writing their own history to fit the modern values of their profession.

Local clubs' attention to AFA goals grew in tandem with the AFA's increasing power as a voice for economic conservatism.[62] The organization marshaled its members for legislative lobbying and defense against consumer movements. Membership surpassed fifty thousand, derived from 131 affiliates, in 1959.[63] In the 1950s and 1960s, this nationwide network received manuals and "blueprints" from association leadership, guides to standardize their activities.[64] As women's advertising clubs incorporated these directives, the industry had made some notable concessions to women's importance in the profession. Gradually, between the 1930s and 1970s, many local advertising clubs opened to female members, enabling adwomen to hold dual member-ship in the women's advertising club and the city's main advertising group.[65] In some cities women's advertising clubs merged with their male counter-parts, while other women's advertising clubs rejected invitations to unite, stressing the importance of women's clubs as a space for female cooperation.[66]

Even as they devoted increased attention to broader civic concerns, women's advertising clubs strategized to stimulate career opportunities for multiple generations of women. In 1939, the PCAW had initiated a Senior Guidance Program for members facing age discrimination in hiring. In 1950, members began collaborating with other local women's clubs to promote the capabilities of women workers over thirty-five. As evidence of adwomen's professional contributions, the PCAW produced a 1955–1956 exhibit of adver-tisements created by Philadelphia adwomen, displayed for the public in the Strawbridge & Clothier department store.[67]

Meanwhile, women's advertising clubs deployed historical pageantry to draw industry attention. By dressing in costume, adwomen increased their chance for inclusion in *Advertising Age*, a national trade publication that documented professional activities in a section called Photo Review of the Week. Throughout the 1950s and 1960s, this feature typically focused on photographs taken at regional and national meetings. Models and actresses— typically clothed in revealing, sexualized costumes—hired as event entertain-ment often outnumbered adwomen. Corporate publicity photographs and advertisements also appeared, seemingly selected for inclusion as an excuse for featuring the female form.[68] However, women's advertising clubs staged costumed retrospectives, creating an alternative route to news coverage that

emphasized women's intellectual and patriotic contributions along with their physical appeal. In 1961, the Photo Review column published six scenes from the Women's Advertising Club of Chicago's *Panorama of Advertising* performance, a series of skits tracing adwomen's contributions to iconic campaigns, performed by the group's new members at their initiation meeting.[69] The narrative began in the 1920s, with a club member in a modest, knee-length flapper-style dress dramatizing the role of an adwoman on the Ford Motors account. A scene for each subsequent decade traced the expansion of women's business roles, ending with the "Soaring 60's." *Advertising Age*'s allowance of multiple images for the event was unusual; by producing this photogenic spectacle, the club secured prominent publicity for its new members, getting their names and employers printed in the captions, and linking these newcomers to adwomen's past successes. This celebratory approach allowed adwomen to differentiate themselves from contemporary stereotypes, their demeanor and attributes divergent from the ones that earned models inclusion in *Advertising Age*. While a female advertiser in an outmoded costume provided visual interest without appearing solely as a sex object, this approach was nevertheless an accommodationist one that did not explicitly challenge the logic of measuring women through their physical appearance.

In 1962, the fiftieth anniversary of the Advertising Women of New York (AWNY) provided occasion for a more serious retrospective, as the group celebrated adwomen's evolving place in the industry and their role in the history of feminism. Social events observed the past playfully: for a "Gold Nugget Cafe" cocktail party at the Waldorf Hotel, members dressed in Old West costumes.[70] Simultaneously, the group worked to document its own historical role. As club historian, Dorothy Dignam compiled detailed digests of milestones for inclusion in commemorative publications and for retention by the organization.[71] Even amid new cultural resistance to women professionals, industry and civic audiences recognized AWNY as a pathbreaker. Members held a conference, publishing a companion book, *Golden Salute to Advertising*, which described historical adwomen as feminists in their efforts to challenge biases against women's employment.[72] Then AWNY president Florence Goldin's introduction to the volume celebrated the broader significance of adwomen's achievements, explaining, "In 1912, when this organization was founded, advertising—and the role of women in business management—were both still in their infancy." She credited women for helping the advertising industry advance and for transforming social norms by proving their own capabilities: "Women have reached a position of achievement and recognition which certainly must exceed any projection of their hopes and dreams back in their early days. Not only have they taken their

places in the advertising sphere, but they have also accepted their responsibilities in all levels of business, civic, and political influence—based incidentally, not on token recognition but on definite contribution and achievement."[73] These statements linked the present with the past by crediting adwomen's accomplishments for expansions of gender roles.

While this narrative celebrated the present, it challenged dominant contemporary ideals by claiming historical feminism as a model. In the early 1960s, as historian Leila Rupp and sociologist Verta Taylor have shown, few activists identified publicly with the word *feminist*, and the popular press derided the label as passé. Many advocates of gender equality avoided the word, citing public disdain for it.[74] However, the *Golden Salute* paid tribute to Christine Frederick as "an ardent feminist, [who] marched militantly with the first of the suffragettes." Her transgression brought significant social progress: "Fifty years ago, when AWNY was first conceived, virtually everybody believed that woman's place was in the home, and the few brave and brilliant feminists who challenged this dogmatic pronouncement got scant encouragement."[75]

While applauding improvements in women's career opportunities by recalling the obstacles to adwomen's initial activism, the book also candidly acknowledged persistent barriers to women's success. As an essay from *McCall's* senior editor Lenore Hershey explained, "The point is that women in advertising are sure bets for the stereotyping pool. Still a minority group in the profession, still battling the larger good fight for the rights of women in business, still caught up in the mesh of advertising's percolating personalities of both sexes, ad women make attractive targets for criticism and pigeonholing."[76] Another essay compiled quotes from contemporary adwomen to document their grievances. Those polled described double standards: women received less pay than their male counterparts for equivalent work and labored against assumptions about feminine emotional irrationality.[77] But AWNY presented its own history as a guide for addressing such modern biases. It celebrated adwomen's successes for improving the employment of subsequent generations and for easing the burdens of household labor by promoting innovative consumer technologies. Identifying this progress, an essay tracking the group's evolution urged contemporary members to find inspiration in the past. This "Informal History" acknowledged that "it is difficult for present-day members to visualize some of the problems of our predecessors. In 1912 women were still marching in suffrage parades. Advertising women not only had to find jobs; in many cases they had to persuade bosses that they were capable of work more creative than transcribing a letter."[78] However, after bravely challenging such biases, historical adwomen left

inspirational records. The chronicle concluded with a tribute to the archives collected by longtime AWNY historian Dorothy Dignam, proclaiming, "Any university would have awarded Dorothy Dignam a degree for this scholarly piece of work."[79] The essay's author, Helen Peffer Oakley, urged members to visit AWNY headquarters and review the more detailed history that Dignam had compiled.

These celebrations of feminist history were presented to a broad professional audience that indicated its receptivity to the message of women's historical importance in advertising. Prominent businesses placed ads in *Golden Salute to Advertising*, cheering the group's 608 current members and celebrating the group's longevity as a sign of its prestige and of the vital roles adwomen played in the media's past.[80] *Life* magazine contributed an ad claiming, "AWNY was already a quarter-century old when *Life* was born 25 years ago."[81] The McGraw Hill publishing company's tribute melded the past and the present: the illustration of an adwoman in 1912 attire, laboring over a copy assignment as her posture, her feet resting on her desk, conveyed her nonchalance and confidence. The ad's caption praised this figure for her persistence into 1962: "We are told you're 50 years old! You could have fooled us, kid. All that vitality. Meeting all those business and social deadlines. Looking ahead. McGraw-Hill salutes you!"[82] Such tributes reinforced the adwomen's own narrative, treating the evolution of women in business as a collective accomplishment that should inspire modern adwomen's pride.

The public also encountered chronicles of adwomen's historical feminism. In a 1963 *Chicago Tribune* article about the forty-fifth anniversary meeting of the Women's Advertising Club of Chicago, reporter Fred Farrar contextualized the group's founding by praising both the suffrage movement and early adwomen. He described the lack of political rights and the limited career opportunities women experienced in the 1910s, hypothesizing that modern readers would need reminders that founding members' decision to organize together to protest their professional marginalization was "unusual for that time." However, Farrar proclaimed the long-term influence of the group by crediting it for well-deserved improvements in the professional opportunities of women who followed.[83] Such narratives placed adwomen's historical challenges to gender norms in a larger, celebratory story of corporate and national progress.

Betty Friedan's Call to Recover Women's Histories

Often hailed as a spark that touched off feminist activism that followed, *The Feminine Mystique* memorably blamed twentieth-century cultural amnesia

for the pressure women felt to emulate the "happy housewife heroine" ideal promoted by women's magazines.[84] According to Friedan, modern women ignored the suffragist past, duped by popular media's antifeminism and its vicious ridicule of the rare historical feminists mentioned in cultural discourse. If they revisited the "passionate journey" toward the Nineteenth Amendment that American feminists had begun a century earlier, Friedan argued, contemporary women would find the inspiration to reignite women's rights activism. She compared suffragists' challenges to "the crisis in women's identity" experienced by members of her own generation, who were unsure of a pathway for active contributions to public life after they retreated from college into domesticity. She identified women who agitated for the right to use their natural abilities, citing Susan B. Anthony, Sojourner Truth, Louisa May Alcott, Elizabeth Blackwell, Jane Addams, and Carrie Chapman Catt. Denying that historical feminists were "sex-starved spinsters . . . castrating, unsexed, non-women," she emphasized stories of married activists, including Angelina Grimké, Ernestine Rose, Elizabeth Cady Stanton, Julia Ward Howe, Margaret Sanger, and Lucy Stone.[85]

Friedan's approach proved shrewd, as her book garnered significant media and reader attention. Contemporary critics and readers seemed to accept Friedan's summary of popular culture; reviewers were largely positive, and their criticisms did not quibble with Friedan's description of mass media content, although some denied that popular culture should be blamed for the modern problems the book identified.[86] The influence of *The Feminine Mystique* thus helped obscure some of the complexities in media depictions of women's history.

As her activist career progressed, Friedan continued asserting that, prior to 1963, American culture had suppressed feminist histories of women. In the introduction to *The Feminine Mystique*'s twentieth anniversary edition, she claimed that she had experienced shock when leaving her suburban home to research the book at the New York Public Library in the late 1950s and early 1960s, allowing her to "uncover the women's history that had been buried by the feminine mystique in the 1940's and 1950's," learning about women's rights activists "whom most educated women like myself had never studied then, even at Smith."[87] Indeed, Smith College offered no women's history courses during Friedan's time as a student.[88] However, Daniel Horowitz's biography of Friedan interrogates this account of personal discovery. As Horowitz writes, before she researched her bestseller, "Friedan had long been aware of women's historic struggles, as many of her earlier writings make clear." Working as a reporter for the radical United Electrical, Radio and Machine Workers of America, Friedan was the anonymous author of the 1953 pamphlet *Women*

Fight For a Better Life! UE Picture Story of Women's Role in American History, a survey of historical victories against discrimination from the colonial era through the present. The narrative emphasized achievements of African American and working-class women while simultaneously echoing popular precedents.[89] Opening with an illustration of a colonial woman sitting at a loom, the text mirrored suffragists' efforts in 1911 to parallel women's preindustrial labor and their subsequent factory employment.[90] Friedan evoked nostalgic imagery by characterizing labor leader Mother Jones as "a little old woman in a black bonnet." She praised Deborah Sampson Gannett; Susan B. Anthony; and Leonora Barry, a nineteenth-century organizer of women employed as typists. Biographies of Gannett, Anthony, and the fictional typist "Miss Pilgrim" had appeared in 1940s popular culture, although Friedan's advocacy of unions in response to companies' "exploitation of workers" separated her from the advertisements, radio series, and periodicals that preceded her.[91] As Horowitz demonstrates, however, Friedan later chose not to claim authorship of this piece, likely fearing that her involvement with a union that had Communist connections would put her at risk in the climate of Cold War anticommunism.[92]

Given her familiarity with mass circulation women's magazines, having contributed to them as a freelance writer in the 1950s, it is also likely that Friedan had encountered their diverse portrayals of the past. In some cases, corporations cited history to pitch products and support the "happy housewife heroine" ideal that Friedan criticized. Less frequently, acknowledgments of past feminist achievements demonstrated the media's capacity to accommodate multiple perspectives.[93] However, *The Feminine Mystique* focused on popular culture's omission of and vicious ridicule of women's history.

RESPONSES TO FRIEDAN

Unsurprisingly, adwomen protested Friedan's characterization of popular culture, citing women's prominence in advertising and business as evidence of historical progress. In a 1965 address to the Advertising Federation of America's national convention, Jo Foxworth, an agency vice president and Women's Advertising Club of Chicago member who had previously served as president of the Advertising Women of New York, criticized Friedan.[94] Titling her speech "The Mistaque of the Feminine Mystique," Foxworth responded not only to the famous book but also to a guest lecture Friedan gave before AWNY. As Foxworth recalled, this speech devalued adwomen's work, as Friedan "came at us with her own verbal meat cleaver and, with unalloyed joy, gave credit to Advertising for most of the nation's more serious ailments."[95]

Foxworth's rebuttal proclaimed Friedan's ignorance of the actual experi-
ences of "career women" and reached broad audiences when newspapers
reported her remarks.[96] Defending her industry, she asserted, "the American
woman is the most powerful woman in history. And the most privileged,"
a status linked to her power as a consumer and a mother.[97] Foxworth then
contrasted Friedan's depiction of feminine discontent with "the woman you
and I know . . . the woman who has won the right not only to vote, but to
hold high government office." This woman "can smoke and drink and wear
pants . . . wear levis, capris, bell-bottoms, jamaicas, bermudas and short-
short shorts" while also pursuing a variety of career possibilities as "a doctor,
lawyer, merchant chief, a stockbroker, judge or bank president."[98] According
to Foxworth, Friedan's dramatic portrayal of women's discontent downplayed
these advances and ignored the consumer economy's role in enabling them.

The *New York Times* reported positive reception for Foxworth's message,
in a convention crowd featuring "a heavy sprinkling of other advertising
women," who responded particularly enthusiastically to the closing, titled
"Nine Commandments for Women in Business." Here, Foxworth again
highlighted a narrative of progressive change over time, playfully referring
to outdated social norms to contrast women of the past with the modern
advertising industry worker. Foxworth advised her colleagues, "Thou shalt
not attempt to hide behind thine own pettycoat," and "When success cometh,
thou shalt not get too big for thy bustle."[99] Because no adwoman in 1965 wore
the cumbersome nineteenth-century petticoat or bustle, Foxworth's jokes
urged listeners to visualize changes that had occurred during the advertis-
ing industry's lifespan. Simultaneously, her emphasis on women's bodies
highlighted the continued differences between women and men, reflecting
accommodationism to gender norms. She directed women to censor them-
selves strategically: "Thou shalt know when to zip thy ruby lips and let the
men do the talking." Yet Foxworth also mocked the stereotype of female
weakness, previously used to exclude women from business. Reversing the
familiar stereotype that chivalrous men must protect women's delicate sen-
sibilities, her seventh commandment proclaimed, "Thou shalt watch thy
language. There may be gentlemen present."[100] Foxworth thus urged career
women to exploit gender stereotypes, at the same time calling attention to the
artifice behind performances of femininity.

Foxworth's speech credited adwomen as pathbreakers for women in pub-
lic life. This perspective celebrated the present, while the growing women's
liberation movement rejected contemporary norms. For example, echoing
elements of *The Feminine Mystique* in its argument that re-examining the
feminist past would cast new light on modern sexism, Shulamith Firestone's

opening essay for New York Radical Women's 1968 *Notes from the First Year* criticized the absence of women's histories in popular memory. When textbooks and literature acknowledged women, Firestone argued, they selected only those whose achievements fit within traditional ideals of femininity. She wrote, "Why are little girls familiar with Louisa May Alcott rather than Margaret Fuller, with Scarlett O'Hara and not Myrtilla Miner, with Florence Nightingale and not Fanny Wright? Why have they never heard of the Grimke Sisters, Sojourner Truth, Inez Milholland, Prudence Crandall, Ernestine Rose, Abigail Scott Duniway, Harriet Tubman, Clara Lemlich, Alice Paul, and many others in a long list of brilliant courageous people?" Determining that histories of feminism had been obscured, she commented, "Something smells fishy when scarcely fifty years after the vote was won, the whole [women's rights movement] is largely forgotten, remembered only by a few eccentric old ladies."[101]

In reality, popular histories remained complex. For decades, mass media had often favored stories of women like Alcott, O'Hara, and Nightingale over the more radical alternatives Firestone provided. As Firestone also argued, African American histories remained marginalized.[102] Nevertheless, women's suffrage was not forgotten, although popular uses of this past did not necessarily correspond with the goals of the modern women's liberation movement. Prominent films set in the late nineteenth and early twentieth centuries—including Disney's 1964 musical *Mary Poppins* and *The Great Race* of 1965, starring Natalie Wood—simultaneously sympathized with and spoofed fictional characters' suffragist goals. Ultimately, the plots dramatized the importance of maternal nurturing and romance in the ideal woman's life: because of this vacillation, recent critical analyses identify incoherence in these films' and their characters' viewpoints on gender.[103] Meanwhile, women's advertising clubs of the 1960s clearly celebrated ties between early adwomen and historical feminism. But adwomen's championing of capitalism separated them from Firestone and many other feminists.[104] Still, by advocating the inspirational power of the suffrage movement and of other women's histories, adwomen shared elements of Friedan's and Firestone's strategies.

ADWOMEN AND ADVERTISING IN THE ERA OF WOMEN'S LIBERATION

Adwomen tailored their depictions of the past to their own organizational and professional goals. In its fiftieth anniversary year of 1967–1968, the Women's Advertising Club of Chicago published a history, *A Half-Century of Service to Advertising and the Community*, describing its founders as "far-seeing

women" who worked to prove they could "be successful in their daring venture into the men's world of business" and who benefited from the "help and confidence" of men who hired them.[105] The chronicle emphasized the WACC's recent work to encourage young men and women to enter the advertising field, through publication of the career guides *Help Yourself to a Better Job*, published in 1960, and *111 Jobs for Women in Advertising*, of 1964, which were distributed to high school and college students. Describing regional and national renown for Chicago's adwomen as the goal behind the anniversary celebration, members distributed informational packets on the group to the press; earned a mayoral proclamation of the Women's Advertising Club Year in Chicago; and staged social events, including a fiftieth "birthday party."[106]

The club's December 19, 1967, Christmas party also celebrated the milestone, with young adwomen of the auxiliary Junior Women's Advertising Club (JWAC) presenting a retrospective fashion show.[107] This performance dramatized the WACC's lifespan, evoking its founding year with silent films from the 1910s projected as a backdrop while JWAC members paraded on stage in "authentic fashions."[108] Then, 1920s flapper attire gave way to "nylons and Dior and the bikini," representing the 1940s. The show concluded as "Twiggy miniskirts and the Pill set the '60s pace."[109] Kathy Farkas, a JWAC member in stylish boots, miniskirt, and poncho, carried with one hand a placard bearing the assertion "WE WANT OUR RIGHTS." In her other hand was a cigarette. The *Chicago's Advertising Woman* newsletter printed a photograph of her walk down the runway before the applauding and smiling audience of club members, their dates, and influential male industry leaders.[110] The image's caption both aligned adwomen with and distanced them from the marching activist character ending the parade. The text explained that Farkas "keeps pace with past and present as she demands 'our' rights at The Women's Advertising Club Christmas gala."[111] By suggesting that contemporary women's activism stemmed both from "past and present" the WACC asserted that modern feminism was a movement rooted in history and that it was a development understood by modern adwomen "keep[ing] pace" with the public. Rather than summarizing the scene as a performance, the caption aligns club members with women's liberationists by referring to "our" rights and asserts distance by placing the word in quotation marks. Simultaneously, the playful pageantry of the fashion show depicted women's liberation activism as a style.

Parallel with the philosophy of feminism that Jennifer Scanlon identifies in *Cosmopolitan* magazine editor Helen Gurley Brown, who rose to prominence in the 1960s after working as a secretary and then an advertising copywriter, adwomen's activism challenged assumptions about gender by working within the framework of popular culture and spotlighting the performative

nature of femininity. For Brown, clothing and makeup were enjoyable per-
formances, rather than markers of an inherent femininity.[112] When adwomen
turned clothing into a costume by dramatizing the changes in gender norms
over time, they also emphasized the artifice behind female identity. Within
their profession, fluency in this language bolstered their credentials.

Advertising agencies were also paying attention to the history of modern
feminism, invoking the movement strategically for their clients. For four
weeks beginning in late December 1967, the Leo Burnett agency, also based
in Chicago, developed the Virginia Slims cigarette brand identity for Philip
Morris. Tested in San Francisco in July 1968, the long-running, influential
Virginia Slims campaign juxtaposed modern fashion-conscious consumers
with women of the past, burdened by household drudgery and restrictive
social norms.[113] By celebrating women's increased presence in public life,
magazine and television advertisements echoed the activist messages from
women's advertising clubs. However, an all-male team developed the Virginia
Slims concept, and these admen identified themselves as savvy outsiders who
successfully capitalized on contemporary feminism.

After the product's successful nationwide launch in September 1968, Burnett
employees made presentations to local and national professional groups,
narrating the brainstorming process of "15 Guys in Search of a Feminine
Identity."[114] This story made it clear that promotion of Virginia Slims, not of
feminism, was their goal. Philip Morris executives had recommended the
tagline "The first cigarette for women only" for the company's new thin ciga-
rette.[115] After exploring ways to define the product's unique appeal to women,
developing storyboards for commercials dramatizing romance and fun, "elev-
enth hour" inspiration struck the Burnett team: "one great brain came up with
the concept of women's rights, and a strong line that expressed it: 'You've come
a long way, Baby.'"[116] The resulting campaign applauded American women for
their evolution from the early twentieth century through the present, benefit-
ing from current interest in women's liberation but focusing on a narrative
of past triumph, suggesting that all the important changes had already been
made. To communicate this, one magazine advertisement borrowed a vintage
front page suffrage clipping from the *Chicago Tribune*, its headline reading:
"Women's Victory Needs One More Step."[117]

The "15 guys" made no acknowledgment of advertising women's previous
inclusions of the past in publicity, although their work paralleled Chicago
adwomen's ongoing anniversary celebrations. The holiday party fashion show
occurred in the same late December window that Burnett executives identi-
fied for their creative breakthrough. Echoing the photograph of Women's
Advertising Club directors featured in the summer 1968 anniversary First

Federal Savings and Loan exhibit, one Virginia Slims magazine advertisement featured a group portrait of women in modest early twentieth-century dress.[118] However, while the captions created for First Federal emphasized the professional, civic, and philanthropic contributions of the city's adwomen, Virginia Slims annotated its group portrait—appearing in magazines and newspapers in October 1968—with terse biographies tying the subjects entirely to their identities as cigarette consumers. Numbered captions identified figures in the photograph by indicating the dates when they had smoked their first cigarettes and explaining the obstacles they faced in doing so. For example, "Cynthia Irene Bell smoked her first cigarette behind the old barn out back on Jan. 4, 1912. It was cold." Following these anecdotes came the payoff: "You've come a long way. Now there's a new slim-filter-cigarette that's all your own."[119] Underneath this copy stood a svelte model in a vividly printed modern mini-dress, establishing a sharp visual contrast with the sepia-toned past of strident suffragists and sly smokers. Minimizing the political significance of historical and contemporary women activists, this narrative presented fashion as the culmination of feminist change.

Philip Morris distributed the campaign widely, ultimately reaching larger audiences than those of the advertising women's histories that cast women not only as consumers but also as workers actively shaping cultural norms. Magazine placements included *Ebony*, the *Ladies' Home Journal*, *Mademoiselle*, *McCall's*, *Life*, and *Vogue*. The majority of the promotional budget funded prime time television commercials, targeted to "reach 96% of all women in America with high weekly frequency."[120] With multiple variations, each spot began with a comedic dramatization of early twentieth-century women's daily lives, shot to mimic 1910s silent films. A manipulated frame rate accelerated the action, evoking the style of slapstick shorts, and piano music provided the score.[121] A typical version opened with a young woman walking along the shore in a demure bathing costume.[122] The unseen male announcer narrates, "In 1918, Leona Curry revealed her knees on a New Jersey beach. The nation frowned. Then she smoked a cigarette, thereby irking the establishment even more. Leona Curry was promptly arrested." After a shot of Curry behind the bars of a police vehicle, there is a cut to a 1910s suffrage bandwagon, driving down a residential street as suffragists clash cymbals and toss leaflets. The announcer exclaims, "And then in 1920, women started winning their rights!" The beat of the suffragists' drums then gives way to modern, quick-paced percussion, and the camera cuts to a fashion model in an up-to-date formal pantsuit, ruffled blouse, decorative cape, and chandelier earrings. Timed to accentuate the beat of the music, close-ups of her face are intercut with full-body shots of her posing, accompanied by the sung commentary, "You've come a long way, baby."

With this transition into the present, a female announcer takes over the narration, extolling the product's virtues as the camera pans the model's face and body, the shots superimposed with extreme close-ups of the cigarettes and their package. Filmed against a completely white backdrop, the model does nothing but smile, walk toward and away from the camera, smoke, and place the Virginia Slims pack in her purse. Her identity is centered entirely on her fashionable appearance, as the voiceover highlights the product's "slim purse pack" and cigarettes "made for feminine hands." The spot ends with a choral rendition of the lyrics "You've come a long way, baby, to get where you've got to today. You've got your own cigarette now, baby, you've come a long, long way." The 60-second commercial speeds viewers from 1920 to 1968, celebrating feminism but defining its success entirely through the existence of Virginia Slims and the physical beauty of its ideal consumer. In some versions of the commercial she applies makeup; another spot opens on the shot of a model in historical clothing, as she alters it, using scissors to produce a mod minidress.[123] As always, the modern woman performs no work and does not protest, simply posing and smoking against a white background.

African American women played unique roles in this narrative. Black models in modern clothing posed alongside white models in television ads, and they starred in print advertisements produced for *Ebony*.[124] However, the campaign's architects strove to sidestep the issue of racial equality. By omitting black models from the campaign's "nostalgic photographs," the advertisements were constructed to avoid making a claim on progress or lack of progress toward racial equality.[125] In their presentation on the campaign's origins, executives explained, "Frankly, we weren't sure, with our theme 'You've come a long way, Baby'—that we could run this advertising in *Ebony*, but why not? As long as it still comes off as a cigarette ad, not a civil rights message."[126] The women's liberation story formed the core of the brand's identity, and advertisers assumed it would appeal to African American women, but Virginia Slims ads adopted a strategic silence on African American history.

Like the women's advertising club institutional histories that presented the events of decades past as personal experiences directly relevant to young moderns, the personal address in the tagline "You've come a long way, baby" suggested that the journey over the previous fifty years belonged to the contemporary woman. Some commercials further personified feminism by addressing viewers as suffragettes. One such example opens on silent film–style footage of a woman simultaneously attending to her baby's cradle, the stove, and the dining table. The male announcer explains, "For years men told you, 'The hand that rocks the cradle is the hand that rules the world.' And for years you listened. Until one day you discovered something. You

couldn't go anywhere with your hand on the cradle. And you said, dear, you rock the cradle. I'm going out to win the vote. And you did. And soon you won a lot more."[127] Leaving her husband to care for the child, the frustrated heroine distributes suffrage leaflets to shocked barbershop patrons, before the dramatic scene shifts to the modern, young model, posing alone with her Virginia Slims.

The Leo Burnett agency reworked well-established tropes to highlight this difference between the modern consumer and her historical counterparts. One commercial placed its modern model alongside a vintage scene that was displayed like a framed painting on the wall behind her. Unlike the Armand and Avon cosmetics magazine ads of decades past that showed modern models admiring framed historical portraits, however, Virginia Slims' version derided the past. The ad begins with this mock early twentieth-century footage, depicting men and women at a dinner party with the narration stating that "back in the old days, certain rights were for men only," particularly the rights of men who retreated after the meal, "talked politics and puffed their fat cigars." The camera pulls back so that this vintage scene fills only part of the frame, allowing a model in a red pantsuit and fur-trimmed vest to walk up and station herself in front of the tableau, provoking astonishment from the men and women inhabiting it as she lights and smokes her cigarette. After the female announcer describes the product's virtues, the model walks away from the backdrop, smiling and laughing as she looks back over her shoulder at the historical scene.[128]

This juxtaposition of past and present highlighted modern fashions, and consumers later reported that aspirations to look like the campaigns' models attracted them to the brand. The costuming was glamorous, and casting selections promoted the slender form as the ideal female body type, encouraging the implicit association of the name Slim with weight control.[129] Some media commentary questioned whether this narrative of progress through consumption was valid and whether it condescended to women.[130] But Philip Morris deemed the campaign a success: Virginia Slims filtered cigarettes produced 2.8 billion units in sales in 1969, rising to 3.3 billion units in 1971, a 0.6% market share.[131] The "You've Come a Long Way, Baby" slogan gained broad cultural recognition and industry acclaim.

In reacting to the campaign, the WACC playfully cast adwomen as consumers of the male Virginia Slims messages. At its October 1968 meeting, the club welcomed the Burnett agency's slide show about the brand's development.[132] While the club's November 1968 newsletter report gave second billing to the cigarette, first emphasizing the talk by the WACC's vice president Patricia Doyle Purdy on computers, the publication's subsequent

photographic retrospective of 1968 summarized that October meeting with the image of Purdy as Virginia Slims consumer.[133] Under the heading "Happenings of 1968," the caption explained, "'You've Come a Long Way Baby,' said Lauren Williams of Philip Morris Co. to Pat Doyle Purdy, Trade Talker at October meeting, as he lights her Virginia Slims cigarette. Hal Weinstein of Leo Burnett looks on."[134]

However, Jane Trahey, who began her career as a Chicago department store copywriter before creating an independent agency in New York, later used the Virginia Slims campaign to illustrate the sexism saturating contemporary advertisements.[135] Trahey was a regular contributor to *Advertising Age*, where she published her 1970 essay "We've Come a Long Way—to What?"—a pointed critique of the cigarette campaign's premise. Trahey wrote: "I must admit that every time I see a Virginia Slims commercial I have to wonder just what we've come a long way to. As far as I can figure, we got the vote and we can now drink and smoke in public and wear wildly chic pants suits. We have freedom in fashion, according to Virginia Slims, but looking back on history, that has always been one indulgence the male kingdom has always let us have. I don't mind the manufacturers of soap and food and polish selling us what we must have anyway, but must females always come on as simperish, idiotic and nagging low I.Q. people?"[136] She implored the "fraternal members of the Advertising World" to create commercials that "let women live in a rational intelligent ambiance and act like human beings" as she protested the depictions defining modern women entirely through their consumption of cigarettes and of clothing.

While Jo Foxworth's 1965 convention speech linked improvements in women's employment opportunities with their roles as consumers, Trahey denied fashion's power to liberate. She criticized the psychological implications of advertisers' condescension toward women in a way that echoed some of Betty Friedan's arguments.[137] Advertisements' dramatizations of women entranced by "shiny floor cleaner" created a barrier to realizing the humanity of women who did, of course, want and need to buy products, but who also played other economic roles. Even when framed as a celebration of advances in women's "rights," Trahey lamented, the Virginia Slims campaign differentiated women as frivolous.

Members of the women's liberation movement shared Trahey's frustrations with the brand. On August 26, 1970, as feminists commemorated the fiftieth anniversary of the Nineteenth Amendment with a nationwide Women's Strike for Equality, they reconfigured the Virginia Slims slogan as shorthand, not for how far women had come, but for how many obstacles still remained. Chicago politician Patricia Siebert told participants: "You may have come a long way, baby . . . but you still have a long way to go."[138] Speaking to the press,

Congress member Edith Green remarked, "Despite the tirelessly iterated theme, 'You've come a long way, baby,' the facts belie it."[139] Mainstream publication *Time* voiced similar skepticism. The headline "Who's Come a Long Way, Baby?" set the tone for an editorial that lampooned many aspects of the current feminist movement while nevertheless offering detailed statistics proving the continued economic inequality of men and women.[140] Created to co-opt contemporary activism by celebrating feminist progress as a marker of the difference between past and present, the Virginia Slims campaign ultimately caused activist frustration with the persistence of familiar stereotypes. In seeking industry acceptance, women's advertising clubs had made strategic accommodations to gender stereotypes, but they had promoted women's professional capabilities by emphasizing their intelligence. Now, even as women's employment opportunities shifted, these gender stereotypes persisted.

POSITIONING THE VIRGINIA SLIMS BRAND AS A HISTORIAN OF WOMEN

In spite of criticisms, the "You've Come a Long Way, Baby" slogan dominated Virginia Slims marketing until 1996.[141] However, when the tobacco industry responded to government pressure with an agreement to end broadcasts of cigarette advertising, effective in early 1971, marketers had to develop new strategies. To preserve the brand's name recognition, Philip Morris relied on promotional gifts and on sponsorship of public events.[142] Through these campaigns, the cigarette manufacturer continued proclaiming women's historical progress and, increasingly, positioned itself as a recorder and distributor of women's histories.

Between 1970 and 2000, Philip Morris sponsored eight Virginia Slims American Women's Opinion Polls, produced in collaboration with Louis Harris and Associates and with the Roper Association to document contemporary women's reactions to feminism and other social changes.[143] These polls functioned as publicity tools rather than market research. Press releases, distributed widely to media outlets, secured news mentions for Virginia Slims.[144] Because the project produced unique data, it featured prominently in the work of journalists and activists, as they started documenting the history of modern feminism.[145] From the 1980s through the 2010s, scholars and historians have cited the polls as primary source evidence—not of marketing history but of women's social and political history. The data is often acknowledged for its attention to the opinions of African American women.[146]

This data's utility appealed to feminist Gloria Steinem. In the first issue of *Ms.*, the magazine Steinem cofounded because of existing news publications'

resistance to publishing stories about feminism, she praised *The 1972 Virginia Slims American Women's Opinion Poll,* acknowledging its Virginia Slims sponsorship but asserting that the project had transcended its "Madison Avenue origins."[147] As an editor negotiating with potential advertisers, however, Steinem opposed the messages of the "You've Come a Long Way, Baby" campaign. *Ms.* had promised readers that it would reject advertisements that objectified women, and the magazine hesitated to print Virginia Slims ads. Steinem later recalled that Philip Morris dismissed the *Ms.* staff's warnings that referring to the female consumer as "baby" and equating cigarettes with social progress would offend feminist readers. After deliberation, the magazine agreed to run one Virginia Slims ad as a trial, and the November 1972 issue featured a mail-in offer for the Virginia Slims *Book of Days* engagement calendar, touted for "anecdotes and facts and quotes about women throughout history, their loves and hates, their ups and downs."[148] Superficially, this attention to women's history echoed the magazine's own efforts. *Ms.* featured a regular column called Lost Women, designed as a corrective to women's marginalization in dominant narratives, as well as feature articles by feminist historians. In the issue containing the Virginia Slims ad, Lost Women profiled Margaret Fuller, and the article "Finding Women's History" promoted the importance of understanding not just women's suffrage but also the history of everyday life, offering Deborah Sampson Gannett, Lucy Maynard Salmon, and Sarah Josepha Hale as subjects meriting attention.[149] However, *Ms.* readers protested the presence of the Virginia Slims ad, and the publication subsequently banned the brand. The manufacturer retaliated by withdrawing advertisements for all its products, costing the fledgling publication a quarter of a million dollars in ad revenue that year.[150]

Nevertheless, Steinem continued to draw from the Virginia Slims polls to support her activism. In a 2014 *Ms.* article, she again cited the same 1972 poll data praised in the inaugural issue. Reflecting on the legacy of 1970s feminism as she received the Presidential Medal of Freedom, Steinem described "a 1972 poll by Louis Harris and Associates—the first to survey U.S. women on issues of our own equality."[151] For Steinem, the compilation of this data still marked a milestone: it reflected growing attention to the concerns of women themselves. She also championed the poll's lasting value in aiding modern understandings. Without identifying the tie to Virginia Slims this time, she cited its findings on African American women's perspectives to challenge narratives of the movement's history that placed white middle-class women's concerns at the center.[152]

While sponsoring the polls that would inform later historical interpretations, Virginia Slims navigated its post-television era by producing its own

historical narratives for immediate popular consumption. To replace the prominence of broadcast advertisements in daily life, Philip Morris offered a variety of promotional objects, including sewing needle kits, stationery, and the calendar advertised in *Ms.* These items featured photographs of historical re-enactments, including stills from the brand's early commercials.[153] In 1974, Philip Morris provided "nostalgic matches" as a gift with purchase, designed to entice smokers of competing brands.[154] The matchbook covers featured black-and-white photographs of "old-fashioned" scenes: women laboring over laundry scrub boards, playing tennis in cumbersome full-length dresses, and struggling to fit into corsets. Each image bore the credit line "From the Virginia Slims Collection," the only text printed on the matchbooks. Echoing the style of citations used to credit museums and libraries in scholarly works, the tag cast fictional dramatizations as legitimate historical documents.[155] Under this model, the product name appeared, not as a direct sales pitch, but as an acknowledgment of the brand's ostensible role in archiving women's history.

Meanwhile, seeking even greater visibility, Philip Morris offered free display posters to retailers. Featuring the advertising campaign's "sepia tone" photographs and the "YOU'VE COME A LONG WAY, BABY" tagline, but no product name or imagery, the posters promised to supplement merchandisers' own decor and sales strategies. A photograph of a woman being laced into her corset by a maid was offered to *Women's Wear Daily* readers, touted as a valuable display tool for boutiques and department stores that "will showcase the styles you're showing today with an amusing contrast of what women went through yesterday."[156] A trade press advertisement offered beauty shop proprietors the image of a woman in Victorian dress sitting in an electrical permanent wave machine, constrained by its elaborate cables.[157] Another set of display images, under the heading "The 1907 Washer-Dryer Combination," featured "put-upon ladies" laboring to launder clothes by hand. A *Merchandising Weekly* advertisement offered these posters to appliance retailers as "a nice way to remind your customers of the way things used to be."[158] In Canandaigua, New York, one retailer applied these images to his own newspaper ad.[159]

Philip Morris conducted detailed customer surveys to track the effectiveness of promotional objects. By these measures, the *Book of Days* engagement calendar, an item designed to maximize consumers' daily contact with the "You've come a long way, baby" philosophy, caused many to try Virginia Slims.[160] The hardcover book, supplying two pages for each week in the year, in addition to ample pages of illustration, was conceptualized by brand manager Ellen Merlo, who joined Philip Morris's New York headquarters in 1970 to coordinate "special projects" for Virginia Slims, including the American Women's Opinion Poll.[161] First introduced in 1971, the *Book of Days* featured

"nostalgic" and modern images from preexisting ads, supplementing them with new photographs and with historical facts and anecdotes about women's history.[162] Philip Morris printed more than one million copies of the book each year through 1979, offering it in exchange for proofs of purchase or as a free gift with purchase.[163] Like the opinion poll, the annual calendar carried the brand from the 1970s through the end of the century.

To highlight its narrative of progress, the *Book of Days* satirized earlier eras' cultural prescriptions with mock versions of vintage recipes, advertisements, and photographs interspersed in the calendar pages. For example, the 1977 datebook featured a sepia-toned spoof ad for an invented product, Washburn's Washtubs, prescribing that women devote themselves happily to "hours" spent cleaning clothes by hand. Like the Thomas Jefferson quotation about the importance of ladies' spelling skills that was placed adjacent, this faux advertisement dramatized ideals that required tedious effort. By contrast, color photographs elsewhere in the book featured smiling models posing leisurely with cigarettes and up-to-date fashions—and seemingly having more carefree fun. By mocking historical advertising's standards as burdensome and artificial, the book strove to naturalize the modern gender norms the brand was selling—and even to obscure the promotional function of the *Book of Days*.

Simultaneously, feminism of the 1800s and early 1900s provided frequent subject matter for the *Book of Days*, and a broader scope of women's histories received acknowledgment than in Virginia Slims television and magazine advertisements. Decades after Rose Arnold Powell's agitation to secure calendar commemoration for Susan B. Anthony's birthday, Philip Morris offered a February 15, 1975, annotation wishing "Happy Birthday to Susan B. Anthony (1820), a leader of women." Underneath the text stood a model dressed in a formal green pantsuit with sequined jacket, hands on her hips and a cigarette between her fingers. The book also commemorated the anniversary of Anthony's June 18, 1873, conviction for "illegal voting" in the state of New York, characterizing Anthony as a "stubborn woman." Such descriptions fell short of acknowledging Anthony's broader significance to American history as the "third great emancipator," but they did support feminism by mocking the nineteenth-century resistance to women's equality. A description of the 1848 Seneca Falls Women's Rights Convention commemorated Elizabeth Cady Stanton and Lucretia Mott by remarking sarcastically, "They adopt a Declaration of Sentiments which says novel things like, 'Men and Women are created equal.'" Women's rights activists Carrie Chapman Catt, Elizabeth Blackwell, Myra Bradwell, Lucy Stone, and Lillie Devereux Blake also received recognition.[164]

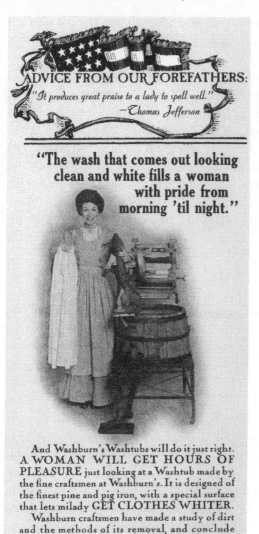

Figure 6.1. Spoofing vintage advertising, Virginia Slims contrasted modern consumers with their historical counterparts. *Book of Days: 1977 Virginia Slims Engagement Calendar* (Philip Morris, 1976). Author's collection.

In a departure from the brand's print and television advertisements, the calendar also provided specific examples of contemporary feminists' political and economic achievements. Although Philip Morris still refused to advertise any of its brands in *Ms.*, the 1975 calendar wished the magazine a "Happy

Birthday" on the anniversary of its debut.[165] Other entries acknowledged recent milestones in women's employment. In June, Mary Wells Lawrence earned the title of Woman of the Week as "former copywriter, and now chairman of the board of her own advertising agency, Wells, Rich, Greene, Inc., which billed $185 million in 1973." But other acknowledgments of women's career achievements offered playful concessions to gender stereotypes and to the assumption that marriage and motherhood remained ultimate goals. Peggy Sue Griffith earned note for her 1972 appointment as "the first woman assigned to active sea duty for the U.S. Navy"; this was followed by a playful warning that navy regulations would prohibit her from marrying a shipmate. Meanwhile, women's roles as consumers were never far from sight, no matter the era described. A description of Deborah Sampson Gannett's service in the Continental Army noted the dresses she purchased after abandoning her male identity. Smoking and Virginia Slims received frequent mention, including observance of the brand's own August 10 birth date. Simultaneously, Virginia Slims urged consumers to take pride in the historical significance of their own lives. The opening page of the 1975 book urged them to "remember" that "the history you make today is tomorrow's engagement calendar."

However, celebration of the "long way" women had traveled tended to minimize the biases that contemporary women still faced. The response of photographer Imogen Cunningham to her prospective naming as Woman of the Week in the 1973 book identified this failing. The artist rejected the proposed tribute: "Imogen Cunningham, called by many the mother of American photography, has been taking magnificent photographs since 1901." As scholar Judith Fryer Davidov observes, Cunningham had faced discrimination throughout her career, so she objected to the biography's emphasis on acclaim. She replied to Philip Morris, "I am definitely NOT the mother of photography, but the mother of three sons. When I become like Martha Washington—then you can use me. . . . If you really wanted to honor me you would give me the kind of job I can still do—and that is photographing some of those female smokers."[166] Stressing that her own maternal and professional work had not received the respect granted to Martha Washington, the octogenarian favored employment over memorialization.

For consumers and creators of the *Book of Days*, utility was also paramount. Philip Morris conducted follow-up telephone interviews with recipients, pleased when they demonstrated a high degree of recall that the calendars were Virginia Slims products and a high rate of satisfaction with the promotional items.[167] Seventy-one percent of the 1974 *Book of Days* recipients interviewed reported using the calendar.[168] When asked to describe its positive attributes, the highest percentage of consumers (24 percent) identified

its convenience.[169] Thirteen percent praised the anecdotes and sayings, while 12 percent characterized the publication as "interesting" or "informative." Eight percent of respondents praised its imagery. One participant, displeased with the book, criticized its "silly" and "women's libby" content. According to Philip Morris data, feminism did not feature in any other responses to questions about the book.[170] The following year, telephone surveys suggested similar reactions to the 1975 *Book of Days*. Thirty-eight percent of participants cited its utility as a benefit, 11 percent referred to informative content, and 8 percent cited the publication's imagery.[171]

Another promotional offer, Nostalgic Notecards from the Virginia Slims Collection, inspired more consumer attention to historical themes, but the majority of reactions focused on aesthetic appeal. The 1973 note cards combined "nostalgic images" with antique quotes providing ironic commentary: John Milton's line, "For nothing lovelier can be found in woman, than to study household good" accompanied the image of a woman overburdened by inefficient early twentieth-century household tools.[172] In a telephone survey about these cards, consumers focused on this content. In the most frequently cited positive opinion, 18.7 percent of respondents praised the illustrations. The next most popular opinion, shared by 17.6 percent of the audience, referred more specifically to the "old-fashioned pictures" or "nostalgic theme." A smaller segment, at 4.7 percent, identified a "Women's Lib Theme" as a positive attribute.[173] These responses suggest that Philip Morris had produced women's histories that consumers and scholars could interpret in a variety of ways. Some consumers identified feminist and educational value in Virginia Slims' promotional items, while others focused on aesthetics and style.

Virginia Slims advertisements had many superficial similarities with earlier popular culture feminist histories—their juxtaposition of past and present; their disdain for some of the historical norms that had limited women's activities; and even their celebration of smoking, which echoed women's advertising club performances. But Philip Morris viewed brand consumption as the greatest marker of modern triumph, minimizing the creativity of the women who shaped home and business and suggesting that women's liberation was already complete. In television and magazine ads for Virginia Slims, the intellectual abilities adwomen activists had long attributed to consumers and to businesswomen receded into the background as fashion became paramount. By contrast, it was the legacy of diverse, active contributions to business and public life, and the accompanying conviction that further progress was necessary to provide women the opportunities they deserved, that had defined popular culture's feminist histories throughout the twentieth century.

EPILOGUE

Recalling *Wonder Woman* as a childhood inspiration and criticizing the character's current incarnation, Gloria Steinem (1934–) famously resurrected the heroine's 1940s persona—when the comic touted "Wonder Woman for President"—on the inaugural 1972 cover of *Ms.* magazine.[1] *Ms.* also published an anthology of thirteen *Wonder Woman* stories from the 1940s, alongside interpretive essays by Steinem. Adopting the capitalized writing featured in *Wonder Woman*, Steinem remarked: "LOOKING BACK NOW AT THESE WONDER WOMAN STORIES FROM THE '40'S, I AM AMAZED BY THE STRENGTH OF THEIR FEMINIST MESSAGE."[2] The collection focused on Wonder Woman herself, omitting the "Wonder Women of History" biographies. However, reflecting the centrality of history to the comic's feminist message, five of the episodes juxtaposed past and present. Stories of time travel, science fiction, encounters with modern communities whose social mores were dramatically outdated, and the Amazons' origins in ancient Greece all highlighted the artificiality of gender norms.[3] Steinem included the 1943 episode of Dr. Psycho's masquerade as George Washington, characterizing that story's dialogue on female self-confidence a classic example of the serial's "sisterhood."[4] Another of Steinem's selections depicted Wonder Woman's aid to Prudence, an 1840s Western pioneer exploited by her deceitful fiancé.[5] Preaching the importance of female independence from men and of sisterly solidarity, the episode challenged twentieth-century romantic ideals. Reflecting the repetition of

familiar historical archetypes, the dilemmas of this Oregon Trail Prudence mirrored those of radio's Prudence Dane, who had debuted just three years before the 1946 comic.

Steinem positioned these stories as an important corrective to contemporary popular culture and academia. She defended the comics against accusations of triviality, arguing that Wonder Woman fulfills readers' unconscious desires for recognition of women's history. She wrote, "THE GIRL CHILDREN WHO LOVE HER ARE RESPONDING TO ONE SMALL ECHO OF DREAMS AND CAPABILITIES IN THEIR OWN FORGOTTEN PAST." Steinem hypothesized, "IF WE HAD ALL READ MORE ABOUT WONDER WOMAN AND LESS ABOUT DICK AND JANE, THE NEW WAVE OF THE FEMINIST REVOLUTION MIGHT HAVE HAPPENED LESS PAINFULLY AND SOONER."[6] An essay by feminist scholar Phyllis Chesler followed, proposing that patriarchal biases omitted real Amazonian societies in Europe, Africa, and the Americas from historical scholarship.[7] Substituting popular histories for these academic silences, *Ms.* urged contemporary feminists to connect not only with women's history but also with the media that had previously explored it.

Two decades later, when activists and commentators identified the emergence of a "third wave," feminists continued using pop culture to define the past's relationships with the present. However, by the 1990s, many young feminists expressed identification with the 1950s gender ideals that Steinem sought to displace by looking back to the 1940s.[8] Independently produced zines and publications like *Bust* magazine embraced retro styles.[9] Writing in 2000, feminist journalists Jennifer Baumgardner and Amy Richards described "girls in their twenties or thirties who are reacting to an antifeminine, antijoy emphasis that they perceive as the legacy of Second Wave seriousness. [They] have reclaimed girl culture, which is made up of such formerly disparaged girl things as knitting, the color pink, nail polish, and fun." Baumgardner and Richards quoted an activist who found herself "buying pictures of these very coquettish pinup women at antique shows, and putting them up on the wall," observing, "I feel like I am trying to reconnect with this part of myself."[10] Such women enjoyed the "feminine" artifacts of previous decades, interpreting this aesthetic choice as free expression, symbolic of individuals' ability to create their own identities and to enjoy social equality.

In other cases, activists used vintage source material to build larger narratives about their own modern experiences. For example, an issue of Neely Bat Chestnut's 2006 self-published zine *Mend My Dress* juxtaposed clippings of images from Disney's *Cinderella* (1950) film, fragments of publications about 1950s mental hospitals, and personal commentary from Chestnut

about her relationship with her grandmother. As scholar Alison Piepmeier notes, this bricolage criticizes the repressive function of gender ideals while simultaneously reflecting Chestnut's own professed identification with the Cinderella character.[11] Placing familiar imagery in new contexts, zine authors shared strategies with earlier feminists and consumers who worked to supply new backstories for cultural archetypes. Feminist efforts to archive this self-published third wave ephemera further reflect this continuum. As scholar Kate Eichhorn argues, university archives and special collections began acquiring activists' zine libraries in the 1990s, suggesting that "Riot Grrrl—a movement defined by an explosive repertoire of gestures, styles, performances, rallying cries, and anonymous confessions reproduced on copy machines . . . was also a movement that had been collecting, preserving, and preparing itself for the archive all along."[12] Thus—like suffragists, adwomen activists, and feminist historians from the early and mid-twentieth century—many third wave feminists produced popular histories for immediate consumption by their contemporaries, simultaneously strategizing for this work to become primary source evidence for later scholars.

In another parallel with earlier decades, turn-of-the-twenty-first-century products capitalized on such feminist histories. On stationery, housewares, and fashion accessories, designer Anne Taintor juxtaposed vintage commercial imagery with sarcastic new captions, demonstrating a supposed chasm separating midcentury mannerisms and contemporary candor about women's lives. (In one image, a smiling, apron-clad model gestures towards a fully stocked 1950s refrigerator. The superimposed text supplies her dialogue: "Make your own damn dinner.")[13] Echoing earlier works from the feminist art movement and the pop art movement, such reappropriation of outmoded imagery often highlighted the artificiality of social norms while asserting links between women past and present.[14]

Commercial entertainments of the 2000s also wielded retro aesthetics. Acclaimed television drama *Mad Men* (2007–2015) made mid-twentieth-century Madison Avenue an object of complex nostalgia, dramatizing the lives of ad agency employees at work and at home from 1960 through 1970. The show inspired Internet fansites dissecting the characters' style, and Banana Republic stores offered profitable tie-in clothing collections helmed by the series' costume designer, Janie Bryant.[15] Although some viewers emulated the fashions of *Mad Men*'s 1960s, critics, scholars, and fans also read its narrative for critical insights on history. At the fictional Sterling Cooper agency, female characters struggle against discrimination. Secretary Joan Holloway (Christina Hendricks) provides essential, but underrecognized, management, before slowly advancing within the company and ending the

series as an entrepreneur. The transition of Peggy Olson (Elisabeth Moss) from secretary to copywriter is marked by injustice: male coworkers exclude her from crucial meetings, dismiss her talents, and treat her as a sexual object. The series thus sympathizes with compromises its female characters make in a male-dominated economy. However, adwomen's organizations and activism are absent, and the plot suggests that women's prominence in creative advertising positions was new and rare in the 1960s. By contrast, the Advertising Women of New York (AWNY), in the midst of the show's timeline, celebrated its fiftieth anniversary by publicizing a feminist history of adwomen that promoted expansions in women's employment opportunities. In the *New York Times*, AWNY announced social events to gather adwomen isolated at their own workplaces, an overture that could have reached women like Peggy.[16] Focusing its stories elsewhere, *Mad Men* detaches its characters from this genealogy, leaving them naive about the extent to which women before them had challenged gender oppression.

Nevertheless, the series' depictions of workplace sexual harassment and the restrictive domestic ideal for middle-class white women inspired reflections on modern cultural change. Writing in the *Washington Post* that "'Mad Men' is TV's most feminist show," historian Stephanie Coontz praised the program's accuracy in "portray[ing] the sexism of that era so unflinchingly" that it offered the public "a much-needed lesson on the devastating costs of a way of life that still evokes misplaced nostalgia."[17] Citing the series to advocate a modern feminist cause, Barack Obama's 2014 State of the Union address criticized the twenty-first-century pay gap between men and women and endorsed expansions to family leave by remarking, "It's time to do away with workplace policies that belong in a *Mad Men* episode." Resonating with the public, this was reported as the speech's "most-tweeted moment."[18] After inspiring such reflection, the AMC network positioned the show as a unique type of historical milestone. Publicity for the 2015 series finale included the donation of props to the Smithsonian Institution's National Museum of American History.[19] These items—including authentic clothing, cigarette packaging, and liquor bottles from the 1960s—would now be artifacts of American history and of the popular culture celebrating that history.[20]

As *Mad Men* viewers celebrated some of the program's stylistic depictions of femininity, while simultaneously disdaining other gender norms in the show's fictionalized historical world, corporate sponsors reworked the show's themes to promote products. The resulting advertisements reflected twenty-first-century popular culture's continued tendency to tell women's history as a story of continuity in behavior and norms across time. A Clorox bleach campaign alluded playfully to admen's sexism while naturalizing gender

differences. A promotional message featured on the program's second season DVDs offered the tagline "Getting ad guys out of hot water for generations," accompanying the image of a man's shirt with lipstick on the collar. While businessmen's philandering continued across time, according to this promotion, so did women's housework. Also included on the DVD, a commercial dramatizing domestic laundry room scenes from Clorox's 1913 debut through the present equated the product's quality with women's devotion to domesticity. A female announcer accompanies the montage by asserting, "Laundry is not new. Your mother, your grandmother, her mother, they all did the laundry." Paired with images of 1970s fashion and decor, the voiceover acknowledges the effects of feminism with the statement that "maybe even a man or two" has also contributed. The spot ends with an emphasis on the continued effectiveness of Clorox, in the face of changing styles.[21] Similar pitches had served national brands for more than a century, and in spite of the brief nod to men's potential contributions in the modern household, this advertisement continued elevating homemaking to the status of women's historical legacy. Such examples reflect the persistence of common tropes, in spite of changes in women's roles and in media. Gendered historical narratives have long been embedded into common advertising images and into everyday objects.

American women have long used the past as a consciousness-raising tool. But their narratives have often obscured earlier feminist histories by asserting that culture, like academia, has previously ignored women's pasts. Ingrained in everyday life, mass culture's diverse, conflicting depictions of history pose challenges to historians and activists. Popular texts can be both liberating and repressive. Their complex authorship encompasses feminist and commercial perspectives. Without considering the gendered histories that have been integrated into popular culture throughout the past century, we cannot fully understand the work feminists face when they set out to construct usable pasts or to deepen understandings of history's complexities.

NOTES

INTRODUCTION

1. On nineteenth- and twentieth-century feminists' strategic uses of history, see Lisa Tetrault, *The Myth of Seneca Falls: Memory and the Women's Suffrage Movement, 1848–1898* (Chapel Hill: University of North Carolina Press, 2014) and Judith M. Bennett, *History Matters: Patriarchy and the Challenge of Feminism* (Philadelphia: University of Pennsylvania Press, 2006).

2. Bonnie G. Smith, *The Gender of History: Men, Women, and Historical Practice* (London: Harvard University Press, 1998), 7–9, 157–160.

3. Julie Des Jardins, *Women and the Historical Enterprise in America: Gender, Race, and the Politics of Memory, 1880–1945* (Chapel Hill: University of North Carolina Press, 2003), 17–18; Anne H. Wharton, *Martha Washington* (New York: Charles Scribner's Sons, 1897), vii, quoted in Des Jardins, *Women and the Historical Enterprise*, 18; see Susan Reynolds Williams, *Alice Morse Earle and the Domestic History of Early America* (Amherst: University of Massachusetts Press, 2013), 1–15.

4. Des Jardins, *Women and the Historical Enterprise*, 3, 124.

5. Francesca Morgan, *Women and Patriotism in Jim Crow America* (Chapel Hill: University of North Carolina Press, 2005), 1–2, 63, 127, 139–142.

6. Des Jardins, *Women and the Historical Enterprise*, 4.

7. Ibid., 124.

8. Ibid., 64–68.

9. Morgan, *Women and Patriotism*, 133–134.

10. Jennifer Scanlon, *Inarticulate Longings: The Ladies' Home Journal, Gender, and the Promises of Consumer Culture* (New York: Routledge, 1995); Simone Weil Davis, *Living Up to the Ads: Gender Fictions of the 1920s* (Durham, NC: Duke University Press, 2000); Denise H. Sutton, *Globalizing Ideal Beauty: Women, Advertising, and the Power of Marketing* (New York: Palgrave Macmillan, 2009).

11. Nancy F. Cott, *The Grounding of Modern Feminism* (New Haven, CT: Yale University Press, 1987), 4–5.

12. Nancy Hewitt, "Feminist Frequencies: Regenerating the Wave Metaphor," *Feminist Studies* 38, no. 3 (2012): 658.

13. For pioneering analyses of feminism between the 1920s and the 1960s, see Dorothy Sue Cobble, *The Other Women's Movement: Workplace Justice and Social Rights in Modern America* (Princeton, NJ: Princeton University Press, 2004); Cott, *The Grounding*

of Modern Feminism; Lois Scharf and Joan M. Jensen, *Decades of Discontent: the Women's Movement, 1920-1940* (Boston: Northeastern University Press, 1987); and Susan Ware, *Beyond Suffrage: Women in the New Deal* (Cambridge, MA: Harvard University Press, 1981). Reexaminations of the wave model include Nancy Hewitt, ed., *No Permanent Waves: Recasting Histories of U.S. Feminism* (New Brunswick, NJ: Rutgers University Press, 2010).

14. Mary K. Trigg, *Feminism as Life's Work: Four Modern American Women through Two World Wars* (New Brunswick, NJ: Rutgers University Press, 2014), 203-204.

15. Hewitt, "Feminist Frequencies," 668.

16. In the 1980s and 1990s, cultural historians assessed monuments, museums, family genealogies, historical tourism, reenactments, and television documentaries. Although gender was not the focus, some scholars considered ideals of womanhood, as in George Lipsitz's analysis of early television's depictions of the past. Tony Horwitz, *Confederates in the Attic: Dispatches from the Unfinished Civil War* (New York: Pantheon, 1998); Roy Rosenzweig and David Thelen, *The Presence of the Past: Popular Uses of History in American Life* (New York: Columbia University Press, 1998); George Lipsitz, *Time Passages: Collective Memory and American Popular Culture* (Minneapolis: University of Minnesota Press, 1990), 77-96.

17. Michael Kammen, *Mystic Chords of Memory: The Transformation of Tradition in American Culture* (New York: Vintage Books, 1993), 300.

18. David Lowenthal, *The Past Is a Foreign Country* (New York: Cambridge University Press, 1985).

19. Karal Ann Marling, *George Washington Slept Here: Colonial Revivals and American Culture, 1876-1986* (Cambridge, MA: Harvard University Press, 1988), 15-20.

20. William Leach, *Land of Desire: Merchants, Power, and the Rise of a New American Culture* (New York: Vintage Books, 1993), 162, 276-277; Scanlon, *Inarticulate Longings*, 16.

21. Margaret Finnegan, *Selling Suffrage: Consumer Culture and Votes for Women* (New York: Columbia University Press, 1999); Grace Elizabeth Hale, *Making Whiteness: The Culture of Segregation in the South, 1890-1940* (New York: Vintage Books, 1998).

22. Finnegan, *Selling Suffrage*, 10; Alan Dawley, *Struggles for Justice: Social Responsibility and the Liberal State* (Cambridge, MA: Harvard University Press, 1991), 305; T. J. Jackson Lears, *Fables of Abundance: A Cultural History of Advertising in America* (New York: Basic Books, 1994).

23. M. M. Manring, *Slave in a Box: The Strange Career of Aunt Jemima* (Charlottesville: University Press of Virginia, 1998), 110-148.

24. J. E. Smyth, *Reconstructing American Historical Cinema: From "Cimarron" to "Citizen Kane"* (Lexington: University Press of Kentucky, 2006), 13-14, 284-285.

25. Pamela Robertson, *Guilty Pleasures: Feminist Camp from Mae West to Madonna* (Durham, NC: Duke University Press, 1996), 25-53; Susan Sontag, "Notes on 'Camp,'" in *Against Interpretation and Other Essays* (New York: Delta, 1966), 285.

26. William L. Bird Jr., *"Better Living": Advertising, Media, and the New Vocabulary of Business Leadership, 1935-1955* (Evanston, IL: Northwestern University Press, 1999), 72-85; Erik Christiansen, *Channeling the Past: Politicizing History in Postwar America* (Madison: University of Wisconsin Press, 2013), 61.

27. Christiansen, *Channeling the Past*, 100-103.

28. Wendy L. Wall, *Inventing the "American Way": The Politics of Consensus from the New Deal to the Civil Rights Movement* (New York: Oxford University Press, 2008); Ian Tyrrell, *Historians in Public: The Practice of American History, 1890-1970* (Chicago: University of Chicago Press, 2005).

29. Christiansen, *Channeling the Past*, 23.

30. Pamela Walker Laird, *Pull: Networking and Success since Benjamin Franklin* (Cambridge, MA: Harvard University Press, 2006), 56.

31. Roland Marchand, *Advertising the American Dream: Making Way for Modernity, 1920–1940* (Berkeley: University of California Press, 1985), 8.

32. League of Advertising Women By-Laws, quoted in 1917–1918 Program, AWNY Scrapbook 2, SHSW. On the league's early history, see Scanlon, *Inarticulate Longings*, 62; and Stephen R. Fox, *The Mirror Makers: A History of American Advertising and Its Creators* (Urbana: University of Illinois Press, 1997), 286.

33. Scholarship incorporating the personal and institutional records Dignam donated to SHSW and to SL includes Davis, *Living Up to the Ads*; Vicki Howard, *Brides, Inc.: American Weddings and the Business of Tradition* (Philadelphia: University of Pennsylvania Press, 2006); Laird, *Pull*; Lears, *Fables of Abundance*; Marchand, *Advertising the American Dream*; Kathy Peiss, *Hope in a Jar: The Making of America's Beauty Culture* (New York: Metropolitan Books, 1998); Blain Roberts, *Pageants, Parlors, and Pretty Women: Race and Beauty in the Twentieth-Century South* (Chapel Hill: University of North Carolina Press, 2014). A fictionalized Dignam, based on SL material, appears in a novel: J. Courtney Sullivan, *The Engagements* (New York: Random House, 2013).

34. Bertha Fenberg, "Began Her Writing Career in Early Childhood," *Chicago Daily News*, June 28, 1929, clipping in Dorothy Dignam, Scrapbook, "The Development of a Copywriter: An album of samples of published work by and publicity about the donor," DDPW; Dorothy Dignam, Diary, vol. 7, January 17, 1918, Box 2, DDPSL; Dorothy Dignam, Diary, vol. 6, 1916, Memoranda section, Box 2, DDPSL; "Advertising Careers for Women," radio typescript, April 6 [1940], Box 1, Folder 3, DDPW.

35. Articles included coverage of DAR activities. Dorothy Dignam, "Most Attractive War Shop Is Found," *Women's Press*, February 9, 1928; Dorothy Dignam, "Transform Stevens Building into Huge War Time Work Shop," *Women's Press*, January 26, 1918, both in Dorothy Dignam, Scrapbook, DDPW.

36. Irene Sickel Sims, "Greetings to the Women's Advertising Club of Chicago at Its Fiftieth Anniversary Dinner!," November 13, 1967, Box 3, Folder 33, WACCP.

37. "Martha Washington Bags, Greetings to Heroines in France," *Women's Press*, February 23, 1918, in Scrapbook, DDPW.

38. Ibid.

39. Dorothy Dignam, Diary, vol. 7, January 22, 1918, Box 2, DDPSL; Dorothy Dignam, Diary, vol. 8, May 15, 1919, Box 2, DDPSL.

40. Dorothy Dignam, Diary, vol. 7, September 17, 1919, Box 2, DDPSL; Dorothy Dignam, Diary, vol. 8, November 4, 1919, Box 2, DDPSL.

41. Dorothy Dignam, Diary, vol. 9, October 5, 1920, Box 2, DDPSL.

42. Dorothy Dignam, Diary, vol. 8, October 6, 1919, Box 2, DDPSL.

43. Dorothy Dignam, Diary, vol. 10, October 10, 1921, Box 2, DDPSL.

44. Dorothy Dignam insurance record, Series 19, Box 6, File 11, Ayer.

45. Dignam was not part of the four-member committee that developed the Quaker Maid emblem. Report of the Club Emblem Committee, June 17, 1929, Scrapbook, 1928–1929, PCAWR.

46. Box 1, Radio Programs Folder, PCAWR.

47. Dorothy Dignam, "When Women Were Back-Seat Drivers," *Philadelphia Record*, November 10, 1935, in Scrapbook, DDPW.

48. Finding aid, "Dorothy Dignam Papers, 1907–1962," SHSW, http://digicoll.library .wisc.edu.

49. Howard, *Brides, Inc.*, 49–50.

50. Mary E. Lewis and Dorothy Dignam, *The Marriage of Diamonds and Dolls, Including the History of American Bridal Customs* (New York: H. L. Lindquist, 1947); J. Courtney Sullivan, "How Diamonds Became Forever," *NYT*, May 5, 2013.

51. Dorothy Dignam to Dear Sir, December 15, 1944, Box 1, Folder 1, DDPW. Dignam noted that she sent other materials from her mother's collections to the Indianapolis Public Library, New York Public Library, and Museum of Costume Art. Dorothy Dignam, War Diary, 1944, 209, Microfilm M-82, DDPSL.

52. Dorothy Dignam to Dear Sir, December 15, 1944.

53. Finding aid, "Dorothy Dignam Papers, 1907–1962," SHSW.

54. The word "*Historic*" is underlined on the document. Dorothy Dignam to Dear Sir, December 15, 1944.

55. Dorothy Dignam to Helen Berg, June 22, 1951, Carton 2, Digests—Historical Overview of Early Women in Advertising Folder, AWNY 86–M216, SL.

56. Dorothy Dignam, "To Mary Reinmuth for February AdLibber," n.d., Carton 2, Digests—from 1912 Folder; Dorothy Dignam, "Yesterday's Corner," *AdLibber*, January 1952, 4, Carton 2, Digests—Historical Overview of Early Women in Advertising, 1890s Folder; Dorothy Dignam, "Yesterday's Corner," *AdLibber*, April 1952, 3, Carton 2, Digests—Historical Overview of Early Women in Advertising, 1890s Folder, all in AWNY 86–M216, SL.

57. Dorothy Dignam, "Biography to 'Tell All' about Club Past," n.d., Carton 2, Founders—History of AWNY Folder, AWNY 86–M216, SL.

58. Dorothy Dignam to Mabel Stringer, January 7, 1952, Carton 2, Digests—Historical Overview of Early Women in Advertising, 1890s Folder, AWNY 86–M216, SL.

59. Catherine Elsie Ryan, ed., *Golden Salute to Advertising* (New York: Advertising Federation of New York, 1962).

60. Dorothy Dignam, "Biographer's Statement," n.d., Carton 2, Digests Folder, AWNY 86–M216, SL; Dorothy Dignam to Wilbur Jordan, September 22, 1960, and Barbara Miller Solomon to Dorothy Dignam, February 27, 1964, Carton 2, Smith and Radcliffe Letters 1962 Folder, AWNY 86–M216, SL.

61. Betty Friedan, *The Feminine Mystique*, 20th anniversary ed. (Laurel: New York, 1984), 82, 124.

62. Ibid., 80–102.

63. Joanne Meyerowitz, "Beyond the Feminine Mystique: A Reassessment of Postwar Mass Culture, 1946–1958," *Journal of American History* 79, no. 4 (1993): 1481; Daniel Horowitz, *Betty Friedan and the Making of the Feminine Mystique: The American Left, the Cold War, and Modern Feminism* (Amherst: University of Massachusetts Press, 2000), 203.

64. Meyerowitz, "Beyond the Feminine Mystique," 1482.

CHAPTER 1 — MARTHA WASHINGTON (WOULD HAVE) SHOPPED HERE:
WOMEN'S HISTORY IN MAGAZINES AND EPHEMERA, 1910–1935

1. Karal Ann Marling, *George Washington Slept Here: Colonial Revivals and American Culture, 1876–1986* (Cambridge, MA: Harvard University Press, 1988), 12.

2. Cultural studies scholarship demonstrates the importance of considering reception and the dialectical relationship between production and consumption. Janice A. Radway, *Reading the Romance: Women, Patriarchy, and Popular Literature* (Chapel Hill: University of North Carolina Press, 1984); Victoria E. Bonnell and Lynn Hunt, eds. *Beyond the Cultural Turn: New Directions in the Study of Society and Culture* (Berkeley and Los Angeles: University of California Press, 1999); James W. Cook, Lawrence B. Glickman, and Michael O'Malley, eds., *The Cultural Turn in U.S. History: Past, Present, and Future* (Chicago: University of Chicago Press, 2012).

3. Ellen Gruber Garvey, *The Adman in the Parlor: Magazines and the Gendering of Consumer Culture, 1880s to 1910s* (New York: Oxford University Press, 1996), 1–5; Ellen

Gruber Garvey, foreword to *Blue Pencils and Hidden Hands: Women Editing Periodicals, 1830–1910*, ed. Sharon M. Harris (Boston: Northeastern University Press, 2004), xi.

4. Jennifer Scanlon, *Inarticulate Longings: The "Ladies' Home Journal," Gender, and the Promises of Consumer Culture* (New York: Routledge, 1995), 6–7.

5. For examples of colonial romantic couple imagery in *Good Housekeeping*, see August 1911, title page; June 1911, 776; and May 1913, 659. For images of colonial women performing household tasks, see Irene Nash Scott, "Housekeeping Gone Mad," *GH*, June 1911, 777; and Lucy M. Salmon, "On Beds and Bedding," *GH*, June 1911, 781. *Good Housekeeping* is digitized in the Home Economics Archive: Research, Tradition, and History, Cornell University, http://hearth.library.cornell.edu/h/hearth/.

6. Temple Bailey, "Burning Beauty," *McCall's*, October 1928, 13–15; Arthur Somers Roche, "Modern Merry-Go-Round," *McCall's*, February 1934, 28, 30. See also *McCall's*, October 1930, 128, 141; May 1930, 69.

7. Gardner Teall, "Women Sculptors of America," *GH*, August 1911, 175–187; Octave Uzanne, "The Tyrant Rule of the Corset," translated by Lady Mary Lloyd, *GH*, August 1911, 209–218.

8. Mary Field Parton and Bertrand Zadig, "Your Girl Makes Good," *McCall's*, November 1930, 4, 44; Elisabeth May Blondel, "Gifts and Greetings—Plan Them Early," *McCall's*, November 1930, 100; Mary Ellen Zuckerman, "*McCall's*," in Kathleen L. Endres and Therese L. Lueck, *Women's Periodicals in the United States: Consumer Magazines* (Westport, CT: Greenwood, 1995), 218.

9. Mary Louise Roberts, *Disruptive Acts: The New Woman in Fin-de-Siècle France* (Chicago: University of Chicago Press, 2002), 76, 244–246.

10. Ibid., 47.

11. Bertha E. Shapleigh, "A Suffrage Luncheon," *GH*, January 1914, 136.

12. On suffragist influence in magazines and advertisements, see Scanlon, *Inarticulate Longings*, 126–136, 183–188; and Margaret Finnegan, *Selling Suffrage: Consumer Culture and Votes for Women* (New York: Columbia University Press, 1999), 45–75, 111–138.

13. On the flapper aesthetic, see Lois W. Banner, *American Beauty: A Social History through Two Centuries of the American Idea, Ideal, and Image of the Beautiful Woman* (Los Angeles: Figueroa Press, 2005), 253–55, 311–313.

14. Resinol advertisement, *Woman's Home Companion*, February 1922, 112.

15. Karen Joyce Kriebl, "From Bloomers to Flappers: The American Women's Dress Reform Movement, 1840–1920" (PhD diss., Ohio State University, 1998), 111–123; Angela J. Latham, *Posing a Threat: Flappers, Chorus Girls, and Other Brazen Performers of the American 1920s* (Hanover, NH: Wesleyan University Press, 2000), 54–62; Jill Fields, "'Fighting the Corsetless Evil': Shaping Corsets and Culture, 1900–1930," *Journal of Social History* 33, no. 2 (1999): 355–384; Patricia A. Cunningham, *Reforming Women's Fashion, 1850–1920: Politics, Health, and Art* (Kent, OH: Kent State University Press, 2003), 219–220.

16. Gossard advertisement, *Woman's Home Companion*, September 1921, 69.

17. Selby Shoe Company advertisement, *GH*, March 1922, 144A; *Woman's Home Companion*, April 1922, 89.

18. Pamela Walker Laird, *Pull: Networking and Success since Benjamin Franklin* (Cambridge, MA: Harvard University Press, 2006), 60–68.

19. Julie Des Jardins, *Women and the Historical Enterprise in America: Gender, Race, and the Politics of Memory, 1880–1945* (Chapel Hill: University of North Carolina Press, 2003), 120–121.

20. *GH*, September 1916, 173.

21. Christopher J. Lukasik, *Discerning Characters: The Culture of Appearance in Early America* (Philadelphia: University of Pennsylvania Press, 2011), 134–139.

22. Gwendolyn DuBois Shaw, *Seeing the Unspeakable: The Art of Kara Walker* (Durham, NC: Duke University Press, 2004), 19–30.

23. Frank Mehring, "Hard-Boiled Silhouettes: Transnational Remediation and the Art of Omission in Frank Miller's *Sin City*," in *Transnational Perspectives on Graphic Narratives: Comics at the Crossroads*, ed. Daniel Stein, Shane Denson, and Christina Meyer (London and New York: Bloomsbury Academic, 2013), 219.

24. This imagery appeared in multiple issues. See, for example, Evelyn Northington, "Beauty Hints: The Perfect Foot," *Half-Century Magazine*, January 1920, 11; and Leona Eldridge Porter, "Domestic Science: A Variety of Good Things," *Half-Century Magazine*, January 1920, 16, reprinted in *The Black Experience in America: Negro Periodicals in the United States, 1840–1960* (New York: Negro Universities Press, 1969). The tagline appeared on the cover of select issues: for example, see, *Half-Century Magazine*, February 1920 in *Black Experience in America*.

25. Noliwe M. Rooks, *Ladies' Pages: African American Women's Magazines and the Culture That Made Them* (New Brunswick, NJ: Rutgers University Press, 2004), 22–23, 68–70.

26. Bonnie G. Smith, *The Gender of History: Men, Women, and Historical Practice* (London: Harvard University Press, 1998), 7–9, 157–160; Des Jardins, *Women and the Historical Enterprise*, 4, 17, 67–68.

27. Nicholas Adams and Bonnie G. Smith, "Introduction: Lucy Maynard Salmon and the Texture of Modern Life," in *History and the Texture of Modern Life: Selected Essays by Lucy Maynard Salmon*, ed. Nicholas Adams and Bonnie G. Smith (Philadelphia: University of Pennsylvania Press, 2001), 1–25.

28. Ibid., 1–7.

29. Lucy Maynard Salmon, "History in a Back Yard," in *History and the Texture of Modern Life*, ed. Adams and Smith, 82.

30. Adams and Smith, "Introduction," 11–12. "History in a Back Yard" was printed privately. A compilation appeared posthumously: Lucy Maynard Salmon, *Historical Material* (New York: Oxford University Press, 1933).

31. "Domestic Service by Lucy Maynard Salmon," *GH*, April 1897, 180.

32. Mary P. Hamlin, "The Beauty of the House Is Order: A Plea for Just a Little More Dirt and Much More Order and Happiness," *GH*, December 1910, 692–696, quoted in Louise Fargo Brown, *Apostle of Democracy: The Life of Lucy Maynard Salmon* (New York: Harper, 1943), 196.

33. Lucy M. Salmon, "On Economy," *GH*, January 1911, 98–101, and February 1911, 251–253; Salmon, "On Beds and Bedding," 781–782.

34. Salmon, "On Economy," 253.

35. Ibid., 101.

36. Salmon, "On Beds and Bedding," 781.

37. Adams and Smith, "Introduction," 23.

38. Ibid., 16; Chara Haeussler Bohan, *Go to the Sources: Lucy Maynard Salmon and the Teaching of History* (New York: Peter Lang, 2005), 68–69.

39. "Kitchen Literature," *NYT*, April 8, 1926.

40. L.M.S., letter to the editor, *NYT*, April 12, 1926.

41. Briann Greenfield, *Out of the Attic: Inventing Antiques in Twentieth-Century New England* (Amherst: University of Massachusetts Press, 2009), 1–55.

42. Helen Sheumaker, "True Collector: The Collecting Narratives of Alice Van Leer Carrick," *Journal of the History of Collections* 25, no. 1 (2013): 119–135.

43. Alice Van Leer Carrick, "To Our Foremothers!" *GH*, December 1920, 16.

44. Ibid., 17, 144.

45. Ibid., 144–145.

46. Ibid., 146–147; Alice Morse Earle, *Colonial Dames and Good Wives* (Boston: Houghton Mifflin, 1895), 55–56.

47. Carrick, "To Our Foremothers!," 147.

48. Ibid.

49. Kimberly Jensen, *Mobilizing Minerva: American Women in the First World War* (Urbana: University of Illinois Press, 2008), 2; Finnegan, *Selling Suffrage*, 58–59.

50. Ellen Carol DuBois, *Harriot Stanton Blatch and the Winning of Woman Suffrage* (New Haven, CT: Yale University Press, 1997), 136.

51. "New York Women in Huge Parade Demand Ballot," *Chicago Daily Tribune*, May 7, 1911, 1, PQHN.

52. Deborah Gray White, *Too Heavy a Load: Black Women in Defense of Themselves, 1894–1994* (New York: W. W. Norton, 1999), 21–23, 29–31.

53. Ibid., 123–132.

54. Hallie Q. Brown, comp. and ed., *Homespun Heroines and Other Women of Distinction* (Xenia, OH: Aldine Press, 1926; reprint, Freeport, NY: Books for Libraries Press, 1971), iii; Lisa E. Rivo, "Hallie Quinn Brown," in *African American Lives*, ed. Henry Louis Gates and Evelyn Brooks Higginbotham (New York: Oxford University Press, 2004), 107–109.

55. Josephine Turpin Washington, foreword to Brown, *Homespun Heroines*, v.

56. White, *Too Heavy a Load*, 130–131.

57. Hallie Q. Brown, "Sojourner Truth," in Brown, *Homespun Heroines*, 15–17.

58. Nettie L. Ransom, "C. J. Walker," in Brown, *Homespun Heroines*, 220; Des Jardins, *Women and the Historical Enterprise*, 135–136.

59. W. E. B. Du Bois, "The Browsing Reader," *Crisis*, June 1927, 129.

60. For example, see *Crisis*, July 1925, back cover.

61. *Wanamaker Diary*, 1909, 272, Box 83, WP.

62. For example, see *Wanamaker Diary*, 1909, 65, 85–87, 118–120.

63. Advertisement, February 21, 1921, Box 247, WP.

64. Advertisement, "American Housewives Today Enjoy What Martha Washington Could Not!" *GH*, February 1924, 121.

65. Advertisement, "Dolly Madison, Hostess Incomparable!" *GH*, March 1924, 192.

66. Advertisement, "American Housewives Today Enjoy What Martha Washington Could Not!"

67. Martha Washington held dower rights over slaves owned by her first husband. Henry Wiencek, *An Imperfect God: George Washington, His Slaves, and the Creation of America* (New York: Farrar, Straus and Giroux, 2004), 354.

68. Ruth Schwartz Cowan, *More Work for Mother: The Ironies of Household Technology from the Open Hearth to the Microwave* (New York: Basic Books, 1983), 89–101, 175–178; Nancy F. Cott, *The Grounding of Modern Feminism* (New Haven, CT: Yale University Press, 1987), 162–163.

69. Agnes Hooper Gottlieb, "*Good Housekeeping*," in Endres and Lueck, *Women's Periodicals in the United States*, 124; Angel Kwolek-Folland, *Incorporating Women: A History of Women and Business in the United States* (New York: Twayne, 1998), 87.

70. Advertisement, "Dolly Madison, Hostess Incomparable!"

71. Advertisement, "A Seamstress Was Mother of Our Flag," *GH*, April 1924, 221.

72. Laurel Thatcher Ulrich, *Good Wives: Image and Reality in the Lives of Women in Northern New England, 1650–1750* (New York: Knopf, 1982), 8–9, 51–67; Jeanne Boydston, *Home and Work: Housework, Wages, and the Ideology of Labor in the Early Republic* (New York: Oxford University Press, 1990).

73. *GH*, September 1924, 214, Series 3, Box 517, Ayer.

74. Cowan, *More Work for Mother*, 89–101, 178–179, 62–65.

75. Anthony M. Sammarco, *The Baker Chocolate Company: A Sweet History* (Charleston, SC: The History Press, 2011), 9, 15, 46, 110.

76. James Beniger, *The Control Revolution: Technological and Economic Origins of the Information Society* (Cambridge, MA: Harvard University Press, 1989), 336; Richard B. Franken and Carroll B. Larrabee, *Packages That Sell* (New York: Harper and Brothers, 1928), 91.

77. Franken and Larrabee, *Packages That Sell*, 91.

78. *GH*, January 1924, 75.

79. *McCall's*, November 1929, 73; *GH*, November 1929, 167. Ellipses in original.

80. *McCall's*, October 1929, 44; *GH*, October 1929, 226. A similar advertisement appeared in *McCall's*, December 1929, 55.

81. *McCall's*, March 1930, 137.

82. *McCall's*, January 1930, 93.

83. *McCall's*, January 1930, 57; *McCall's*, December 1929, 50.

84. *McCall's*, January 1930, 57.

85. M. M. Manring, *Slave in a Box: The Strange Career of Aunt Jemima* (Charlottesville: University Press of Virginia, 1998).

86. Karen L. Cox, *Dreaming of Dixie: How the South Was Created in American Popular Culture* (Chapel Hill: University of North Carolina Press, 2011), 42–43.

87. "Mrs. F. D. Roosevelt Becomes Partner in Novel Business," *New York Sun*, May 16, 1927, Box 2, "Roosevelt, Mrs. Franklin D." file, LTPP.

88. "Names of Prominent Women Who Have Endorsed Simmons Beds," April 20, 1927, Box 1, Spool Beds Folder, LTPP.

89. Blanche Wiesen Cook, *Eleanor Roosevelt*, vol. 1, *1884–1933* (New York: Viking, 1992), 320–325, 332, 419–420; Blanche Wiesen Cook, *Eleanor Roosevelt*, vol. 2, *The Defining Years, 1933–1938* (New York: Penguin, 2000), 360–362.

90. George S. Fowler to Miss Eaton, April 14, 1927, Box 1, "Women Endorsers-General, 1926–1927, Sept." file, LTPP.

91. Scanlon, *Inarticulate Longings*, 7–8, 132–133, 187–194.

92. A. G. Casseres, "Simmons: Concerning Public Interest in Names," May 10, 1927, Box 1, "Women Endorsers-General, 1926–1927, Sept." file, LTPP. On Casseres's career and suffragist background, see Denise H. Sutton, *Globalizing Ideal Beauty: Women, Advertising, and the Power of Marketing* (New York: Palgrave Macmillan, 2009), 33–35.

93. Advertising copy, "Mrs. J. Borden Harriman . . . Mrs. Charles Tiffany . . . Mrs. Charles Dana Gibson," January 27, 1927, 2, Box 2, Gibson Folder, LTPP.

94. Advertising copy, letter enclosure to Mabel Choate, February 24, 1928, Box 1, Choate Folder, LTPP.

95. Advertisements, "In the Delightfully Contrasting Homes of Mrs. Frederic Cameron Church Jr. and Mrs. Joseph Leiter"; and "Exceedingly Comfortable," both in Series 2D1, Box 117, Folder 1, SCR.

96. Advertisement, "Among America's Distinguished Women Who Have Chosen Simmons Sleeping Equipment for Their Homes," n.d., Box 117, Folder 1, SCR.

97. "Mrs. F. D. Roosevelt and Associates Are Making Furniture," *New York Herald Tribune*, May 14, 1927, Box 2, "Roosevelt, Mrs. Franklin D." file, LTPP; Cook, *Eleanor Roosevelt*, vol. 1, 332; Simmons advertisement, *Vogue*, May 15, 1927, 129.

98. George S. Fowler to Aminta Casseres, May 17, 1927, Box 2, "Roosevelt, Mrs. Franklin D." file, LTPP.

99. "Mrs. F. D. Roosevelt Becomes Partner in Novel Business."

100. Diana Rice, "Mrs. Roosevelt Tells of Woman-Run Factory," *NYT*, November 16, 1930, X13, PQHN.

101. Simmons Company, promotional newspaper, 1929, Box 117, Folder 1, SCR.

102. Lucile T. Platt to Miss Lampe, June 25, 1929, Box 2, "Roosevelt, Mrs. Franklin D." file, LTPP.

103. Louis Torres, "Historic Resource Study: Eleanor Roosevelt National Historic Site (Val-Kill), Hyde Park, New York" (Denver: Denver Service Center, National Park Service, August 1980), 116–121.

104. Simmons Company, promotional newspaper, 1929.

105. "Women's Exposition Opens Tomorrow," NYT, October 5, 1930, N3, PQHN.

106. Rice, "Mrs. Roosevelt Tells of Woman-Run Factory."

107. Cook, Eleanor Roosevelt, vol. 1, 332, 420.

108. Kathy Peiss, Hope in a Jar: The Making of America's Beauty Culture (New York: Metropolitan Books, 1998), 100; Advertisement, n.d., Series 2, Box 206, Book 386, Folder 2, Ayer; Advertising proof, 57 G, 1924, Series 2, Box 205, Book 383, Ayer.

109. Advertising proofs, Series 2, Box 205, Book 384, Ayer.

110. Advertising proof, Christian Science Monitor, July 7, 1927, Series 2, Box 205, Book 384, Ayer.

111. Advertising proof, 44 A L 1927, Series 2, Box 205, Book 384, Ayer.

112. Advertising proof, 44 Z 1927, Series 2, Box 205, Book 384, Ayer.

113. Advertising proof, Ladies' Home Journal, May 1928, and advertising proof, Christian Science Monitor, February 16, 1928, both in Series 2, Box 205, Book 384, Ayer.

114. Advertising proof, Woman's World, April 1928, Series 2, Box 205, Book 384; Advertising proof, Christian Science Monitor, February 6, 1928, Series 2, Box 205, Book 384; Advertising proof, Better Homes and Gardens, April 1928, Series 2, Box 205, Book 384; Advertising proof, Holland's, April [1928], Series 2, Box 204, Folder 2, Book 382, all in Ayer. See also, GH, April 1928, 191.

115. Peiss, Hope in a Jar, 61–96.

116. Crisis, May 1925, back cover; Crisis, July 1925, back cover.

117. Crisis, July 1925, 154.

118. Crisis, May 1925, back cover.

119. Advertising proof, 30 M 1918, Series 2, Box 206, Book 386, Folder 2, Ayer. Cleopatra also appeared prominently in Palmolive facial soap ads. Advertisement, "Keep That Schoolgirl Complexion," Photoplay, 1921, Ad Access, Duke University Libraries, http://library.duke.edu/digitalcollections/adaccess_BH0999/.

120. McJunkin Advertising Company proof, Job No. 3810, Holland's, April 1924, Package 1, DDPW; Peiss, Hope in a Jar, 150.

121. Blain Roberts, Pageants, Parlors, and Pretty Women: Race and Beauty in the Twentieth-Century South (Chapel Hill: University of North Carolina Press, 2014), 41, 78; Peiss, Hope in a Jar, 149–150.

122. Dorothy Dignam, annotation on McJunkin Advertising Company proof, Job No. 6231, newspapers, 1924, Package 1, DDPW. In material accompanying her archival donation, Dignam stated that the 1920s cosmetics advertisements reflected her responsibility for "(1) copy appeal (2) subject and form of picture (3) text and (4) carry-through trade and retail copy when it was called for." Dorothy Dignam, "Contribution of Miss Dorothy Dignam, Writer," August 1960, Box 1, Folder 2, DDPW.

123. William Henry Chafe, Civilities and Civil Rights: Greensboro, North Carolina, and the Black Struggle for Freedom (New York: Oxford University Press, 1980).

124. McJunkin Advertising Company proof, Job No. 6231.

125. "Nadine Advertising for 1926," booklet, Package 1, DDPW.

126. Roberts, Pageants, Parlors, and Pretty Women, 78.

127. Claude Lévi-Strauss, The Savage Mind (Chicago: University of Chicago Press, 1966).

128. Elaine S. Abelson, *When Ladies Go A-Thieving: Middle-Class Shoplifters in the Victorian Department Store* (New York: Oxford University Press, 1990), 52; William Leach, *Land of Desire: Merchants, Power, and the Rise of a New American Culture* (New York: Vintage Books, 1993), 80–81.

129. *Wanamaker Diary*, 1909, 392, Box 83, WP.

130. Leach, *Land of Desire*, 81.

131. *Wanamaker Diary*, 1912, 102, 48, LCP.

132. Molly A. McCarthy, *The Accidental Diarist: A History of the Daily Planner in America* (Chicago: University of Chicago Press, 2013), 234–238.

133. Annotations in the *Wanamaker Diary* included customers' reports of store patronage and product preferences. Consumers documented their disinterest in some advertisements, pasting or writing over them. McCarthy, *Accidental Diarist*, 201–220.

134. Diary of Margaret Moffat, *Wanamaker Diary*, 1914, 191, 246, 359, Box 83, WP.

135. *Wanamaker Diary*, 1914, 11.

136. Ibid., 67–68.

137. Ibid., 53.

138. Ibid., 246.

139. Diary of Margaret Moffat, *Wanamaker Diary*, 1914.

140. McCarthy, *Accidental Diarist*, 211–212.

141. Estes scrapbook, Box 34, Archives Center Scrapbooks Collection, Archives Center, NMAH. Suggesting Emma Estes's authorship, the book contains greeting cards addressed jointly to Mr. William A. Estes and Mrs. Emma E. Estes, and other cards addressed to Emma alone, with no documents identifying William as the sole recipient.

142. 1900 United States Federal Census, Clifton, Alleghany, Virginia; 1910 United States Federal Census, Clifton, Alleghany, Virginia; 1920 United States Federal Census, Clifton, Alleghany, Virginia; 1930 United States Federal Census, Iron Gate, Alleghany, Virginia, all in Ancestry.com (Provo, UT: Ancestry.com Operations, 2006).

143. On nostalgic modernism, see Michael Kammen, *Mystic Chords of Memory: The Transformation of Tradition in American Culture* (New York: Vintage Books, 1993), 300.

144. Estes scrapbook.

145. Undated clippings, Estes scrapbook: "Cabinet Wives Differ in Choice of Pursuits," *George Washington's Travels*, First National Bank advertisements.

146. Ellen Gruber Garvey, *Writing with Scissors: American Scrapbooks from the Civil War to the Harlem Renaissance* (New York: Oxford University Press, 2012).

147. Library of Congress Copyright Office, *Catalogue of Copyright Entries, New Series: 1932, Part 1* (Washington, DC: Library of Congress, 1933), 288. The columns also appeared in book form: James W. Brooks, *George Washington's Travels: An All-Picture Story of His Journeyings by Mount and Coach in Founding the American Republic* (Washington, DC: American Highway Educational Bureau, 1932).

148. Undated clippings, James W. Brooks, *George Washington's Travels*, Estes scrapbook.

149. "Cabinet Wives Differ in Choice of Pursuits," Estes scrapbook.

150. Leigh Eric Schmidt, *Consumer Rites: The Buying and Selling of American Holidays* (Princeton, NJ: Princeton University Press, 1995), 97.

151. Miscellaneous cards, Series 1I, Box 18, Norcross Greeting Card Collection, Archives Center, NMAH; Modern Vogue Company, Inc., "Modern Vogue Decorated Gift-Wrapping Papers," ca. 1930s, Box 1, Folder 1, Bernard Levine Sample Book Collection, Archives Center, NMAH.

152. "Scrapbook of Competitors' Cards," Series 3F, Box 14, Norcross Greeting Card Collection.

153. Telegram from Geo Busey to Bernice Dutrieuille, January 5, 1933, Box 8, Folder 3, BDSP.

154. Manring, *Slave in a Box*, 155–157; Paul K. Edwards, *The Southern Urban Negro as a Consumer* (New York: Prentice-Hall, 1932).

155. Correspondence, December 9, 1929–December 26, 1929, Box 3, Folder 5, BDSP; Christmas Cards 1932, Box 8, Folder 2, BDSP; Christmas Cards 1935, Box 11, Folder 8, BDSP.

156. Emilie to Mrs. G. A. Shelton, December 20, 1935, Box 11, Folder 8, BDSP; Nino Guillermo E. Rodgers Jr. to Bernice Shelton, n.d., Box 11, Folder 8, BDSP.

157. Bernice Dutrieuille, typed manuscript, "Negro Women in Journalism," n.d., Series IV, Box 27, Folder 6, BDSP; Bernice Dutrieuille, typed manuscript, "Double Col. from Feminine Point of View," n.d., Series II, Box 25, Folder 4, BDSP.

158. Barry Shank, *A Token of My Affection: Greeting Cards and American Business Culture* (New York: Columbia University Press, 2004), 193–197.

CHAPTER 2 — "THE QUAKER GIRL TURNS MODERN": HOW ADWOMEN PROMOTED HISTORY, 1910–1940

1. Simone Weil Davis, *Living Up to the Ads: Gender Fictions of the 1920s* (Durham, NC: Duke University Press, 2000); T. J. Jackson Lears, *Fables of Abundance: A Cultural History of Advertising in America* (New York: Basic Books, 1994); Pamela Walker Laird, *Pull: Networking and Success since Benjamin Franklin* (Cambridge, MA: Harvard University Press, 2006); Juliann Sivulka, *Ad Women: How They Impact What We Need, Want, and Buy* (Amherst, NY: Prometheus Books, 2009).

2. Susan A. Glenn, *Female Spectacle: The Theatrical Roots of Modern Feminism* (Cambridge, MA: Harvard University Press, 2000), 4.

3. Nancy F. Cott, *The Grounding of Modern Feminism* (New Haven, CT: Yale University Press, 1987); Mary K. Trigg, *Feminism as Life's Work: Four Modern American Women through Two World Wars* (New Brunswick, NJ: Rutgers University Press, 2014).

4. Nancy Hewitt, "Feminist Frequencies: Regenerating the Wave Metaphor," *Feminist Studies* 38, no. 3 (2012): 658.

5. Cott, *Grounding of Modern Feminism*, 134–142.

6. Ibid., 128; Trigg, *Feminism as Life's Work*, 9–11.

7. Cott, *Grounding of Modern Feminism*, 136–137.

8. Board meeting minutes, February 18, 1935, Minute Book, vol. 3, PCAWR.

9. "What Does the Equal Rights Amendment Mean to You as a Business Woman?" *Ad Chat*, November 1938, Box 4, Item 8, WACCP, Supplement II; Sheila Houle Oscar, "A Decade of Service to Advertising and the Community, 1968–1978: A Current History of the Women's Advertising Club of Chicago," Box 2, Folder 15, WACCP, Supplement 95–03. The WACC was considering the ERA after the 1938 Fair Labor Standards Act had expanded federal protections for workers of both genders, lessening the concerns of some advocates of feminist protective legislation about the proposed amendment. Nancy F. Cott, ed., *Mary Ritter Beard through Her Letters* (New Haven, CT: Yale University Press, 1991), 243.

10. Roland Marchand, *Creating the Corporate Soul: The Rise of Public Relations and Corporate Imagery in American Big Business* (Berkeley: University of California Press, 1998), 44–47.

11. "Women Winning Laurels in Field of Advertising," *Christian Science Monitor*, June 20, 1922, 11, PQHN.

12. The Modern Girl Around the World Research Group, "The Modern Girl as Heuristic Device: Collaboration, Connective Comparison, Multidirectional Citation," in *The Modern Girl Around the World: Consumption, Modernity, Globalization*, ed. Modern

Girl Around the World Research Group (Alys Eve Weinbaum, Lynn M. Thomas, Priti Ramamurthy, Uta G. Poiger, Madeleine Y. Dong, and Tani E. Barlow) (Durham, NC: Duke University Press, 2008), 1–24.

13. Trigg, *Feminism as Life's Work*, 70.

14. Ibid., 4; Elaine Showalter, ed., *These Modern Women: Autobiographical Essays from the Twenties*, rev. ed. (New York: Feminist Press, 1989).

15. Trigg, *Feminism as Life's Work*, 8, 92–93.

16. Lears, *Fables of Abundance*, 88–99; Roland Marchand, *Advertising the American Dream: Making Way for Modernity, 1920–1940* (Berkeley: University of California Press, 1985), 7–9.

17. *Printers' Ink*, March 16, 1916, 107.

18. Advertisement, *Printers' Ink Monthly*, January 1928, 79–80.

19. Janet Cunningham, "Type in Advertising," March 24, 1931, Box 3, Folder 5; and William Day, "Importance of Strategy in Copy," June 4, 1930, Box 2, Folder 4, JWTA Staff Meeting Minutes Collection.

20. Howard Henderson, "Advertising Roots Go Deep," April 6, 1937, Box 6, Folders 1 through 5, JWTA Staff Meeting Minutes Collection.

21. Lears, *Fables of Abundance*, 209; Marchand, *Advertising the American Dream*, 33–35.

22. Davis, *Living Up to the Ads*, 80–104; Jennifer Scanlon, *Inarticulate Longings: The Ladies' Home Journal, Gender, and the Promise of Consumer Culture* (New York: Routledge, 1995), 62; Dorothy Dignam, "Club Growth," Carton 2, "Digests from 1912" folder, AWNY 86–M216, SL.

23. Scanlon, *Inarticulate Longings*, 61–76; Sivulka, *Ad Women*, 148–153.

24. Bruce Roche, *A Unifying Voice: A Centennial History of the American Advertising Federation, 1905–2005* (Washington, DC: American Advertising Federation, 2005); Dorothy Dignam, "Date of A. F. A. Affiliation of Women's Clubs," Carton 2, "Women's Clubs in A.F.A." folder, AWNY 86–M216, SL.

25. Lears, *Fables of Abundance*, 209; undated clipping, "Upon Attaining Success," *Forbes Magazine*, AWNY Scrapbook, vol. 2, SHSW; Untitled clipping, December 17, 1916, *New York Tribune*, AWNY Scrapbook, vol. 2, SHSW; "Miss Jane J. Martin and Her $10,000 Salary," *New York City Herald*, February 11, 1917, AWNY Scrapbook, vol. 2, SHSW; Bessie Kempton, "Atlanta Women Prominent in Advertising Work," *Atlanta Constitution*, June 12, 1921, E8, PQHN.

26. Scanlon, *Inarticulate Longings*, 80.

27. "Women Trained in Business Make Best Wives and Mothers," *Syracuse Herald*, January 29, 1913, AWNY Scrapbook, vol. 1, SHSW.

28. Allyne V. Scheerer, untitled clipping, *Publishers' Guide: A Monthly Journal for all Departments of the Publishing Business*, January 1913, 34, AWNY Scrapbook, vol. 1, SHSW.

29. Rose D. Westion, "Suffragist Ad Women Want Publicity Men to Adopt Their Plank," *North American*, June 29, 1916, AWNY Scrapbook, vol. 2, SHSW.

30. "Miss Jane J. Martin and her $10,000 salary," *New York Herald*, February 11, 1917, AWNY Scrapbook, vol. 2, SHSW.

31. League of Advertising Women, 1917–1918 Program, AWNY Scrapbook, vol. 2, SHSW.

32. "Gentlemen Prefer Advertising Women" Program, June 23, 1926, AWNY Scrapbook, vol. 18. SHSW.

33. League of Advertising Women, Costume ball invitation, n.d.; Unidentified clipping, "Pictures of Ad Women's Costume Appear in Rotogravure," n.d.; "Ad Women at Costume Ball," *American Printer*, December 20, 1921; "Centuries Fashions Shown at

Fancy Ball," *Morning Telegraph*, December 11, 1921, all in AWNY Scrapbook, vol. 4, SHSW.

34. "Miss Jane Martin," unidentified clipping; "So This, Then, Is Miss Jane Martin," unidentified clipping; "Gold Not Enough," *New York Journal*, December 27, 1921; "Success Enough for Woman? No!" *Superior Telegram* [WI], December 21, 1921; "Her Headdress Is Colonial, but Her Salary Is Modern," *Chicago Daily Tribune*, January 3, 1922, all in AWNY Scrapbook, vol. 4, SHSW.

35. Invitation, postmarked February 28, 1928, AWNY Scrapbook, vol. 7, SHSW; "Advertising Women Hold Dance," *NYT*, March 21, 1928, 46, PQHN.

36. Minute Book, vol. 1, PCAWR; *The Poor Richard Club: Its Birth, Growth, and Activities; and Its Influence on Advertising, the City, State, and Nation* (Philadelphia: Poor Richard Club, 1953), 37.

37. "Advertising Women Confer for National Organization," *Advertising and Selling*, July 1916, 49, AWNY Scrapbook, vol. 2, SHSW.

38. Minutes, April 11, 1922, Minute Book 1, PCAWR.

39. Minutes, March 10, 1936, Minute Book 3, PCAWR; Program, "Federation of Women's Advertising Clubs of the World," Twelfth Annual Meeting, July 8–12, 1928, 26, in Scrapbook, 1928–1929, PCAWR.

40. Program, "Federation of Women's Advertising Clubs of the World," Twelfth Annual Meeting, July 8–12, 1928, 26, in Scrapbook, 1928–1929, PCAWR.

41. Mary Denton to Club Members, August 20, 1927, Scrapbook, 1928–1929, PCAWR.

42. Minute Book 1, 138–189, PCAWR.

43. Syllabus and review sheet, May 17, 1928, and exam, May 21, 1928, Scrapbook, 1928–1929, PCAWR.

44. Program, 1921, Colonial Dinner-Dance Folder, Box 1, PCAWR. The script for this toast was handwritten inside the back cover.

45. The Photo-Illustrators, "Procession of Poor Richard Club Members down Locust Street, Philadelphia," ca. 1925, Library Company Prints Department; Minute Book 1, 46, PCAWR; *Adland News*, December 1928, 2, PCAWR; *Adland News*, February 1931, 8, PCAWR.

46. Edward Muschamp, "Poor Richard Club Spoke for City in Honoring Ben Franklin," *Editor and Publisher*, January 29, 1921, 9–10.

47. Program, Poor Richard Club, *The Twenty-Eighth Annual Dinner*, January 17, 1933, HSP, Pennsylvania Room.

48. Laird, *Pull*, 60–68.

49. Poor Richard Club, *The Book of the Twenty-Second Annual Banquet of the Poor Richard Club*, January 17, 1927, 30, 39, 20, 9, HSP, Pennsylvania Room.

50. Ibid., 9, 13.

51. Report of the Club Emblem Committee, June 17, 1929, Scrapbook, 1928–1929, PCAWR; "Poor Richard Club, Philadelphia, Club Pin," in U.S. Government Print Office, *Catalog of Copyright Entries*, part IV, vol. 16, 1919, 5393.

52. Program, Second Annual Dinner Dance, February 12, 1918, Box 1, PCAWR; David Berg and Alfred Solman, "There's a Quaker down in Quaker Town" (New York: Joe Morris Music, 1916), Series 10.19 A, the Sam DeVincent Illustrated Sheet Music Collection, Archives Center, NMAH.

53. Program, Dinner Dance of the Philadelphia Club of Advertising Women, February 14, 1919, Box 1, PCAWR.

54. James Emmett Ryan, *Imaginary Friends: Representing Quakers in American Culture, 1650–1950* (Madison: University of Wisconsin Press, 2009), 187–222; Jennifer L. Connerley, "Quaker Bonnets and the Erotic Feminine in American Popular Culture," *Material Religion* 2, no. 2 (2006): 174–203; Jennifer Connerley, "Friendly

Americans: Representing Quakers in the United States, 1850–1920" (PhD diss., University of North Carolina, Chapel Hill, 2006), 153–154.

55. Connerley, "Friendly Americans," 153–156.

56. Ibid., 4.

57. Ibid., 27, 206–208, 227–228. Quaker efforts to restrict commercial uses of the religion, a response to alcohol advertising, failed in the 1910s.

58. Ibid., 6, 147.

59. Ibid., 83–86, 153–154. Quakers did not attribute the bonnet to scripture or to the subordination of women.

60. Margaret Finnegan, *Selling Suffrage: Consumer Culture and Votes for Women* (New York: Columbia University Press, 1999); "New York Women in Huge Parade Demand Ballot," *Chicago Daily Tribune*, May 7, 1911, 1, PQHN.

61. Connerley, "Friendly Americans," 180–188.

62. "'A Quaker Girl' Is Fascinating," *NYT*, November 6, 1910, 13; "Musical Comedy in English Great Attraction in Paris," *Chicago Daily Tribune*, June 25, 1911, A1; "Scotch Comedy Delights New York; Miss Burke in New Play," *Christian Science Monitor*, October 14, 1911, 16; "'The Quaker Girl' a Hit; 'The Million' Also Pleases," *Washington Post*, October 29, 1911, A2; "'Quaker Girls' Bar Johnnies," *Atlanta Constitution*, October 7, 1912, 2, all in PQHN.

63. James T. Tanner, Adrian Ross, and Percy Greenbank, *The Quaker Girl* (London: Chappell, 1910), 10, Performing Arts Reading Room, Library of Congress.

64. Ibid., 22.

65. "'Quaker Girls' Bar Johnnies"; Grace Kingsley, "No Chance for Johnnies," *Los Angeles Times*, November 21, 1912, III4, PQHN.

66. R. H. White Co. advertisement, *Boston Daily Globe*, January 21, 1912, 12; G. A. Simon Co. advertisement, *Hartford Courant*, March 14, 1912, 6; Butler's advertisement, *Boston Daily Globe*, March 29, 1912, 4; Mandel Brothers' advertisement, *Chicago Daily Tribune*, February 11, 1912, F8, all in PQHN.

67. "Tango-Mad, Man-Aping Maid of Easy Codes Is Giving Way to New Girl of Puritan Type, Miss Ermel Says," *Washington Post*, September 26, 1915, ES13, PQHN; "Says Puritanism to Be Revived—Girls to Demand Better Morals," *Day Book* (Chicago), August 25, 1915, 14–15, Chronicling America: Historic American Newspapers, Library of Congress.

68. Grace Margaret Gould, "Why Clothes?" *McClure's*, November 1917, 12, APS.

69. Quotes appear in Edward Doherty, "Trail to Flyer's Slayer Haunted by 'Quaker Girl,'" *Chicago Daily Tribune*, February 21, 1923, 11, PQHN. References to this "Quaker Girl" also appear in "Widow Gives Police Clews," *Los Angeles Times*, February 21, 1923, II, 1, PQHN.

70. L. M., "To a Quaker Maid in Fashion," *Life*, April 28, 1927, 20, APS.

71. "As Four Women Hear It," *Atlanta Constitution*, July 24, 1927, D6, PQHN.

72. "Quaker Maids Await Democrats—Congressmen Prepare for Journey Home," *Los Angeles Times*, June 22, 1936, 20, PQHN.

73. Marc Levinson, *The Great A&P and the Struggle for Small Business in America* (New York: Macmillan, 2011), 93. A&P advertisements in *Pittsburgh Courier*, November 10, 1928, 3; January 5, 1929, 3; July 20, 1929, 3; August 24, 1929, 3; and *New York Amsterdam News*, May 8, 1929, 3, all in PQHN.

74. *Pittsburgh Courier*, October 1, 1932, 7, PQHN.

75. See, for example: A&P advertisements, *Pittsburgh Courier*, April 29, 1933, 7; and December 9, 1933, 5, PQHN.

76. For example, *Atlanta Daily World*, October 21, 1932, 2; and *Pittsburgh Courier*, October 1, 1932, 7, both in PQHN.

77. For example, *Pittsburgh Courier*, April 16, 1932, 7; and *New York Amsterdam News*, April 21, 1934, 5, both in PQHN.

78. Report of the Club Emblem Committee, June 17, 1929, Scrapbook, 1928–1929, PCAWR.

79. Pins and charms, Miscellaneous History Folder, Box 12, PCAWR. The figure remained the dominant design element for *Adland News* through November 1946.

80. "La Danse Moderne" program, 1930, Danse Moderne Folder, Box 1, PCAWR.

81. Silhouette portraiture was part of American Quaker history. Colonial Quakers who followed plain dress linked portrait sitting with vanity, but some late eighteenth-century Friends commissioned simple silhouettes. Dianne C. Johnson, "Living in the Light: Quakerism and Colonial Portraiture," in *Quaker Aesthetics: Reflections of a Quaker Ethic in American Design*, ed. Emma Jones Lapsansky and Anne A. Verplanck (Philadelphia: University of Pennsylvania Press, 2002), 122; Emma Jones Lapsansky, "Past Plainness to Present Simplicity: A Search for Quaker Identity," in *Quaker Aesthetics*, ed. Lapsansky and Verplanck, 12.

82. "Report on the Fourteenth Annual Dinner Dance of the Philadelphia Club of Advertising Women," Scrapbook, Box 10, PCAWR.

83. *Adland News*, February 1930, Danse Moderne Folder, Box 1, PCAWR.

84. "A Night in the Nineties" program, February 20, 1931, Box 10, PCAWR.

85. "Elections and Fashions," *Adland News*, Midsummer 1936, Box 10, PCAWR. Ellipses appear in the original. Harry S. Hood, photograph of bathing costume, Photographs Folder, Box 12, PCAWR.

86. Dorothy Dignam, "Women's Driver Manual," n.d., typed transcript, Box 2, Folder 2, DDPW.

87. Dorothy Dignam, "Up the Ladder We Must Go," 1933, speech script, Box 3, Folder 19, DDPSL. Quoted in Sivulka, *Ad Women*, 192–193.

88. "News and Notes of the Advertising Field," *New York Times*, June 19, 1939, PQHN; Sylvia Emery to Dorothy Dignam, November 23, 1939, Box 1, Folder 1, DDPW; *Useful to the Community*, 1948, 9, Box 12, PCAWR. On the development of academic advertising curricula, see Donald G. Hileman and Billy Ross, *Toward Professionalism in Advertising: The Story of Alpha Delta Sigma's Aid to Professionalize Advertising through Advertising Education, 1913–1969* (Dallas, TX: Taylor, 1969).

89. Blanche Clair and Dorothy Dignam, eds., *Advertising Careers for Women: Twenty-Two Lectures on Advertising Vocations* (New York: Harper & Brothers, 1939). AWNY later published its own text. Mary Margaret McBride, ed., *How to Be a Successful Advertising Woman: A Career Guide for Women in Advertising, Public Relations, and Other Fields* (New York: McGraw Hill, 1948).

90. Philadelphia Club of Advertising Women, *Silver Anniversary*, 1941, 21, unlabeled box, PCAWR.

91. Invitation to Vocation-Vacation Conference, June 8, 1939, Box 2, Folder 2, DDPW.

92. Elsie Weaver, foreword to Clair and Dignam, *Advertising Careers for Women*, x.

93. Blanche Clair, "The Next Move Is Yours," in Clair and Dignam, *Advertising Careers for Women*, 251.

94. Christine Frederick, introduction to Clair and Dignam, *Advertising Careers for Women*, xiii–xiv.

95. Ibid., xvii–xviii.

96. Ibid., xx–xxi.

97. Inger L. Stole, *Advertising on Trial: Consumer Activism and Corporate Public Relations in the 1930s* (Urbana: University of Illinois Press, 2006), x–xi, 106–116.

98. Cynthia B. Meyers, *A Word from Our Sponsor: Admen, Advertising, and the Golden Age of Radio* (New York: Fordham University Press, 2014), 104–105.

99. Anna Steese Richardson, *Let's Scrap It* (New York: Crowell, 1935).

100. Flier, n.d.; "Review of the Year's Production of Let's Scrap It by the PCAW," n.d., both in Box 1, "'Let's Scrap It' Folder," PCAWR.

101. Kristin L. Hoganson, *Consumers' Imperium: The Global Production of American Domesticity, 1865–1920* (Chapel Hill: University of North Carolina Press, 2007), 137–140; Patricia Campbell Warner, *When the Girls Came Out to Play: The Birth of American Sportswear* (Amherst: University of Massachusetts Press, 2006), 156.

102. Alys Eve Weinbaum, "Racial Masquerade: Consumption and Contestation of American Modernity," in *Modern Girl Around the World*, ed. Modern Girl Around the World Research Group, 126.

103. Ibid., 128.

104. Ruth E. Clair, "Welcome to the Gay Nineties," *Adland News*, February 1931, Box 10, PCAWR.

105. "An Egyptian Holiday" invitation, September 14, 1930, Box 1, Egyptian Holiday Folder, PCAWR; Mrs. John G. Fleck, "Radio Play Over WFIL," Scrapbook, Box 10, PCAWR.

106. Fleck, "Radio Play Over WFIL."

107. "An Egyptian Holiday" program, October 17, 1930, Box 1, Egyptian Holiday Folder, PCAWR.

108. Edith Ellsworth to Dear Girls, n.d., Box 1, Egyptian Holiday Folder, PCAWR.

109. "An Egyptian Holiday" invitation, September 14, 1930.

110. Elizabeth Bronfen, "Cleopatra's Venus" in *Ancient Worlds in Film and Television: Gender and Politics*, ed. Almut-Barbara Renger and Jon Solomon (Leiden and Boston: Brill, 2012), 137–150.

111. Unsigned letter carbon, September 14, 1930, to Mrs. Quennel, Box 1, Egyptian Holiday Folder, PCAWR.

112. Edith Ellsworth to members, September 22, 1930; unsigned letter to Emily, September 14, 1930, both in Box 1, Egyptian Holiday Folder, PCAWR.

113. Henrietta Harrison to Edith Ellsworth, n.d., Box 1, Egyptian Holiday Folder, PCAWR. Sample references to "Old Egypt" are in Estelle H. Ries, "The Seats of the Mighty: The Development of the Chair," *GH*, August 1927, 58; and "Shadows of Old Egypt," *Outlook*, January 19, 1921, 88, APS.

114. Howard Cox, *The Global Cigarette: Origins and Evolution of British American Tobacco, 1880–1945* (Oxford: Oxford University Press, 2000), 259–261; William Wesley Young, *The Story of the Cigarette* (New York: D. Appleton, 1916), 56–58.

115. "Supper Dance Receipts," Box 1, Egyptian Holiday Folder, PCAWR.

116. Amira Jarmakani, *Imagining Arab Womanhood: The Cultural Mythology of Veils, Harems, and Belly Dancers in the U.S.* (New York: Palgrave Macmillan, 2008), 117–122; Fatima packaging, Box 16, Virgil Johnson Collection of Cigarette Packages, Archives Center, NMAH. Print advertising featured the logo prominently. See, for example, Series 2, Box 414, Folder 1, Ayer.

117. Unsigned, "Dear Marie," September 16, 1930, Box 1, Egyptian Holiday Folder, PCAWR.

118. Ann to Edith Ellsworth, n.d., Box 1, Egyptian Holiday Folder, PCAWR.

119. Matthew Frye Jacobson, *Whiteness of a Different Color: European Immigrants and the Alchemy of Race* (Cambridge, MA: Harvard University Press, 1998), 5; Jane Nicholas, *The Modern Girl: Feminine Modernities, the Body, and Commodities in the 1920s* (Toronto: University of Toronto Press, 2015), 100–109.

120. Blanche to Edith Ellsworth, n.d., Box 1, Egyptian Holiday Folder, PCAWR.

121. "Report on Supper Dance," Box 1, Egyptian Holiday Folder, PCAWR.

122. Invitation, Box 1, Southern Serenade Folder, PCAWR.

123. Photograph and clipping, *Philadelphia Record*, February 27, 1940, *Philadelphia Record* Photograph Collection, V7:3062, HSP; 1938–1939 PCAW Roster, Box 12, PCAWR.

124. Plantation breakfast invitation, Box 1, Southern Serenade Folder, PCAWR.

125. Tara McPherson, *Reconstructing Dixie: Race, Gender, and Nostalgia in the Imagined South* (Durham, NC: Duke University Press, 2003), 23–27, 55–65.

126. "A Quaker Maid at Ocean City," *Philadelphia Tribune*, September 6, 1924, 11, PQHN.

127. "Omega Bal Masque Provides Bright Note Despite the Soft Pedal on Philly's Lenten Season," *Chicago Defender*, April 9, 1938, 14, PQHN.

128. Monique Borque, "Register of the Papers of Bernice Dutrieuille Shelton, 1913–1983, MSS 131," HSP.

129. "Bits by Bernice," n.d., clipping, Series III, Box 26, Folder 14, BDSP.

130. "Report on Prospective Members Contacted but Not Obtained as Members," Box 10, Membership Campaign File—1932, PCAWR.

PCAW bylaws did not address race, but these 1932 records note suspicion that a woman nominated for membership was African American, ending her candidacy. Not until the 1955–1956 club year did Freda DeKnight join the Women's Advertising Club of Chicago, becoming the first African American member of any Advertising Federation of America affiliate. Women's Advertising Club of Chicago, *A Half Century of Service to Advertising and the Community*, Box 3, Folder 31, WACCP.

131. Course syllabi and assignments, 1935, Box 16, Folder 14, BDSP; Untitled typed manuscript, n.d., Series III, Box 25, Folder 6, BDSP; Bernice Dutrieuille-Shelton, "Business and Professional Women—1938 Model," n.d., typed manuscript, Series III, Box 25, Folder 6, BDSP.

132. Bernice Dutrieuille, "Negro Women in Journalism," n.d., typed manuscript, Series IV, Box 27, Folder 6, BDSP; Bernice Dutrieuille, "Double Col. From Feminine Point of View," n.d., typed manuscript, Series II, Box 25, Folder 4, BDSP.

133. The records of women's advertising clubs in New York, Philadelphia, and St. Louis contain invitations and correspondence from other cities' clubs. The Women's Advertising Club of St. Louis archived publications by the Philadelphia and Chicago women's advertising clubs alongside their own. See copies of Philadelphia's *Adland News* and Chicago's *AdChat* in reel 1, vol. 3, AWSL.

134. "Panoramic Review as Presented at W.A.C. Silver Anniversary Party," October 27, 1941, reel 1, vol. 3, AWSL.

135. Marie Capp and Bea Adams, "Washington Bi-Centennial Luncheon Bridge," reel 1, vol. 1, AWSL.

136. Victoria Sherrow, *Encyclopedia of Hair: A Cultural History* (Westport, CT: Greenwood, 2006), s.v. "Marcel Wave."

137. George Chauncey, *Gay New York: Gender, Urban Culture, and the Making of the Gay Male World* (New York: Basic Books, 1994), 328.

138. Marjorie Garber, *Vested Interests: Cross-Dressing and Cultural Anxiety* (New York: Routledge, [1992] 2011), 60.

139. "History of Gridiron," 1942, unidentified clipping, reel 1, vol. 3, AWSL.

140. "St. Louis Stages Its Own Gridiron Show," *Look*, May 10, 1949, 90.

141. Unidentified photo caption clipping, March 24, 1939; and "Gridiron Dinner Skits by Women's Ad Club," *St. Louis Post-Dispatch*, March 24, 1939, reel 1, vol. 2, AWSL; "Ad Women Rewrite Classics for Skits," *St. Louis Post-Dispatch*, February 28, 1939, reel 1, vol. 2, AWSL.

142. Mary Kimbrough, "Headaches and Laughs Dot History of Gridiron," *St. Louis Star-Times*, March 4, 1949, reel 2, vol. 7, AWSL.

143. "Gridiron Dinner Skits by Women's Ad Club."

144. June R. Geraghty, "Romeo Spurns Juliet," *Flying Horse*, March 31, 1939, reel 1, vol. 2, AWSL.

145. "Gridiron Dinner Skits by Women's Ad Club."

146. "Women Finally Let Men See Gridiron Skit," *St. Louis Star-Times*, April 4, 1940, reel 1, vol. 2, AWSL.

147. *Adventure: Women's Advertising Club News of St. Louis*, October 1934, cover; *Adventure: Women's Advertising Club News of St. Louis*, May 1934, cover, both in reel 1, vol. 2, AWSL.

148. Armand advertising proof, *Holland's*, April [1928], Series 2, Box 204, Folder 2, Book 382, Ayer.

149. "Greetings!" *Adventure: Women's Advertising Club News of St. Louis*, May 1934, reel 1, vol. 2, AWSL.

150. Bernice Adams, "Women's Ad Club Has Done Much in Its 18 Years," *St. Louis Star-Times*, January 22, 1935, 3, reel 1, vol. 2, AWSL.

151. "Roller Skating Party to Recall Gay Nineties Period," undated clipping; "W.A.C. Plans 'Gay Nineties' Skating Party," undated clipping; and "Gay Nineties Skating Party," *St. Louis Daily Globe-Democrat*, December 14, 1941, all in reel 1, vol. 3, AWSL.

CHAPTER 3 — BROADCASTING YESTERYEAR:
WOMEN'S HISTORY ON COMMERCIAL RADIO, 1930–1945

1. Bruce Lenthall, *Radio's America: The Great Depression and the Rise of Modern Culture* (Chicago: University of Chicago Press, 2007), 1–16.

2. Michelle Hilmes, *Radio Voices: American Broadcasting, 1922–1952* (Minneapolis: University of Minnesota Press, 1997), 159–165.

3. Lenthall, *Radio's America*, 7.

4. Hilmes, *Radio Voices*, 159–165.

5. William L. Bird Jr., *"Better Living": Advertising, Media, and the New Vocabulary of Business Leadership, 1935–1955* (Evanston, IL: Northwestern University Press, 1999), 72–73.

6. Hilmes, *Radio Voices*, 3–4, 80, 115–116.

7. As Hilmes observes, the availability of NBC broadcast recordings, compared with the scarcity of sources for smaller stations, has obscured the medium's diversity. Hilmes, *Radio Voices*, xvi.

8. *Concise Encyclopedia of American Radio*, ed. Christopher H. Sterling and Cary O'Dell (New York: Routledge, 2010), s.v. "KYW," by A. Joseph Borrell.

9. "With the Words, 'The Philadelphia Club of Advertising Women Is on the Air,'" January 5, 1937, Box 1, Radio Programs Folder, PCAWR.

10. Ruth Clair to Edith Ellsworth, November 15, 1936; Flier, "The Philadelphia Club of Advertising Women Present 'Famous Philadelphia Women of Yesteryear'"; Brochure, "The Philadelphia Club of Advertising Women Is on the Air!"; Brochure, "The Philadelphia Club of Advertising Women Presents 'Famous Pennsylvania Women of Yesteryear'"; Brochure, "World-Famous Women of Yesteryear," all in Box 1, Radio Programs Folder, PCAWR.

Dignam's papers also hold a script by Ruth Clair summarizing the entire series of Pennsylvania biographies. Scripts were not archived in PCAWR. Untitled script, 1937, Box 1, Folder 3, DDPW.

11. Report of Radio Committee for Club Season of 1930, 1928–1929 Scrapbook, PCAWR.

12. Hilmes, *Radio Voices*, 115–116.

13. Report of Radio Committee for Club Season of 1930.

14. Dorothy Dignam, "Aunty Antique and Mary Modern Discuss Slogans," Box 1, Folder 3, DDPW.

15. Richard B. Franken and Carroll B. Larrabee, *Packages That Sell* (New York: Harper and Brothers, 1928), 91.

16. Ronald C. Tobey, *Technology as Freedom: The New Deal and the Electrical Modernization of the American Home* (Berkeley: University of California Press, 1997), 7, 18, 23, 37.

17. Flier, "The Philadelphia Club of Advertising Women Present 'Famous Philadelphia Women of Yesteryear'"; Brochure, "The Philadelphia Club of Advertising Women Is on the Air!"; Brochure, "The Philadelphia Club of Advertising Women Presents 'Famous Pennsylvania Women of Yesteryear'"; Brochure, "World-Famous Women of Yesteryear"; "Radio Committee News," *Adland News*, April–May 1936, 5.

18. Edith Ellsworth, "As One Club President to Another," January 13, 1936, Box 1, Radio Programs Folder, PCAWR; Photographs of broadcasters, n.d., Box 12, Photographs Folder, PCAWR.

19. Ross Federal Research Corporation, "Facts in Philadelphia," Box 85, Folder 34, Albert M. Greenfield Papers, HSP; Advertisement, "Here Is the Story in Philadelphia," *Broadcasting Magazine*, April 1, 1937, 48–49, http://www.americanradiohistory.com. This survey considered 18,840 completed phone calls made from February 9 through February 15, 1937.

20. Ellsworth, "As One Club President to Another."

21. Flier, "The Philadelphia Club of Advertising Women Present 'Famous Philadelphia Women of Yesteryear.'"

22. Brochure, "The Philadelphia Club of Advertising Women Is on the Air!"; Brochure, "The Philadelphia Club of Advertising Women Presents 'Famous Pennsylvania Women of Yesteryear'"; Brochure, "World-Famous Women of Yesteryear."

23. Dorothy Dignam, "Fanny Crosby: The Blind Hymn-Writer," February 24, 1938, Box 1, Folder 3, DDPW.

24. Dorothy Dignam, "My Hobby . . . The Queen!" October 18, 1939, Box 1, Folder 3, DDPW.

25. Dorothy Dignam, "Sarah Hale: 'The Lady of Godey's,'" January 16, 1936, Box 1, Folder 3, DDPW.

26. Ibid.

27. Dorothy Dignam Personnel File, Series 19, Box 6, File 11, Ayer. For examples of De Beers ads celebrating marriage and romance, see Series 3, Box 148, Folder 1, Ayer.

28. Dorothy Dignam, annotated script, "Motor Matters: Script for Second Program," August 27, 1937, Box 1, Folder 3, DDPW; Brochure, "World-Famous Women of Yesteryear."

29. Dorothy Dignam, first script for "Motor Matters," August 1937, Box 1, Folder 3, DDPW.

30. Dignam, "Motor Matters: Script for Second Program."

31. Ibid.

32. Dorothy Dignam, "The Silk Lady of the Susquehanna," April 1, 1938, Box 1, Folder 3, DDPW. The emphasis appears in the original.

33. Ibid.

34. Ibid.

35. PCAW roster for 1938–1939, Box 12, PCAWR. Dignam later recalled her disappointment that women frequently left club activity after marrying. Dorothy Dignam, "Biography to 'Tell All' About Club Past," n.d., Carton 2, Founders—History of AWNY Folder, AWNY 86–M216, SL.

36. "PCAW on the Air," *Adland News*, March 1939, 7, Box 1, PCAWR.

37. Mrs. E. M. Govan, January 7, 1937, Box 1, Radio Programs Folder, PCAWR.

38. Simon Nathan, February 12, 1937, Box 1, Radio Programs Folder, PCAWR.

39. Festina Lente [pseud.], letter to the editor, *NYT*, November 7, 1928, PQHN.

40. *American National Biography Online* (New York: Oxford University Press, 2000), s.v. "Pitcher, Molly," by John K. Alexander; Linda Grant De Pauw, *Battle Cries and Lullabies: Women in War from Prehistory to the Present* (Norman: University of Oklahoma Press, 1998), 126–131.

41. Simon Nathan, February 12, 1937.

42. Carolyn Fox, January 7, [1937], Box 1, Radio Programs Folder, PCAWR.

43. Bird, *"Better Living,"* 66.

44. "Women in Public Service," *Cavalcade of America*, January 6, 1936.

45. "Enterprise," *Cavalcade of America*, January 29, 1936.

46. "Eleuthère Irénée du Pont," *Cavalcade of America*, May 29, 1939; Bird, *"Better Living,"* 99.

47. Anne Boylan, "Women's History on the Radio: The Search for a Usable Past, 1935–1953," unpublished conference paper, Center for the History of Business, Technology, and Society, Hagley Museum and Library, October 7, 2010, 2.

48. "Sara [*sic*] Josepha Hale," *Cavalcade of America*, November 24, 1937, https://archive.org/details/OTRR_Cavalcade_of_America_Singles.

49. "Mehitabel Wing," *Cavalcade of America*, January 16, 1940, https://archive.org/details/OTRR_Cavalcade_of_America_Singles.

50. Bird, *"Better Living,"* 97, 106; "Mehitabel Wing."

51. "Wait for the Morning," *Cavalcade of America*, January 22, 1941.

52. "Jane Addams of Hull House," *Cavalcade of America*, May 21, 1940, https://archive.org/details/OTRR_Cavalcade_of_America_Singles.

53. Addams's 1910 autobiography credited her father with inspiring her interest in history. Recent scholarship details John Huy Addams's encouragement of his daughter's education. Jane Addams, *Twenty Years at Hull House with Autobiographical Notes*, ed. James Hurt (Urbana: University of Illinois Press, 1990), 29; Victoria Bissell Brown, *The Education of Jane Addams* (Philadelphia: University of Pennsylvania Press, 2004), 13–15; Louise Knight, *Citizen: Jane Addams and the Struggle for Democracy* (Chicago: University of Chicago Press, 2005), 57–67; Jackson Lears, *Rebirth of a Nation: The Making of Modern America, 1877–1920* (New York: Harper Collins, 2009), 45–46.

54. Lillian Faderman, *To Believe in Women: What Lesbians Have Done for America—a History* (New York: Houghton Mifflin Harcourt, 1999), 118–132. Assessing Addams's relationships with Mary Rozet Smith and Ellen Gates Starr, historians acknowledge that definitions of female friendship and of sexuality have shifted over time, and that Addams did not describe herself as a lesbian. Her correspondence reflects domestic and romantic relationships with women but does not document physical sexual activity. Brown, *Education of Jane Addams*, 361n6.

55. "Susan B. Anthony," *Cavalcade of America*, June 18, 1940; Boylan, "Women's History on the Radio," 22.

56. In telling her life story, Anthony credited her father and other family members for supporting her public work. "Interview with SBA by Nellie Bly," c. January 31, 1896, in *The Selected Papers of Elizabeth Cady Stanton and Susan B. Anthony: An Awful Hush, 1895 to 1906*, ed. Ann D. Gordon (New Brunswick, NJ: Rutgers University Press, 2013), 24–25.

57. Hilmes, *Radio Voices*, 108.

58. Robert Clyde Allen, *Speaking of Soap Operas* (Chapel Hill: University of North Carolina Press, 1985), 110; Hilmes, *Radio Voices*, 155.

59. Irna Phillips, plan presentation: Montgomery Ward, n.d., Box 4, Proposed Programs: Painted Dreams Folder, IPC.

60. Phillips's parents were German Jewish immigrants. Jim Cox, *Historical Dictionary of American Radio Soap Operas* (Lanham, MD: Scarecrow Press, 2005), s.vv. "Ethnic Dramas," "Today's Children."

61. Phillips, plan presentation: Montgomery Ward.

62. Hilmes, *Radio Voices*, 94–95, 1–4; Allen, *Speaking of Soap Operas*, 114; John Dunning, *On the Air: The Encyclopedia of Old Time Radio* (New York: Oxford University Press, 1998), s.v. "Today's Children." The 1933 incarnation focused on an Irish American family; the 1943 incarnation focused on a German American family. Cox, *Historical Dictionary of American Radio Soap Operas,* s.v. "Ethnic Dramas."

63. *"Today's Children" Family Album* (n.p.: Pillsbury Flour Mills Company, 1935), Author's collection.

64. Walter C. Wicker to H. K. Painter, May 29, 1935, enclosure, Box 7, Pillsbury Advertising Folder, IPC; *"Today's Children" Family Album.*

65. Louise Boyd, "Thumbnail Sketches: Irna Phillips," *Radio Guide Weekly*, June 19–25, 1932, 20, Internet Archive, http://archive.org/details/radio-guide-1932-06-25.

66. Dunning, *On the Air,* s.v. "When a Girl Marries."

67. Benton & Bowles, Inc., opening commercial, *When a Girl Marries,* January 21, 1942, Box 7, General Foods Corporation Radio Script Collection, Manuscript Division, Library of Congress. Ellipses and emphasis appear in the original. My transcription incorporates minor handwritten revisions on the archival copy. Magazine ads for Baker's had previously touted Martha Washington's cake recipe. Advertisement, "Looky, Mother! Martha Washington's Own Recipe for Devil's Food Cake!" *Life*, February 6, 1939, 69.

68. Benton & Bowles, Inc., closing commercial, *When a Girl Marries,* January 21, 1942, Box 7, General Foods Corporation Radio Script Collection.

69. After the plot shifted to modern-day protagonist Prudence Dane Barker in September 1945, announcers continued acknowledging "great grandmother Prudence Dane [who] crossed the continent in a caravan four generations ago." Script 174, *A Woman of America*, Series 3, Box 58, Folder 11, Mona Kent Papers, Library of American Broadcasting, University of Maryland, College Park; *A Woman of America*, April 18, 1946, NBCRC; *A Woman of America*, May 17, 1946, NBCRC; Jack French and David S. Siegel, eds., *Radio Rides the Range: A Reference Guide to Western Drama on the Air, 1929–1967* (Jefferson, NC: McFarland, 2014), 204.

70. *A Woman of America*, June 7, 1944, NBCRC.

71. Ibid., July 3, 1944.

72. Ibid., June 7, 1944; June 28, 1944; and August 9, 1944.

73. Ibid., June 7, 1944.

74. Ibid., August 14, 1945 and June 7, 1944.

75. Ibid., June 20, 1944.

76. Ibid., January 5, 1944.

77. Ibid., July 10, 1944.

78. Ibid., June 27, 1944.

79. Ibid., July 4, 1944 and August 1, 1944.

80. Advertisement, "Beginning Mon., Jan. 25, 'A Woman of America': The Story of Prudence Dane," *NYT*, Jan. 24, 1943, PQHN; Advertisement, "Inspiration for These Times!" *NYT*, May 16, 1943, PQHN.

81. Advertisement, "'A Woman of America': The Story of Prudence Dane," *NYT*, May 17, 1943, PQHN; Advertisement, "'A Woman of America': The Story of Prudence Dane," *NYT*, May 24, 1943, PQHN.

82. Undated, unsigned pencil sketches on script pages, *A Woman of America*, Series 3, Box 58, Folder 11, Mona Kent Papers, Library of American Broadcasting, University of Maryland, College Park.

CHAPTER 4 — GALLANT AMERICAN WOMEN:
FEMINIST HISTORIANS AND THE MASS MEDIA, 1935–1950

1. Rose Arnold Powell, April 18, 1944, Journal, vol. 4, Box 1, RAPP; John Taliaferro, *Great White Fathers: The True Story of Gutzon Borglum and His Obsessive Quest to Create the Mount Rushmore National Monument* (New York: Public Affairs, 2004), 310–318; Ida Husted Harper, *The Life and Work of Susan B. Anthony*, 2 vols. (Indianapolis and Kansas City: Bowen-Merrill, 1898); Anna Howard Shaw, with Elizabeth Jordan, *The Story of a Pioneer* (New York: Harper and Brothers, 1915).

2. Rose Arnold Powell, April 18, 1944, Journal.

3. Leila J. Rupp and Verta Taylor, *Survival in the Doldrums: The American Women's Rights Movement, 1945 to the 1960s* (New York: Oxford University Press, 1987), 112–113.

4. Rose Arnold Powell, April 18, 1944, Journal; Rose Arnold Powell, June 1, 1943, Journal, vol. 3, Box 1, RAPP; "A Book Agent and a Roomer Both," [Rose Arnold Powell], published letter to Nancy Brown, ed., Woman's Page, *Detroit News*, 1921, Scrapbook, vol. 10, Box 5, RAPP.

5. Rose Arnold Powell, May 15, 1946, Journal, vol. 4, Box 1, RAPP, quoted in Rupp and Taylor, *Survival in the Doldrums*, 112–113.

6. Rupp and Taylor, *Survival in the Doldrums*, 112–115.

7. Rose Arnold Powell, April 18, 1944, Journal.

8. Simon Schama, *Landscape and Memory* (New York: Vintage Books, 1995), 385–411; Taliaferro, *Great White Fathers*, 312–326; Rupp and Taylor, *Survival in the Doldrums*, 113; Transradio transcript, June 17, 1936, Box 5, Folder 81, RAPP.

9. Rose Arnold Powell to Belle Sherwin, December 12, 1933, Box 4, Folder 41, RAPP; Rose Arnold Powell, "Memorial Is Urged for Susan Anthony," *Washington Post*, January 31, 1932, 7, PQHN.

10. Rose Arnold Powell, May 6, 1934, Journal, vol. 1, Box 1, RAPP; Rose Arnold Powell, March 5–10, 1947, Journal, vol. 5, Box 1, RAPP.

11. Rose Arnold Powell to *Amos 'n' Andy*, NBC, January 6, 1935; Rose Arnold Powell to *Southern Airs*, NBC, January 10, 1935, both in Box 2, Folder 14, RAPP. On *Amos 'n' Andy*, see Michele Hilmes, *Radio Voices: American Broadcasting, 1922–1952* (Minneapolis: University of Minnesota Press, 1997), 81–93.

12. Rose Arnold Powell, February 15, 1935, Journal, vol. 1, Box 1, RAPP. Emphasis appears in the original.

13. Rose Arnold Powell to Carrie Chapman Catt, January 18, 1934, Box 2, Folder 32, RAPP; Rose Arnold Powell to Carrie Chapman Catt, January 24, 1935, Box 2, Folder 32, RAPP; *America's Twelve Great Women Leaders during the Past Hundred Years as Chosen by the Women of America, a Compilation from the Ladies' Home Journal and the Christian Science Monitor* (Chicago: Associated Authors Service, 1933); Rose Arnold Powell to Carrie Chapman Catt, August 9, 1939, Box 2, Folder 32, RAPP.

14. Carrie Chapman Catt to Rose Arnold Powell, June 21, 1938; Carrie Chapman Catt to Rose Arnold Powell, February 2, 1935, both in Box 2, Folder 32, RAPP.

15. Rose Arnold Powell to Mary Ritter Beard, March 22, 1935; Mary Ritter Beard to Rose Arnold Powell, April 16, 1935, both in Box 2, Folder 27, RAPP.

16. Rose Arnold Powell, April 30, 1935, Journal, vol. 1, Box 1, RAPP; Rose Arnold Powell to Mary Ritter Beard, April 9, 1935, Box 2, Folder 27, RAPP; Mary Ritter Beard to Rose Arnold Powell, April 28, 1935, Box 2, Folder 27, RAPP.

17. Mary Ritter Beard to Rose Arnold Powell, July 10, 1935; and Rose Arnold Powell to Mary Ritter Beard, July 13, 1935, both in Box 2, Folder 27, RAPP. This exchange echoed when Beard advised Eva Hansl on the traveling Freedom Train exhibit, stressing the importance of Ida Husted Harper's writing. Mary Ritter Beard to Eva Hansl, July 9, 1947, unprocessed box 1, HPSSC.

18. Mary Ritter Beard to Rose Arnold Powell, May 16, 1935, Box 2, Folder 27, RAPP.

19. Mary K. Trigg, *Feminism as Life's Work: Four Modern American Women through Two World Wars* (New Brunswick, NJ: Rutgers University Press, 2014), 5.

20. Bonnie G. Smith, *The Gender of History: Men, Women, and Historical Practice* (London: Harvard University Press, 1998), 232.

21. Mary Ritter Beard to Rose Arnold Powell, March 27, 1935, Box 2, Folder 27, RAPP.

22. Trigg, *Feminism as Life's Work*, 165–170; Julie Des Jardins, *Women and the Historical Enterprise in America: Gender, Race, and the Politics of Memory, 1880–1945* (Chapel Hill: University of North Carolina Press, 2003), 238.

23. Charles Beard and Mary Ritter Beard, *America in Midpassage*, vol. 2 (New York: Macmillan, 1939), 647–649, quoted in Bruce Lenthall, *Radio's America: The Great Depression and the Rise of Modern Mass Culture* (Chicago: University of Chicago Press, 2007), 26.

24. Mary Beard, ed., *America through Women's Eyes* (New York: Macmillan, 1933), quoted in Trigg, *Feminism as Life's Work*, 104.

25. Trigg, *Feminism as Life's Work*, 103.

26. Ibid., 145, 168–170; Des Jardins, *Women and the Historical Enterprise*, 218–219, 225–257; Mary Ritter Beard biography, n.d., Box 1, "*Gallant American Women* Proposals" folder, HPSSC.

27. Eva Hansl to B. P. Brodinsky, October 12, 1939, Box 10, "Women" folder, RG12, Entry 187, ROE.

28. Des Jardins, *Women and the Historical Enterprise*, 230.

29. David Goodman, *Radio's Civic Ambition: American Broadcasting and Democracy in the 1930s* (New York: Oxford University Press, 2011), 39; John Dunning, *On the Air: The Encyclopedia of Old Time Radio* (New York: Oxford University Press, 1998), s.v. "Women in the Making of America."

30. J. Clark Waldron to William D. Boutwell, memo, March 2, 1940, Box 2, RG12, Entry 177, ROE.

31. J. Clark Waldron to William D. Boutwell, memo, May 3, 1940, Box 2, RG12, Entry 177, ROE; Anne Boylan, "Women's History on the Radio: The Search for a Usable Past, 1935–1953," unpublished conference paper, Center for the History of Business, Technology, and Society, Hagley Museum and Library, October 7, 2010, 16–17.

32. Flier, "Listen!!! 'Gallant American Women,'" "Mary R. Beard's Correspondence and Commentaries" folder, Unprocessed Box 1, HPSSC.

33. "Special Spot Announcement for NBC Blue and Supplementary Stations Scheduling Gallant American Women," October 23, 1939, Box 2, RG12, Entry 177, ROE.

34. "Women in the Making of America" outline, Box 1, Folder 1, HPSL; Jane Ashman, "These Freedoms," *Gallant American Women*, October 31, 1939, Box 1, Folder 16, HPSL; "These Freedoms," *Gallant American Women*, October 31, 1939, NBCRC. Ellipses appear in the original.

35. Trigg, *Feminism as Life's Work*, 172–173; Boylan, "Women's History on the Radio," 25–26; U.S. Office of Education press release, "Historic Negro Woman Figures in New Office of Education Radio Program," n.d., Box 10, "Women" folder, RG12, Entry 187, ROE.

36. Eva Hansl biography, n.d., Box 1, "*Gallant American Women* Proposals" folder, HPSSC.

37. Eva Hansl to Morris Jones, October 26, 1939, Box 5, "W. D. Boutwell" folder, RG12, Entry 187, ROE.

38. J. Morris Jones to W. D. Boutwell, "January 'Activity Report,'" February 7, 1940, Box 8, "Weekly Reports" folder, RG12, Entry 187, ROE; Jane Ashman biography, n.d., Box 1, "*Gallant American Women* Proposals" folder, HPSSC; William D. Boutwell, Semi-monthly report, December 2, 1939, Box 5, "W. D. Boutwell" folder, RG12, Entry 187, ROE.

39. J. Morris Jones to W. D. Boutwell, "January 'Activity Report.'"

40. Eva Hansl to Morris Jones, October 26, 1939, Box 5, "W. D. Boutwell" folder, RG12, Entry 187, ROE.

41. Boylan, "Women's History on the Radio," 24.

42. Eva Hansl to Margaret Cuthbert, May 19, 1940, Box 1, "*Gallant American Women* Proposals" folder, HPSSC.

43. Trigg, *Feminism as Life's Work*, 172.

44. Eva Hansl memo, "Re: Gallant American Women—Its Educational Value," April 15, 1940, Box 1, Correspondence Folder, HPSSC.

45. Jane Ashman, "Freedom of Citizenship" script, June 23, 1939, 35, Box 1, Folder 8, HPSL; "Freedom of Citizenship," *Women in the Making of America*, June 23, 1939, NBCRC.

46. Mary Ritter Beard to Eva Hansl, n.d.; Mary Ritter Beard, "Women in Politics and Government" notes, June 30, [1939], broadcast, both in Box 5, "Politics and Government" folder, HPSSC.

47. Jane Ashman, "Women in Politics and Government" script, June 30, 1939, Box 1, "Women in Politics and Government" folder, HPSL.

48. William Boutwell to Margaret Cuthbert, November 16, 1939, Box 5, "W. D. Boutwell" folder, RG 12, Entry 187, ROE.

49. J. Morris Jones to Philip H. Cohen, March 29, 1940; and J. Morris Jones to Philip H. Cohen, April 5, 1940, both in Box 6, "Philip Cohen Production Manager" folder, RG 12, Entry 187, ROE; U.S. Office of Education press release, "Women's Mark on America Continued in U.S. Office of Education Radio Series," n.d., Box 10, "Women" folder, RG 12, Entry 187, ROE.

50. Des Jardins, *Women and the Historical Enterprise*, 226.

51. Trigg, *Feminism as Life's Work*, 105.

52. Mary R. Beard, "Suggested Revisions of Advertising Material," January 12, 1940; and Eva Hansl, "Gallant American Women Series III," January 10, 1940, both in Box 10, "Women" folder, RG12, Entry 187, ROE.

53. Jane Ashman, "Cavalcade of American Women," script, *Women in the Making of America*, May 19, 1939, Box 1, HPSSC; Outline for "Women in Business," n.d., Box 3, "Gallant American Women" folder, RG 12, Entry 174, ROE.

54. Eva vom Baur Hansl, "Women in Commerce and Trade," *Gallant American Women*, June 17, 1940, 2–3, Box 1, HPSSC. Emphasis appears in the original.

55. Ibid., 10.

56. Ibid., 18, 21.

57. Juliann Sivulka, *Ad Women: How They Impact What We Need, Want, and Buy* (Amherst, NY: Prometheus Books, 2009), 71–74; Wendy Woloson, *Refined Tastes: Sugar, Confectionery, and Consumers in Nineteenth-Century America* (Baltimore: Johns Hopkins University Press, 2002), 218.

58. *Dainty Desserts for Dainty People* (Longstown, NY: Charles B. Knox Gelatine Co., 1915); *Dainty Desserts for Dainty People* (Longstown, NY: Charles B. Knox Gelatine Co., 1924); *Dainty Desserts for Dainty People* (Charles B. Knox Gelatine Co., 1930), all in Box 1, Folder 41, Frances S. Baker Product Cookbooks, Archives Center, NMAH.

59. Hansl, "Women in Commerce and Trade," 19.

60. "The Bronze Tablet," *Gallant American Women*, February 20, 1940, Box 2, Folder 31, HPSL.

61. Ibid., 20, 11.

62. Eva Hansl to May Field Lanier, February 13, 1940, Box 4, "The Bronze Tablet" folder, HPSSC.

63. "The Bronze Tablet," 20–21.

64. Trigg, *Feminism as Life's Work*, 85.

65. "Women the Providers," *Gallant American Women*, November 21, 1939, 1, Box 1, HPSSC; "Women the Providers," *Gallant American Women*, November 21, 1939, NBCRC.

66. "Women the Providers," 8–9, 11–12, HPSSC.

67. Ibid., 20; Hilmes, *Radio Voices*, 3–6.

68. Trigg, *Feminism as Life's Work*, 171.

69. Alice Stone Blackwell to Eva Hansl, May 21, 1939, Box 4, "Women in Medicine" folder, HPSSC; Alma Lutz to Dear Sirs, May 19, 1939 and Alma Lutz to Eva Hansl, July 1, 1939, Box 1, Correspondence Folder, HPSSC; Alma Lutz, *Created Equal: A Biography of Elizabeth Cady Stanton* (New York: The John Day Company, 1940); Alma Lutz, *Susan B. Anthony: Rebel, Crusader, Humanitarian* (Boston: Beacon Press, 1959); Henriette M. Heinzen to Eva Hansl, June 23, 1939, Box 1, Correspondence Folder, HPSSC.

70. Eva Hansl to William Boutwell Jones, February 29, 1940, Box 4, "Women in Medicine" folder, HPSSC.

71. Eva Hansl to J. Morris Jones, February 28, 1940, Box 4, "Women in Medicine" folder, HPSSC; *American National Biography Online* (New York: Oxford University Press, 2000), s.v. "L'Esperance, Elise Strang," by Marilyn Elizabeth Perry.

72. Eva Hansl to William Boutwell Jones, February 29, 1940, Box 4, "Women in Medicine" folder, HPSSC.

73. Jane Ashman to Mr. Jones, February 28, 1940, Box 4, "Women in Medicine" folder, HPSSC.

74. John Marsh to Eva Hansl, June 29, 1940; Eva Hansl to L. H. Titterton, July 8, 1940; John Marsh to Eva Hansl, August 6, 1940; Eva Hansl, letter to customers who purchased "Women of Letters" script, August 1940, all in Box 4, "Women of Letters" folder, HPSSC.

75. Eva Hansl to Ida Tarbell, January 15, 1940, Box 4, "Mothers of Great Americans" folder, HPSSC.

76. Biographer Kathleen Brady writes that Tarbell proposed the topic to McClure. Kathleen Brady, *Ida Tarbell: Portrait of a Muckraker* (Pittsburgh: University of Pittsburgh Press, 1989), 95, 121–122.

77. Typed memo, "Ladies of the Press: Changes suggested by Eva Hansl, Margaret Cuthbert, Ishbel Ross," January 19, 1940; Jane Ashman to Ida Tarbell, January 19, 1940, both in Box 4, "Ladies of the Press" folder, HPSSC. Ellipses and emphasis appear in the original.

78. Jane Ashman to Ida Tarbell, January 19, 1940.

79. Parke C. Bolling to Eva Hansl, January 11, 1940, Box 4, "The Bronze Tablet" folder, HPSSC; Parke C. Bolling to Eva Hansl, February 8, 1940, Box 4, "Mothers of Great Americans" folder, HPSSC; Eva Hansl to Parke C. Bolling, February 9, 1940, Box 4, "The Bronze Tablet" folder, HPSSC.

80. Eva Hansl to Parke C. Bolling, February 2, 1940, Box 4, "The Bronze Tablet" folder, HPSSC.

81. Parke C. Bolling to Eva Hansl, February 28, 1940; Parke C. Bolling to Eva Hansl, January 11, 1940, both in Box 4, "The Bronze Tablet" folder, HPSSC.

82. Eva Hansl and Jane Ashman, n.d. [after May 1941], "Gallant American Women," Box 1, Proposals Folder, HPSSC.

83. William D. Boutwell memo, April 5, 1940, Box 3, "Gallant American Women" folder, RG 12, Entry 174, ROE.

84. William D. Boutwell memo, April 11, 1940, Box 3, "Gallant American Women" folder, RG 12, Entry 174, ROE; Eva Hansl script, "From Tavern to Tearoom," *Gallant American Women*, April 9, 1940, Box 2, 13, HPSSC.

85. Richard Philip Herget to William Boutwell, October 23, 1939, Box 3, "Gallant American Women" folder, RG 12, Entry 174, ROE. Herget added "vile maniac that she was" to his typed letter by hand.

86. Eva Hansl, broadcast record and memo, "Re: Corrections on Scripts of *Gallant American Women*," n.d, Box 1, "Corrections on Scripts #27–#47" folder, HPSSC.

87. "Women of Learning," *Gallant American Women*, January 2, 1940, RWB 5394 A3, Library of Congress Division of Recorded Sound; Seth Koven and Sonya Michel, "Introduction: 'Mother Worlds,'" in *Mothers of a New World: Maternalist Politics and the Origins of Welfare States*, ed. Seth Koven and Sonya Michel (New York: Routledge, 1993), 1–42.

88. Jane Ashman, "Women of Learning," Box 2, Folder 25, HPSL.

89. William D. Boutwell, "Semi-monthly Report (November 1–15)," November 16, 1939; B. P. Brodinsky and J. Clark Waldron, "Report of Audience Preparation and Station Relations," November 15–December 1, 1939, both in Box 2, RG 12, Entry 177, ROE.

90. Julia D. H. Whittlesey to William Boutwell, April 18, 1940, Box 1, Correspondence Folder, HPSSC.

91. B. P. Brodinsky and J. Clark Waldron, "Report of Audience Preparation and Station Relations," November 1 to December 15, 1939, Box 2, RG 12, Entry 177, ROE. These were the second through seventh broadcasts under the *Gallant American Women* title.

92. B. P. Brodinsky to William D. Boutwell, memo, "Report for January 15 to January 31," February 2, 1940, Box 2, RG 12, Entry 177, ROE.

93. Hansl memo, "Re: Gallant American Women—Its Educational Value."

94. William D. Boutwell to B. P. Brodinsky, memo, February 23, 1940, Box 2, RG 12, Entry 177, ROE.

95. U.S. Office of Education, "Weekly Report on Incoming Mail," April 29–May 3, 1940 and U.S. Office of Education, "Weekly Report on Incoming Mail," October 9–October 13, 1939, Box 2, RG 12, Entry 177, ROE.

96. Eva Hansl and Jane Ashman, "Gallant American Women," n.d. [after May 1941], Box 1, Proposals Folder, HPSSC.

97. Des Jardins, *Women and the Historical Enterprise*, 236–241; Nancy F. Cott, ed., *Mary Ritter Beard through Her Letters* (New Haven, CT: Yale University Press, 1991), 48–50, 219.

98. Trigg, *Feminism as Life's Work*, 173.

99. Des Jardins, *Women and the Historical Enterprise*, 237–238.

100. Trigg, *Feminism as Life's Work*, 193.

101. Mary R. Beard to Margaret Grierson, "Addenda," June 1943, Box 1, Folder 10, Mary Ritter Beard Papers, SSC.

102. Mary Ritter Beard, "What Nobody Seems to Know about Woman," June 3, 1950, Box 2, Folder 27, RAPP. The script is published in *Mary Ritter Beard: A Sourcebook*, ed. Ann J. Lane (Boston: Northeastern University Press, 1988), 195–199.

103. Des Jardins, *Women and the Historical Enterprise*, 251–252.

104. Beard, "What Nobody Seems to Know about Woman."

105. Mary Ritter Beard to Rose Arnold Powell, July 21, 1954, Box 2, Folder 27, RAPP.

106. "Nancy Wilson Ross: An Inventory of Her Papers at the Harry Ransom Center," Harry Ransom Center, University of Texas at Austin, http://norman.hrc.utexas.edu /fasearch/findingAid.cfm?eadid=00114.

107. Nancy Wilson Ross, *The WAVES: The Story of the Girls in Blue* (New York: Henry Holt and Company, 1943); Nancy Wilson Ross to June Wetherell, January 13, 1947, Series 1A, Box 11, Folder 1, NWRP.

108. Nancy Wilson Ross, *Westward the Women*, 4th ed. (New York: Knopf, 1945), 5–6.

109. Ibid., 193–194.

110. "Look at the World through Borzoi Books," *Book Review*, November 5, 1944, 19, Series 1A, Box 11, Folder 4, NWRP.

111. "Westward the Women," *Cavalcade of America*, January 1, 1945, Internet Archive, https://archive.org/details/OTRR_Cavalcade_of_America_Singles; Ross, *Westward the Women*, 137–154.

112. Ross, *Westward the Women*, 139–140.

113. Ibid., 191.

114. Ibid., 154; Abigail Scott Duniway, *Path Breaking: An Autobiographical History of the Equal Suffrage Movement in Pacific Coast States* (Portland, OR: James, Kearns, and Abbott, 1914), 291.

115. Ross, *Westward the Women*, 153; Duniway, *Path Breaking*, 74.

116. Ross, *Westward the Women*, 143; "Westward the Women," *Cavalcade of America*.

117. Nancy Wilson Ross to June Wetherell, January 13, 1947, Series 1A, Box 11, Folder 1, NWRP.

118. Nancy Wilson Ross to Ed, n.d., Series 1A, Box 11, Folder 1, NWRP; Nancy Wilson Ross to Cass Canfield, July 28, 1970, Series 1A, Box 10, Folder 9, NWRP.

119. Nancy Wilson Ross to Swanie, October 13, 1944, Series 1A, Box 11, Folder 1, NWRP.

120. Stanley Corkin, "Cowboys and Free Markets: Post–World War II Westerns and U.S. Hegemony," *Cinema Journal* 39, no. 3 (2000): 66–91; Jane P. Tompkins, *West of Everything: The Inner Life of Westerns* (New York: Oxford University Press, 1993), 38–45; Sandra Schackel, "Barbara Stanwyck: Uncommon Heroine," in *Back in the Saddle: Essays on Western Film and Television*, ed. Gary A. Yoggy (Jefferson, NC: McFarland, 1998), 113.

121. Nancy Wilson Ross to Swanie, October 13, 1944.

122. *Westward the Women*, directed by William Wellman (Metro Goldwyn Mayer, 1951; Warner Home Video, 2012), DVD.

123. Nancy Wilson Ross to Dear Sirs, Loew's Incorporated, January 2, 1951, Series 1A, Box 13, Folder 3, NWRP; Nancy Wilson Ross to Cass Canfield, July 28, 1970, Series 1A, Box 10, Folder 9, NWRP.

124. Nancy Wilson Ross to Merian C. Cooper, March 21, 1956, Series 3, Box 104, Folder 4, NWRP.

125. Arthur M. Eckstein and Peter Lehman, eds., *"The Searchers": Essays and Reflections on John Ford's Classic Western* (Detroit: Wayne State University Press, 2004); Tompkins, *West of Everything*, 40–41; Susan Faludi, *The Terror Dream: Myth and Misogyny in an Insecure America* (New York: Picador, 2007), 259–281.

126. Nancy Wilson Ross, "List of Cooper's Tabus," May 1955, Series 3, Box 104, Folder 12, NWRP.

127. Nancy Wilson Ross to Merian C. Cooper, March 21, 1956.

128. Nancy Wilson Ross to Ivan von Auw Jr., November 15, 1954, Series 3, Box 104, Folder 2, NWRP.

129. Carro C. Braunlich to Nancy Wilson Ross, April 30, 1945, Series 1A, Box 11, Folder 1, NWRP.

130. Johanna Marie Brewer to Nancy Wilson Ross, n.d., Series 1A, Box 10, Folder 10, NWRP.

131. Paula Mitchell Marks, "Introduction to the Bison Books Edition," in Dorothy Gray, *Women of the West* (Lincoln: University of Nebraska Press, [1976] 1998), vii; John Mack

Faragher, *Women and Men on the Overland Trail*, 2nd ed. (New Haven, CT: Yale University Press, 2001), xiv.

132. J. Almus Russell to Nancy Wilson Ross, August 8, 1945, Series 1A, Box 11, Folder 3, NWRP; Susan Groves to Nancy Wilson Ross, April 2, 1979, Series 1A, Box 10, Folder 9, NWRP.

133. Margaret Grierson to Nancy Wilson Ross, copy, n.d., Series 1A, Box 10, Folder 10, NWRP; Brochure, *An Historical Collection of Books by Women and on Women*, n.d., Series 1A, Box 11, Folder 1, NWRP.

134. The Friends of the Library's brochure sympathized with the quest for gender equality but defended the project against the anticipated "charge of 'feminism,'" citing its scholarly purpose. Brochure, *An Historical Collection of Books by Women and on Women*.

135. Nancy Wilson Ross to Margaret Grierson, n.d., Series 1A, Box 11, Folder 1, NWRP; Nancy Wilson Ross to Mac, October 19, 1944, Series 1A, Box 10, Folder 10, NWRP; Margaret Grierson to Nancy Wilson Ross, November 4, 1944, Series 1A, Box 11, Folder 1, NWRP.

136. Taliaferro, *Great White Fathers*, 315–316.

137. Rose Arnold Powell, July 7, 1943, Journal, vol. 3, Box 1, RAPP; Rose Arnold Powell, "Declaratory Act," 1943, Box 5, Folder 93, RAPP.

138. Rose Arnold Powell to Henry Wallace, February 14, 1944; Rose Arnold Powell to Joseph R. Ball, February 24, 1944, both in Box 2, Folder 19, RAPP.

139. Rose Arnold Powell, June 1, 1943, Journal, vol. 3, Box 1, RAPP; Rupp and Taylor, *Survival in the Doldrums*, 63.

140. Powell had started articulating these ideas in the 1930s. Rose Arnold Powell to Mary Ritter Beard, March 25, 1937, Box 2, Folder 27, RAPP.

141. Rose Arnold Powell, April 18, 1944, Journal, vol. 4, Box 1, RAPP.

142. Des Jardins, *Women and the Historical Enterprise*, 200–202.

143. Clipping, *Time*, November 13, 1950, 56, Box 3, Folder 38, RAPP.

144. James Truslow Adams to Rose Arnold Powell, October 21, 1940; James Truslow Adams to Rose Arnold Powell, November 1, 1940; James Truslow Adams to Rose Arnold Powell, November 18, 1940; Rose Arnold Powell to James Truslow Adams, November 7, 1940; James Truslow Adams, "The Six Most Important American Women," *GH*, February 1941, 30, all in Box 3, Folder 38, RAPP.

145. Jill Lepore, *The Secret History of Wonder Woman* (New York: Knopf, 2014), 187.

146. Lillian S. Robinson, *Wonder Women: Feminisms and Superheroes* (New York: Routledge, 2004), 58–60.

147. Lepore, *Secret History of Wonder Woman*, 220–221.

148. Ibid., 222; Alice Marble to Elsa Butler Grove, July 24, 1942, Miriam Y. Holden Collection, Princeton University Special Collections, Box 63, Folder 14; Vassar College Libraries, "Guide to the Elsa Butler Grove Papers, 1921–1969," http://specialcollections .vassar.edu/collections/findingaids/g/grove_elsa.html. Grove, one of Marble's correspondents on this poll, had contributed to the World Center for Women's Archives.

149. Lepore, *Secret History of Wonder Woman*, 222; Les Daniels, *Wonder Woman: The Complete History* (San Francisco: Chronicle Books, 2004), 92.

150. Lepore, *Secret History of Wonder Woman*, 222.

151. William Moulton Marston to Sheldon Mayer, April 12, 1942, WWLC.

152. William Moulton Marston to M. C. Gaines, February 20, 1943; William Moulton Marston to W.W.D. Sones, March 20, 1943, both in WWLC.

153. Daniels, *Wonder Woman*, 33; Robinson, *Wonder Women*, 42–43.

154. William Moulton Marston to Sheldon Mayer, February 23, 1941, WWLC.

155. Undated article transcript, "Noted Psychologist Revealed as Author of Best-Selling 'Wonder Woman,' Children's Comic," [1943], WWLC.

156. "A Wife for Superman," *Hartford Courant*, September 28, 1942, WWLC.

157. Lepore, *Secret History of Wonder Woman*, 222, 373–74n8.

158. William Moulton Marston to Mr. Waugh, March 5, 1945, WWLC.

159. *Wonder Woman*, Summer 1942; Undated article transcript, "Noted Psychologist Revealed as Author of Best-Selling 'Wonder Woman,' Children's Comic."

160. "Wonder Women of History: Florence Nightingale," *Wonder Woman*, Summer 1942; "Wonder Women of History: Clara Barton," *Wonder Woman*, Fall 1942; "Wonder Women of History: Edith Cavell," *Wonder Woman*, February–March 1943; "Wonder Women of History: Lillian D. Wald," *Wonder Woman*, April–May, 1943.

161. "Wonder Women of History: Florence Nightingale."

162. "Wonder Women of History: Lillian D. Wald."

163. "Wonder Women of History: Florence Nightingale."

164. "Wonder Women of History: Susan B. Anthony," *Wonder Woman*, June–July 1943.

165. Powell corresponded with All-American Comics president M. C. Gaines about completed Anthony drafts in January 1943, suggesting that she approached the comic soon after it began publication. Powell does not indicate whether she received Marble's formal request for nominations. Rose Arnold Powell to M. C. Gaines, January 28, 1943, Box 2, Folder 18, RAPP; Rose Arnold Powell to Mrs. MacGee, May 16, 1943, Box 2, Folder 18, RAPP; Rose Arnold Powell to Miss Boyles, June 3, 1943, Box 2, Folder 18, RAPP.

166. Various correspondence, Rose Arnold Powell to Charl Williams, Box 4, Folder 60, RAPP.

167. Lepore, *Secret History of Wonder Woman*, 222–224.

168. Rose Arnold Powell to M. C. Gaines, May 4, 1943, Box 2, Folder 18, RAPP. Emphasis appears in the original.

169. Rose Arnold Powell to M. C. Gaines, January 28, 1943, Box 2, Folder 18, RAPP.

170. "Wonder Women of History: Susan B. Anthony."

171. Rose Arnold Powell to Miss Boyles, June 3, 1943, Box 2, Folder 18, RAPP.

172. Ibid.

173. Rose Arnold Powell to Miss Boyles, June 24, 1943, Box 2, Folder 18, RAPP.

174. Rose Arnold Powell to Margaret Louise Wallace, April 7, 1943, Box 2, Folder 18, RAPP; Rose Arnold Powell to Mrs. MacGee, May 16, 1943, Box 2, Folder 18, RAPP.

175. "Wonder Women of History: Susan B. Anthony."

176. Marston deployed bondage imagery as a central element in his portrayal of Wonder Woman as an emancipator. Noah Berlatsky, *Wonder Woman: Bondage and Feminism in the Marston/Peter Comics, 1941–1948* (New Brunswick, NJ: Rutgers University Press, 2015); William Moulton Marston to Sheldon Mayer, February 23, 1941, WWLC; William Moulton Marston to M. C. Gaines, February 20, 1943, WWLC; M. C. Gaines to William Moulton Marston, September 14, 1943, WWLC.

177. Tom Buxton, "Feb. 15 Was Birth Date of Woman Who Fought for Their Moral, Political, and Economic Rights," reprint from *School Bulletin of Minnesota Public Schools*, February 8, 1940, Box 4, Folder 79, RAPP.

178. "Wonder Women of History: Susan B. Anthony."

179. "Battle for Womanhood," *Wonder Woman*, June–July 1943. Emphasis appears in the original.

180. Ibid.; Lepore, *Secret History of Wonder Woman*, 227.

181. "Wonder Women of History: Jane Addams," *Wonder Woman*, Summer 1944; "Wonder Women of History: Carrie Chapman Catt," *Wonder Woman*, November–December 1947; "Wonder Women of History: Sojourner Truth," *Wonder Woman*, Summer 1945.

182. "Wonder Women of History: Sojourner Truth"; "Slaves in the Electric Gardens," *Wonder Woman*, Summer 1945.

183. "Wonder Women of History: Abigail Adams," *Wonder Woman*, Fall 1945. Ellipses appear in original.

184. "Wonder Women of History: Juliette Low," *Wonder Woman*, Fall 1944.

185. Lepore, *Secret History of Wonder Woman*, 286–288.

186. Rose Arnold Powell to Editor, *American Childhood*, February 29, 1944, Box 2, Folder 19, RAPP.

187. Rose Arnold Powell to Editors, *Reader's Digest*, February 20, 1944, Box 2, Folder 19, RAPP; O. K. Armstrong, "Susan B. Anthony, Trail Blazer: Condensed from The Christian Science Monitor," *Reader's Digest*, February 1944, 89–92.

188. Rose Arnold Powell to Bertha Lyons, March 26, 1950, Box 3, Folder 38, RAPP; Rose Arnold Powell to Mrs. Adamson, April 4, 1945, Box 2, Folder 19, RAPP; Brown & Bigelow, "Calendar," 1948, Box 4, Folder 67, RAPP; Louis F. Dow Co., "Housewife's DeLuxe Recipe Calendar," 1946, Box 4, Folder 7, RAPP; Thomas Murphy to Rose Arnold Powell, April 11, 1946, Box 4, Folder 67, RAPP.

189. Rose Arnold Powell to Mrs. MacGee, May 16, 1943, Box 2, Folder 18, RAPP.

190. Rose Arnold Powell, Journal, vol. 3, Box 1, Sept. 18–19, 1942, RAPP.

191. Marjorie Spruill Wheeler, *New Women of the New South: The Leaders of the Woman Suffrage Movement in the Southern States* (New York: Oxford University Press, 1993), 20–22, 115–118.

192. Rose Arnold Powell to Alma Lutz, August 8, 1944, Box 3, Folder 33, RAPP.

193. Ibid.; Rose Arnold Powell to Alma Lutz, August 29, 1944, Box 3, Folder 43, RAPP.

194. Rose Arnold Powell to Alma Lutz, September 4, 1946, Box 3, Folder 43, RAPP; Elizabeth Cady Stanton, Susan B. Anthony, and Matilda Joslyn Gage, eds., *History of Woman Suffrage*, vol. 3 (Rochester, NY: Charles Mann Printing, 1886), 29–30; Alma Lutz to Rose Arnold Powell, September 27, 1946, Box 3, Folder 43, RAPP.

195. Alma Lutz to Rose Arnold Powell, October 8, 1947, Box 3, Folder 43, RAPP. On the Freedom Train, see Wendy L. Wall, *Inventing the "American Way": The Politics of Consensus from the New Deal to the Civil Rights Movement* (New York: Oxford University Press, 2008), 3–7.

196. Alma Lutz to Rose Arnold Powell, August 18, 1948; Rose Arnold Powell to Alma Lutz, March 6, 1948, both in Box 3, Folder 43, RAPP.

197. Alma Lutz to Rose Arnold Powell, August 18, 1948.

CHAPTER 5 — BETSY ROSS RED LIPSTICK:
PRODUCTS AS ARTIFACTS AND INSPIRATION, 1940–1950

1. Melissa McEuen, *Making War, Making Women: Femininity and Duty on the American Home Front, 1941–1945* (Athens: University of Georgia Press, 2011); Donna B. Knaff, *Beyond Rosie the Riveter: Women of World War II in American Popular Graphic Art* (Lawrence: University Press of Kansas, 2012).

2. Knaff, *Beyond Rosie the Riveter*, 72.

3. Ibid., 74; Phyllis McGinley, "Mistress Pitcher, '43," *Stanford Daily* (CA), January 14, 1944, http://stanforddailyarchive.com.

4. Maureen Honey, *Creating Rosie the Riveter: Class, Gender, and Propaganda during World War II* (Amherst: University of Massachusetts Press, 1984), 112.

5. *Life*, January 11, 1943, 93. Fritchie was memorialized for stopping Confederate advance into Maryland. John Greenleaf Whittier, "Barbara Frietchie" (1863), in *Oxford Book of American Poetry*, ed. David Lehman (New York: Oxford University Press, 2006), 54–56.

6. Dorothy Blake [pseudonym of Dorothy Atkinson Robinson], *It's All in the Family: A Diary of an American Housewife, December 7, 1941–December 1, 1942* (New York: William Morrow, 1943), North American Women's Letters and Diaries Database,

Alexander Street Press; Dorothy Blake, *The Diary of a Suburban Housewife* (New York: William Morrow, 1936); Eleanor Roosevelt, "My Day," June 8, 1936, Eleanor Roosevelt Papers Project, http://www.gwu.edu/~erpapers/myday/displaydoc.cfm?_y=1936&_f=mdo54351. Articles by Blake include Dorothy Blake, "Husbands Must Eat," *House Beautiful*, October 1936, 78; "She Never Tells Me Anything!" *Parents' Magazine*, August 1938, 18; "Grin When You Want To," *Better Homes and Gardens*, October 1940, 94; and "I Love to Volunteer," *Woman's Home Companion*, November 1943, 40.

7. Diary entry, January 19, 1942, in Blake, *It's All in the Family*, 55.

8. The *New York Times* praised Blake's advertising critiques. Katherine Woods, "The Suburban Life in Wartime: *It's All in the Family*," *NYT*, March 7, 1943, PQHN.

9. "J. C. Furnas, Wry Historian of American Life, Dies at 95," *NYT*, June 12, 2001.

10. Eleanor Roosevelt, "American Women in the War," *Reader's Digest*, January 1944, 42-44.

11. J. C. Furnas, "Are Women Doing Their Share in the War?" *Saturday Evening Post*, April 29, 1944, 12.

12. Ibid., 44.

13. Richard Erdoes, "The American Woman—as an Ancestor," *Mademoiselle*, July 1944, 72-73, 116-117.

14. Gladys Shultz, "Career Girls, THEN and NOW," *Glamour*, March 1942, 34-37, 88, Betsy Talbot Blackwell Papers, Box 54, American Heritage Center, University of Wyoming. Quotes on 35-36.

15. Dorothy Dignam, "More Women in Advertising Now Than in World War I," *Printers' Ink*, May 29, 1942, 16-17, 38, Box 3, Folder 18, DDPSL.

16. Simultaneously, Dignam's coy remark reflects her industry's association of youth with professional innovation. *Printers' Ink* had long analyzed ramifications of aging for admen's careers. T. J. Jackson Lears, *Fables of Abundance: A Cultural History of Advertising in America* (New York: Basic Books, 1994), 168-169.

17. David E. Sumner, *The Magazine Century: American Magazines since 1900* (New York: Peter Lang, 2010), 81; Mary Ellen Zuckerman, "*Woman's Day*," in Kathleen L. Endres and Therese L. Lueck, *Women's Periodicals in the United States: Consumer Magazines* (Westport, CT: Greenwood, 1995), 441.

18. Margaret Mead, "Will Women Be Able to Choose?" *Woman's Day*, May 1944, 20-21, 66-69.

19. Katina Lee Manko, "'Ding Dong! Avon Calling!': Gender, Business, and Door-to-Door Selling, 1890-1955" (PhD diss., University of Delaware, 2001), xii-xiii, 192, 213-214.

20. Ibid., 176, 207-209.

21. McEuen, *Making War, Making Women*, 46-54.

22. Kathy Peiss, *Hope in a Jar: The Making of America's Beauty Culture* (New York: Metropolitan Books, 1998), 239-245.

23. Avon recorded a national sales staff of thirty-five thousand in 1940. The reduction by 1944 reflected the wartime economy; nevertheless, sales representatives' average yearly sales increased in 1942, 1943, and 1944. Manko, "'Ding Dong! Avon Calling!'" 252, 257.

24. Manko, "'Ding Dong! Avon Calling!'" 256.

25. "Announcing Betsy Ross Red," *Avon Outlook*, April 29–May 14, 1941, HID; Photograph, Betsy Ross Red Nail Polish and Base Box, 1941, ACC, http://digital.hagley.org/cdm/ref/collection/p15017coll20/id/17943.

26. Advertising proofs: "Romantic Mississippi Days Inspired This Enchanting Coiffure by Émile," *GH*, January 1942; "Borrowed from the Texas Rangers: This Striking Sport Suit by Helen Cookman, Eminent Stylist," *Ladies' Home Journal* and *McCall's*, September 1942; "Old California Inspires This Captivating Gown by Adrian of Hollywood," *GH*,

October 1942; "A Charming 'Pilgrim Hat' by Sally Victor," *GH*, January 1943, all in Record Group I, Series 7A, Box OS-15B, APR.

27. Advertising proof, "In the Spirit of Early America," *McCall's, Woman's Home Companion,* and *Ladies' Home Journal,* February 1943, Record Group I, Series 7A, Box OS-15B, APR.

28. Advertising proof, "Old New England Inspires an Enchanting Gown by Omar Kiam, Paul Revere Red by Avon," *Woman's Home Companion* and *McCall's,* June 1942, Record Group I, Series 7A, Box OS-16, APR.

29. Although not pictured in this campaign, some Avon products bore historical imagery; gift set packages often depicted colonial men and women. "Gifts of Charm by Avon," Christmas catalog, 1945, Record Group I, Series 6B, Box 26, APR.

30. "It's Coming Soon—All about Avon's Great New Advertising Campaign," *Avon Outlook,* March 15–April 3, 1943, 16–17, HID.

31. American Heroine advertisements, Record Group I, Series 7, Box OS-16, APR.

32. Manko, "'Ding Dong! Avon Calling!,'" 220.

33. Advertisement, "Heroines of Yesterday and Today," 1943, Record Group I, Series 7, Box OS-19B, APR. Ellipses appear in the original.

34. Ruth Milkman, *Gender at Work: The Dynamics of Job Segregation by Sex during World War II* (Urbana: University of Illinois Press, 1987).

35. Advertisement, "American Heroines," *GH,* May 1943, Record Group I, Series 7, Box OS-19B, APR.

36. Advertisement, "She Brought Loveliness to the Halls of Montezuma," 1944, ACC, http://digital.hagley.org/cdm/ref/collection/p15017coll20/id/17.

37. Advertisement, "Her Courage Lives Today," 1945, ACC, http://digital.hagley.org/cdm/ref/collection/p15017coll20/id/13.

38. Henry Bachler, "It's Coming Soon: All About Avon's Great New Advertising Campaign," *Avon Outlook,* March 1943, 17, HID.

39. Advertisement, "Heroines of Yesterday and Today."

40. "'Miss Avon' Always Is Welcome at the House Next Door," *Avon Outlook,* May 5–June 3, 1944, 6, HID; "Backing You Up 100%," *Avon Outlook,* October 9–October 28, 1944, 9–12, HID.

41. "Avon's New American Heroine Advertising Touches Hearts of Millions of Readers," *Avon Outlook,* August 16–September 4, 1943, 21, HID.

42. Manko, "'Ding Dong! Avon Calling!,'" 241.

43. "The Year Was 1886," *Avon Outlook,* May 24–June 12, 1943, 2–3, HID.

44. Ibid. See also, for example, "You Have Demonstrated Your Ability since the Beginning," *Avon Outlook,* June 14–July 3, 1943, 6–7, HID; Cover illustration, *Avon Outlook,* May 20–June 9, 1941, HID.

45. Advertisements, 1945–1946, Record Group I, Series 7, Boxes OS-18A and OS-18B, APR; Advertisement, "Honoring a Wave," 1948, ACC, http://digital.hagley.org/cdm/ref/collection/p15017coll20/id/16.

46. While letters in the Avon museum correspondence file begin by expressing viewpoints on the museum project, some segue into discussions of other practical matters, including product availability, training, payment, and illness. Avon Ladies' commentary on such matters does not otherwise feature prominently in the corporation's archival collection. For example, see Dora Cardinal to R. Myers, July 9, 1945; Mrs. W. J. Bay[illegible] to Dear Sir, June 11, 1945; Mrs. A. E. Jennings to Henry Bachler, May 26, 1945, all in Record Group II, Series 10, Box 130, museum correspondence, APR.

47. Lindsey Feitz, review of APR and of *Avon Celebrating Women for 125 Years: Avon Historical Archive at the Hagley Library,* Digitized Collection, *Public Historian* 33, no. 4 (2011): 116.

48. Monroe F. Dreher, Inc., "Company Museum for Avon Products Inc.," 1945, Record Group II, Series 10, Box 130, Avon Museum Prospectus Folder, APR. The Dreher offices were noted for displaying artifacts of advertising history, an extension of founder Monroe Dreher's collecting hobby. Photo essay, *Tide*, June 15, 1943, 86, Box 1, Job Survey 1942–1943 Folder, AWNY SHSW.

49. Manko, "'Ding Dong! Avon Calling!,'" 176–177, 198–206.

50. Ibid., 246; Monroe F. Dreher, Inc., "Company Museum for Avon Products Inc.," 1945, Record Group II, Series 10, Box 130, Avon Museum Prospectus Folder, APR.

51. Henry L. Bachler to "Sales Associate," May 23, 1945, Record Group II, Series 10, Box 130, museum correspondence, APR.

52. J. D. Johnson to Mr. Bachler, June 22, 1945, Record Group II, Series 10, Box 130, museum correspondence, APR.

53. Carrie Abbott to Henry L. Bachler, June 4, 1945, Record Group II, Series 10, Box 130, museum correspondence, APR.

54. Mrs. J. C. Gebs to Dear Sir, June 11, 1945; Cora Wallick Shambarger to Dear Sir, June 6, 1945; Mrs. J. C. Gebs to Mr. Bachler, March 31, 1946, Record Group II, Series 10, Box 130, museum correspondence, APR.

55. Mrs. Fred A. Smith to Henry Bachler, December 8, 1945, Record Group II, Series 10, Box 130, museum correspondence, APR.

56. Hazel Frist to Henry Bachler, July 17, 1945, Record Group II, Series 10, Box 130, museum correspondence, APR.

57. Mrs. F. W. Brady to Henry Bachler, May 31, 1945, Record Group II, Series 10, Box 130, museum correspondence, APR.

58. Bertha Callan to Mr. Bachler, June 28, 1945, Record Group II, Series 10, Box 130, museum correspondence, APR.

59. A. M. Cole to Dear Sir, June 8, 1945, Record Group II, Series 10, Box 130, museum correspondence, APR.

60. Florence Kohli to Henry Bachler, July 19, 1945, Record Group II, Series 10, Box 130, museum correspondence, APR.

61. Ibid.

62. Miss Carter to Henry Bachler, July 22, 1945, Record Group II, Series 10, Box 130, museum correspondence, APR.

63. Allen L. Woll, *The Hollywood Musical Goes to War* (Chicago: Nelson-Hall, 1983), ix.

64. Tim Carter, *Oklahoma! The Making of an American Musical* (New Haven, CT: Yale University Press, 2008), 80.

65. Raymond Knapp, *The American Musical and the Formation of National Identity* (Princeton, NJ: Princeton University Press, 2005), 122–124, 130–131; Richard Rodgers and Oscar Hammerstein II, *Oklahoma! A Musical Play* (London: Williamson Music Ltd., 1954).

66. Ethan Mordden, *Beautiful Mornin': The Broadway Musical in the 1940s* (New York: Oxford University Press, 1999), 97–101.

67. Raymond Knapp, *The American Musical and the Performance of Personal Identity* (Princeton, NJ: Princeton University Press, 2010), 209.

68. Andrea Most, *Making Americans: Jews and the Broadway Musical* (Cambridge, MA: Harvard University Press, 2004), 142–152.

69. Jeanine Basinger, *A Woman's View: How Hollywood Spoke to Women* (Hanover, NH: Wesleyan University Press, 1993), 468–470.

70. George Sidney, commentary [supplementary material on DVD], *The Harvey Girls*, directed by George Sidney (Metro Goldwyn Mayer, 1946; Warner Home Video, 2002), DVD; Stephen Fried, *Appetite for America: Fred Harvey and the Business of Civilizing the Wild West—One Meal at a Time* (New York: Bantam Books, 2011), 373; Woll, *Hollywood*

Musical Goes to War, ix; Ronald W. Lackmann, *Women of the Western Frontier in Fact, Fiction, and Film* (Jefferson, NC: McFarland, 1997), 146.

71. *The Harvey Girls* promotional brochure, Decca Records, Inc., 1945, Box 33, Folder 11, HWP.

72. *The Harvey Girls*, directed by George Sidney.

73. J. E. Smyth, *Reconstructing American Historical Cinema: From Cimarron to Citizen Kane* (Lexington: University Press of Kentucky, 2006), 37–39, 120–122.

74. Marisa Kay Brandt, "'Necessary Guidance': The Fred Harvey Company Presents the Southwest" (PhD diss., University of Minnesota, 2011), 182–183.

75. *Life*, November 13, 1944, 117; March 5, 1945, 54.

76. *Life*, December 24, 1945, 94. See also July 16, 1945, 81; October 1, 1945, 56; February 11, 1946, 90.

77. In his 1987 Directors Guild of America oral history interview with Irene Atkins and Brooks Jacobsen, George Sidney characterized the saloon workers as prostitutes. Interview transcript, 87–95, George Sidney Collection, Archives Center, NMAH.

78. *The Harvey Girls* promotional brochure.

79. "It's a Great Big World," music by Harry Warren and lyrics by Johnny Mercer, used by permission of Alfred Music Publishing Co., Inc.

80. Midori V. Green, "Sec's Appeal: The Secretary in American Popular Culture, 1872–1964" (PhD diss., University of Minnesota, 2012), 93.

81. Frederica Sagor Maas, *The Shocking Miss Pilgrim: A Writer in Early Hollywood* (Lexington: University Press of Kentucky, 1999), 232–234.

82. Edward Jablonski, *Gershwin: A Biography*, rev. ed. (New York: Da Capo Press, 1998), 347–350.

83. Maas, *Shocking Miss Pilgrim*, 239.

84. This narrative of liberation simplified history. As the typewriter became the domain of women, new managerial opportunities emerged for men and secretarial work declined in status. Angel Kwolek-Folland, *Engendering Business: Men and Women in the Corporate Office, 1870–1930* (Baltimore: Johns Hopkins University Press, 1994), 1–14.

85. Jablonski, *Gershwin*, 349; Box Office Barometer [regular column], *Box Office Magazine*, February 8, 1947, 38; February 15, 1947, 42; February 22, 1947, 24; March 1, 1947, 36.

86. Exhibitors ranked Grable the highest or second-highest female box office draw every year from 1942 to 1951. In 1947, Grable began a five-year streak heading the list. Adrienne L. McLean, "Betty Grable and Rita Hayworth: Pinned Up," in *What Dreams Were Made Of: Movie Stars in the 1940s*, ed. Sean Griffin (New Brunswick, NJ: Rutgers University Press, 2011), 191; Basinger, *A Woman's View*, 509–510.

87. Remington Rand typewriter division memo, "20th Century Fox Publicity Tie-in with *The Shocking Miss Pilgrim*," April 9, 1946, Box 2, Folder 8, SRC.

88. Sales Promotion Department, Remington Rand Inc. to B. J. Shepherd, February 6, 1947, Box 2, Folder 6, SRC. The modern product and fashions were not in the film.

89. A. H. Barsh to George W. Fotis, February 6, 1947, Box 2, Folder 6, SRC.

90. Sam Shain, press release, "Shocking Miss Pilgrim Stunt Gets Newspaper Publicity in Fresno, CA," Box 2, Folder 8, SRC.

91. Remington Typewriter, "The Invention of the Typewriter," Box 1, Folder 10, SRC.

92. Walter Winchell radio transcript, "Now is the Time for All Good Men. . . ." Box 2, Folder 8, SRC; Remington Rand typewriter division memo.

93. Advertisement, "Shocking in 1873 . . . Essential Today," Box 2, Folder 7, SRC.

94. Image proof, August 26, 1946, Box 2, Folder 7, SRC; Remington Rand Company, *Memo: How to Be a Super Secretary*, 1945, HID, http://cdm16038.contentdm.oclc.org /cdm/ref/collection/p268001coll12/id/16559.

95. Photograph and memo, L. E. Perkins to George Fotis, March 26, 1947, Box 2, Folder 7, SRC.

96. Maas, *Shocking Miss Pilgrim*, 14, 19.

97. Ibid., 8.

98. Ibid., 11.

99. Ibid., 243–247.

100. Ibid., 246–247.

101. Ibid., 248–253.

102. Stephanie Coontz, *A Strange Stirring: The Feminine Mystique and American Women at the Dawn of the 1960s* (New York: Basic Books, 2011), 47–52; Susan J. Douglas, *Where the Girls Are: Growing Up Female with the Mass Media* (New York: Times Books, 1994), 48. For an overview of women in 1940s and 1950s films, see Molly Haskell, *From Reverence to Rape: The Treatment of Women in the Movies*, 2nd ed. (Chicago: University of Chicago Press, 1987), 189–276.

103. Coontz, *Strange Stirring*, 59.

104. Dorothy Sue Cobble, *The Other Women's Movement: Workplace Justice and Social Rights in Modern America* (Princeton, NJ: Princeton University Press, 2004).

105. Marc Levinson, *The Great A&P and the Struggle for Small Business in America* (New York: Macmillan, 2011), 55, 284n4; United States Patent Office, *Annual Report of the Commissioner of Patents for the Year 1903* (Washington, DC: Government Printing Office, 1904), 617; Hearn Company, "Mother's Brand" tomato package label proof, October 20, 1915, Food Box 22, Misc. Labels F–K, WCBA; A&P "Grandmother's Bread" package, n.d., Bakers and Baking Box OS 82, Folder 1, WCBA.

106. Katherine J. Parkin, *Food Is Love: Food Advertising and Gender Roles in Modern America* (Philadelphia: University of Pennsylvania Press, 2006), 43–49.

107. Corporate invocation of colonial legacies also flourished in patriotic 1940s advertisements. Parkin, *Food Is Love*, 93–97.

108. *Northwest Life*, December 1944, 14; *Woman's Day*, September 1944, 20.

109. *Pillsbury's Diamond Anniversary Recipes: Celebrating Three-Quarters of a Century of Food Pioneering* (Minneapolis: Pillsbury Flour Mills Company, 1944), Minnesota Historical Society.

110. On visual clichés of the male protector role, see Erving Goffman, *Gender Advertisements* (New York: Harper & Rowe, 1979), 28, 32, 39, 40, 57, 65.

111. *Pillsbury's Diamond Anniversary Recipes.*

112. Introduction to "Cookies" section, in *Pillsbury's Diamond Anniversary Recipes.*

113. *Pillsbury's Diamond Anniversary Recipes.*

114. Research Department, *McCall's* magazine, "Consumer Market for Baking Mixes," February 19, 1948, 1–2, Box 3, Folder 17, CCSP.

115. Cramer Products Company to Dear Sir, n.d., Box 3, Folder 15, CCSP; John Ranck, "This Is America!" *Industrial Press Service*, October 16, 1944, Box 9, Folder 4, CCSP.

116. Cramer Products Company, "These New Joy Cake and Muffin Mixes Are Hot Sellers," 1942, Box 3, Folder 17, CCSP.

117. Cramer Products Company, "Reproduction of Current Newspaper Advertising," n.d., Box 3, Folder 17, CCSP.

118. Cramer Products Company, "These New Joy Cake and Muffin Mixes Are Hot Sellers."

119. Cramer Products Company to Dear Sir.

120. Ibid.; Joy products prepared mix packaging, Box 3, Folder 14, CCSP.

121. Cramer Products Company, "Our Work, Your Family's Delight," n.d., Box 3, Folder 14, CCSP.

122. Amy S. Babilot, response to August 28, 1947, form; and Angelina Amiano, response to August 28, 1947, form, Box 3, Folder 17, CCSP.

123. Edna P. Farrington, response to August 28, 1947, form, Box 3, Folder 17, CCSP.

124. Laura Shapiro, *Something from the Oven: Reinventing Dinner in 1950s America* (New York: Viking, 2004), 75–77.

125. Quoted in Parkin, *Food Is Love*, 43.

126. Soap collection binder, Virgil Whyte Collection, Box 6, Archives Center, NMAH.

127. Lux soap advertisements: *GH*, June 1934, 119; October 1937, 115; February 1942, 79; February 1945, 137.

128. The association of embroidery with luxury reflects the task's evolution: after mechanization replaced the stitchery women performed as part of their education and household labor, fancy needlework and quilting became leisure hobbies signifying a woman's status. While many women expressed pride in this creative expression, late nineteenth- and early twentieth-century feminist writers described time-consuming needlework as a symbol of women's wasted potential. Rachel P. Maines, *Hedonizing Technologies: Paths to Pleasure in Hobbies and Leisure* (Baltimore: Johns Hopkins University Press, 2009), 63–79.

129. On the initial mythologization of such handiwork, see Laurel Thatcher Ulrich, *The Age of Homespun: Objects and Stories in the Creation of an American Myth* (New York: Knopf, 2001).

130. *Woman's Day*, September 1940, 10. Ellipses and emphasis appear in the original.

131. Regina Lee Blaszczyk, *Imagining Consumers: Design and Innovation from Wedgwood to Corning* (Baltimore: Johns Hopkins University Press, 1999), 86; China give-away photographs, Series 4, Box 12, Folder 3; Undated flier, "Victory by Salem: A New Shape of Unparalleled Beauty," Series 3, Box 7, Folder 3, SCCC.

132. Advertisement mats, Series 3, Box 7, Folder 4, SCCC.

133. Promotional photograph, Series 3, Box 13, Folder 4, SCCC; Advertisement half-tone, "Salem Leaders in 1939: A New Shape to Lead in 1940," Series 5, Box 18, Folder 2, SCCC; Form, Deco No. 11/UF/82, Series 5, Box 18, Folder 1, SCCC. This advertisement promoted the line's previous success.

134. Advertisement proof, "We Want You to Have This Lovely Dinner Set," Series 5, Box 18, Folder 5, SCCC.

135. Promotional brochure, Series 5, Box 17, Folder 3, SCCC.

136. Virginia Soltow, "Childhood Hobby Wins National Acclaim for Mrs. A. B. Snyder," *Sunday World Herald* (Omaha, NE), July 6, 1947, Series 5, Box 16, Folder 11, SCCC; Grace Snyder, as told to Nellie Irene Snyder Yost, *No Time on My Hands* (Lincoln: University of Nebraska Press, 1986), 528; Clipping, "Flats Ranchwife Shows Prize Quilts," n.d., Series 5, Box 16, Folder 11, SCCC.

137. Soltow, "Childhood Hobby Wins National Acclaim for Mrs. A. B. Snyder"; International Quilt Study Center and Museum, University of Nebraska—Lincoln, "Grace Snyder: A Life in Extraordinary Stitches," http://www.quiltstudy.org/exhibitions/online_exhibitions/grace_snyder/snyder.html. In 2013, NET Learning Services, the International Quilt Study Center and Museum, and the Nebraska State Historical Society produced an online educational module deploying Snyder's quilts to narrate Nebraska history, http://nequilters.org.

138. "Flats Ranchwife Shows Prize Quilts"; Salem China Co. memo, F. W. McKee to Jim, July 30, 1947, Series 5, Box 16, Folder 11, SCCC.

139. Snyder, *No Time on My Hands*, 530. Emphasis appears in the original.

140. Ibid., 528–529.

141. Grace Snyder to F. W. McKee, July 20, 1947; Salem China Co. memo, F. W. McKee to Jim, July 30, 1947; Eleanor Spencer to F. W. McKee, July 28, 1947, all in Series 5, Box 16, Folder 11, SCCC.

142. Wendelin Grossman to Grace Snyder, transcribed in Snyder, *No Time on My Hands*, 529–530.

143. Shelley Nickles, "More Is Better: Mass Consumption, Gender, and Class Identity in Postwar America," *American Quarterly* 54, no. 4 (2002): 581–622.

144. Photograph, Series 5, Box 14, Folder 24, SCCC; Blaszczyk, *Imagining Consumers*, 259; "Build-A-Set [sic] The Best Friend Your Grocer Ever Had," February 1, 1954, Series 3, Box 7, Folder 4, SCCC; J. A. Armstrong, "Special Bulletin to Our Retail Salesmen," February 3, 1954, Series 3, Box 7, Folder 4, SCCC.

145. Whitman's Chocolates advertising proofs, Series 3, Box 470, Ayer; Whitman's Chocolates advertisement, *Life*, November 6, 1944, 92.

146. Wendy Woloson, *Refined Tastes: Sugar, Confectionery, and Consumers in Nineteenth-Century America* (Baltimore: Johns Hopkins University Press, 2003), 207; Whitman's Sampler chocolate boxes, Whitman's Chocolate Collection, Division of Work and Industry, NMAH.

147. Maines, *Hedonizing Technologies*, 83.

148. N. W. Ayer & Son, Inc., advertising proof, *Poor Richard's Almanack*, January 1956, Series 3, Box 470, Whitman 1957–1959 folder, Ayer.

149. *Poor Richard's Almanack*, January 1956, Franklin Collection, Library of Congress Rare Books and Special Collections.

150. N. W. Ayer & Son, Inc., advertising proof. Ellipses in original.

151. Ibid.

152. Ibid.

153. Woloson, *Refined Tastes*, 207.

154. Pet Incorporated, *The Story of Samplers* (Philadelphia: Philadelphia Museum of Art, 1971); Judy Chicago and Susan Hill, *Embroidering Our Heritage: The Dinner Party Needlework* (Garden City, NY: Anchor Books, 1980).

155. Advertisement, "You Can Embroider Favorite Museum Samplers from Easy-to-Follow Kits," *Ladies' Home Journal*, December 1974, 162.

CHAPTER 6 — "YOU'VE COME A LONG WAY, BABY": WOMEN'S HISTORY IN CONSUMER CULTURE FROM WORLD WAR II TO WOMEN'S LIBERATION

1. "First Federal Salutes WAC in 'The Grand Old American Ad' Windows," *Ad Chat*, June 1968, Box 1, Folder 11, WACCP; "Minutes of Ninth Meeting, Board of Directors," March 19, 1968, Box 1, Folder 7, WACCP, Supplement IV.

2. "Ad Club, First Federal Co-Op on May Windows," *Ad Chat*, May 1968, Box 1, Folder 11, WACCP.

3. "First Federal Salutes WAC in 'The Grand Old American Ad' Windows"; "Minutes of Twelfth Meeting, Board of Directors," June 13, 1968, Box 1, Folder 7, WACCP, Supplement IV.

4. "Minutes of Twelfth Meeting."

5. Juliann Sivulka, *Ad Women: How They Impact What We Need, Want, and Buy* (Amherst, NY: Prometheus Books, 2009), 202–223.

6. Dorothy Dignam, statement for *Charm* requested by Eileen Murphy, 1950, Box 1, Job Survey 1950 Folder, AWNY SHSW.

7. On variety within feminist activism, see Alice Echols, *Daring to Be Bad: Radical Feminism in America, 1967–1975* (Minneapolis: University of Minnesota Press, 1989), 1–22; and Stephanie Gilmore, *Groundswell: Grassroots Feminist Activism in Postwar America* (New York: Routledge, 2013), 12–14.

8. Betty Friedan, *The Feminine Mystique*, 20th anniversary ed. (1963; New York: Laurel, 1984), 206.

9. Stephanie Coontz, *A Strange Stirring: "The Feminine Mystique" and American Women at the Dawn of the 1960s* (New York: Basic Books, 2011), 81–99; Joanne Meyerowitz, "Beyond the Feminine Mystique: A Reassessment of Postwar Mass Culture, 1946–1958," *Journal of American History* 79, no. 4 (1993): 1455–1456.

10. Echols, *Daring to Be Bad*, 92–101; Susan J. Douglas, *Where the Girls Are: Growing Up Female with the Mass Media* (New York: Times Books, 1995), 157–161; New York Radical Women, press release, August 22, 1968, "No More Miss America!" http://www .redstockings.org/index.php?option=com_content&view=article&id=65&Itemid=103/.

11. Echols, *Daring to Be Bad*, 195–197, 208–209; Jennifer Scanlon, *Bad Girls Go Everywhere: The Life of Helen Gurley Brown* (New York: Oxford University Press, 2009), 178–179.

12. Friedan, *Feminine Mystique*, 33–68.

13. Friedan, *Feminine Mystique*, 34–35.

14. Meyerowitz, "Beyond the Feminine Mystique," 1455–1482.

15. Richard Harrity and Ralph G. Martin, "Eleanor Roosevelt: Her Life in Pictures," 51–56, 58, 60, 62–63; and Virginia Claiborne Orr, "Magnolias for Shade," 40–41, 79, 81, 84–85, 88, 92–94, 98–100, 102, 107, both in *McCall's*, October 1958. For this sample, each page containing a reference to women's history was counted.

16. Caitlyn Kamm and Sara B. Marcketti, "Illustrating the Future for Smart Young Women: *Mademoiselle* Magazine, 1946–1959," *Studies in American Culture* 36, no. 1 (2013): 105–123.

17. Mary Ellen Zuckerman, "*McCall's*," in Kathleen L. Endres and Therese L. Lueck, *Women's Periodicals in the United States: Consumer Magazines* (Westport, CT: Greenwood, 1995), 222; *Information Please Almanac* (New York: Simon and Schuster, 1947, 1954, 1958, 1965), s.v. "Leading Magazines: United States and Canada."

18. After William Moulton Marston's death in 1947, *Wonder Woman* increased its emphasis on romance and family. Shortened "Wonder Women of History" biographies continued appearing sporadically in *Sensation Comics*. Rebecca Munford and Melanie Waters, *Feminism and Popular Culture: Investigating the Postfeminist Mystique* (New Brunswick, NJ: Rutgers University Press, 2014), 3–4; Lillian S. Robinson, *Wonder Women: Feminisms and Superheroes* (New York: Routledge, 2004), 78–79; Les Daniels, *Wonder Woman: The Complete History* (San Francisco: Chronicle Books, 2004), 102; Jill Lepore, *The Secret History of Wonder Woman* (New York: Knopf, 2014), 382n38.

19. Gary A. Yoggy, "Prime-Time Bonanza! The Western on Television," in *Wanted Dead or Alive: The American West in Popular Culture*, ed. Richard Aquila (Urbana: University of Illinois Press, 1996), 160, 164, 179; Eric Burns, *Invasion of the Mind Snatchers: Television's Conquest of America in the Fifties* (Philadelphia: Temple University Press, 2000), 109.

20. Friedan, *Feminine Mystique*, 37–46; Meyerowitz, "Beyond the Feminine Mystique," 1455–1482.

21. Nancy A. Walker, *Shaping Our Mothers' World: American Women's Magazines* (Jackson: University Press of Mississippi, 2000).

22. Friedan, *Feminine Mystique*, 44.

23. Erik Christiansen, *Channeling the Past: Politicizing History in Postwar America* (Madison: University of Wisconsin Press, 2013), 79.

24. Martin Grams Jr., *The History of the Cavalcade of America* (Kearney, NE: Morris, 1998); Christiansen, *Channeling the Past*, 80, 249n61.

25. Gary Edgerton, *The Columbia History of American Television* (New York: Columbia University Press, 2013), 87–88.

26. Donald R. Boyle, "An Evaluation and Historical Survey of *Kraft Television Theatre*, 1947–1958," (MA thesis, Temple University, 1964), 64.

27. Tom Wiener interview of Fran Holland, April 13, 1992, KTTOHP; Jessamyn Neuhaus, *Housework and Housewives in American Advertising: Married to the Mop* (New York: Palgrave Macmillan, 2011), 122.

28. Boyle, "Evaluation and Historical Survey of *Kraft Television Theatre*," 64.

29. "KTT 1948–58 Chronological Listing," Box 1, Folder 12, KTTOHP; Broadcast recording, "Gramercy Ghost," April 20, 1955, NBC Television Collection, Library of Congress.

30. "KTT 1948–58 Chronological Listing"; Kraft Television Theatre Alphabetical Listing, Box 1, Folder 13, KTTOHP.

31. "KTT 1948–58 Chronological Listing"; Tom Wiener interview of Fran Holland; Tom Wiener interview of Al Durante, July 8, 1992; Tom Wiener interview of Fielder Cook, 1992, all in KTTOHP. The Ross source material appeared in John F. Kennedy, *Profiles in Courage* (1956; New York: Harper Perennial Modern Classics, 2006), 115, 134.

32. Leigh Goldstein, "'This Week on the Hallmark Hall of Fame . . . ': The Episodic Drama of Feminine Discontent in 1950s American Television," paper presented at the annual meeting of the American Historical Association, January 3, 2013.

33. "Television Programs This Week," *NYT*, May 2, 1954, X11, PQHN; "Story of 'Petticoat Revolution' Told," *Charleston* (WV) *Daily Mail*, May 2, 1954, Newspapers.com, http://www.newspapers.com/image/36740762.

34. Friedan, *Feminine Mystique*, 82–83. Friedan referenced a 1960 broadcast, not specifying the series. There were no highly-publicized broadcasts of *A Doll's House* that year.

35. Elaine Tyler May, *Homeward Bound: American Families in the Cold War Era*. Rev. and updated ed. (New York: Basic Books, 1999), 16.

36. Marie Kimball, "Feast Days at Monticello," *McCall's*, November 1955, 42; Hermann Hagedorn, "Good Living at Teddy Roosevelt's," *McCall's*, June 1956, 38; Christine Sadler, "Arlington: Robert E. Lee's House of Decision," *McCall's*, January 1959, 32; Anne Colver, "At Home with the Abraham Lincolns," *McCall's*, February 1957, 54. On photographic depictions of cooking, see Karal Ann Marling, *As Seen on TV: The Visual Culture of Everyday Life in the 1950s* (Cambridge, MA: Harvard University Press, 1994).

37. Sarah Leavitt, *From Catharine Beecher to Martha Stewart: A Cultural History of Domestic Advice* (Chapel Hill: University of North Carolina Press, 2002), 173.

38. Advertisement, "Imagine! You Can Make Yellow Cake Inspired by a Favorite Recipe of Abraham Lincoln's Wife," *McCall's*, January 1956, 95; Advertisement, "Now You Can Bake White Cake Inspired by a Favorite Recipe of Mrs. James Monroe," *McCall's*, April 1956, 117; Advertisement, "Now! Bake Devil's Food Cake Inspired by a Favorite Recipe Used in the Home of President Theodore Roosevelt," *McCall's*, March 1956, 74. Other advertisements in the series include *McCall's*, February 1957, 111; *McCall's*, March 1957, 122; *McCall's*, April 1957, 131; and *McCall's*, May 1957, 103.

39. E. B. Weiss, "Coming—a Gay '90s Fad," *Advertising Age*, August 11, 1958, 54.

40. See, for example, Duncan Hines advertisements: *McCall's*, August 1961, 176; and *McCall's*, October 1961, 217.

41. "Step-by-Step to Old-Fashioned Icebox Cookies," *McCall's*, June 1962, 125; Elizabeth Sweeney Herbert et al., "Blend It Round [*sic*] the Clock," *McCall's*, November 1963, 76.

42. Mary Davis Gillies, "Country Airs," *McCall's*, July 1961, 55; Mary Davis Gillies, "Perfect Accents," *McCall's* October 1962, 118.

43. Mary Davis Gillies, "More Than a Tick and a Tock," *McCall's*, October 1961, 100.

44. Eileen Herbert Jordan, "The Cradle," *McCall's*, June 1960, 66.

45. Jack Finney, "Where the Cluetts Are," *McCall's*, January 1962, 72. Another portrayal of a ghostly rescue of a modern woman's domestic happiness is George Summer Albee, "The Strange Family in the Old Stone House," *McCall's*, June 1962, 85.

46. John F. Kennedy, "Three Women of Courage," *McCall's*, January 1958, 37; The Editors, "Eminent Women," *McCall's*, May 1959, 55–57, 125; Leonard Slater, "Woman's Suffrage," *McCall's*, September 1961, 93.

47. Elizabeth Hardwick, "The Feminine Principle," *Mademoiselle*, February 1958, 133, 178–180.

48. Ibid., 133.

49. Ibid., 180.

50. This Week in Negro History, *Jet*, December 13, 1951, 25; Yesterday in Negro History, *Jet*, October 22, 1953, 10.

51. For example, see "Findings in Two New Books Show Negroes Making Impressive Gains," *Jet*, November 1, 1962, 48–49. *Jet* also highlighted public recognition for women's historical roles in supporting civil rights, noting Prudence Crandall's inclusion in Kennedy's *McCall's* article. "Negro Rights Pioneer Called 'Woman of Courage,'" *Jet* January 16, 1958, 49.

52. Lerone Bennett Jr., "Should Schools Teach Negro History? Whites and Negroes Hurt When History is Ignored," *Jet*, February 28, 1963, 18–20.

53. Bethune had received some mainstream recognition in a 1952 *Reader's Digest* story. Meyerowitz, "Beyond the Feminine Mystique," 1462.

54. "Dolls for Democracy," *Ebony*, December 1961, 93–98; "Harlem's Antique Collector," *Ebony*, April 1963, 105–110. Reflecting the publication's style, Thurman's and Finkley's given names never appeared.

55. *Useful to the Community*, 1948, 3, 12–13, Box 12, PCAWR; Inger L. Stole, *Advertising at War: Business, Consumers, and Government in the 1940s* (Urbana: University of Illinois Press, 2012), 12, 66.

56. Wendy L. Wall, *Inventing the "American Way": The Politics of Consensus from the New Deal to the Civil Rights Movement* (New York: Oxford University Press, 2008), 172–200; Stole, *Advertising at War*, 153–157; Dawn Spring, *Advertising in the Age of Persuasion: Building Brand America, 1941–1961* (New York: Palgrave Macmillan, 2011); Daniel L. Lykins, *From Total War to Total Diplomacy: The Advertising Council and the Construction of the Cold War Consensus* (Westport, CT: Praeger, 2003).

57. Stole, *Advertising at War*, 16.

58. Helen Peffer Oakley, "AWNY—An Informal History," in *Golden Salute to Advertising*, ed. Catherine Elsie Ryan (New York: Advertising Federation of New York, 1962), 98; Untitled news item, *Voice of P.A.A.*, October 1945, 3, Box 9, AFA.

59. *Useful to the Community*, 6. Winners of AFA awards appeared prominently in *Advertising Age*.

60. "Club Histories" memo, April 18, 1949, Box 12, Club History Folder, PCAWR. AFA membership was eighteen thousand in 83 clubs across the country. *Useful to the Community*, 5; Harry L. Hawkins to Helen Carroll Corathers, December 6, 1948, Box 12, Club History Folder, PCAWR.

61. *Useful to the Community*, 6.

62. Stole, *Advertising at War*, 182; "Board of Directors Meeting Minutes," August 1, 1946, Carton 1, AWNY Additional Records, SL.

63. "Executive Committee Meeting Minutes," June 6, 1959, Box 5, AFA.

64. Advertising Federation of America, "Blue Print for Club Activity," 1952, Box 3, Folder 27, WACCP; *AFA Bulletin*, April–May 1961, Science, Industry, and Business Library, New York Public Library.

65. Boston was the site for an early merging of preexisting advertising men's and women's clubs in 1926. The male Advertising Club of New York admitted "ladies associate members" in response to low participation during the Depression. Groups welcoming women and men as equal participants tended to be in the West, where membership

pools were smaller. Dorothy Dignam, "'Note on the Founding,' a History of Advertising Women of New York, Inc.," 1952, 7, Box 1, History Folder, AWNY SHSW; Dorothy Dignam, "Section on Relations with Men's Club," n.d., Carton 2, Digests Folder, AWNY 86–M216, SL; Helen Holby, "History of Fed. of Women's Clubs," n.d., Carton 2, Women's Clubs in AFA Folder, AWNY 86–M216, SL; *St. Louis Ad Club Weekly*, June 10, 1951, Box 17, Folder 110, WACCP; "Ad Chatter," *Ad Chat*, November 1951, Box 1, Folder 7, WACCP; "Agreement of Unification," 1974, in "Unification" folder, Women's Advertising Club of Washington Papers, Washingtoniana Division, D.C. Community Archives, Martin Luther King Jr. Memorial Library, Washington, DC; "Photo Review," *Advertising Age*, January 5, 1970.

66. "Ad Chatter," *Ad Chat*, November 1951, 4.

67. Florence F. McClellan to "PCAW Member," n.d. [1955], Box 11, "The Advertising Women Exhibit of 1955 and 1956" folder, PCAWR; "Advertising Women Award Prize for Exhibition," April 10, 1956, George D. McDowell *Philadelphia Evening Bulletin* Photographs, Temple University Libraries, Special Collections Research Center, http://digital.library.temple.edu/cdm/ref/collection/p15037coll3/id/11586.

68. For example, a 1961 issue depicted a scantily clad model posing with a map to promote travel to a Detroit Public Utilities Advertising convention. A 1967 issue simply reproduced an advertisement for California chain Ohrbach's "backless bikinis." Photo Review of the Week, *Advertising Age*, April 17, 1961, 44; Photo Review, *Advertising Age*, June 19, 1967, 76.

69. "Eighth Regular Meeting Minutes," June 20, 1961, Box 2, Folder 6, WACCP, Supplement IV; "Photo Review of the Week," *Advertising Age*, July 19, 1961, 72.

70. Photo, "High Style, Western Style," Carton 8, Photographs 1961–1962 Folder, AWNY 86–M216, SL.

71. "Register of the Dorothy Dignam Papers, 1907–1962 (Bulk 1918–1955)," SHSW; "Dorothy Dignam Papers, 1876–1980: A Finding Aid," SL, http://oasis.lib.harvard.edu/oasis/deliver/~scho0553; Dorothy Dignam to Wilbur K. Jordan, September 22, 1960, Carton 2, Smith and Radcliffe Letters 1962 Folder, AWNY 86–M216, SL; Barbara Miller Solomon to Dorothy Dignam, February 27, 1964, Carton 2, Smith and Radcliffe Letters 1962 Folder, AWNY 86–M216, SL.

72. Catherine Elsie Ryan, ed., *Golden Salute to Advertising* (New York: Advertising Federation of New York, 1962).

73. Florence W. Goldin, "A Message from the President," in Ryan, *Golden Salute to Advertising*, 5.

74. Leila J. Rupp and Verta Taylor, *Survival in the Doldrums: The American Women's Rights Movement, 1945 to the 1960s* (New York and Oxford: Oxford University Press, 1987), 52–59.

75. Eileen Barry Wiseman, "Christine Frederick: Accolade to a First Lady," in Ryan, *Golden Salute to Advertising*, 17.

76. Lenore O. Hershey, "As Others See Us," in Ryan, *Golden Salute to Advertising*, 33.

77. Bernice Fitz-Gibbon, "As We See Them," in Ryan, *Golden Salute to Advertising*, 39, 41–42, 95.

78. Helen Peffer Oakley, "AWNY—An Informal History," in Ryan, *Golden Salute to Advertising*, 63.

79. Ibid., 101.

80. Florence W. Goldin, "A Message from the President."

81. Advertisement in Ryan, *Golden Salute to Advertising*, inside front cover.

82. Advertisement in Ryan, *Golden Salute to Advertising*, 12.

83. Fred Farrar, "Feminine Ad Industry Place Won Long Ago," *Chicago Tribune*, November 21, 1963, PQHN.

84. Friedan, *Feminine Mystique*, 33–68.

85. Ibid., 82.

86. Meyerowitz, "Beyond the Feminine Mystique," 1480–1482.

87. Friedan, *Feminine Mystique*, xi.

88. Daniel Horowitz, *Betty Friedan and the Making of the Feminine Mystique: The American Left, the Cold War, and Modern Feminism* (Amherst: University of Massachusetts Press, 2000), 35.

89. Ibid., 202, 314n14; United Electrical, Radio, and Machine Workers of America, *Women Fight for a Better Life! UE Picture Story of Women's Role in American History*, Pamphlets in American History: Labor, L646 (Sanford, NC: Microfilming Corporation of America, 1979).

90. "New York Women in Huge Parade Demand Ballot," *Chicago Daily Tribune*, May 7, 1911, 1, PQHN.

91. United Electrical, Radio, and Machine Workers of America, *Women Fight for a Better Life!*

92. Horowitz, *Betty Friedan and the Making of the Feminine Mystique*, 133, 237.

93. Ibid., 182–183.

94. "Advertising Women to Cite Jo Foxworth," *Chicago Tribune*, September 21, 1966, PQHN.

95. Jo Foxworth, "The Mistaque in the Feminine Mystique," June 29, 1965, 5–6, Box 3, AFA.

96. Ibid., 10; Walter Carlson, "Advertising: Feminine Mystique Under Fire," *NYT*, June 30, 1965, PQHN; Associated Press, "Ambitious Career Women: Carry a Big—Lipstick!" *Ocala Star-Banner*, July 1, 1965, Google newspapers, https://news.google.com/news papers?id=zWtPAAAAIBAJ&sjid=FQUEAAAAIBAJ&pg=2135%2C1191413.

97. Foxworth, "Mistaque in the Feminine Mystique," 3–4.

98. Ibid., 7. Ellipses appear in the original.

99. Carlson, "Advertising."

100. Ibid.

101. Shulamith Firestone, "The Women's Rights Movement in the U.S.: A New View," in *Notes from the First Year*, by New York Radical Women, June 1968, 2, Documents from the Women's Liberation Movement: An Online Archival Collection, Duke University Special Collections, http://library.duke.edu/digitalcollections/wlmpc_wlmms01037/.

102. Ibid.

103. Raymond Knapp, *The American Musical and the Performance of Personal Identity* (Princeton, NJ: Princeton University Press, 2010), 141–150; Sam Wasson, *A Splurch in the Kisser: The Movies of Blake Edwards* (Middletown, CT: Wesleyan University Press, 2009), 98–108; Harry M. Benshoff and Sean Griffin, *America on Film: Representing Race, Class, Gender, and Sexuality at the Movies*, 2nd ed. (Oxford: Wiley-Blackwell, 2009), 280.

104. Firestone, "The Women's Rights Movement," 2–3.

105. Genevieve T. Raymond, *A Half-Century of Service to Advertising and the Community, 1917–1967*, 3, Box 3, Folder 31, WACCP.

106. Ibid., 9, 26–27; Lois Winterberg, Memo to Anniversary Year Committee, May 2, 1967, Box 3, Folder 32, WACCP.

107. JWAC members were women under thirty, either employed below the executive level in advertising or planning future advertising careers. Raymond, *A Half-Century of Service to Advertising and the Community*, 13; "Junior Women's Advertising Club Bylaws," April 1952, Box 4, Folder 5, WACCP, Supplement II.

108. "Christmas Is a Red Balloon," *Chicago's Advertising Woman*, January 1968, Box 1, Folder 11, WACCP.

109. "It Was a Happy 50th Birthday Party . . . and a Very Merry Christmas Party," *Chicago's Advertising Woman*, January 1968, Box 1, Folder 11, WACCP.

110. "Platform and Podium Limelighters," *Chicago's Advertising Woman*, February 1968, Box 1, Folder 11, WACC Records; "It Was a Happy 50th Birthday Party."

111. "Platform and Podium Limelighters."

112. Scanlon, *Bad Girls Go Everywhere*, ix–xv.

113. Hal Weinstein, "How an Agency Builds a Brand—the Virginia Slims Story," Papers from the 1969 American Association of Advertising Agencies Region Conventions, 20, LTDL, https://www.industrydocumentslibrary.ucsf.edu/tobacco/docs/xgdg0122.

114. "Virginia Slims Filter 100s," n.d., LTDL, https://www.industrydocumentslibrary.ucsf.edu/tobacco/docs/srnn0139; Weinstein, "How an Agency Builds a Brand."

115. Weinstein, "How an Agency Builds a Brand," 7.

116. Ibid., 15–16.

117. Advertisement proof for *Women's Wear Daily*, October 28, 1968, LTDL, https://www.industrydocumentslibrary.ucsf.edu/tobacco/docs/prdco111.

118. "First Federal Salutes WAC in 'The Grand Old American Ad' Windows."

119. Weinstein, "How an Agency Builds a Brand," 19; "News Flash! Virginia Slims: The San Francisco Success Story," September 4, 1968, LTDL, https://www.industrydocumentslibrary.ucsf.edu/tobacco/docs/ffpm0117; Advertisement, *Life*, October 18, 1968, 27 and *Independent Star-News* (Pasadena, CA), October 20, 1968, 86, Newspapers.com, http://www.newspapers.com/image/31813189.

120. "News Flash! Virginia Slims"; "Virginia Slims Filter 100s"; "Virginia Slims Menthol," n.d., LTDL, https://www.industrydocumentslibrary.ucsf.edu/tobacco/docs/mjnn0139.

121. Dan Kamin, *The Comedy of Charlie Chaplin: Artistry in Motion* (Lanham, MD: Scarecrow Press, 2008), 31–32.

122. Commercial beginning at 11:30, Virginia Slims reel 1968D, Internet Archive, University of California, San Francisco Tobacco Industry Videos, https://archive.org/details/tobacco_ndo23eoo; Leo Burnett Company, Inc., "Beach" commercial script, LTDL, https://www.industrydocumentslibrary.ucsf.edu/tobacco/docs/gghvo117.

123. Commercials beginning at 1:30 and at 2:50, Virginia Slims reel 1968D.

124. See, for example, commercial beginning at 37:15, Virginia Slims reel 1968D; and Advertisement, *Jet*, December 16, 1971, 2.

125. "Virginia Slims Filter 100s."

126. Weinstein, "How an Agency Builds a Brand," 19.

127. Commercial beginning at 9:26, Virginia Slims reel 1968D; Leo Burnett Company, Inc., "Cradle" commercial script, LTDL, https://www.industrydocumentslibrary.ucsf.edu/tobacco/docs/qfhvo117.

128. Commercial beginning at 13:20, Virginia Slims reel 1968D.

129. Philip Morris limited the descriptor *slim* to cigarette and package design. Following government pressure, the industry resolved in 1964 to remove unproven health and weight loss claims from advertising. Allan Brandt, *The Cigarette Century: The Rise, Fall, and Deadly Persistence of the Product That Defined America* (New York: Basic Books, 2007), 200, 259, 325; "Virginia Slims Advertising Study," 1987, Internet Archive, University of California, San Francisco Tobacco Industry Videos, https://archive.org/details/brp23eoo.

130. Inez Robb, "A Puff for Milady," *New York Daily News*, December 30, 1968, LTDL, https://www.industrydocumentslibrary.ucsf.edu/tobacco/docs/spnx0020.

131. "Virginia Slims Filter 100s."

132. Hennie Cisco, "Bright Note," *Chicago's Advertising Woman*, November 1968, Box 17, Folder 103, WACCP; "Virginia Slims Presentation Draft," October 15, 1968, Box 17, Folder 103, WACCP.

133. Cisco, "Bright Note."

134. "Happenings of 1968," *Chicago's Advertising Woman*, January 1969, Box 17, Folder 104, WACCP.

135. Sivulka, *Ad Women*, 290–291.

136. Jane Trahey, "We've Come a Long Way—to What?" *Advertising Age*, March 16, 1970.

137. Friedan, *Feminine Mystique*, 206–232.

138. "Women Rock Boat Rather Than Cradle," *San Bernardino* (CA) *County Sun*, August 26, 1970, 2, Newspapers.com, http://www.newspapers.com/image/61291107.

139. "What Our Congresswomen Think of Women's Lib," *Prescott* (AZ) *Courier*, November 1, 1970, 12, Google newspapers, https://news.google.com/newspapers?id=a6ZMAAAAIBAJ&sjid=aVADAAAAIBAJ&pg=4450%2C3650245.

140. "Who's Come a Long Way, Baby?" *Time*, August 31, 1970, 16–21.

141. B. A. Toll and P. M. Ling, "The Virginia Slims Identity Crisis: An Inside Look at Tobacco Industry Marketing to Women," *Tobacco Control* 14, no. 3 (2005): 176.

142. Brandt, *Cigarette Century*, 271–272.

143. Roper Center for Public Opinion Research, "Virginia Slims American Women's Opinion Polls, 1970–2000," Public Opinion Research Archive, http://ropercenter.cornell.edu/virginia-slims-american-womens-opinion-polls/.

144. Deposition of Ellen Merlo, June 14, 1984, *Rose D. and Antonio Cipollone, Plaintiffs, vs. Liggett Group, Inc., a Delaware Corporation, Philip Morris, Incorporated, a Virginia Corporation, Loew's Theatres, Inc., a New York Corporation, Defendants*, 19, 99–101, LTDL, https://www.industrydocumentslibrary.ucsf.edu/tobacco/docs/jmwc0175.

145. For example, the feminist book *Manifesta* used data from *The 1972 Virginia Slims American Women's Opinion Poll* while also criticizing the cigarette industry. On its website in the 2010s, the consciousness-raising organization Feminist Majority Foundation provided statistics from the 1970s and 1980s Virginia Slims polls to trace growing public acceptance of feminism. Jennifer Baumgardner and Amy Richards, *Manifesta: Young Women, Feminism, and the Future* (New York: Farrar, Straus and Giroux, 2000), 62, 309–310; Feminist Majority Foundation, "Feminists Are the Majority," in *Empowering Women in Business*, http://feminist.org/research/business/ewb_fem.html.

146. Influential works citing the polls include bell hooks, *Ain't I a Woman: Black Women and Feminism* (1981; Cambridge, MA: South End Press Collective, 1999), 148, 187; Paula Giddings, *When and Where I Enter: The Impact of Black Women on Race and Sex in America*, 1984 (New York: Harper Collins, 2001), 345; Susan Faludi, *Backlash: The Undeclared War against American Women* (1991; New York: Three Rivers Press, 2006), 470; Linda K. Kerber and Jane Sherron de Hart, eds., *Women's America: Refocusing the Past* (New York: Oxford University Press, 1987), 464; and Gilmore, *Groundswell*, 32.

147. Gloria Steinem, *My Life on the Road* (New York: Random House, 2015), xviii–xix; Gloria Steinem, "Women Voters Can't Be Trusted," *Ms.*, July 1972, 47–51.

148. "A Personal Report," *Ms.*, July 1972, 4–7; Gloria Steinem, *Moving beyond Words: Age, Rage, Sex, Power, Money, Muscles: Breaking the Boundaries of Gender* (New York: Simon and Schuster, 1994), 141–142; Advertisement, *Ms.*, November 1972, 15.

149. Judith M. Bennett, *History Matters: Patriarchy and the Challenge of Feminism* (Philadelphia: University of Pennsylvania Press, 2006), 65; Fred C. Shapiro, "Lost Women: The Transcending Margaret Fuller," *Ms.*, November 1972, 36–39; Sheila Tobias, "Finding Women's History," *Ms.*, November 1972, 49–50.

150. Steinem, *Moving beyond Words*, 141–142.

151. Gloria Steinem, "Our Revolution Has Just Begun," *Ms.*, Winter/Spring 2014, 27.

152. Ibid.

153. "Product Promotion Plan," August 17–September 25, 1970, LTDL, https://www.industrydocumentslibrary.ucsf.edu/tobacco/docs/khny0109; "Building to #1: Product

Promotion Plan, Fourth Sales Cycle," July 2, 1973, LTDL, https://www.industrydocuments library.ucsf.edu/tobacco/docs/xkxpo109; Marketing Research Department to J. T. Landry, December 27, 1973, "Promotional Activity Report," October 1973, LTDL, https://www.industrydocumentslibrary.ucsf.edu/tobacco/docs/rtddo122; Needle kit, author's collection.

154. Marketing Research Department to Thomas Keim, "Virginia Slims: Evaluation of Nostalgic Matches Promotion," January 13, 1975, 2, LTDL, https://www.industry documentslibrary.ucsf.edu/tobacco/docs/zzyko112.

155. Matchbooks, author's collection.

156. Advertisement proof, *Women's Wear Daily*, 1976, LTDL, https://www.industry documentslibrary.ucsf.edu/tobacco/docs/qlpbo111.

157. Advertisement proof, *Modern Beauty Shops*, November 1973, LTDL, https://www .industrydocumentslibrary.ucsf.edu/tobacco/docs/jnpbo111.

158. Advertisement proof, *Merchandising Week*, n.d., LTDL, https://www.industry documentslibrary.ucsf.edu/tobacco/docs/gxpbo111.

159. W. E. Hook & Son Advertisement, *Daily Messenger* (Canandaigua, NY), November 1, 1973, 16, Newspapers.com, http://www.newspapers.com/image/22217727.

160. Marketing Research Department to Thomas Keim, "Virginia Slims: Evaluation of Nostalgic Matches Promotion," 2.

161. Deposition of Ellen Merlo, June 14, 1984, 18; Ellen Merlo, résumé, 1995, LTDL, https://www.industrydocumentslibrary.ucsf.edu/tobacco/docs/jlgmoo90.

162. "Virginia Slims Filter 100s"; Richard Kluger, *Ashes to Ashes: America's Hundred-Year Cigarette War, the Public Health, and the Unabashed Triumph of Philip Morris* (New York: Vintage Books, 1997), 316, 387–388.

163. James J. Morgan, "A Philosophy for Successful Marketing: Presented to Time Incorporated," February 15, 1979, 8, LTDL, https://www.industrydocumentslibrary.ucsf .edu/tobacco/docs/rjhwo131; Marketing Research Department to Thomas Keim, February 28, 1975, 2, LTDL, https://www.industrydocumentslibrary.ucsf.edu/tobacco /docs/zzyko112.

164. *Book of Days: 1975 Virginia Slims Engagement Calendar* (Philip Morris, 1974), author's collection.

165. Ibid.; Gloria Steinem, "Sex, Lies, and Advertising," *Ms.*, July/August 1990, 18–28.

166. Judith Fryer Davidov, *Women's Camera Work: Self/Body/Other in American Visual Culture* (Durham, NC: Duke University Press, 1998), 385.

167. Marketing Research Department to Thomas Keim and Ellen Merlo, "Virginia Slims: Evaluation of Note Card Promotion," October 23, 1973, LTDL, https://www .industrydocumentslibrary.ucsf.edu/tobacco/docs/skfmo105. This study surveyed 386 smokers who reported approval of the *Book of Days*.

168. Ibid.

169. Marketing Research Department to Thomas Keim, "1974 Virginia Slims Book of Days Offer," March 15, 1974, LTDL, https://www.industrydocumentslibrary.ucsf.edu /tobacco/docs/tkfmo105.

170. Ibid.

171. Marketing Research Department to Thomas Keim, "Virginia Slims: Value of December '74 A-1's," February 7, 1975, LTDL, https://www.industrydocumentslibrary .ucsf.edu/tobacco/docs/fslvo145.

172. Advertising proof, *Ladies' Home Journal*, 1973, LTDL, https://www.industry documentslibrary.ucsf.edu/tobacco/docs/qyybo111; "Slims Notes from the Virginia Slims Collection," LTDL, https://www.industrydocumentslibrary.ucsf.edu/tobacco/docs /tjxdoo49.

173. Marketing Research Department to Thomas Keim, "Virginia Slims: Evaluation of Nostalgic Matches Promotion"; Marketing Research Department to Thomas Keim and Ellen Merlo, "Virginia Slims: Evaluation of Note Card Promotion."

EPILOGUE

1. Laurel Thatcher Ulrich, *Well-Behaved Women Seldom Make History* (New York: Knopf, 2007), 59–61; *Wonder Woman*, Winter 1943.

2. Gloria Steinem, "Wonder Woman: An Introduction," in *Wonder Woman: A Ms. Book*, by William Moulton Marston (New York: Holt, Rinehart and Winston and Warner Books, 1972).

3. Charles Moulton, "Introducing Wonder Woman" (1941); Charles Moulton, "Battle for Womanhood" (1943); Charles Moulton, "The Redskins' Revenge" (1946); Charles Moulton, "The Mysterious Prisoners of Anglonia" (1946); Charles Moulton, "Girl from Yesterday" (1949), all in *Wonder Woman*, by Marston.

4. Moulton, "Battle for Womanhood."

5. Moulton, "The Redskins' Revenge."

6. Steinem, "Wonder Woman."

7. Phyllis Chesler, "The Amazon Legacy: An Interpretive Essay," in *Wonder Woman*, by Marston.

8. Rebecca Munford and Melanie Waters, *Feminism and Popular Culture: Investigating the Postfeminist Mystique* (New Brunswick, NJ: Rutgers University Press, 2014), 2.

9. Maria Elena Buszek, *Pin-up Grrrls: Feminism, Sexuality, and Popular Culture* (Durham, NC: Duke University Press, 2006); Elizabeth Groenevald, "'Join the Knitting Revolution': Third-Wave Feminist Magazines and the Politics of Domesticity," *Canadian Review of American Studies* 40, no. 2 (2010): 259–277.

10. Jennifer Baumgardner and Amy Richards, *Manifesta: Young Women, Feminism, and the Future* (New York: Farrar, Straus and Giroux, 2000), 80, 162.

11. Alison Piepmeier, *Girl Zines: Making Media, Doing Feminism* (New York: New York University Press, 2009), 99–103.

12. Kate Eichhorn, *The Archival Turn in Feminism: Outrage in Order* (Philadelphia: Temple University Press, 2013), ix.

13. "Anne Taintor: Making Smart People Smile since 1985," http://www.annetaintor .com/captions/.

14. Jo Anna Isaak, *Feminism and Contemporary Art: The Revolutionary Power of Women's Laughter* (London: Routledge, 2002), 27–46. Taintor's designs parallel work Barbara Kruger and other feminist artists produced in the 1980s.

15. Amy Odell, "See Banana Republic's Complete *Mad Men* Collection," *NYMag.com*, June 23, 2011, http://nymag.com/daily/fashion/2011/06/mad_men_banana_republic .html/; Saphna Maheshwari, "Gap Channels Best Quarter with Banana Republic's Mad Men: Retail," *Bloomberg.com*, May 29, 2012, http://www.bloomberg.com/news/articles / 2012-05-29/gap-channels-best-quarter-with-banana-republic-s-mad-men-retail.

16. "Cocktail Party Planned By Advertising Women," *New York Times*, June 4, 1964, 32, PQHN.

17. Stephanie Coontz, "Why 'Mad Men' Is TV's Most Feminist Show," *Washington Post*, October 10, 2010.

18. Tevi Troy, "What Obama's 'Mad Men' SOTU Moment Tells Us about His Presidency," *Forbes.com*, January 31, 2014, http://www.forbes.com/sites/realspin/2014 / 01/31/what-obamas-mad-men-sotu-moment-tells-us-about-his-presidency/.

19. Helena Andrews, "'Mad Men' Donates Booze Bottle and More to the Smithsonian," *Reliable Source* (blog), washingtonpost.com, March 27, 2015, http://www.washington post.com/blogs/reliable-source/wp/2015/03/27/mad-men-donates-booze-bottle -and-more-to-the-smithsonian/.

20. Roger Catlin, "Don Draper's Gray Suit and Fedora Are among 'Mad Men Props' Donated to the Smithsonian," *Smithsonian.com*, March 27, 2015, http://www.smithson ianmag.com/smithsonian-institution/don-drapers-gray-suit-and-fedora-are-among -mad-men-props-donated-smithsonian-1-180954772/?no-ist.

21. Clorox advertisements, *Mad Men: Season Two* DVD, disc 1 (Santa Monica, CA: Lionsgate Entertainment, 2008).

INDEX

Note: Page references in italic indicate images.

ABOUT THE AUTHOR

EMILY WESTKAEMPER is an assistant professor of history at James Madison University.

Printed in the United States
By Bookmasters